Making a Difference

Libertina I. Amathila

University of Namibia Press
Private Bag 13301
Windhoek
Namibia

Photographs have been drawn from the following sources: Dr Libertina Amathila's personal collection; Isabel Katjavivi; National Archives of Namibia; Office of the Prime Minister (OPM); Per Sanden; *Republikein* newspaper; the SWAPO Party Archives and Research Centre (SPARC); and the UN High Commission for Refugees.

First Published: 2012
Design and layout: John Meinert Printers, Windhoek
Cover design: Ritsuko Shimabukuro Abrahams
Printed by: John Meinert Printers, Windhoek

ISBN: 978-99916-870-8-7

Distribution:
In Namibia by Demasius Publications:
www.demasius-publications.com
In the rest of Southern Africa by Blue Weaver:
www.blueweaver.co.za
Internationally by the African Books Collective:
www.africanbookscollective.com

In memory of my awesome grandmother,
Jerimorukoro Paulina Vihajo Apollus,
who made me what I am today.

Contents

Acknowledgements

I have many people to thank. Firstly, a friend's daughter, Emmarine Lottering, who helped me purchase a laptop and showed me how to use it. Every time my finger touched a wrong key and things became wild, she came running to rescue me from the dangers of modern equipment. Thank you, Emmarine, for being patient with me. Then Kenny Abrahams who was on standby and assisted when I lost it and called on him to bail me out when the laptop refused to do what I wanted it to do. Also for all his help in organising and scanning the photos for the book and to his wife, Ritsuko Shimabukuro Abrahams, for designing the cover. Next, warm thanks to Jane Katjavivi, Publisher at UNAM Press, for her encouragement and advice. When I hesitated, she said to me 'Go ahead and write. It's a great story.' Also gratitude to my many friends and co-workers who urged me to finish the book because they wanted to read it. They jolted my brain when it was tired and I couldn't remember time frames, and reminded me when certain incidents happened. Much appreciation also to my niece and housekeeper Yvonne Murorua, who looked after my health and cooked for me. Finally to my excellent editor, Helen Vale, who while editing made sure that my spirit and humour were preserved. Thanks to you all.

Southern Africa

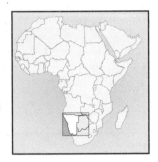

Namibia

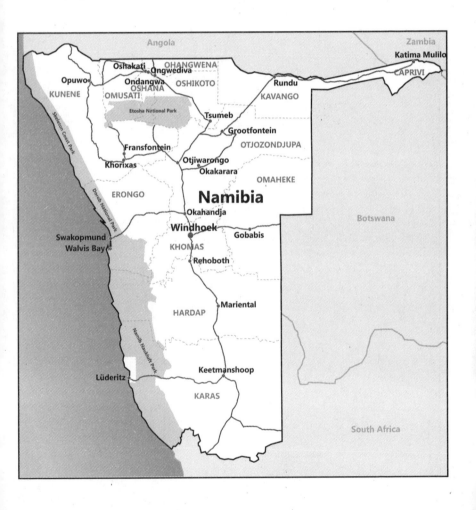

Kunene Region

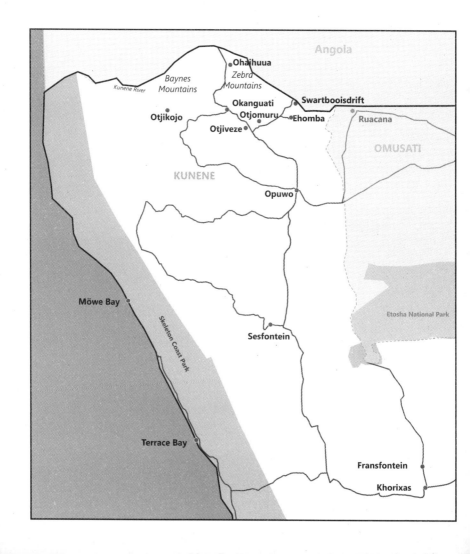

Prologue

In the early 1970s I thought of telling a story about my life; not an autobiography as such but a story. My story, I decided, would deal with myself and how I contributed to the history of independent Namibia. I wanted to share my story with young women from Namibia, who want to do something but who may think that it is difficult or that this is only for boys or that it will take too long. I wanted to encourage them that nothing is insurmountable; all it needs and takes is the will to do it, the focus, the determination, courage and discipline, and then go for it!

When I decided to share my story during the struggle years, I started to scribble notes and the first thing I thought about was my grandmother. But as it turned out, I was too busy with what was more urgent in my life at that time, which was working with the refugees, so I put my notes aside and never looked at them again until I retired on 21 March 2010. When I retired, the thought of sharing my story with Namibians, particularly those who looked up to me as their role model, haunted me and I decided to give it a go. I had lost my original notes so I had to start again.

I also decided to tell my story because during my life as a doctor and a Government Minister, I often came across well-meaning but annoyingly ignorant remarks from people of other cultures, who assumed that every black person automatically came from grinding poverty. One day a good friend of mine said to me: 'I am really impressed with you how intelligent you are, coming from such a poor background.' Being black does not mean that you are automatically poor. What we black people regard as being well to do is not the same as having loads of money in the bank, rather for us it is how much grain you have in your storage bins or the number of cattle or animals you have, and whether you are able to feed your family. Our elders kept money in tins or under the mattresses until recently. Stories abound of people who kept their money in tins,

buried them and forgot under which tree they had hidden the money. A bank is new way of storing money for us in modern Namibia.

I have never written a book before and had no idea how to start, but like everything else in my life, I woke up one Sunday morning and started. I began with the story I told my grandmother about the teacher who went to the bush. I thought that story is unique and some of my generation will recall their own ignorance when they read it. I hope my grandson will not be embarrassed by the childhood stupidity of his grandmother.

This book is not about the political history of Namibia but about how I contributed to the struggle for independence. Enough has been written about the colonial history of a country then known as South West Africa; thus, I will just touch on a few things for non-Namibian readers. This book is written mainly for Namibians but I am aware that others will want to read it. Forgive me if I don't spend a lot of time on Namibia's colonial history. Suffice it to say that our country and our communities suffered for over 100 years from German and then South African occupation. The Germans came to South West Africa first as missionaries in the nineteenth century, colonized South West Africa, and from 1904 to 1908 killed over 80,000 indigenous people in what is known as the genocide. The colonisation and subsequent genocide left many communities scarred; some have not recovered. After the First World War, South West Africa was placed under the protection of the League of Nations as a mandated territory. It was a British mandate but they appointed South Africa as caretaker of the country, so to speak.

They dumped us into the hands of the worst colonial regime on earth and we suffered unspeakable destitution, the worst kind of discrimination, under the apartheid system that was extended to Namibia. What is more, South Africa wanted to annex our country as its fifth province. Our forefathers and mothers woke up and fought for their rights. They started first with peaceful petitions in the 1950s to the United Nations, which inherited the mandate after the Second World War. When the number of these petitions reached the ceiling of the offices of the UN with no solution in sight, realising that these peaceful petitions would not take us anywhere, we, the young people of Namibia, took up arms to liberate ourselves. We embraced the language of the armed struggle; no more peaceful petitions. We decided to leave the

country to train in proper warfare. Thousands of mainly young people fled the country. It was not just to fight the war of liberation but also to seek better education than the dreadful Bantu education we were given at home. The first bullet which started the armed struggle was fired on 26 August 1966 at Ongulumbashe in northern Namibia by the likes of Comrade John Otto Nankudhu. Sadly he died on 21 June 2011.

This time we did not fight with knobkerries as our forefathers had done but with proper ammunition. We fought a long, bitter and protracted war against the apartheid regime of South Africa and liberated ourselves, gaining our Independence on 21 March 1990, and joining the free and independent nations of the world. It took us many years of armed struggle but finally we won our independence. Free at last.

These introductory remarks are an opening note to give the reader a taste of what the book is all about and to introduce Namibia to unfamiliar readers. Please enjoy my story.

Childhood Innocence

I ran to my grandmother out of breath and shouted, 'Grandma, the teachers can also kaka, yes, I saw my teacher with my own eyes.' I saw him going to the bush and I couldn't believe my eyes, because the direction he was taking was where village people went to kaka and I decided to follow and to see what a teacher was doing there. I even went to where he was behind a big mopane tree and there was this big kaka he had made.

My grandmother was not amused. In the first place, I had no business to follow grown-ups. Secondly, how stupid was I to think that teachers don't relieve themselves since they are people like us. I said, 'But, grandmother, they are so clean, I thought they don't do such smelly things.'

That was the life of a real village girl. I was five or six years old and I still remember the incident. Later, as I grew up, I discovered that I was not alone in that trend of thought; my age mates also wondered about many things. We grew up in the era when 'children were to be seen but not heard'. There were many things we didn't understand. In our house there was a gramophone – His Master's Voice – and records that we overused. We used to sharpen the needles on stones. The records were fragile and broke easily but we kept on playing them all the time until they cracked. My grandmother never complained about the misuse of this poor gramophone. I think she never listened to that music; all she cared about was to go to church and sing the church hymns. One day the boys, my brothers, were about to chop the gramophone up to release the man who was singing inside it. They wanted to find out who he was. Such seemingly stupid stories will be laughed at by the kids of 2012, but in the 1950s, in a village where there were no radios and televisions, how would those children have known better? For them the logic was to open up the gramophone and see who was singing. One of my older sisters overheard the boys and explained to them that there was no man

inside; the music was on the records. These records, although so old, still played.

Let me explain about the teachers of my childhood. They were the most respected members of the community. They were always neatly dressed, always wearing a tie. Amongst them was my elder brother, Phillipus, whom I loved and admired. He was a violinist, a singer and very well dressed. He was one of the first teachers from my family and village. Later my sister became one of first woman teachers; she was not a musician, but she was a good teacher. Others in the family followed and teaching became a family profession. In my village school, our teachers did not beat us. If a child didn't come to school the teacher would go to the home of that child to check why the child had not come. It wasn't possible to play truant and get away with it, as the teacher would come and report you to your parents.

After school we went to the garden to chase away the birds which were threatening our crops – the wheat and maize. The garden had lots of fruit trees and as we watched the birds we helped ourselves to the fruit. My grandfather was very strict about the fruit trees. We were not allowed to eat the fruit until the whole tree was yellow with ripe fruit so that proper harvesting could take place. However, those notorious brothers of mine would attempt to steal the oranges, and as you all know you cannot steal an orange because the smell will give you away, so the boys always had problems with my grandfather. One day my naughty brother, Alub, broke open a huge watermelon. It was so sweet and juicy and as we were thirsty we devoured it. My dress was clinging to my body from the sweet juice of that watermelon when my elder brother appeared from nowhere. I think he was coming on holiday from Augustineum School, and when he was told that we were in the garden he came to see us. He couldn't pick me up, since I was glued to my dress by the juice. He took off my dress and washed me and my dress and carried me home. Nothing happened to the boys or to me because my brother didn't report our crime to our grandfather. I think my grandparents were so happy to see my brother that we were forgotten for the moment and they didn't notice the shiny legs of the boys.

My Village, Fransfontein

Fransfontein is in the Kunene Region. It has a church built in 1906, a school, a big garden and a fountain that was the lifeline of the village. It also had a police station, though I never understood why there was a police station in such a small village with no crime. This was where the contract labourers were sent for punishment by their farm bosses, who didn't pay them for their labour. At the end of the contract, when the contract workers should have received their year-end payment, they were often sent to the police on the pretext of their having committed some crime. The stories were rampant that these poor workers were beaten up by the police and sent back to their bosses to work and they wouldn't receive any payment for the year they had worked.

Later my elder brother told me how he and his friends would intercept these labourers and hide them at our place, and then let them escape. In fact I later met someone who was rescued in that manner in Fransfontein. One day during the struggle, a man I worked with told me that he knew Fransfontein, when I mentioned that I was from there. He said he had stayed there, hidden for some time, but he didn't know the family with whom he stayed. He later found his way back to his home in Owamboland in the north. There are many stories of those who escaped and in those days the lions roamed around freely and those who walked those long and dangerous journeys were at risk of attacks.

I was told a story about a contract labourer who ran away from his farm owner after he discovered that he was about to be killed, and headed home to his village. As he walked, he saw lions but he was lucky enough to see a big tree, which he climbed. The lions came after him and sat under the tree waiting for him to come down. The man thought he was safe in the tree and would wait there until the lions got tired and moved on. The lions had the same idea of waiting! However, when the man started climbing to a higher branch to make himself comfortable and safe, he saw a snake in the tree. So he started praying fervently: 'Dear God, please come and help me. Come yourself, don't send your Son, this problem is not child's play, it is a very serious affair and it cannot be solved by a child. Dear God, please come now and come you, yourself in the flesh.' When he had finished the prayer, a whirlwind came from nowhere and the snake fell off the tree onto the lions, and they ran away. Thus the man was saved. He climbed down from the tree

and continued with his journey, undoubtedly with a pumping heart, and finally reached home safely.

Indeed these were very real stories. The farm workers who came on contract were abused in many ways; there are notorious places in Namibia known as places where farm workers were killed instead of being paid their hard-earned wages.

One other story I was told was about a farmer's child. This child loved one farm worker who herded the sheep and, unnoticed by his mother, he crept out and followed the herder to the fields one day. Since it got very hot, the herder gave his hat to the child and as they sat on the bank of a dry riverbed, the child sat on the higher ground and his hat was visible from behind. That day the farm owner, who was the boy's father, had plans to kill the herder rather than paying him. His contract was over and he was due to be paid and to return to Owamboland the next day. The farmer was not prepared to pay the worker, and he sneaked up behind him, saw the farm worker's hat and shot at it. He returned to the farm thinking that he had committed the perfect crime since there were no witnesses. Seeing what had happened, the herder ran as fast as his legs could carry him to the nearest farm and reported the incident. The police were called and came to the spot, picked up the body of the child and took it to the farm. On seeing the body with the bullet wound in the head the farmer realized the enormity of his crime and was arrested. The worker was sent back with the help of the police and reached home safely. The farmer was charged with the murder of his own son. These stories had a lot of truth in them; there are farms where these things happened.

When I was growing up in Fransfontein, it was almost a tradition or a lifestyle that children stayed with their grandparents until they were ready to start real school. I started to follow my big sisters to school at the age of five, but during winter I was grounded. I stayed at home with my grandmother who didn't let me go to school because of the cold weather. During winter it could be minus 2 or 3 degrees Centigrade, so I stayed in the warm bed which I shared with my grandmother. Our blankets were made of karakul sheep skin. I went back to school only when the weather improved.

In those days we actually went to pre-school, but it was not called pre-school then. My grandmother made me a bag of cloth to carry my

slate. I think most of the children had their bags made the same way by their grandmothers. We used slates and wrote with chalk; we didn't have books. The first class at our school was Klein (small) A followed by Groot (big) A and then Groot B. I attended all those classes in Fransfontein and only started real school in Otjiwarongo where my parents lived. I started my proper school in Standard 1. In fact, my grandmother thought that Standard 1 was lower than Groot B and one day she scolded one of my brothers, the naughty one who had stolen the watermelon, with the words: 'All you do is chase the goats, even the little sister who started school yesterday is already in Groot B while you are in Standard 1.' One Christmas my mother brought me a proper school bag, and I felt like I was in a big school.

Church

On Sundays everyone put on their best clothes and congregated at the church. I always went with my grandmother, carrying her Bible. As I write this story, I am starting to wonder whether my grandmother had ever learnt how to read, but I remember her reading the Bible. I planned to ask one of my nephews about this – the one who took over my task of going to church and carrying my grandmother's Bible after I left the village to live with my parents – but unfortunately he died before I had time to ask him.

Even though I went to church almost every Sunday I never remembered what the priest was preaching, because there was a secret competition amongst the children, which was to count the number of teeth of the old women who seemed to lose a tooth every so often. After church we would share our findings on the condition of the teeth of our respective *oumas* (old ladies). This exercise was done during the singing and we would target our intended victims. When they opened their mouths to sing, we could check on their teeth. On our way home my granny would ask me what the preacher had talked about but, of course, I couldn't answer since I had not listened to the preacher, being busy with my assignment of counting the lost teeth.

After the church service, people usually stood around in front of the church inquiring about each other's well-being and about those who didn't attend the service. My grandmother and I would go to visit her friends, particularly those who were sick. Later in the afternoon we

would be sent to take food to those who were ill. I must add here that I don't recall ever seeing my grandmother sick or anyone bringing her food; it was always us carrying food to sick people. My grandmother told us that some of her friends didn't have much to eat, so when we visited them after church and they offered us food we should politely decline and say we had already eaten; in that way we would leave enough food for that friend for the evening. However, one Sunday, when one *ouma* offered us something to eat, my brother (the naughty one) replied that yes, he was going to eat. Then when the *ouma* brought him a plate of food he exclaimed: 'It's too small, I am not going to eat.' My grandmother gave him a look which could kill and that was the end of him accompanying us on those after church visits.

After I became a government Minister, I renovated our old church. It is now a beautiful and big church.

The Fountain

The fountain was the next meeting point, because that's where we collected water and women used to gossip. By the way, this fountain is still going strong and supplying water to the gardens as it did during my childhood. Our homestead is about a kilometre from the fountain and in those days we used donkey carts or ox wagons with iron wheels to collect the water in big containers, or sometimes we came to school with buckets and collected water after school. There was an old man in the village, who had a habit of waiting for us to fetch water for him on our way to or from school. His house was on our route to school and there was no way to avoid him. Sometimes we took another road but then he would go to our grandmother to report that we had not brought him water and our grandmother would remind us that we should help him since he was an old man and had no children to help him.

Nowadays in Fransfontein, it's all modern and easy. People don't collect their drinking water from the fountain anymore; it comes in pipes, and you just open your tap and get your clean water. The canal that used to flow through the village is closed and a borehole has been sunk so people have piped water. Although I appreciate the safe and clean water from the pipes, I miss the beauty of the canal that used to run through the village to the gardens. People used to collect drinking water from the fountain itself and not from the canal.

Self-sufficiency

Every family had a plot of land in the village gardens near the fountain, on ground that was a bit lower than the fountain so that gravity would allow the water to flow down to our crops. There were channels that could be opened or closed and a daily rota for irrigating the different plots. After school, we children would go to our plots to chase the birds from the wheat, and sometimes we would raid the gardens. Wheat was the main grain and in those days we would fry the stack of fresh green wheat. It was the best activity we used to occupy ourselves with as children, and the wheat was very tasty. People in our village went to the village shop only to buy sugar. We ate what we produced. Our grandparents planted their tobacco in the garden so they didn't even need to buy that. My grandfather didn't smoke; it was only my grandmother and other *oumas* who smoked. I remember their long iron pipes with the mouthpiece made of something else; I think it was made of wood so as not to burn their lips. The only available sugar in those days was the brown sugar reserved for black people. Thus in local village shops, such as the one in Fransfontein, there was no white sugar. Only white people were allowed to buy white sugar. As children we were sent to buy sugar, and we used to eat half of it on the way home. My grandmother would give us an extra tickey (a threepenny bit) to buy our own sugar.

The old people used to drink a lot of tea and coffee; the kettle was on the fire all day and water was added to the teapot so that there was always tea brewing. *Oumas* used to refer to this as '*brau*'. I remember that children weren't allowed to drink coffee, because that was one of the things reserved for elders so that they didn't have to share with the children. Other than that I don't recall any plausible reason why we didn't drink tea or coffee as children. I remember that it was compulsory to drink sour milk or fresh milk and my grandmother would insist that I stand upright to drink that cup of milk with my legs spread out so that the milk would spread equally down both legs! I was not very fond of milk but I had to drink it. When we children played 'house', we imitated our grandmothers, and also made our own pipes out of the bones of the goats and our tobacco was dried droppings from the donkey; I can remember the sweet taste even today. Maybe the reason I never smoked later in adult life was that I had tasted enough of the sweet 'tobacco of childhood'.

We actually knew the names of some of our cattle. We had milk and butter from our many cows. We made cream from the milk which was put in big aluminium drums and was collected by a truck that came once a week to collect the cream and take it to what was called the Creamery in Outjo, a town about 100 kilometres from Fransfontein. The rest of the time, or the days when cream was not collected, we made our own butter and sour milk. Making butter was an odious task and it was the responsibility of children. Two of you sat on opposite sides of a big calabash that was suspended on a pole and it was pushed between you. It was the task of the children to stir the milk in this way and we hated it, because when it was your turn, there was no time to play until the butter was formed. I was lucky because I was small and wasn't enlisted to do that arduous task. I don't know why we didn't make cheese; maybe we didn't have the know-how. I think I appreciated the taste of cheese only when I lived in Sweden; I don't remember eating cheese when I studied in Poland. It was mainly my big sisters and the boys who were assigned those tasks of shaking the big calabash; the boys tried to run away but my grandmother would catch them and put them back to work.

Bread was made from pounded wheat. My grandmother baked the tastiest bread in a big, black, three-legged pot. A special hole was dug and fire was made in it; the pot with the dough was placed on the charcoal in the hole; and some coal was placed on the lid of the pot. The bread was eaten with fresh homemade butter, and was the best in the whole world. I remember it was so delicious. The wheat was also cooked separately and I was told that my grandmother continued to cook wheat into her old age. I also recall that my grandfather loved eating boiled wheat; for some reason he didn't like maize meal.

There were lots of taboos concerning food. Meat was divided; adults ate the tongue and softer parts of the goat, while children had the tough meat such as the bones. I later put two and two together and realized that because they didn't have teeth it was a ploy, so that the softer pieces of meat were left for older people.

All the old women in the village made their own soap and I remember that this soap had very little, if any, foam. Later when white sugar was introduced in our local shop, there were some accidents. Children mistook the soda with which soap was made for sugar and swallowed it with disastrous consequences.

From when I was about nine years old my sister and I would use the thorns of the acacia trees as needles to make our own dolls and dresses for them. I can remember making my own very colourful dress, in a silky material, by the time I was fourteen, and ever since then I have been making my own clothes.

We grew up not knowing hunger, Fransfontein was a well-to-do village and I spent a very happy childhood there, which has served as an anchor in my life.

Grandmother

My grandmother deserves a special mention, because she was so unique as far as I am concerned. I loved my grandmother and respected her profoundly, and as I was growing up I decided never to betray her trust or disappoint her in any way. I listened to her stories as we slept under our warm karakul sheep blankets and if my grandmother said something is blue it was blue, period, even if I saw another colour. I have inherited her looks and stature although I actually never knew her name as a child. It was the culture in those days in my village to call older people as mothers of their first-born children. I only learned later that my grandmother's Christian name was Paulina and her Herero name was Jerimorukoro Vihajo. She had twin sisters, but I only ever met one of them. This I learned when I was researching material for this book.

My grandmother was kidnapped from her village in what is now the Otjozondjupa Region during the Nama–Herero war in the late nineteenth century, when the Nama warriors raided her village. She and two of her cousins were taken to Fransfontein and handed over to the Nama chief there. There are many Herero children who were taken that way. The story is that there was apparently some agreement not to harm women and children, so that when the Nama horsemen raided a village and adults ran away, they took the children to their chiefs (or *kapteins*, as they are known) for protection, and they ended up with different names.

I am sure the name Paulina was given to my grandmother by her Nama family. When I was growing up, I assumed that all those Nama *oumas* were my grandmother's sisters. I didn't notice the difference until very late in life. Later when I was fourteen years old, my mother, one of my sisters, and I, visited the sister of my grandmother in Ozonahi in Hereroland. I recall how we were taken to a hut that contained traditional

ondjupa calabashes in which special sour milk was kept, and there was also a place where sticks were kept. I think each stick represented one of our ancestors. In front of the hut was the holy fire. As we were seated by the fire our ancestors were called one by one and we were introduced to them. Water was splashed on our faces as each of the ancestors was called. All these rituals were strange but fascinating to me.

My grandmother was very hard-working. I'm told she was still collecting her own firewood well into her eighties. Her upbringing made me very independent and it paved the way for my future. It made me strong and I worked hard in my life to achieve whatever I wanted.

Grandfather

There are many Herero people who have a similar history to mine and were given surnames such as ours, which was Appolus. My grandfather Jeremia, on the other hand, was an Omuhimba tribesman from Kaokoland, handsome as they mostly are, and tall. He landed in Fransfontein after the First World War. I learned later that there are men of my grandfather's tribe from the same region as my grandfather, who fought in those wars. It is said that when he landed at the *kaptein's* home in Fransfontein, the chief decided that this tall, handsome man would marry his daughter – my grandmother.

My grandfather must have had an interesting story to tell but, as I said earlier, 'children had to be seen, but not heard', so I never asked him questions. I was also very young and couldn't ask anything of substance. He had been in a war and used to limp. It was said that he had a bullet in his thigh. I acted as a physiotherapist when he was complaining of backache and when I was little I would walk on his back to ease the pain. He had a very powerful voice but spoke very poor Nama. I don't remember that he went to church but unlike my grandmother, who was a good singer, I don't think he could sing. He didn't bother asking what the sermon was all about; maybe since he spoke very little Nama he had difficulties following the sermons. What I also remember is that he had a sweet tooth. He ate mostly bread and put a tremendous amount of sugar in his tea or coffee; after he finished drinking the cup was still left with some sugar at the bottom.

My grandfather died early in 1954, and I recall that people came from Kaokoland in their traditional skins and didn't like the way we

were dressed. I think they wanted to take some cattle but they were only given my grandfather's hat and his walking stick.

Mothers and Fathers

My grandparents had four daughters; my mother is the last born. Our clan is matrilineal, which means that the children of the four sisters are regarded as brothers and sisters. Had there been a brother amongst these four, his children would have been my cousins and, traditionally, I could have married one of his sons. Therefore my uncle would be the most important elder in my family. All eighteen children from the four sisters are considered my brothers and sisters, not my cousins, so when I speak of my sisters and brothers, I am referring to them.

The first-born of my grandparents was called Emma and she had only one son, Phillipus. She died very early before I was born. Her son is the teacher, the one whom I refer to as my big brother; he was brought up by my grandparents. The second daughter of my grandparents was named Petrina and she had nine children. The third-born was called Sara and she had seven children. My mother was the last born; her name was Cornelia, and like her eldest sister she had only one child, me. All of us grew up with our grandparents at different times and we all started our schooling in Fransfontein. We were a very close knit family; our mothers lived nearby except my mother who lived in Otjiwarongo with her husband, my stepfather.

My real father played no role in my life or upbringing. He was rejected by my grandparents on my mother's side since they discovered that he was married already and had his own family. I never knew my paternal grandparents.

Fortunately, my stepfather was a wonderful man who loved me so much when I eventually went to live with them to go to big school. He was a builder and he taught me bricklaying, which was very useful later in life. We lived in perhaps the only brick house in our location, which he had built himself, but we children preferred to stay with our grandparents. Maybe we lived a more carefree life there, climbing trees and following the tracks of big snakes. The main reason we, as children, were looking for snakes was to find the one with the lamp. There was a story in our village that there was a snake with a lamp that used to come out at night looking for food. We never did find it!

Story-telling

My grandmother was somehow quiet, but whenever she decided to talk she made a lot of sense to me. She also liked to tell stories and we would sit open-mouthed around the fire when she was telling us stories.

One very interesting story was about a particular boy who struck his father in the face. Shortly after this incident the boy died, and was buried. A few days later, a passer-by noticed a hand sticking out of the boy's grave. Alarmed and fearful, the man ran back to alert the village. The whole village came to see the phenomenon. The elders came together to ponder about what they saw and the soothsayer, one very old man of the village, predicted that this was the hand of God warning young people, particularly children, never to raise their hand and to strike their elders, whether they were their parents or any other elderly person.

The story continued that the hand which had struck the father kept on growing longer and longer. A solution had to be found, as the villagers were very concerned. The soothsayer's advice was that the father must forgive his dead son, and take a branch from the Mopane tree and strike the protruding hand, and it would return to where it should be, back in the grave. The father took some time to consider the verdict; later he agreed to the advice, and the date and time was set. That morning the whole village was there jostling for a better view; the father took the Mopane branch and hit the arm once and indeed it slowly disappeared back into the grave.

I think this story was told to instil discipline into young people to respect their elders, not to fight their parents or any older person. There were so many stories around the evening fire teaching us youngsters how to behave. There were always some new stories, such as: Don't look adults in the eyes when spoken to (it was considered bad manners). Don't stare at people when they come to the home to visit; wait until they greet you. The 'Don't look adults in the eye when spoken to' philosophy has made children accept what they are told and not ask questions. It has also made us not have eye contact with an older person when spoken to, which is regarded as cunning in other cultures, particularly in Europe, where they regard such non-communication as sly. When I went to study and work Europe, where they see eye contact as important, I had difficulties looking people in the eyes when spoken to. For us children it was a sign of respect. That was how it was and I never asked 'why not?'

To this day, many Namibian children from rural areas bend down when they talk to elderly people, and don't look elders in the eye when spoken to.

Later in life, I realized that I was unable to draw a picture of somebody I had met, unlike the British who will try to make sketches of the face of a criminal for the police (fortunately I didn't ever have to do that). The other thing we were taught was not to point at a grave with a straight finger but again, no explanation was given why that wasn't done. To this day I bend my forefinger when I point at a grave. I didn't tell my grandson not to point at a grave with a straight finger, because I know he would ask me 'why not?' and I don't know the answer. I was told by my grandmother not to and that's why. Emphasis was also put on 'Don't talk too much because if you do, your tongue will grow long and you will not be able to close your mouth.' I think that story was to shut me up because as I was growing a little older I started asking too many questions, for which my grandmother had no answers.

The other advice was that I was not to be defeated by something that does not talk: I was good enough to do whatever others are doing.

I remember the story that my grandmother told us about white people stealing children. We were told to take cover and hide if we heard a car coming. There was a particular red car that used to come to the village; it was a Dodge. My grandmother had translated the name 'Dodge' on the car as meaning that it was bringing death. In Afrikaans, *dood* means death and *gee* means give, and my grandmother had deciphered Dod=*dood* and ge=*gee,* and told us to keep away from cars. Sometimes when we heard the sound of a car on our way to school or back from school, we would run and hide in our cave, that is if we were nearby, or else we would go and hide behind the trees until the car passed.

I also remember a story I was told when I was growing up, that my mother and her cousin, Uncle Joshua, could speak English. Everybody in my family had the same impression; my mother was said by many in the family, particularly by her sisters, to be the clever one in the family. Nobody else in the village spoke English and the story was left at that. Later when I was at Augustineum School, I confronted my mother about the story of her speaking English. She told me how it came about. The third eldest of her sisters was living with her husband who was the foreman on a farm, called Naraxams, about 20 kilometres

from Fransfontein. The farm was in the business of skinning one-day-old karakul lambs to sell their skins. One day my mother and Uncle Joshua went to visit her sister and there they met visitors who came from England. I don't know how old these people were but they taught my mother and Uncle Joshua a children's nursery rhyme: 'Baa baa black sheep, have you any wool?' When they came back to Fransfontein, they spoke their English, to show off to the people. Uncle Joshua started and said to my mother: 'Cornelia, Baba black sheep,' to which my mother responded 'Joshua, have you any wool? My uncle then replied, 'Yes sir, yes sir' (actually 'Jash sha, Jash sha'), and the dialogue continued to the end of the rhyme!

Schooling

My education was driven by my grandmother. I went up to the end of pre-school in Fransfontein (Groot B). My mother was not very impressed with my village education. My carefree life where I was allowed to do whatever I wanted to do irked her and she was worried what I would become with my grandmother spoiling me, so she came to beg my grandmother to let me go to the big school in Otjiwarongo, the capital of the Otjozondjupa region. My mother was a Standard 4 graduate and knew something about education and how important it was. We already had two teachers in the family. My elder brother and my sister were teaching, and my sister was amongst the three women who graduated as teachers from Augustineum School.

My grandmother was also convinced that I was clever and needed to go to big school but she was reluctant to send me with others, so she took me there herself. Thus I started schooling in Otjiwarongo, beginning in Standard 1. My grandmother advised me to study diligently, and I did. The school only went up to Standard 5, however, since only three children passed to proceed to Standard 6 and the school was unable to open a new class for only three pupils. We were then sent to Augustineum Secondary School in Okahandja, 70 kilometres north of Windhoek. This was the first secondary school for black children south of the Red Line. There was another high school for the Catholics at Döbra, just north of Windhoek. One of my brothers went there and converted to the Catholic faith.

For the readers who are not Namibians let me briefly explain about the 'Red Line'. It is a veterinary cordon fence, which means that animals from northern Namibia are not allowed to come to the south, to prevent any spread of disease. During colonial times, people were also not allowed to come to the south unless they were contract workers, and even if they found work their families weren't allowed to come with them. Although the majority of Namibians live in the north, they couldn't freely visit

south of this line; they only came to work in the mines and on farms, leaving their families behind. Some never returned. That Red Line is still applicable today for animals, particularly cattle. As for the people, we are free at last. Our Constitution stipulates that Namibians are free to live wherever they want to in the country of their birth.

Augustineum School

There were only three other girls at Augustineum, one of whom was Francisca who became my best friend; we are still in touch today. We stayed in the school hostel. I recall that the food we were given was nothing to write home about. On many occasions the mealie-meal was full of tiny worms and I don't remember whether we had meat. We, the girls, were locked in like prisoners at 9PM but we didn't feel like prisoners, in fact it didn't upset us. Maybe since we were four girls together we enjoyed the privacy. Looking back now, I am not sure whether it was a good or bad thing. I personally had no thought of boys at that time and I think the same was true for my roommates. I now wonder what could have happened if we hadn't been locked in. Perhaps it was good protection, come to think of it! The boys didn't harass us, though; we all studied together and became friends. Students worked hard. The language of instruction was Afrikaans and there was a kind of competition as to who could speak the most bombastic Afrikaans. We would use the dictionary to change a word to a more unusual sounding one that we found in the dictionary.

We had very good teachers, both black and white. One of the most elegant and well groomed teachers was Mr Martin Shipanga. He is still alive and even, as an octogenarian, dresses well. We used to imitate his Afrikaans as it was so good. We had a music teacher, Mrs Woods, who was also the choir mistress. She taught us songs and we had a choir. Students also had their own singing and dancing groups. There was a guy who looked and sang like Nat King Cole; we called him Sloppy Joe. His real name was Ismail Tjoombe. Thus, Augustineum was a cultural and 'intellectual' place that made us respect education. When we went to town we would speak our bombastic Afrikaans to the Afrikaners in their shops and sometimes they would curse us for speaking those complicated words to them.

I completed Standard 8 with high marks, coming second in the class. That was in 1957 before Bantu Education was introduced in black schools in Namibia. We wrote our exams at the same time as white-only schools, the same day, the same subjects, but in different classes. Many of the liberation struggle politicians who became government Ministers at Independence in 1990 and formed the first Cabinet are products of Augustineum Secondary School. A few who were at Augustineum during my time were Josef Ithana, who became Chairperson of the Public Service Commission; Hage Geingob, who became the first Prime Minister of independent Namibia; Theo-Ben Gurirab, the first Foreign Minister; Ben Amathila, who became Minister of Trade and Industry (and my husband); Hidipo Hamutenya, who became Minister of Information; Katuutire Kaura, who later became President of the Democratic Turnhalle Alliance (DTA), one of the main opposition parties; Onesmus Akwenye, the Reverend Hendrik Witbooi, who became Deputy Prime Minister; and Moses Garoeb, the first Minister of Labour. I was made the first Minister of Local Government and Housing. I apologize if I have forgotten anyone, I assure you that it's not intentional; sometimes one gets a mental blackout! All of us have remained friends to this day and we pride ourselves on that good education, never mind the tiny worms that infested our mealie-meal.

While we were in exile, Augustineum was moved to Windhoek and our old Augustineum school building was converted into a military training camp. We were hoping to make it a heritage site. It is our alma mater and should be preserved as a monument. However, it has now been pulled down for new structures to be built for training the army.

Before I went to Augustineum I had a life-changing experience that pointed me towards my goal. I was only thirteen or fourteen, and still at Otjiwarongo Secondary School. I came home one day from school and found my mother in bed. She wasn't feeling well, so my father and I took her to the hospital, and I stayed on with her there. The treatment I witnessed was so appalling that I decided there and then that I was going to be a doctor. The patients were lined up in groups, those 'kaffirs' (a derogatory word used for black people) with stomach pain in one row and those with coughs in the next row, and medicines were administered to them. I suspected that those with stomach pain were given castor oil and the ones who were coughing were given some kind of cough

mixture and then sent home. I recently read a book by Sedick Isaacs, a former Robben Island prisoner, where he describes how sick prisoners were given castor oil, so now I am convinced that my suspicion was correct. I remember that people used to come and 'steal' their sick relatives out of that hospital at night to take them to traditional healers. I always think that had it not been for that experience my life might have taken a different route. That day I decided to be a doctor.

The experience was devastating to say the least. My decision was reinforced when around the same time, one Saturday afternoon, a beloved teacher, whose name was Kaskie, broke his leg in a football game and was taken to that same hospital. He remained there and died the following Tuesday without having been seen by a doctor. That was such a blow to the school and it added to my resolve and urgency to become a doctor so that this kind of treatment of our people should stop. It was a traumatic experience for me. During my five days' stay I also witnessed how women in my mother's ward were teased with a cup of water which was put in front of them after the operation, and they would want to get out of their bed to get to that cup. I must add here that in those days ether was used as the anaesthetic of choice and it made patients very thirsty when they woke up from the operation. Those nurses were so cruel or rather didn't care about the well-being of the patients. Now having taken my decision to be a doctor, every step I took from then on was towards that goal.

Wellington High School

After Augustineum, we all went abroad to different countries to study and my life took an unusual direction. I left for Cape Province in South Africa to attend Wellington High School. This was a high school for coloured children.

Those of you who may read my story may wonder about the term 'coloured'. In South Africa, history has it that when the first white men touched down in the Cape of Good Hope they married Khoisan women and the children born from those unions were of mixed race, some of them were very white with blue eyes and others light in complexion. The vast majority of these people inhabited the Cape Province and were called Cape Coloureds. We had coloureds in Namibia as well: the

children of German fathers and Herero or Damara mothers, but these children remained within their mothers' traditions and cultures.

I am not coloured, but we South West Africans were allowed to attend coloured schools since we couldn't speak the Bantu languages spoken in South Africa, and it was convenient to go to coloured schools where the teaching was in Afrikaans, which is what we were used to. We also had no senior secondary schools in South West Africa. Thus after Augustineum we had to go to South Africa for our senior secondary education.

It was at Wellington High School that I completed Standard 9. I encountered lots of problems at that school. Firstly, I had to pretend to be coloured and we had to stay with families because there was no hostel for boarders. Most importantly, however, no science subjects were taught that would guarantee my entry to any medical school. I decided not to go back the following year to complete Standard 10 because I felt it would be a waste of time and a drain on my mother, who was paying for my education. I decided to take a correspondence course and work to save money for travel abroad. I had gotten the idea of leaving the country to study abroad, and I decided to work a bit to save money and escape to pursue my dream of studying Medicine abroad. The subjects I was taking in high school wouldn't allow me to enter medical school, so I had to find a school where I could study Biology, Chemistry and Physics. Without these science subjects I would have to be a teacher. We had plenty of them already in the family and I had no interest in being a teacher. I had already made up my mind that I would be a doctor and nothing would derail my resolve. I needed to start to prepare for my ultimate task.

The Start of My Journey

My political consciousness started at a young age. I was very aware of apartheid and the terrible oppression our people were subjected to. A black man couldn't be in the white town after 9PM. Black people were subjected to untold abuse: any white person could beat up a black person at will for no apparent reason, and get away with it. I remember to this day how a young white boy slapped an elderly black man in front of people at an auction pen in Fransfontein, just because he identified his cow in the pen, which he did not want to sell, and requested that the cow be taken out. Black people stood there powerless because if they had touched that white boy they might have been shot. In some butchers shops, black people had to buy their meat, already packed, through the window – they were not allowed to enter the butchery. Even if they were allowed, they had no choice but to buy what was known as offal, which consisted of the intestines and poor cuts of meat. The town of Outjo near Fransfontein was also known as a place for unexplained and unreported deaths of black people.

The blatant disregard for dignity and the rights of black people was illustrated when the white municipal authority started moving the black people out of their homes in a particular part of town, where they had lived for a long time comfortably, to further separate them from the white population. Both in Namibia and in South Africa, black people were subject to forced removals – they were bulldozed out of their homes and sometimes resettled in uninhabitable areas. In Namibia, Katutura was the township where black people in Windhoek were resettled from 1959. The very name 'Katutura' means 'where we do not wish to stay'. When they refused to move they were gunned down in what became known as the Windhoek Shootings of 10 December 1959. Thirteen people were killed and dozens more wounded. This event is in living memory. People were then forcibly moved from their original homes to the new township, where matchbox houses were built for them on

plots measuring less than 300 square metres. There was no place for the children to play.

I was schooling in the Cape Province in South Africa and remember the much-loved area in Cape Town known as District Six, where coloured people lived. They too were forcibly removed. The same happened in the famous Sophiatown in Johannesburg. People were forcibly removed from their original homes to make room for whites.

As a student at Augustineum I was very aware politically of the conditions around us and those incidents awakened tremendous resistance and rebellion in me. When we were schooling there we used to write notes saying: 'Give a loaf of white bread to the boy' (or the maid), and take it to the bakery, where we would be given nice bread, because the salesperson would think it was for a white person. When we went to the shops we would address the white woman as '*Mevrou*' (madam) and she would be so mad at us and say to us, '*Ek is nie jou Predikant se vrou nie, hoor* – I am not the wife of your priest.' However, there were some, albeit a few, white people who hated apartheid. Fortunately, we were protected from daily abuses because our school was just outside the town of Okahandja and we only went into town maybe once a month. The rest of the time we were at school and studying very hard.

What used to irk me was that even if you were in a shop first and you were buying something expensive, as soon as a white person walked in, the salesperson would drop you like a hot potato and serve the white person. All this abuse made us radical and many of us left the country with a desire to study and came back to improve the lives of our people and throw out the colonizers. This was also the background to my own decision to leave the country.

Preparing to Leave

After I came back from school in South Africa, I got a job in Swakopmund as a salesgirl at a wholesale business. The owner was a Namibian of German origin, Mr Josef Koep. He was a very progressive man; he loathed apartheid and had no love for the South African regime that occupied Namibia. During the Second World War he was interned by the South African regime at Baviaanspoort and was very bitter about it. I was paid a good salary and treated with respect; he appreciated my honesty and hard work. However, I worked with a tall Afrikaner

woman who told me one day that I should forget my stupid idea and stop dreaming of one day becoming a doctor because we blacks have short noses and our intellect is as short as our noses; only white people with long noses could become doctors. Despite this, I enjoyed my stay in Swakopmund, my boss was very good to me and we often discussed politics. He told me that he had wanted to become a doctor himself but instead had been interned. When I confided to him that I was intending to study Medicine, he was very supportive.

Swakopmund is a coastal town on the Atlantic Ocean, a very German town, and with its German colonial architecture it looks almost like Munich. During summer, when temperatures soar in the interior of the country to sometimes 40 degrees Centigrade, some people relocate to the coast, and particularly to Swakopmund. The town is characterized by a cool climate, sometimes blanketed by mist, especially in the mornings. I rented a small house in the township and went to work riding a bicycle with other girls who were also working there. I also went to Walvis Bay to get a SWAPO membership card from Ben Amathila, who was the underground organizer for SWAPO, along with Nathaniel Maxhuilili.

That period was as if some kind of awakening (renaissance) was taking place; young people were leaving their countries all over Southern Africa to join the liberation struggle or go abroad to get a better education. Namibia was no different. We heard of some people who were leaving the country or going abroad to study. Some were arrested at the borders between Namibia and Botswana. I was also planning my escape quietly but I had no idea when that would be. I was worried about being arrested and decided not to tell a soul about my plans.

One very misty Tuesday I found a letter with unusually large stamps on it. I went inside my small house and tore it open. It was from an acquaintance, a student who had left Namibia and was studying in Ghana. His name was Tunguru Huaraka, and I knew him because we both used to take the same train to South Africa to a place called De Aar; from there each of us had taken a different direction. He was studying in a place called Wilberforce. Namibia is a small society so we knew each other, and all of us who were studying in South Africa took the same train. The content of the letter was very simple: 'Try and leave Namibia and get to Tanganyika. There you will get a scholarship from a friendly nation. Here in Ghana there are women doctors so I am sure you will make it.'

From that day on I resolved to plan my escape from the country. I had saved every penny I was earning for the trip, but I kept everything to do with my escape plan a secret; not even my mother knew about my plans. I was afraid that she would be very scared and would maybe tell one of her sisters in confidence, word would get round, and my plans would be foiled. Some students who left before me were arrested in Botswana, which was then still Bechuanaland and a British Protectorate. They were going in groups, and were easily recognisable and detectable. I decided to go alone. I took the same route as others did but since I was alone I aroused very little attention.

Crossing Borders

I left Namibia in August 1962 after visiting my mother. She had divorced my father and moved to Okahandja, and after secretly paying all her municipality bills (water and electricity), I left. I pretended to be returning to Swakopmund but instead I went to Windhoek. I had made an appointment with one of the stalwarts of the SWAPO party, a man we were told used to cycle to Owamboland during the struggle. His name was Levy Nganjone and he met me at Windhoek railway station and drove me about three hours east to the border town of Gobabis in his beaten-up bakkie. That day was a Wednesday. The next day he gave me a pass in the name of Mungunda to cross the border between Namibia and Botswana. On a hot Friday morning I boarded a truck to cross the Namibia/Botswana border. In the same truck were also two white girls on their way to Botswana. I was disguised as a small girl; I had cut my long hair and was wearing old sandals with a short old dress, and all my nice clothes and a beautiful coat from Swakopmund were in my suitcase. I was advised to leave the suitcase unlocked to avoid questions by the border guards, but when they mounted the truck to check they totally ignored my existence and talked only to the white girls. They did, however, open my suitcase and I overheard one of them telling the other to leave it because it belonged to one of the young misses.

We crossed the border safely and I was dropped at a place where I was to wait for the next lift. I stayed there for three days with a San family. The wife could speak Damara (similar to Nama, which I speak), mixed with Bushman language, and my stay there was uneventful. I don't actually remember much of it, because I was consumed with

thoughts of my journey and I didn't pay too much attention to what I ate and the environment surrounding me, save to say that I had no fear of anything. The family were friendly and gave me whatever they were eating. I waited for a certain lorry that was expected, and when it arrived it picked me up and took me to Francistown in north-eastern Botswana, near the border with Southern Rhodesia (now Zimbabwe). I found my way to the SWAPO office, where I met Comrade Maxton Mutungulume, a fierce and fearless no-nonsense comrade whom even the British representative respected. He used to call the whites 'Shoemakers', but I don't know why. The refugees were staying in a place called the White House; Comrade Maxton looked after all of the refugees passing through, regardless of where they came from. Even Samora Machel, who became the first President of Mozambique in 1975, knew him very well. One day, many years later, President Machel met Comrade Maxton in a greeting line-up and stood for some time in front of him, holding his hand and asking him, 'Comrade, are you still around?' That was years after the Independence of Mozambique in 1975; I can't recall the occasion but I was there.

Comrade Maxton was known for his unusual way of speaking English, the word 'sit' sounded like 'shit'. Indeed Comrade Maxton kept us grounded; he was so committed to his duty to see the students pass through without problems and would share what little money he had with others.

The other comrade who was there was Peter Nanyemba, who later become the Secretary of Defence of SWAPO and Head of PLAN (the People's Liberation Army of Namibia). I noticed that the shoes Comrade Nanyemba was wearing were so broken and old. He had big feet, size 10 I think. I had come with some money, and when we went to the shops I bought him a pair of shoes.

I stayed for three weeks in Francistown. When the time came to leave for Tanganyika, I felt mixed emotions. I was happy to finally move on but I was sad to leave my comrades behind. I bade them farewell and proceeded into the unknown. I took a morning train to Bulawayo, in Southern Rhodesia. There was a place known to escaping students as 'do or die'. That was Plumtree, on the border between Bechuanaland and Southern Rhodesia. If you were able to make that crossing, the rest of the journey was easy. Comrade Nanyemba had gone to Plumtree

the night before to see me safely off and had slept under a tree. When the train stopped in Plumtree he was there standing on the platform to make sure I was alright, and we acknowledged each other's presence. I was extremely moved and even as I am writing this story I have a lump in my throat remembering him.

The commitment and the dedication to the struggle and our resolve at that time were incredible. I was happy that Comrade Nanyemba didn't have to walk in the worn-out shoes I had found him with; he was now wearing the new pair of shoes I bought him. I was very emotional and had to be strong not to cry. Here was this comrade walking through the night and sleeping rough in the bush to see me off and he didn't even know me before. He wasn't my family but we became close because of the struggle, and here he was risking his life to make sure that I passed through safely.

As I am writing about this I am filled with emotions. It is very sad to know that Comrade Nanyemba didn't live to see the independent Namibia that he had fought so hard for. He died in a car accident in Angola on 1 April 1983 and I miss him to this day. It was a great loss to the country as far as I am concerned. I remember that day when the news came through, I thought that the person who told me was playing an April Fool's joke, but soon I learnt that it was really true. I was dumbstruck and so upset that it took me some time to react. Nanyemba had been a tall, strong, fearless and friendly man, and I was inconsolable at the news of his death.

That is the nature of the sacrifices we made as liberation fighters. We fought not for ourselves but for the Namibian nation to be free. We lived from day to day, but we were not consumed by fear of death. I actually never thought of death. I am writing this small narrative for those who didn't know about the struggle to learn of sacrifices people like the late Nanyemba had to go through on our behalf, for the liberation of our country.

After safely passing through Plumtree, I relaxed and thought about the way ahead. I was ready to face whatever came. I had made it this far and I would not look behind me. 'Forward March', as our Founding Father Sam Nujoma loves to say.

The train took me to Bulawayo and I was met at the station by a bulky black policeman who took me to a small room away from the

white policeman, who certainly could have searched me. It turned out that he was a member of ZAPU, one of the liberation movements from Southern Rhodesia, led by Joshua Nkomo. He told me that the train to Northern Rhodesia (now Zambia) would depart in a few hours and that when it was about to cross the border close to the Victoria Falls, somebody in a white waiter's uniform would take me to the restaurant car, and I should stay there until we had crossed the border. I crossed the Victoria Falls in awe of this huge dancing volume of water. As a Namibian I had never seen so much water except the Atlantic Ocean at Swakopmund, but this was totally different. The sound was awesome, the water was roaring like a lion and there was spray like smoke coming from the Falls. I was actually frightened, and thought that if one fell in there, what an awful death it would be.

I did as I was told and was given food and escorted back to my seat when the coast was clear. I had entered Northern Rhodesia on my way to Lusaka and then on to a town called Broken Hill (now Kabwe). UNIP, the political party headed by Kenneth Kaunda (later to be the first President of an independent Zambia), was very active and the political push for independence was gathering momentum. The British Prime Minister at that time, Harold Macmillan, had said in 1960 that, 'The winds of change are sweeping across Africa,' and he was right. Members of UNIP were very helpful in protecting the refugees, particularly students, who passed through from Southern Africa on our way to the only independent African country within reach, Tanganyika, which had gained its independence from Britain in December 1961. I was taken to the house of one of the UNIP activists, where I was given a place to sleep and fed. I didn't stay long in Broken Hill though. Within a day or two after my arrival the bus was ready for the trip to Tanganyika, my final destination. The next stop would be Mbeya, and from there on to the capital, Dar es Salaam.

The journey to Mbeya took five days and nights by bus; it was a fascinating trip, a journey that taught me what African culture and hospitality means. I had no food, but the other people who were getting on and off the bus were seasoned travellers. They had food, pots, buckets, you name it, and when we stopped for the night I would be invited by the family who were my neighbours on the bus to eat with them. I also learned that several African languages have many words in common. As

we were moving in that bus through the villages I could pick up some words similar to words with the same meaning in some of our Namibian languages. When the bus arrived early at a particular village and stopped for the night, I was silently wondering why we couldn't proceed, but I couldn't discuss that with anybody due to the language barrier. Later, I suspected that maybe the driver had friends in those places where we stopped.

Finally, we arrived in Mbeya in the early afternoon. The first thing I noticed was Indians who were wearing white clothes playing sports (they were probably playing cricket), but I saw no black person. The next day I was taken to the Office of the Commissioner. I don't remember how I got there; what I do recall is that I was very tired and hungry.

This kind gentleman took me to his house. I was fed and given a place to sleep. The bus to Dar es Salaam was ready the next day and the journey was to take three more days and nights. This wonderful family gave me money for food and put me on the bus. The journey followed more or less the same pattern as before. Fortunately Africa is not cold, particularly as we were approaching the Indian Ocean. As luck would have it, we didn't encounter any rain although it was September; maybe my grandmother was looking after me. During this whole journey we slept out in the open. I had two blankets, which I had bought in Francistown, in Botswana. One I used as a mattress and the other as a cover. Now just imagine if it had rained! I strongly believe that God protects the innocent.

Dar es Salaam

I arrived in Dar in the late afternoon, one day in mid-September 1962, and was directed to the SWAPO office and then to the house of a senior nurse, Auntie Putuse Appolus (not a relative of mine), who lived in the nursing quarters of Muhimbili Hospital, where she worked. Shortly after my arrival at her house she returned from work. After a warm embrace she exclaimed, 'Child, what did you do to your hair? Why did you cut it off?' I explained that I had needed a camouflage, a disguise. I had to look as unassuming as possible so as not to be noticed, but she was not to worry since my hair would grow back in no time. The important thing was that I had finally made it to Tanganyika. Later I met President Nujoma and other SWAPO leaders. Auntie Putuse was a SWAPO

stalwart. She was a nurse by training and left Namibia for Tanganyika shortly after its Independence in 1961, the year after President Nujoma left. Many of us soon followed them into exile. Thus all, if not most of us, stayed at Auntie Putuse's house.

After a while, a girl I had met on the train to Cape Province during our schooldays arrived and we shared a room there. I was happy to meet her and we discussed our forthcoming trips abroad. Her name was Nora Schimming, who was later to become Norah Chase after her marriage to a doctor from St Lucia. She wanted to go to Germany; I had no preference. I would go to any country that offered me a scholarship to study Medicine. I knew that I would study Medicine but first I needed to finish my last year of high school which should include those science subjects I lacked.

I was intrigued by what I saw in Dar es Salaam. Coming from Namibia, where men wear trousers, I was surprised to see men wearing what looked to me like skirts, and scarves on their heads. Many of the women wore long, often black, robes, although there were some who wore normal dresses. They also covered their heads. I asked Nora why the men were wearing these skirts. I also noticed big protrusions under the skirts, not that I paid particular interest to what was under their skirts but things were visible and dangling. Nora had no idea when I asked her what these protrusions were, but instead of saying she didn't know she, in a manner typical of her, responded with, 'Libby what are you looking for under the skirts of the men?' I gave up on her then and asked Auntie Putuse, since she was a nurse. She explained to me that some of these men had hydroceles, a huge enlarged testicle filled with fluids. I had no idea that one day I would come back and operate on this condition when seven years later I returned to do my internship at Muhimbili Hospital in Dar es Salaam.

A hydrocele denotes a pathological accumulation of serous fluid in a body cavity. In this case I am discussing the accumulation of the fluid in the testicles and it is a fairly common condition in the coastal regions of Tanzania. The medical explanation is that hydrocele is caused by fluid secreted from a remnant peritoneum wrapped around the testicle, the tunica vaginalis. In East Africa the cause was thought to be the infection of *Wuchereria bancrofti* or *Brugia malayi*, two mosquito-borne parasites from Africa and South-East Asia, respectively. It is treated surgically.

Dar es Salaam was a pleasant town, and very humid. One didn't need moisturiser since the humidity was like an inexpensive moisturiser; you washed and once you went outside, your skin was moist. I also liked the laid-back manner of the people. They were very friendly and easy going. We spent our time between going to the SWAPO office and going to the cinema. Auntie Putuse gave us money to go to the cinema every weekend. We also went to the beach, and unlike the cold water of the Atlantic Ocean, the water of the Indian Ocean was warm and very pleasant, and the beaches were sandy and clean. Coming from Swakopmund, where the beaches are rocky and the water is cold, it was great to walk on the sand.

For the first time we, from Namibia, learned that there were women who were engaged in the sex trade. There was nothing like that in Namibia when we had left the country, so this was also new to our men. One night we overheard an argument between one of our colleagues and a woman who was asking for her pay of two and a half Tanzanian Shillings. The man didn't understand why she wanted to be paid. After all, he argued, she had also enjoyed herself, so why should he pay? Nora overheard this and told the colleague to give the woman the money. She then asked him to come up and see her for explanation. Auntie Putuse's house was a double storey and Nora and I occupied the top floor, while the male colleague slept downstairs. Thus we could hear what was going on in the street. Nora told him that in many towns men pay for these services, and women make money from it as their profession; it was not like in Namibia where this wasn't done.

I later asked Nora how she knew about this and she told me that unlike me, who had studied in the small town of Wellington, she had been in the big city of Cape Town, in what was known as District Six, and she had seen and learnt about these things there.

I daydreamed all the time about when I would get a chance to go for my studies and I didn't have to wait long. Within two months of arriving in Tanganyika SWAPO was offered two scholarships for students to study Medicine in Poland. So my stay in Dar es Salaam was coming to an end sooner than expected. I was given one of the two scholarships from Poland and Marcus Shivute was given the other one. Nora got a scholarship from a German NGO and went to Germany. She and I have remained friends to this day.

A Dream Come True

'Where is this place, Poland?' I asked myself when I heard about the scholarship. But I told myself, 'I want to study Medicine and here is this opportunity; whether I know the place or not I am going!' I vaguely remembered that during the Second World War there was a story about the war in Warsaw but I didn't really know where it was (Eastern Europe).

I was told that that I would first have to do Chemistry, Physics, and Biology for a year and learn Polish at the same time, and if I passed these subjects then I could enter medical school. I jumped with joy and accepted the offer, because I was determined to become a doctor. I knew that if I worked very hard I could make it. I didn't think Biology would be a problem; I had studied Biology at Augustineum and also as part of my correspondence course after returning from South Africa

Extensive preparations were necessary, which included getting visas to enter Poland. But first the Tanganyika authorities had to issue us with travel documents because Namibians were regarded as stateless and we had no national documents such as passports. By December 1962 we were ready to start our journey. We were joined by two Zambian students and took the flight on the Polish airline LOT to Warsaw, the capital of Poland. We landed early in the morning the next day in very cold weather.

Whilst Lusaka was in the middle of summer, and Dar es Salaam was perpetually hot and humid, Warsaw was in the middle of winter, so the contrast was huge, particularly the difference in temperature. None of us had ever heard of or seen snow before. When we walked off the plane I thought, what cold white sand this place has. In fact it was snow! My male colleagues were dressed in their safari suits. I was lucky to have my beautiful warm coat from Swakopmund, but even that was no match for a Polish winter that can go down to minus 15 degrees. In Namibia temperatures in winter rarely drop below minus 2 degrees Centigrade.

As soon as we disembarked, a bus whisked us off to a department store, where we were given warm but heavy coats, and strong boots. I'm sure the pilot must have radioed the ground staff at Warsaw airport telling them that there were young Africans on board who would freeze to death if they touched down in their summer clothes, because the bus came to the plane when it stopped and we got in and went immediately to the store. Poland was grey and cold but the people who met us were warm and friendly. They seemed to be in shock seeing us dressed so lightly but we had serious problems walking in those heavy clothes and shoes, and struggled through the snow that was up to our knees.

Lodz

After spending a night in Warsaw, we were put on the train to Lodz, the small town east of Warsaw that was our destination. Lodz was where the Polish Language School was and it had also some universities and a medical school. We were late arrivals at the school since classes had actually started in September.

Poland was very cold and it was dark by 3PM. The Polish people found it strange that we prepared for bed as soon as it got dark as we would do in Africa, whilst they would go out or go shopping.

I missed the greenery of Africa, and there were no birds flying around, but during March, with the coming of spring, life returned, trees blossomed and the birds returned. A new culture shock was awaiting us: people started sunbathing, lying almost naked in the sun. I couldn't understand the reason, but later I learnt that they wanted to get tanned and be darker skinned. This was because during winter, with the cold and dark days, people became ash white, and during summer they lay in the sun to get a sun tan and become darker, although of course not as dark as us Africans! This later prompted one of the African students who had a habit of coming late to class to tell the teacher that he was sunbathing when the teacher asked him why he had come late. The teacher answered him, 'You are already so black you don't need to sunbathe.'

We had fun learning the language and made fun of all the new things we were learning – the half-naked people in the sun who at times became so red and the teacher who didn't speak English. This

teacher was good despite not speaking English and was able to make us understand and speak Polish by the end of the course.

One day the school decided to introduce us Africans to Polish culture, and we were taken to the Opera. That happened about a month after our arrival, by which time we had learnt a few words in Polish. Most of us had never heard of an opera, at least I was one of those who had never heard of it. In my village I knew only church songs and some music from His Master's Voice, like the records of Jim Reeves, from my childhood gramophone, the one that had survived the planned attack from my brothers. The other music we knew was African beat, lively African music, so we were expecting great dance music. Polish opera is anything but great dance music! It turned out to be a singing dialogue, and since our Polish was very limited we only understood one word, 'Dlacheko?' which means 'Why?' From the opera house back to Lodz we only spoke to each other in the opera style. The following day the teacher had a hard time because we spoke in singsong for the whole week. We greeted her in opera style singing, as we had been so amused by what we witnessed in the theatre. Later, as I became fluent in Polish, I started to love the opera and went frequently. To this day I love and enjoy the opera. The whole experience was alien to us, the costumes worn by the singers and the way the play was performed, but we noticed how much the Polish people enjoyed it.

The next cultural event was during summer the same year (1963). We were told about a great composer, a Polish son, by the name of Chopin, and we were taken to a concert at his birthplace. Chopin is a very renowned Polish classical composer. We thought this time we would hear Polish jazz music. We had no idea what to expect but thought we were sure to hear nice dancing music. It turned out to be classical music. The elderly people there were dozing in a trance but we were bored stiff. However later, as we understood Polish better, we came to appreciate the culture of the Polish people and started enjoying their music, their humour and their opera. Poles are amongst the nicest people in Europe. I certainly became a better person living amongst them. They treated me very well and looked after me. If I went to buy meat from the butcher I would be given an extra piece of sausage, and I began to feel at home in Poland.

Cold War Pawns

Shortly after we arrived in Lodz, a strange thing happened. To be precise, in late March 1963, a group of African students were invited by the American Embassy in Warsaw. We travelled from Lodz by train and on arrival, we were taken to the embassy and put in a room with thick walls and no windows. We were told about how bad the conditions were in communist Poland, and promised a good life in the West, where we would be given better scholarships in West Berlin, and where everything would be paid for. Amongst the students there were three girls from West Africa, and me. I was scared by this frightening experience, and as we sat on the train back to Lodz, I reflected on my situation. Who was I? Why was I there? Where did I want to go? Coming from the apartheid system I had no problems in Poland. I was given a stipend and although it was not much, I was able to buy my toiletries. I had what I had so much longed for – education. All my teachers were helpful and I was assured of studying Medicine if I succeeded in passing my Chemistry, Polish and Physics. What would I get in the West that would be better?

The other girls were always talking about poor Poland and the rough toilet paper, poor rooms, etc. I came to one conclusion: I was not going anywhere. At home people used stones and sticks to wipe themselves, so it was no big deal using hard toilet paper. I thought that there I was being assisted to become a doctor. If I continued to work hard I would became a doctor. Those who wanted to go, including all the other girls, could go but I didn't want to. The three other African girls left during the Easter holidays 1963 for West Berlin.

Later it dawned on me that we were in the middle of the Cold War. Not only was the weather cold but world politics were even colder. It was better that I stayed put, did what I had come for, and stayed out of other peoples' conflicts. I had no idea about the Cold War between East and West, but I learnt fast.

All this time I thought of my grandmother who had trusted and supported me; what would she say if I failed? To this day I am convinced that I made the best decision in my life. From then on I felt mentally liberated and responsible to run my life and trust my own intuition. If I had to give humble advice to young people it would be this: 'Always follow your heart, always ask yourself, "Why am I here?" Don't just be a follower.' I am 100 per cent convinced that if I had followed the others

there would be no Doctor Libby today to serve the Namibian nation. Fortunately the Cold War is history now. Later I will tell you about my chance meeting with one of the girls in a bus in West Berlin three years after that fateful day in Warsaw. Had we not gone to the American Embassy this girl would certainly have completed her medical school and graduated with me. I really felt sorry for them. If we had had prior knowledge about Cold War politics, we might have been better prepared to face the Americans, but we had absolutely no idea about the Cold War, and the possibility of being used as pawns in a game of dirty politics.

The Polish Language

The Polish language is unlike any other language I have learnt. It is completely different from the Germanic languages I speak and the spelling is out of this world. It was unbelievably difficult to master this language, but since I was young and eager I learnt to speak it fluently over time.

The language teacher who was assigned to teach us didn't speak English and I had a tough assignment to learn the language and the new subjects I needed to pass in order to enter medical school, in Polish. I had many dictionaries to consult, and most African students I found there came to help me with those subjects. Some helped teach me Chemistry in English and others tackled Physics. It worked. At the end of the year an examiner who could speak English came to test me and I passed. I did very well in Polish and Chemistry, which I enjoyed, and Biology, but did poorly in Physics. However, since I had done well in the other subjects, I was admitted to the medical school. Physics was still to be given attention and to continue into my first year in Medicine because I just passed it by a whisker. My teachers in Lodz advised me to start my first year of Medicine there, so they could continue to help me and monitor my progress, because they saw my commitment and hard work and the fact that, despite starting late, I had passed all the required subjects and had a good command of the Polish language. They were actually amazed at how well I had done despite arriving three months late.

I was so delighted that I made it and I buried myself in my studies; I don't remember a day that I went to bed before 2AM. This long night study found me in the classroom when the news broke that President

Kennedy had been shot dead. It was about 3AM in Poland in November 1963. That terrible news stopped me and I went to my room. I'm not sure whether I went to sleep or just cried. President Kennedy was for me the finest man America produced. I feel the same about President Obama. I loved America because of Kennedy's life and work and when he was killed I was very sad and I lost my love and admiration for America. Not long after that his brother Robert Kennedy was also assassinated. I met Robert Kennedy during his visit to Poland, although I don't remember the year. As the only black woman in Poland I stood out like a sore thumb, so I was able to meet and greet him.

I lived and studied in Lodz and successfully passed my Physics and my first year in Medicine. My teachers were very proud and arranged for me to start my second-year Medicine at the Medical Academy of Warsaw (Academia Medyczna Warszawie). I was now fluent in Polish, knew a hell of a lot of Chemistry and had mastered Physics. The second year was not a pushover, though, it was tough. I have never worked so hard in my entire life. It was unrelenting reading those thick books on Anatomy. There were six volumes. Looking back I think those big books on Anatomy were just there to torture students; I don't know how much use they were at the end of the day. But as a medical student you just had to learn about every bone, nerve, muscle, internal organ, and the whole human body. It was such hard work! During my time we used bodies that were preserved in formalin and since they were so dried out we didn't feel we were dealing with a dead person's body or human remains. That feeling only caught up with me during my fourth year, in Pathology. I will come back to this later to talk about the experience of seeing a real body, which is very different from the dried bodies we used in Anatomy classes.

Medical Studies in Warsaw

I moved to Warsaw in the academic year of 1964. I shared a room with two other equally hard-working Polish students and we studied together, late into the night. Since I was the only black girl in the area of our hostel and in Poland in general, there was a lot of interest in me. All the old people in the area, particularly the old ladies, knew about me, where my room was and how I was doing. If I went to the butchers to buy meat and sausages I would be given a bit extra, so my roommates would send me to go shopping for us.

On one occasion an unknown black man, who was seen in the vicinity of my hostel and assumed lost by the old ladies in the area, was redirected to my hostel as a lost and found item! As far as they were concerned, what would a black man be looking for in that area except Libertinko, as I was called? I think that Polish people, not having seen any African woman who spoke Polish, were fascinated and everything about me was a subject of curiosity; sometimes people even asked permission to touch my Afro hair. I had a colleague from Ghana, who was also studying Medicine and the people were very curious about his very dark colour and wondered whether it would rub off when he washed. He was invited to villages and given water in a white basin and a white towel, and his bedding was also white. The next morning people would gather discretely to see what had washed off! One day I went to the house of my classmate. Her little son of about three asked his mother when she put him on the potty whether my bottom was also black. All these questions were not asked out of malice but as a result of ignorance and they stopped as soon as people became used to us. In fact, they adored me and did everything to help me. My classmates would get me to shop for meat and sausage and even vodka, if we had someone's birthday party, because they knew I would be given more.

I was no longer just a Namibian student but an African student reflecting what Africa was in the eyes of the Polish people. Most of the

(male) African students regarded me as their sister. They use to call me 'my man' and some who were in my year became so close that they would give me their stipend money to look after for them.

There was a Sudanese student in my class with whom I used to study Anatomy. His name was Obed Hassan and he was very clever at remembering the nervous system, whilst I was good at internal organs, so we would revise together. We took our final examination in Anatomy together and both passed with a 5, the top score, and at the top of the class. In Poland, maybe because of its socialist orientation, students worked together. My roommates and I studied together, helping each other and cheering for each other when we passed the exams. There was also solidarity amongst the students; we knew for instance what questions a certain professor liked to ask and when you went into his exams there was already a thorough briefing from other students as to what he would probably ask.

During exam time I had to go and wake up Hassan, otherwise he would oversleep. I wonder what happened to him. I left him in the fourth year; I got tired of babysitting him. I hope one day he can read this story and contact me. One day while we were studying, preparing for an exam, his mother called him from Sudan. It was so funny. When the call came Hassan was so excited but he only managed to say 'Hallo Ma', and his mother could not contain herself. When she heard Hassan's voice she started crying while the minutes passed and Hassan could not ask anything, because every time he spoke, his mother just cried.

One day I received an unexpected visit from President Nujoma when he visited me on his way to the Soviet Union. He was told that if he had ten Libertinkos he wanted to send to Poland for studies he was welcome to do so. He gave me a fountain pen which I kept till I finished my medical studies in 1969. One day recently I asked him whether he remembered that visit to Poland, and he responded that yes he did, but he had forgotten about the pen he gave me. President Sam Nujoma has given me support since I left for Poland to study, during my studies, and after my return to Africa. He remained a pillar of support during my fourteen years in the refugee camps in exile and I can safely say that I worked hard all through my life with the knowledge that I had full trust and support from President Sam Nujoma. His unwavering support is one of the strong anchors in my life. I am eternally grateful to him.

Hard Work and a Lot of Fun

My stay in Poland made me a better person. When I went there, I saw for the first time that white people could also do manual work and get their hands dirty – something I had never seen under the apartheid system in Namibia, where the menial, dirty work was left to Africans and white people just sat in their cars. For example, during road work white people would shout at the black men to work harder. In Poland, all that work was done by white people. I didn't see any black person working in Poland; all the black people were students. The Polish people are some of the nicest, and coming from the apartheid system, being in Poland was the best thing that happened to me. I realized that we are the same, black and white, we have equal intellectual potential. The story of short noses and therefore short intellect was and is total hogwash. I used to beat some Polish students despite the fact that they were studying in their own language. So I learnt that it was not your colour that was important, as apartheid made us feel, but how much you worked. My apartheid negativism dissipated in Poland. I saw people not as white or black; as the saying goes, I saw a person not as an object. The Polish people made me a better person with no chip on my shoulder. They made me very confident in life.

I love Poland and to this day I take an interest in what goes on there. I cried a lot when the disaster struck Poland in 2010. The death of the President Lech Kaczinski, his wife and a number of senior Polish political, military and cultural figures in a plane crash in Russia, saddened me immensely.

Now I have forgotten the Polish language, which I once spoke so fluently. One evening after the opera I got into a taxi and was chatting with the taxi driver and when we arrived at my hostel, I got out and came to his window to pay. The driver almost fainted. 'Are you black?' he exclaimed. This shows how fluent I was in Polish!

I had a good life in Poland. I studied very hard there and I thought a lot about my grandmother. If I ever felt a little lazy, the mere thought of my grandmother would send me back to my books. But I also had fun; after every successful examination we would party. One year, my classmates decided that that they would give me a surprise birthday party. My birthday was 10 December, which is now celebrated in independent Namibia as Human Rights Day, in memory of those who died or were

wounded in the Windhoek Shootings of 1959. It's interesting that I was named Libertina which means 'freedom', when all my life I have been striving for that. My mother had actually wanted to call me 'Liberty' but the priest changed it to 'Libertina' at the baptism. 'Inaaviposa' is my Herero name.

On that occasion I was asked to go to the Grand Hotel in Warsaw to collect a parcel which had come from Africa for me. I went unsuspectingly with one of my roommates, to be greeted on my arrival by singing students with flowers. The hotel chef made us a beautiful dinner and we drank not vodka but champagne. We had such a wonderful time and partied into the small hours of the morning. What was also wonderful with Polish culture was the practice of presenting flowers to ladies; any person visiting would come with a bunch of flowers. This culture of taking flowers has stayed with me to this day; even now I always buy fresh flowers in town and take them to the farm.

We also had fun in the class. Before sitting for any exam, there was a red book we each had called the Index, which the professor had to sign if you had attended his/her lectures regularly, to give you permission to sit for the exam. One day during the preparation for the Orthopaedics exam, the professor made sure to sign the red book very early in the morning. He was one of those professors whose lectures started at 7AM. We had to line up for his signature before the examination; if his signature wasn't there the student could not sit for the exam. When it was my turn to present my red book for his signature, he looked at me and said he had never seen me in his class. He was right. I never attended his 7AM lectures! After studying the whole night I had difficulties waking up early to attend his lectures. Thus one of our roommates went to his lectures and we would study from those notes and the book. There was a student by the name of Woiteck, who was standing behind me that morning, and he rescued me. He said 'No, Professor, she does attend the lectures but she sits next to me in the back row and since it's dark early morning and she is dark, you do not notice her.' The professor was a little embarrassed for not noticing me because of my dark skin and signed my book without further ado. Let me hasten to explain that the red book had nothing to do with communism; it was just a student's register. It was red in colour but only by coincidence.

When we were in the fourth year, we started with the study of Human Pathology. Unlike the dried out bodies we had worked on in Human Anatomy, in Pathology we were given fresh bodies. This was it. The first lecturer used the body of a man who had died only three days earlier; his body was still fresh when it was brought in for the post-mortem examination. Most of us African students sat in the front row to have a better view. When the pathologist started dissecting the abdomen and took out the liver and started slicing it, explaining to the students what to look for, I was so nauseated by the sight that I had to struggle not to pass out. When I came to Poland I had often missed eating liver cooked on charcoal, which we did in Namibia after slaughtering a goat, but now after this first lecture in Pathology and watching how the doctor was slicing the liver, I lost all appetite for it. It took me three months before I ate liver again.

Once I got used to it, I was fascinated by Pathology. Sometimes we would dissect bloated bodies pulled out of the river; as students we were not given masks so we had to put up with the smell of decomposing bodies. I had a strange feeling about what human life meant. After dissecting a body the pathologist would put papers in the empty cavities and discard the organs he/she had cut out and cut through, and we students would close the empty shell of the diseased body with most, if not all, of its organs missing. I was fascinated by the domain of Pathology and began to enjoy it. For my final exam I was standing in the lab awaiting my turn and a very bloated body was wheeled in. I knew I would have to dissect some part of it, and I was praying to dissect a part other than the stomach but, lo and behold, that's exactly what I got. Once you open the cavity you become immune to the smell and concentrate on the dissection, so I got on with it, cut out and examined parts as required, answered all the questions and passed Pathology with a 4 (remember that 5 is the top score).

It would need a separate book to talk about my whole seven years in Poland. Suffice it to say those were my best years. Most of the time was spent studying, but once in a while I would go to the villages with my Polish friends or we would go to the opera house to watch ballet or opera. Once, Obed Hassan, my Sudanese class mate, remarked that he would spend a weekend at the cafeteria for the Art students because he was fed up with looking at the pale and tired-looking girls of the medical

school with bags under their eyes from all that constant reading. I think he was right. Medical school is not for the faint-hearted; it is relentless reading all night and all day if you want to pass your exams with good marks. There is very little time for going out or make-up, so for me it was a case of washing and putting on Vaseline, and no make-up. Because of lack of sleep we developed bags under our eyes. The Art students didn't read as much as we did and Hassan was right; the girls at the art school were very beautiful, with long flowing hair and no bags under their eyes!

Life Outside Studies

During the holidays I would go to West Germany to visit my friend Nora, with whom I had been reunited after our days together in Dar es Salaam. In the beginning I also worked there in a restaurant, waiting on table and washing dishes to make some money, but I didn't like it. It felt as if I was working in someone else's kitchen, something my grandmother had told me never to do. I also found the customers very demanding. They took too long to choose what they wanted to eat and treated the waiters like numbers.

One holiday, I went to Sweden and worked in a book-binding factory. That was a very tedious job, worse than working as a waiter, because it was so repetitive. There were lots of us students and each one stood in one spot and did the same activity all day. As the book passed you were required to put a page in or whatever your line was doing. It was so monotonous that we started making frequent trips to the toilets to take a quick nap. However, the owner of the factory discovered this and came up with a 'pay as you produce' system. He told us that from then on we would be paid according to the number of books we bound. I must admit that the queue to the toilet ended and all together disappeared as we were rushing to make more money, and we did make good money. I'm glad that I didn't have to continue to work in a factory, and this was just a once-off situation. I had chosen to become a doctor. I think of people who are working in these very tedious factories and I feel sorry for them; they have no choice so they must work there. I had choices and worked there only temporarily to make money.

As I became a senior student I got a job in a private hospital in West Berlin run by a female doctor. I kept that job until I finished my studies in Poland, and went to work there every holiday. That was real

work and was the beginning of my future medical career. I liked it very much; it felt like I was a real doctor at last. I had been introduced to the doctor who ran the hospital by a family member of hers who lived in East Berlin, with whom I stayed in 1964. From that time on I would go and work for her during the holidays and stay with Nora.

Foreign residents in the Eastern bloc countries were not restricted from going to West Germany during holidays, so sometimes I would take gifts to the doctor from her relatives in East Berlin. As luck would have it, I was with her family when Reverend Martin Luther King came over from West Berlin, which he was visiting, to speak in one of the churches in East Berlin. I went to listen to his sermon in St Marienkirche, along with Comrades Mvula ya Nangolo and Vita Kaukuetu, who were studying in East Berlin. After Dr King's sermon, we three black Namibians went to greet him and introduce ourselves. He was so happy to meet us and spent some time with us. He told us that he knew about South West Africa and had written some articles about its history. I will never forget that day. It was 13 September 1964. I think he is one of the best orators I've ever listened to. He spoke elegantly with such a beautiful voice and such beautiful English. I was spellbound. It's a pity we have lost this wonderful man in the madness of American racism. He was gunned down four years later, on 4 April 1968.

In 1967, I was a fourth-year medical student and again I went to work with the doctor in West Berlin and stayed with Nora. One rainy day I jumped in the bus after work and all of a sudden I heard my name. Guess who was calling me? It was Elsie, one of those West African girls who had left Poland for West Berlin in 1963 after our visit to the American Embassy. She invited me to her place, right away, because we had so much to talk about, and to catch up on. I had so many questions to ask, and so did she. What had happened to them? I wondered. Were they now in medical school as was promised? She told me a grim tale. After they arrived in West Berlin it was dinners and night clubs. Then, like chewing gum, they were spat out (maybe they didn't have useful information). She, however, met a countryman of hers, a doctor, and got married. She was a very pretty girl, so I wasn't surprised she found a man who married her. The others disappeared into thin air. She concluded the story by admiring me for the wise decision I had taken, by not joining them. I said to her that it was my grandmother's spirit

that had guarded me. I am telling this true story 40 plus years later to illustrate how the Cold War affected even innocent Africans who had nothing to do with it. Looking back, I'm glad I didn't follow them; today I am a doctor, well educated in Poland.

Graduation

After so much hard work I finally reached the ultimate success in my life, and the high point was when I graduated on 15 May 1969. I was among the top twenty graduates and so were my two roommates. After seven years of hard work, learning a very strange foreign language, living in a very cold country (but with warm-hearted people), away from my homeland and family, I had at last attained my final goal by sheer tenacity, discipline and focus. I became the first African woman to graduate as a medical doctor in Poland and also became the first woman doctor in the history of Namibia.

In the socialist countries we didn't wear academic gowns like in the West, something I miss now when I attend graduations. I feel embarrassed, as if I have no degree. Anyway the point is that I am a fully qualified medical doctor, never mind the gown. For example, when I graduated at the University of South Africa (UNISA) after a fifteen-month course in advanced administration in the early 1990s, I wore a borrowed gown, but I am very proud of my education. I later worked in Sweden where I found other Polish doctors who were recognized as very competent by the Swedish health fraternity.

Recently, in 2009, I was sent a gown from Poland, but it is so heavy and large that I can't use it much in the hot African weather. However, if an event takes place in winter I will wear it. I think it's not fair to not have a gown and I hope that Poland introduces the system of giving its graduates gowns. A medical degree is as important as any other degree; it is an achievement after students work so hard for seven long years; and they should be given academic recognition and a gown to go with it. There may be those readers who think I am vain, but that's their view. I feel it makes a hell of a difference to the morale of graduates. A gown is a morale booster; it makes you doubly proud.

So there was no gown given to us, but the professor who was overseeing the event, handing us our certificates and leading us into the oath, was wearing his beautiful gown. Nevertheless, it was a great

day, flowers were everywhere, and there were many kisses from well-wishers. I thought of how proud my grandmother would be. I am not a cry baby by nature but that day I shed a tear. I can't describe the mixed feelings I had. I was very happy that I had completed my studies. I was elated but sad at the same time that my grandmother couldn't see this, or any member of my family, and also sad that I wouldn't be able to treat her when she became sick because I was not heading back to Namibia and home, but to refugee camps in exile. Our fight for independence still had a long way to go.

At our graduation we partied into the night and it was all flowers and dancing. I think in life there is nothing so rewarding as accomplishing your goal. You see this when watching sports and see the winners' happy faces or how they jump up and down on the pitch with joy; it's not a small feat to succeed. I felt the same. I wanted to jump for joy. Finally I had made it!

An Intern in Tanzania

After the party it was time to plan my trip back to Africa. I had no intention of hanging around in Europe. I had come to Poland for the one and only reason to qualify as a doctor to go and treat my people. I had accomplished that so I wanted to head home to the continent of my ancestry, which I love. The Government of Poland gave me the ticket and booked me on their national airline, LOT. I had no restriction as to how much luggage I could take with me. I was allowed to take all my books and I must admit that I had a lot of luggage. I had lived there for seven years, so you can imagine the amount of stuff I had collected and the very heavy medical books I had to carry. I was happy to go back to Africa, but I was also sad to leave my friends and a little apprehensive as to where I was going. I was going back to my mother SWAPO, and to Tanzania (formerly Tanganyika), the country that had enabled me to travel with their travel document, for which I was very grateful. I also decided that if I couldn't go back to Namibia I was going to render my services to the people of Tanzania, a country that had enabled me to realise my dream.

I left for Tanzania via Nairobi; the plane was full of flowers as my classmates and other friends and families I knew came to send me off. I was very moved. The flight attendants were excellent and I was well looked after; I was treated like a celebrity. Well, in a way I was Poland's success story, the first black women to qualify as a medical doctor at the prestigious Academia Medyczna Warszawa.

The flight was in the evening and we landed next morning in Nairobi. I was met by a friend who had also studied in Poland and had returned and was working in Nairobi as an economist.

I stayed with my friend's family for three or so days in Nairobi but Kenya was in political and tribal turmoil. The famous and highly respected politician Tom Mboya had been assassinated four days before. The mood in Kenya was sombre and tribalism reared its ugly head.

Mboya was Luo and the family I was staying with was from the Kikuyu tribe. One evening we went out for a meal and the waiter wanted to know which tribe I was from. As a Kenyan he could tell that my friend was Kikuyu but he couldn't tell my tribe. I was thus anxious to get out of Kenya and go on to Dar es Salaam before I was mistaken for someone from one or the other Kenyan tribes.

My preference to do my internship in Tanzania was to thank the Government for giving me a travel document which had enabled me to travel to Poland. Without that document I was never going to be a doctor, thus I felt I owed it to the people and the Government of Tanzania to render my service to them. I left for Dar es Salaam on the next available flight and arrived safe and sound. I managed to take all my luggage along without being charged extra, although I was obviously overweight. I was welcomed by my SWAPO comrades at the airport and went to our SWAPO house in Magomeni, one of the suburbs of Dar. I also met Mzee Kaukungwa and many other comrades there, although I didn't know many of them before. It was a wonderful feeling and a very happy reunion. I also met Meme Mukwahepo and Solomon Mifima and others.

After a few days of rest I went to register for an internship at Muhimbili Teaching Hospital in Dar. I started in September 1969. I don't know the history of Muhimbili Hospital but it was a clean and pleasant multi-storey building. I met two women doctors who had both trained in the Soviet Union. One of them was the late Dr Manto Tshabalala from South Africa, and the other one was Dr Ester Mwaikomo, a Tanzanian. They started their internship a couple of months before me. It is safe to assume that we were the first female interns in Muhimbili Hospital. The patients weren't used to female doctors and would always ask where the doctor was (assuming the doctor would be male). I was worse off because I looked very young, so patients would peep into the casualty room when I was on duty and hesitantly ask me where the doctor was. I would explain to them that I was the doctor on duty. They would come in hesitantly with some apprehension, but after I had treated them the word spread that I was a caring doctor after all.

I quickly learnt the Swahili language that is spoken as a lingua franca in Tanzania and throughout East Africa because, as I discovered, many words are similar to those in Otjiherero, and I could communicate with

my patients. However, I encountered many problems in the beginning. The first one related to my dress code.

After seven years in cold Poland, I found the humid weather in Dar es Salaam oppressive. One day I was in town and I was wearing a miniskirt. Some of you may recall that the 1960s and 1970s were the era of miniskirts. Ben Amathila, who was later to become my husband, dropped me at a shop and went to another one, but when he came back to collect me I was nowhere to be found. As he was looking, bystanders realized that he must be looking for me and told him that I had been taken away by the police. He came to rescue me. However fortunately, as kind as the Tanzanians were, when they discovered I was a foreigner they released me with a warning not to wear miniskirts in their country. Tanzanians are very humble and nice people; if it had been in another country maybe I would have had more problems. There were some countries where vigilantes slashed the legs of girls found wearing miniskirts. Strangely enough, when I got married in January 1970 in Dar es Salaam I wore a smart white mini-dress and the police did nothing.

Malnutrition

When I studied in Poland there was no malnutrition so I had no idea about the existence of malnutrition, but in Tanzania there was kwashiorkor and marasmus, the extreme forms of malnutrition among children under five years old. I saw, for the first time, children who were admitted badly dehydrated, with severe gastroenteritis, who needed intravenous fluids, and due to their serious condition we, the interns, had a mammoth task to find a vein. We were required to do what was then called a cut down to find a vein; we had to cut open at the ankles, insert the needle and connect the drip. That was the only way to save the children. Once a child received intravenous fluid there was very rapid improvement. Sometimes after a night in which we had spent a long time looking for a vein and successfully inserting the drip, next morning at the rounds the child would have improved so much that we didn't recognize him/her. Oral rehydration is not possible in a child who is severely dehydrated and who is vomiting. Thus, intravenous rehydration was the required treatment of choice.

I discovered that the senior nurses were excellent at doing the cut down. I asked one of them to teach me how to do it, so after working

hours, or at night, I learnt from the nurses how to do the cut down. I didn't pretend to be a doctor who knew medicine better than a nurse. The situation was urgent and very serious, if you didn't know the practical things to save the child, you were doomed to failure and could lose a child, so I had no ego about this. Soon I became an expert at putting up the drips using the cut downs.

Internal Medicine

I started with Internal Medicine and the main illness was malaria, followed by other diseases of both a chronic and acute nature, including other tropical diseases such as schistosomiasis. I spent three months in medical wards. I learnt the names of diseases in Swahili and as I went along I could communicate with my patients. Tanzanians are by nature very friendly. The registrars were not pompous and helped us interns along; and the graduates from Makerere University (in Uganda) in particular were very friendly. They were our registrars and very knowledgeable, and they were ready to help those of us who had studied in Europe, where obviously we had little understanding of and no experience of tropical diseases.

The senior nurses were particularly knowledgeable and if you asked them how to do things, as I used to do, they were friendly and helpful. The medical wards were full of very sick people, so it was hard work and sleepless nights when we were on call, and we interns always seemed to be on call as I remember. But it was my first time to be a real doctor and I enjoyed it immensely. I was proud walking through the wards with my stethoscope around my neck. I felt that I had achieved my goal in life. Although it was hard work I was always ready to stand in for colleagues when they asked me and did that with pleasure because I learnt more, saw many new cases and learnt how to treat them.

When on call we could always ask our registrars to come in and help us when in doubt. There were some registrars who harassed us as interns, who would show off by asking some uncalled-for questions when there were beautiful young nurses during the rounds. We knew them so sometimes we managed to avoid them by not following them on their rounds. I had little knowledge of tropical medicine, but I read a lot and I worked with senior nurses, asked them questions and got informed about many of the diseases that were common in the wards.

My Swahili improved quickly and I started feeling at home. I passed the Internal Medicine exam and moved on to the next subject.

Surgery

You find two types of surgeons. On the one hand, you find calm and competent surgeons who know what they are supposed to do and, on the other hand, there are those incompetent ones, who shout and throw instruments around, accusing the theatre nurse of giving them wrong instruments. Those are the types who on some occasion may leave instruments in the abdomen of the patient during an operation. Such cases were a common occurrence in Africa, because of the lack of human rights of the patients. There was no practice of 'taking the doctor to court', so if the patient was lucky he/she would be readmitted, the instrument or even a piece of gauze would be removed and the patient would keep quiet. Nowadays there are patient's charters informing patients of their rights, and the patients and/or their relatives know their rights. Negligence does not happen without retribution, and the press is unforgiving.

There was one surgeon from Europe, one of those half-baked doctors who think they will come to Africa and use African patients as guinea pigs to learn their trade by cutting them up regardless – those who will do a Caesarean section on a pregnant woman even though it is not called for, just to practise the procedure. This surgeon had a shouting match with a senior theatre nurse. I thought he had picked the wrong woman, since this was a very senior nurse from South Africa who had come to assist the Tanzanian health services. She was very well qualified and well respected. Not long after the incident, this doctor was shown the door by the authorities and kicked out of Tanzania.

Working in Surgery, I soon saw my first hydrocele case close up. Fortunately I had been forewarned about the registrar who liked to 'treat' the new interns to a shower of the fluid from the hydrocele, so I stood behind the nurse who was assisting him, and when he punctured the hydrocele the fluid missed me. However, we interns liked this registrar. He was from Makerere University, a graduate who knew his job, and under his tutorship I was able to operate on three hydrocele cases.

Otherwise Surgery is mostly dealing with emergency cases and running to save the life of the patients. When you are on call in the

surgical department, you get palpitations every time you hear the sirens and the ambulance's brakes screeching. 'What is it bringing?' you wonder. Your adrenaline goes up and you know it means a sleepless night. It is a life of drama, particularly at weekends. Car accident victims were the majority of our patients, and they came in with fractures and head injuries. There were also many other acute emergencies and cold (not urgent) cases such as hernias or tumours that needed corrective surgery. However, in Tanzania I never saw a gunshot wound or even a knife wound, not like one sees nowadays in Namibia where alcohol over the weekends causes a horrific amount of surgical emergencies.

I don't remember much of what I did in Surgery, but I do remember that we interns would close up the abdomen after the surgeon had made sure that everything was closed up internally and there was no bleeding, before we sutured the skin. Sometimes, if we worked under a good surgeon, we would be shown the organs and given an explanation as to the nature of the operation and the symptoms of the disease to look out for. However, if we worked under an incompetent surgeon we had to endure harassment and accusations that we didn't know anything and would make useless doctors. It was not my subject of choice so I just went along and finished my time in Surgery without a lot of interest. I did appreciate the chance given by the surgeon to suture the skin and close the abdomen and also other opportunities to suture an open wound by myself. I also learnt about some chronic diseases and what kinds of operations were performed.

Gynaecology

The next subject was Gynaecology. I was planning to specialize in Gynaecology and thus looked forward to it, also thinking it would be less hectic than Surgery. Boy was I mistaken! It turned out to be 100 per cent emergencies and lots of blood. I mentioned the adrenaline surge in the surgical department but in Gynaecology there was 24 hours of raised adrenaline levels. One weekend I was on duty and on call for 36 hours; this is not an exaggeration but the holy truth. That night I had cases from back street abortions to prolonged labours brought in late. In one particular case, a woman presented with what is known as brow presentation and prolonged labour. This is a case for a Caesarean section, no two ways about it. The woman will not deliver that baby

except by an operation. When the uterus is about to rupture, it forms a ring on the abdomen, known as 'Bandis Ring' if I still remember well. When that ring appears, it is a sign of imminent rupture.

My back-up consultant was a surgeon from another African country who had trained in the West. He looked down on those of us who had been trained in Eastern bloc countries. When I called him to report on the woman's condition, he ignored my call; he wouldn't talk or listen to me as an intern on duty but wanted to talk to the registrar, the sister or midwife in charge. I don't remember where the registrar was. After some time, at around 2AM, I reported again that it seemed that there was a sign of imminent rupture, because I noticed the formation of a ring on the abdomen, but again the consultant ignored me and did not respond. However, knowing that eventually we would head for the theatre, I took precautions and prepared with the theatre nurse on duty for a Caesarean section.

At 4AM the woman's uterus ruptured and I gave the consultant a call he would never forget. I threatened to hold him personally responsible if we lost the mother and child and told him to be there immediately; then I hung up the phone. He came in, sweating profusely. You remember that Dar is humid at normal times? Well, in this case of a frightened man the heat must have been intense! Mind you this was a black man who was so pompous about being a specialist called Sir, so he was living in clouds of self-importance. The woman was already in the theatre and we operated on her immediately, as soon as the consultant arrived. Unfortunately the baby was stillborn, but fortunately the mother survived. She already had three children but the loss of a baby owing to the negligent behaviour of those who should have saved it was painful. On the other hand, there was also the late arrival of many patients, which is another drawback. We cannot always blame the patients, though. African governments are trying to bring health services closer to the people, but it's not easy.

The truth of the matter is that I reported this case to the authorities but the attitude was that doctors were mini-gods, and what was the word of an intern, and a refugee for that matter, against the specialist? This incident put me off my plan of specialising in Gynaecology. I was also appalled by the bloodiness of it; there were so many abortions, lots of miscarriages and, above all, the problem of pregnant women not attending anti-natal clinics and coming late with some complications

that at times made our lives as interns a living hell. I remember how my eyes would close from exhaustion. I then decided that Gynaecology and I did not agree; I wouldn't be able to help patients who came in with incomplete abortions, bleeding and white as a sheet and we had no blood to give them. My desire to be a doctor was to save lives, but in this domain, it was impossible, where one felt like a fire brigade; the house was burning and by the time you arrived the property had already burnt down along with the people inside it.

I left that department having realized the enormity of the struggles of African women to cope with the burden of child bearing. The surgeon was full of appreciation and finally respected me for my education. I think he was ashamed of behaving like an idiot; I hope so. He thanked those of us who were on duty that night for our action to prepare the theatre ahead of time. That had at least saved the mother. So I ended my internship in Gynaecology on a high note. I had conquered the pompous specialist and he now respected me and my education. More importantly, I saved the lives of many women, delivered many babies, and contributed to taking care of sick people. I think that, as long as Africa has no proper roads to get the patients to hospitals more quickly, there will always be a high rate of maternal deaths, because Gynaecology is an emergency. Also antenatal clinics are a must, so that complications can be detected in time and the patients referred earlier to proper facilities. I still love delivering babies, though!

Paediatrics

The last major subject was Paediatrics. The senior consultant was a certain Doctor Ebrahim, a very calm man who never raised his voice, and was very patient with the children. I walked into the ward and was greeted by the staff and soon I was introduced to Doctor Ebrahim. The ward sister and the doctor took me around, introduced me to their patients and gave me the reasons for their admission. I immediately liked the calmness of the ward, coming from the rush of Gynaecology. The next day, as a beginner, I started my rounds with the ward sister. On that first round I was to start examining the patients. I approached the first bed and the little girl, who was about four years old, opened her mouth as soon as I came to her bed. I ignored her, took out my stethoscope and went for her chest, but she resisted and lectured me,

telling me that first I should look into her mouth, then check on her tonsils and her glands under her arms and only after all this had been done could I use that thing (meaning the stethoscope). I learned later that this was Dr Ebrahim's routine. By the time the doctor arrived I had done my round and I also told him what I had learnt from one of his patients. He was amazed how observant the children were and also how brutally honest they could be. I learnt the same and that is what attracted me to Paediatrics.

All the children knew the routine and, having gone through the lecture from that little girl, I knew better where to start the next day, so my next round was a success. I looked into the mouth, checked the tonsils, the glands and then the chest. It was a very sobering experience working with children; they are very honest about how they feel. The day they are sick they show it, and if they are well the smile on their faces when you approach them tells you they are well. No two ways about it.

The children suffered mainly from gastro-enteritis, malaria, measles and other preventable childhood diseases. There was also very severe malnutrition. By now I knew all about kwashiorkor and marasmus and how to deal with them. It was a daily occurrence to receive a child who was extremely dehydrated and we had to resort to cut down.

Working with Doctor Ebrahim was a blessing as I learned so much. Polio was still a major debilitating disease, and that little girl who had lectured me was limping because of the aftermath of polio. Measles was the other very serious, acute, and sometimes fatal infection. It was caused by a virus and the condition of the children was mostly compromised by malnutrition, so it was a serious disease. I worked very closely with the nurses, whom I found very knowledgeable. My consultant was excellent and I decided that I would specialize in Paediatrics when I finished my internship.

I learnt from Dr Ebrahim how to conduct myself as a children's doctor. The important lesson was to listen to the children and not ignore anything they said. Also, I listened to the nurses because very often they had vast experience working in the wards for a long time. I respected their views, asked questions when I didn't know or understand, continued to read, and research. When you graduate as a doctor it is just the beginning of a long arduous journey to continuous learning. You need to treat your patients with respect and dignity. Sometimes you

come across some arrogant interns who don't want to be told what to do by the nurse, but if you have that attitude the nurses will leave you alone and the registrar will fix you if he/she finds that you have made mistakes or don't understand what you are doing.

My teacher, the four-year-old, became my friend. She would give me reports about what happened during the night: 'Dactary, this child was crying at night, but the night nurse didn't come,' or 'Dactary, the night was quiet nobody was crying.' This child had polio and was in hospital for some time. I used to take her around the ward to walk her for exercises and sometimes we would walk outside the hospital. I used to call her 'Supervisor'. I should have taken her address or met her family so that I could keep in contact with her when I finished my internship. It would be difficult to trace her but by now, God willing, if she is alive she must be a woman. She was clever and would ask so many questions. I wanted to thank her for teaching me how to examine the children. I decided to specialize in Paediatrics partly because of her.

I finished my internship and was certified as a registered doctor. On 29 October 1970 I received my Certificate of Provisional Registration issued by the Medical Council of Tanzania. Hurrah! I was very proud and felt that I had conquered Mount Kilimanjaro.

Marriage

As a student in Poland I never had time to think of love and marriage. I had also decided that I would go home and I wouldn't marry a foreigner, so there was no need to get involved with people who were not from my country, and as I said I just had no time for anything else but completing my studies. I would never disappoint my grandmother. Before I left for my studies, when I told him that I was going to study Medicine, Theo-Ben Gurirab said to me: 'Ag, you will just go and get pregnant and will not finish your studies.' I don't know why he felt so sure, but I decided that I would fix him and put him to shame. I would finish my medical studies! Thus I had to please my grandmother as well as shame those who thought I would fail. So there was no time to fall in love or even think of love.

When I came back to Dar es Salaam I met Ben Amathila who had been my classmate at Augustineum. Before I left Namibia in 1962 I had gone to Walvis Bay to obtain my SWAPO membership card from Ben,

and now here he was in Tanzania on my return from seven years in Poland. I didn't want to get married to a foreigner and here was my home boy. Even so it was not a relationship in a hurry; I had to finish my internship first.

Ben and I were married on 30 January 1970. Soon afterwards he was sent to Stockholm to represent SWAPO in the Nordic countries. It was important to have a representative in Scandinavia bearing in mind the support the liberation movements such as SWAPO were being given by those countries, particularly Sweden.

We married at the Magistrate's Office in Dar es Salaam. We had a party at our house in Magomeni. All the comrades who were in Dar es Salaam and other places in Tanzania came. Some got intoxicated in the evening and slept around the house. It was a very pleasant day having all the Namibians in a foreign country together. Comrade Lukas Pohamba (now President Pohamba) was our best man and drove the car to take us to the Magistrate's Office and back to our house for the party.

Ben soon left for Sweden and I continued to work in Muhimbili Hospital for six months as a registrar. I joined him in Sweden in 1971. During that period I was also helping our SWAPO comrades who were in Tanzania. Marriages entered into during the struggle years have a high casualty rate of divorce because the pressure of work and the long periods of separation take their toll. Couples grow apart as the time goes by. Our marriage survived 23 years but we only lived together for the four years of my stay in Sweden and another six years in independent Namibia. Back in Namibia, finally at home, life became very hectic as both of us had demanding responsibilities. We both became ministers (Ben as Minister for Information and me as Minister for Local Government and Housing) at Independence and again there was separation. We became so engrossed in our work that in the end, there was no time to nurture the marriage, so our marriage did not survive. We divorced amicably in 1998. We remain a family; there is no animosity to this day. Many people still don't know that we are divorced. Many struggle marriages have not survived the pressure of the struggle but many individuals have remarried. I am not intending to remarry. I think that to be alone brings out the best of you. Ben is also still single.

Further Studies
in the UK and Sweden

After completing my internship and working for six months in Tanzania as a registrar, I was awarded a scholarship by the World Health Organisation (WHO) to study Human Nutrition at the School of Hygiene and Tropical Medicine in the UK. I left for London late September 1970 to take the one-year postgraduate course. I needed training in this subject if I wanted to become a good paediatrician in Africa. During my internship I had discovered how ignorant I was in the field of nutrition and if I was going to work in Africa I needed to know about nutrients. Sound knowledge was essential since good nutrition can solve many childhood illnesses in Africa. Examples are kwashiorkor and marasmus, which affect many children as a result of protein deficiency and general food shortage. Thousands of children die of diseases which normally ought not to be fatal, such as measles, but because of the underlying malnutrition their immunity is compromised.

In Poland we were taught Hygiene and Nutrition by a very boring, elderly lady professor and we didn't pay much attention to what she was saying. The payback was a glaring lack of knowledge in Nutrition and I painfully discovered that I should have apologized to the Professor for not paying attention to her lectures. But I was not the only one who didn't pay attention. There was a student from Cameroon by the name of Isaac Eyuom, who used to sit next to me. He talked throughout the lecture and listened to music through his small tape recorder, using an earphone. One day during class he told me it was his birthday, he wasn't in the mood to do any studying that day, and he wanted to go to the theatre. That day was 10 December, which also happened to be my birthday, so we became good friends. We used to chat during the lectures on Hygiene and I paid dearly for the lack of knowledge in that

subject. One of the consultants in Dar es Salaam made fun of my lack of knowledge of tropical diseases and was always asking me about the signs and symptoms of one or the other tropical disease, knowing quite well that I had studied in Europe and didn't know the answers, but he didn't put me off.

I was very happy that I was given the scholarship to the School of Hygiene and Tropical Medicine and I studied very hard. I also met a Palestinian woman doctor, Radda Garmi, at that school, who was planning to go to Egypt to research Arab medicine. I don't remember why she was studying Nutrition, but we became good friends.

Acclimatizing to Another New Country

During my time in London, I learned that Sweden had the best Paediatrics training, so after my course in Human Nutrition I went to Sweden to do further studies in that area. Since Ben had been posted to Stockholm as SWAPO Representative to the Nordic countries, it worked out well for us and we were able to spend four years together in Stockholm.

I was once again back to the snow in winter but, to add to the misery there were midnight summers as well. In the Nordic countries the sun barely sets during summer time and they have what they term midnight summer festivals. It was daylight till almost midnight and newcomers to Nordic countries had a hard time adjusting. I had problems sleeping properly while it was so light, but I gradually got used to it. During the long winters the opposite happened; it was dark at 3PM and I wanted to go to bed! Later I found that people went shopping at that time and Stockholm was beautiful with candle lights in the windows and beautiful street lights. The streets were white with snow. It was pleasant to walk around town at that time with the streets full of people strolling around, doing their shopping or just window shopping, and restaurants were also full. Unlike in Namibia, people in Europe like eating out. I started enjoying the winter months in Sweden; I found the tradition of candle-lit dinners fascinating and very romantic.

After a few weeks in Stockholm, I secured a job in the radiology department of Karolinska Hospital, the largest teaching hospital in Sweden. In Sweden, English is widely spoken and I didn't have problems in communication. As I mentioned earlier, Sweden was

one of the Nordic countries that supported the liberation movements and we had some NGOs such as the Africa Groups of Sweden, which worked directly with SWAPO. Since we had an office in Stockholm, it was easy for me to make contact with our local supporters and with their assistance I was able to find work. I went to enquire from them where I should go to specialize in Paediatrics and was directed to the Karolinska Hospital to see a certain Professor Hamburg. Sweden was open to doctors from foreign countries who could work there. Those who had trained in Poland were particularly welcome and some were already working at Karolinska Hospital. An appointment was made and I went to see the professor. On the day of the meeting I came early and was shown in to the office to wait. I was surprised that he arrived on the dot. In some countries when one has an appointment with such high-ranking professionals, you are made to wait for hours but here was a professor coming on time. Later I learnt that things in Sweden are done punctually; maybe that's why the country is so well developed.

The first encounter was positive; the professor was impressed by the fact I had learnt Polish, which is a Slavic language, and so different from Germanic languages. He had done some research on Namibia and he knew the history of the struggle and something about the country in general. We then talked about education in Poland and he told me that there were Polish-trained doctors working in Sweden and he was impressed with their competence. We came to the subject matter and I told him why I had chosen Sweden to specialize in Paediatrics. He had no problem in principle but told me that the road to specialize in Sweden was very long for foreign doctors. First you had to learn Swedish. 'Lord knows how long that will take,' he said. Then you had to do an internship for 24 months to obtain a Swedish medical degree and qualify as *Swens legitimerad läkare*. Only then could you start with the specialisation.

I said I would do all that. I would learn Swedish quickly because it was not as difficult as Polish, and I would come back for the internship. After four months I went back to the professor and spoke to him in Swedish; he couldn't believe what he was hearing! While I was still in his office, he phoned one of his aids and told him to make arrangements for me to start in Uppsala, to do the course in Social Medicine for three months and then do the internship. Social Medicine was a new subject for me. I think this three-month course was only found in Sweden.

Uppsala is an old university town 70 kilometres outside Stockholm. The university there is over 500 hundreds years old – nearly as ancient as Oxford University in England. Life in Uppsala is nothing to write home about; it is truly a university town, full of students, so my life was studying and practising in the hospital. I also improved my Swedish. The course lasted three months and after completing it I left for Stockholm to start my second internship. This particular internship was compulsory for foreign graduates, if one wanted to specialize in Sweden.

My Second Internship

I did Internal Medicine for six months at Sabatsberg Hospital, followed by Surgery for six months, then Psychiatry for three months at a psychiatric hospital in Stockholm.

I've learnt a great deal about relationships between doctors and nurses over the years. In Africa, depending on where a doctor studied, there was a nonsensical hierarchy. Nurses were treated as if they were the servants of the doctors; there were separate tea-rooms, with doctors sitting by themselves and nurses sitting by themselves. In Sweden there was harmony. There was one coffee room for all; doctors respected the nurses; and there was no shouting in the operating theatre. People worked quietly. I also found the Swedish nurses very competent. If you were doing a lumber puncture, for instance, the nurse would prepare the tray with everything you needed; all you had to do was sit down and insert the needle. The nurse would even hold the tube to collect the fluid. This was a far cry from my earlier experience during my first internship in Dar es Salaam.

The Internal Medicine was mostly dealing with elderly patients, and one day an old lady was wheeled into the casualty department while I was on duty. When I approached her bed, she got scared. Her concern was how she was going to explain her ailment to the black woman with a big Afro hairstyle. She was sure I didn't speak Swedish. I noticed her apprehension and quickly greeted her in Swedish to put her at ease. She exclaimed: 'So you speak Swedish, I was afraid that you wouldn't understand me.' I was very surprised that this patient, who was wheeled in on a stretcher, walked out herself after we spoke for some time. I discovered that she was very lonely and felt depressed, but after chatting with me she forgot her illness and went home. I promised to visit her at

her home, and I kept my promise. I visited her on several occasions and bought her flowers 'Polish style', and she was very happy.

People lived well in Sweden and medicines were greatly subsidized. Patients paid only 15 Swedish Kroner in those days for every type of medication. We doctors were high earners and paid very high tax. If I remember well that tax was 35 per cent of our salaries. I think that's what President Obama is fighting for those high earners to subsidize the poor. Sweden was a social democratic country and there was no huge gap between rich and poor.

After completing the Internal Medicine component I moved on to Surgery. It was like my previous experience in Dar es Salaam, except there were no hydrocele cases to operate on in Sweden. It was emergencies, cold cases and chronic cases for operation. The atmosphere in the operating theatres was calm and orderly.

I also stayed there for six months, and then moved to Psychiatry for three months at Beckomberg Psychiatric Hospital. The 1970s was the time of LSD and other drugs, so this hospital was mainly looking after drug addicts. I had thoughts which I couldn't tell anybody because the staff members in the hospital were very taken up with the drug addicts. I can mention now my feelings at that time. I thought that these young people had such a good time in Sweden and were idle; I felt like sending them to the forest to cut wood and get busy. I also felt that they were young and should get work instead of squandering government resources in the hospital. Coming from a refugee camp where people were struggling for the basics, I felt these people were spoilt and didn't realise how lucky they were. However, I couldn't say then what I am saying now, otherwise they would have taken me for an uncaring person.

Finally, on 25 February 1975, I received the certificate of authorisation as a fully qualified physician by the Swedish National Board of Health and Welfare. I had beaten Professor Hamburg's calculation of 24 months. He had told me that it would take 24 months but I had completed the whole programme in 21 months, including learning Swedish.

Life and Work in Sweden

Sweden was a very clean and organized country; people were very calm; services were tiptop and punctual; buses came on time to the minute. Life was comfortable; the health services were affordable to everybody.

There was no point to overwork oneself because the tax man took any extra money we made. Sweden was a real social democracy and looked after her citizens very well. I learned too that the unemployed received unemployment benefits.

What was striking in Sweden, however, was that you hardly knew your neighbour, because people were so comfortable and didn't need to bother their neighbours with anything, whether it was asking for sugar or even enquiring about someone's health, as we do in Africa. But there was an undercurrent of loneliness for some people. If you were sick the doctor would come and/or the pharmacy would send the medicine you needed to your house. You could actually choose not to talk to anyone all day if you so wished. Most services were automatized; you walked down to the train station, inserted your card, the door opened, and you went through to the platform. You didn't need to ask someone when the train was coming – everybody went to the timetable and checked the time when the train was to arrive, and when it came, the train door opened and you took your seat. Put simply, you didn't need to talk to anybody or ask when the train was due since the timetable was there to guide you. When going to the shop you took your shopping basket, filled it up with what you needed, went to the cashier, paid and walked out to the train, and went back home, finish and *klaar*. Yet in the midst of this comfortable life, there was a high rate of suicide and even some cases where the person had been dead for some time and nobody noticed until the postman either smelt a foul odour from the house when he/she brought the post or sometimes he/she would be alerted by the piling up of letters in the pigeonhole.

In Africa we greet our neighbours, we visit each other, and sometimes you need sugar or whatever or go to see them out of curiosity. Transport delays are daily occurrences so you start complaining and a group of people waiting for the bus complain together and discuss the bad service, how they need each other's help and maybe some strike action is planned to fix the Transport Minister. In Sweden nothing was out of place, the bus timetable was at every bus stop and buses came on time to the minute and left as indicated. If you came late and were running towards the bus, the driver wouldn't wait for you, he would simply close the door and depart as soon as it was the time of departure, as indicated on the timetable. I was always punctual and when I came

back to Namibia I was horrified by people coming late to events. To this day I can't stand latecomers and if you are late to my lunch or dinner I regard that as rude and disrespectful of my time, and I draw a red line and stop inviting you, because time is money and if I am on time why should someone else disregard the time and come late?

The Swedish people are friendly and helpful; if approached, they will go out of their way to assist you but they mind their own business and wouldn't disturb you. They are generally respectful of someone's privacy, not like us Africans, who like chatting about other people's affairs, or Americans who will give you their life history if you sit next to them in a plane, as if they know you!

One day in Stockholm when we moved to a new flat I wanted to hang my curtains. I knocked on the door of my neighbour and asked him for help. He was very courteous and came to help me and from then on we got to know our neighbours. Sweden was virtually crime free in those days, so I had no fear of asking my neighbour to come to my flat to help me. Ben was in town at the office. He was not keen on the idea of moving to another flat so I took the initiative and furnished the flat and surprised him.

News from Home

In April 1975, after my certification as a physician, I started my specialisation in Paediatrics at the St Goran Barn Klinik (a children's hospital). I was settling down in my new job when one cold afternoon I came home from work to find a long-lost friend from Augustineum days by the name of John Ya Otto. He was a close childhood friend of my husband's. He had come from Zambia to visit us, and Ben brought him to the flat. We chatted all day to catch up with life in Zambia and at home. He told us that the repression at home had intensified and many, mainly young, people had left the country en masse, with school children leaving schools and arriving in Zambia in large numbers. The South African apartheid regime that was occupying Namibia had established military bases in the country and was killing innocent Namibians, burning down their *mahangu* (millet) fields and destroying their property. The situation had forced thousands of Namibians to flee into neighbouring Angola and Zambia and there were health challenges for them, particularly for the women and children in the refugee camps

in Zambia. In those camps there were lots of women and children who needed medical attention.

John Ya Otto didn't come to ask me to go there; he was merely recounting the happenings at home, and conditions in the refugee camps, but I thought a great deal about the situation in which our people found themselves. I thought that Sweden could do without me because they had everything one could wish for, and their people were well looked after. I was there to specialize but a situation had arisen where there was a great need to assist my countrymen, women, and children, and that was my priority. After all, I had gone to study Medicine to help Namibians, and there they were in the refugee camps. There was no need for me to hang around in Sweden when they needed me back in Africa. I decided then and there to take three months unpaid leave to go to Zambia and help. I rushed to Zambia to offer my services, leaving in August 1975, barely six months into my specialization programme.

Responding to the Refugee Crisis

My trip to Africa was the beginning of fifteen years running clinics and kindergartens and keeping our children happy and healthy. It was the end of my planned specialization in Paediatrics, which I now got in practice. I arrived in Lusaka, the capital city of Zambia in September 1975 on a hot Tuesday morning. My idea was to go back to Sweden and complete my specialization after three months, but I was faced with a situation from which I couldn't walk away, so I dropped the whole idea.

Coming from cold and quiet Sweden, I appreciated the hot weather. After the long flight I booked myself into a hotel and slept, only to be woken by people's voices. Looking out of the window I saw two men, walking together side by side, but chatting at the top of their voices. After Sweden, where you don't even flush your toilet after 10PM in order not to disturb or wake up your neighbour, here were these two men chatting and laughing at the top of their voices. I realized that I was back on African soil where we laugh and speak loudly.

The Old Farm

The following morning I was collected by SWAPO comrades and taken to a place called the Old Farm, where our people stayed. It was some 20 kilometres outside Lusaka. I found nurses waiting there for me, and many people, mostly from the northern part of Namibia and some from the Caprivi in the north-west of our country. A problem I hadn't anticipated became apparent when I couldn't communicate with them. This was due to the racial and tribal separation we were subjected to under the South African regime. Earlier I talked about the Red Line, which is the boundary between northern Namibia, where the majority of Namibia's black people then lived, and central and southern Namibia where some other black communities and the whites lived. In the centre and south of the country, the whites had taken the land, driven the blacks into scattered arid areas, and defined those areas as African reserves,

or Bantustans. Each tribe therefore lived in its own area. In the towns, black people lived in townships, each ethnic group in a different location allocated to them. This separation is why I couldn't communicate with people from the north.

For the first time, I met lots of people from Caprivi in the Old Farm. Our SWAPO Vice President Mishake Muyongo was from the Caprivi. He had a beautiful and disarming smile. He had been one of the leaders of the Caprivi African National Union (CANU), a political party that merged with SWAPO in 1964. The President of CANU was then Brendan Simbwaye and he was to become the SWAPO Vice President, but he was arrested by the South Africans and disappeared. We still don't really know what happened to him. So Muyongo became Vice President of SWAPO.

There were many compatriots from the Caprivi in SWAPO's armed wing, the People's Liberation Army of Namibia (PLAN). I later met notable Caprivians like Greenwell Matongo, Richard Kapelwa and many others. I found them all very committed to the struggle and very nice people to work with. I liked Muyongo and worked well with him, except that he seemed to be reserved and I had a lingering feeling that deep down he was CANU first and SWAPO second. I don't think he completely gave up on CANU. I will discuss later the serious problem of Caprivi after Independence.

The reason that these Namibians, youth, women, men and children were in the Old Farm refugee camp was precisely to fight so that we could get our land back from South Africa and live together as one nation.

New Challenges

After Comrade Maxton Mutungulume had shown me around the camp and introduced me to my fellow Namibians I went to see the 'clinic', a very small dingy room, where I found a young woman in labour. I was told that this was her first baby and the process was slow. I wanted to check her status and see how many centimetres she was dilated, so I stretched out my hand to the midwife and asked for a glove, only to discover that my hand remained in mid-air. In the first place, the midwife didn't understand my English because she spoke Oshiwambo but, luckily, one of the nurses could speak Otjiherero and I asked her

in Otjiherero whether they didn't have gloves, since I needed to check how far the patient had progressed. She explained to the midwife and I was told that they didn't have any gloves. It hadn't yet dawned on me that I was not in Sweden now; the conditions in this camp were totally different, and these people had just arrived and had nothing. I was now there to help them. I soon realized that I was in a different world altogether and needed to adapt quickly. I took the young woman to town and she was admitted into the teaching hospital in Lusaka, where she delivered a healthy baby girl. I went back to my hotel but had a hard time falling asleep as I was contemplating my next move; also it was difficult to sleep with these Africans speaking at the top of their voices. My next move was not 'to cut and run' as President George W. Bush liked to say, but to stare the challenges in the face and deal with them effectively. I needed medicines urgently.

What I decided was that firstly, I had to forget about Sweden and continuing my specialization, and secondly, I had to find help for the people. Unknown to me, as I was busy researching where to get the help I needed, a rumour was circulating through the camp: 'Oh, she has run away.' One man told the people that he had come to our flat in Stockholm where I had a colour television and that I would never stay in a camp like this one, and I would have already left on the plane back to Sweden. I was unaware of these rumours because I was in hot pursuit to find medicines and any assistance I could get to help the people in the camp. Fortunately my research paid off and I was directed to the right person.

During the struggle there was a committee known as the Liberation Committee established by the Organisation of African Unity (OAU), which was responsible for the liberation movements. It had medicines and equipment and the allocation for SWAPO had not yet been collected since there were no medical staff. I was informed that as the Namibian refugees had only just arrived in Zambia from Namibia, and there seemed to be no medical service, our allocation of medication had not yet been dispensed, and was available in the OAU office in Lusaka. I was overjoyed. I went to the OAU office, introduced myself to the secretary, and with the help from the same office I was given a truck to collect the medicines and equipment. So on Thursday morning, just a week after I arrived in Lusaka, I returned to the Old Farm. My truck was loaded to

the top with all our medicine and equipment as well as other things I needed, e.g. hospital furniture.

When people saw the truck and me in it with all my loot, they were overjoyed, and it was only then that I was told of the rumours about me having gone back to Sweden. I was even told the names of the rumour-mongers but I knew they must be ashamed of themselves so I didn't make an issue of that and started to organize my clinic. I thought, let their consciences eat them up! Shame on those who were involved in trying to character-assassinate me! I know them and I have forgiven them, for they did not know what they were doing.

I collected together all the nurses and gave them orders that first we needed to thoroughly clean the small room and only then would we unpack the stuff in the boxes. I discussed the issue of cleanliness and also drew up a work schedule and timetable. During the following days, we worked very hard. I screened the patients and found two boys who were malnourished. These boys were said to have walked long distances without food and were only thirteen and fourteen years old. One woman volunteered to cook for them; actually one was her own son. I bought the food for them out of my own pocket.

A large group of people, mainly the youth, had fled from Namibia into Zambia and Angola with the sole purpose of joining the military struggle; some were as young as fourteen. Girls and boys left schools in Namibia to join the struggle. The President of SWAPO, Comrade Sam Nujoma, decided that the young ones should go to school, while those over eighteen years of age could join the struggle and receive military training.

Nyango Health and Education Centre

The Government of Zambia gave SWAPO virgin land on which to resettle the Namibian refugees. This place was called Nyango. I'm not sure how the name came about, whether it was the original name or we gave it that name, as there were no people living there until we settled there. However, there were Zambian farmers who had a village not too far from us across the stream, so maybe the name already existed. I think it was about 200 kilometres north-west of Lusaka. Shortly after my arrival, we moved to the new site and started to construct our houses, the school and the hospital. I took care of health. I had to start a properly built hospital with separate wards for women, men and children. We put in beds, and had a doctor's consulting room and a treatment room; so it was not an 'under the tree' story. It was serious stuff.

When I had arrived in the camp at the Old Farm I met Comrade Nahas Angula and others. Nahas was a teacher, and having studied in Zambia, he was very familiar with the country and spoke the local language, though I am not sure how fluently. He could communicate, of course, since Zambia is English speaking, so there was no communication breakdown. He took care of education at Nyango.

The Hospital

The first group of men who arrived at the site built the basic structure of the hospital and we, that is my nurses and I, had to plaster the walls. Since there was no cement, we used mud. Here too was a difference between those who lived north of the Red Line and those who lived south of it. In the south, we plaster our houses with either cow dung or mud, while people in the north build only with poles and do not plaster. I didn't know this, so I was surprised that they didn't know how

to plaster a house. I had to teach them. It was a hilarious exercise and we had so much fun and laughter. Sometimes the mud balls they had prepared would fall off because it was either too wet or too dry, but with time they perfected the technique.

We worked on the structure in the afternoon after finishing with the patients. First we went to cut the poles to make the structure compact for the mud to stick. After long hours of hard work we finally completed the hospital and painted it. It turned out to be very beautiful. The maternity ward was painted sky blue to soothe the labour pains. I also bought the first generator for the hospital there. My communication with the nurses improved because I soon perfected my Oshiwambo. I did a lot of in-service training with them, so both communication and service delivery improved.

After about six months I started to notice that I was not woken much at night, which meant that my team was ready to take care of the patients without calling on me. One night my very able midwife called me to the hospital. She couldn't speak English, because she had been trained by the Finnish missionaries in her local language but, when it came to performing her job as a midwife, she was brilliant. I knew that it must be a complicated case if she called on me for help in the small hours. Indeed it was a strange case, for when I came, I saw the right foot of the baby greeting me. I took a deep breath and carefully breech-delivered the baby. It went so fast and the mother was very calm and confident that she was in good hands, but she had no idea how much adrenaline I was using up. It is very important that your patient shows confidence and is not panicking; it makes the procedure less frenetic and helps a successful delivery. The mother of that baby went abroad to study and became a doctor. The baby is now a woman who has completed her university studies.

I built my own house a stone's throw from the hospital. It had two rooms and an outside kitchen, and was built with the same material as the hospital, but it wasn't painted blue. My house became a sanctuary for children. I took in young girls and the others who felt lost. Although I didn't know their parents, I was as protective as a hen. I also took care of a boy who suffered from asthma and his younger brother, who at age sixteen had run away from the camp with his friend to the war front. When I went after them they went into hiding. I wanted them to

go to school because they were so young but they wanted to become soldiers, and I didn't find them. Today they are grown men; one is a radio announcer, the other an administrator.

I was very busy as the only doctor and lived on coffee as I had no time to cook. One day as I was returning to my house from work I noticed some movement in my house (we didn't lock our dwellings so anyone could have gone in). When I entered, I met three young girls busy cooking and cleaning the house. They promptly told me that they had come to live with me, because they saw me in the hospital all day and they decided to live with me and to help me in the house. I became their mother. We were very happy. One day I called them together and told them that I wanted to talk about pregnancy and to teach them about the reproductive system. I came with my books and started teaching them about the menstrual cycle and how pregnancy takes place. At fifteen and sixteen years old, they were very shy, and didn't want to look at sexual organs in the book. I continued with the discussion, forcing them to look and learn how the male and female organs differ. They told me it wasn't necessary for them, because they didn't have boyfriends so they didn't need to take the pills. I had noticed some boys lurking around my house, showing interest in the girls, so I confronted them about those boys. They denied seeing or knowing anything about them. I told them they should start taking the pills, boyfriend or no boyfriend. I said that I couldn't sleep under their beds to guard them.

When the girls were awarded scholarships to West Africa, I packed boxes of family planning tablets for them and threatened them with murder if any of them got pregnant before finishing their studies. I think I put genuine fear in them. All three completed their secondary schools, went to university and returned as professionals to Namibia. Two are today serving the nation. One of them is the famous Dr Helena Ndume, the well-known eye specialist who has saved the eyesight of many Namibians. The second of the three unfortunately passed away in 2005 from a brain tumour. May her soul rest in peace. The third is the daughter of one of the struggle heroes, Gertrud Kandanga. She is in politics, as her mother was, and is standing for positions within SWAPO.

The camp commander used to arrange outings once a month for the refugees to go to the nearest town, for people to relax or buy a few things they needed. This trip was made by truck. One day when this truck came

back, it hit a big nail sticking out of the stump of a tree and one woman sustained a deep cut on her back, which led to internal bleeding. She lost too much blood and by the time she reached the hospital she had died. She left two children – a boy of three years and a baby girl of two months. After the funeral the next day, the two children were brought to me. I kept the baby in the hospital waiting for her relatives to come and collect her and I sent the boy to East Germany, where some Namibian children were being looked after. However nobody came for the little girl, so I became her surrogate mother. About a year later, her father came to see her but since he was a soldier he left the child in my care. Sadly, he died (of natural causes) after Independence.

I kept the child, Tumtums, with me until we came back to Namibia at Independence. I took her to her grandmother but her grandmother told me to keep her as she had meagre resources to take care of her, so I brought her back to Windhoek and put her into school. Today she is a working woman with her own son.

Measles Outbreak

After a year of living in our new centre, we were hit by a measles epidemic amongst our refugee population, who had no immunity. Many children and some adults were infected. It was a very daunting situation for me as the only doctor; it is fair to say that I worked myself to a standstill. I had new nurses who needed some in-service training to put up a drip, thus I was running day and night between my house and the hospital. Almost every sick child was on intravenous fluid, and I had to put up every drip myself. It is not advisable to give that responsibility to an untrained nurse. Only an experienced nurse can do it and that happens after years of practice. I had the practice in Muhimbili Hospital in 1969-70, where I had practised cut downs as an intern, so I was fast. Fortunately not every child needed a cut down. Since they were close to our hospital and were admitted quickly, they were not dehydrated and didn't have collapsed veins.

We worked very hard and it took its toll on me; I lost 10 kilograms in six months. Being the only doctor, I was in the hospital day and night and my nurses worked alongside me. The community members gave me respect and support. We lost around ten people to measles, mostly

children. It was due to the extreme hard work that we put in that we saved many souls.

One day I received a child who was very ill with measles. The nurses and I stayed in the hospital till very late and I relieved them to go and have a rest and let the night staff take over. I finally gave the child cortisone as a last resort and at 2AM, when her breathing improved, I told my night duty nurse, 'Don't wake me up, because I took a chance to give her the treatment that I consider the last resort.' I went home, and soon fell asleep because of fatigue, only to wake up at 7AM, realising that the night duty nurse hadn't woken me. I ran to the hospital in panic in my pyjamas, fearing that the girl might have died, and cursing the nurse that he had taken my 'don't wake me up' comment seriously. However, entering the ward, I found the child sitting up in her bed, drinking milk. What relief and astonishment! I was so pleased, and when I called her by name she responded softly. The night duty nurse told me that my last-resort treatment had worked and the child had slept through the night, was breathing normally, and woke just before I came in. I went home and changed into my working clothes. Later, when I was making the morning rounds with my staff, the girl was even better than in the early morning. We were mightily relieved that we saved her. That seemed to be the end of her measles, and she made a rapid recovery. Today she is a well-educated woman with her own family and she keeps telling me that I saved her life.

Normally measles in a virgin population has a high fatality rate. We quickly vaccinated our population and after that we never lost anyone from measles.

Fearless and Grounded

There are a few other individual cases I want to mention. I was often called to Oshatotwa at our Eastern Front, in the border area between Namibia and Zambia, to help PLAN fighters who had been injured. On one such occasion one of our medical assistants, Kokauru Nganjone, and I, rushed there after some of our fighters had been killed by a landmine and others wounded. Because the situation at the front was unstable militarily, we needed a safe place where we could treat our wounded in peace. Those we could treat in our hospital in Nyango were taken there; those we couldn't treat were taken to the hospital in Lusaka. Some had

to be stabilized before transfer to the hospital. There was one comrade who had a fractured thigh bone and we transferred him to Lusaka; his name was Kanesius. One other comrade had his hand shot through and the thumb was dangling; fortunately the bone was intact so we took him to Nyango and sutured his hand in our hospital there.

One day after Independence, I was collected by the driver of the lodge I was visiting in the Caprivi. After greeting me and on our way to the lodge from the airport, he was surprised that I seemed not to recognise him and he said to me, 'Doctor, don't you recognize me?' I didn't, but then he showed me his hand which looked normal to me and said, 'This is the hand you and Comrade Nganjone saved in Nyango hospital and I can drive with it. Please also tell Nganjone that my hand is normal.' I also met the comrade whose thigh bone was broken in Windhoek, walking normally. He is the one who saw me first, and told me who he was.

There was one other comrade who had such severe asthma that I thought he wouldn't make it through the night. The same night duty nurse that had helped me with the little girl with measles, Clifton Sabati, was on duty in Nyango when we had serious problems with this patient. We decided that the only way the patient would breathe was if we hung him up in his bed. So we piled up pillows and bandaged him like someone who had fractured their ribs and clavicle, and suspended him by the bandages from the pole of the roof, to keep him upright so he could breathe. I injected him with my last-resort cortisone and I left Sabati to keep a watch on him while I went to take a nap. My instruction was that he should wake me up if the patient worsened. Again Sabati didn't wake me, but this time I was sure the patient was still alive so I didn't run to the hospital in my pyjamas, but I didn't drink my morning tea either. I got washed and rushed to the hospital to check on the patient and found him no longer suspended, but sitting up in bed.

I also met this former patient in Windhoek years later. He recognized me and told me that he and asthma have never met again. He was cured for good since that night we had hung him up! He told me that he went to Germany for some training and didn't have asthma any more. It's so rewarding to meet people after a long time and they tell you how you saved them.

I worked so hard, mostly surviving on coffee with no time to eat or cook, but I did manage to train my nurses and they rose to the challenge. We defeated measles and other diseases and also treated the local population in our vicinity.

We did lose some children, particularly those who were under weight, from measles, but we saved many lives, as I have described above. This is not bragging but recounting the difficulties in the refugee camp and also to show that one doesn't need elaborate equipment and expensive medicines but common sense and quick action. For me to meet the people whose lives I have saved gives me huge satisfaction.

One morning a patient was wheeled in on a wheelbarrow from a village. This patient was one of our comrades who were apparently taken to the nearby Zambian village, to see a witchdoctor. Since the people from the Caprivi spoke the same language as the Zambians, they were closer to them. I don't know when this woman went to the village to be treated by the Zambian traditional healer. All I know is that she was brought back from the village with an extremely extended abdomen. She could hardly breathe; she was dying. I didn't even have time to find out how and why she left the hospital in Nyango and who took her to that healer. Now that he had messed her up and she was on her deathbed, they brought her to me, so she could die in my hands. I was so angry, but there was no time to waste. I immediately put her on a drip and punctured her stomach with a drip needle to start draining the fluid, because I was afraid that if I used a troca (an instrument used to drain fluids in those days), she would collapse and die of shock. If there is anything I hate, it is a patient dying in my hands. I drained that fluid for three days and removed three buckets full of greenish fluid while giving her antibiotics. As the stomach went down she became better and started to eat. I kept her for weeks in my hospital and sent her to the hospital in Lusaka to check whether there was underlying TB, just to make sure; the result was negative.

What happened to her was the concoction she was given by that witchdoctor. I don't even want to call him a traditional healer because he almost killed the woman. Under my care she recovered completely. Today she is alive and well in Caprivi, and she made me a very nice bag she knitted herself and sent it to me. I meet her often when I go to Katima Mulilo. We used to call her Meme Georgie.

When we had worked hard saving lives, I used to take my nurses out to Kaoma, a small town about 30 kilometres from Nyango, for a beer, the famous Mosi. The Zambian people, particularly the men, were so polite and would buy us some beer and a crate to take home, but they never disturbed us. They would just greet us and after buying and sending a crate or two of beer, they would leave us alone. I have a high regard for the Zambian men for their respectful behaviour.

We had some fun in the hospital as well. As in the case of my child supervisor in Muhimbili Hospital in Tanzania, here too was a supervisor. It was the boy whom I mentioned earlier as being malnourished. He remained in the hospital and became the 'supervisor'. During the morning rounds the nurses would panic as soon as we got to his ward; they knew that the supervisor would report on them. Sometimes they would try to bribe him not to tell me that they were playing cards at night, but as soon as we got to his bed, he would give a report on the condition of the other patients, particularly at night, e.g. that one was coughing and all the other patients slept well, or patient so-and-so did not sleep, he had pains. He would also report on the night staff and on the conduct of the nurses: 'Meme [mother] doctor, this patient did not get his medication, this one was coughing the whole night, the night nurses were playing cards.'

Actually the card playing was an addiction of the nurses and it was the same in other centres; sometimes they would post a lookout to give them an early warning in case I was on my way. I must hasten to say that these cases were not so frequent and when I did night rounds, there was always a nurse in the ward. My supervisor was discharged from the hospital and was in the group of children who were sent to Cuba to study. We had a school in Cuba and many children went to school there. I've never met him again but I was told that he has come back and is probably working.

I sometimes look back on that time and am surprised where I got all that strength and energy from. I was so fearless and grounded. Nothing rattled my nerves. One day one of the children in my house came running to the hospital and crying. She told me that an old man took their buckets, threw out the water and confiscated the buckets. I followed her to show me that old man and when we came to his house, I marched into his tent, grabbed my buckets and walked out. I stood in

the doorway, cursed him in my language and went back to my house with my buckets and my children in tow. What a bully! The man was shocked because he stood there motionless. When I got home I realized what I had done. The man, who was very tall, could have fought back but he didn't. But if you allow one bully to get away, he will continue bullying the children. Since then my kids were left in peace.

Training at the Eastern Front

I also went to Oshatotwa for three weeks basic military training, to learn how to handle an AK47 and a pistol. The South African army came across the border in frequent incursions and there was a very serious battle there where some comrades lost their sight. After my training I brought them back to Nyango and some were transferred to Lusaka teaching hospital for treatment.

Because I often went to the front to collect the wounded, I needed to know how to defend myself. My training officer was Comrade Mwailepeni, a very calm but serious officer. I was taught how to behave with arms, the do's and don'ts. When I went to the army base I would sleep in the dugout of Comrade Nganjone and tie my shoes to my medical bag so that, should the need to run arise, I would have my shoes and not have to start looking for them in the darkness. We were also told not to make fire to attract unwanted attention. Comrade Nganjone's make-shift bed was so short, and I was making jokes that the enemy would come and pull off his leg, sticking out of his bed, because he was so tall. Sadly my training officer passed on in Namibia sometime after Independence. I still remember what he used to emphasize during my training and that was to never point a gun at a comrade; do not drop the gun; hold the AK with a steady hand; never touch the trigger unless you are firing; and don't leave the bullet in the chamber. I can still see his scrutinising eyes, (there is only one language that describes the act of recalling something visually adequately and that is in Nama, '*munanai*'). I was truly inspired by his skills.

After that training I proceeded to see Comrade Nanyemba at Base 32. This was a base for the mechanized brigade, not a makeshift guerrilla base but a proper motorized infantry army brigade in the true sense. I went with Comrade James Awala. I was feeling quite confident that should any attack take place I would be able to defend myself as I had

just undergone training. I was taken around the base and introduced to the soldiers. The training was such that these soldiers were prepared to be deployed if the situation changed from a guerrilla to a conventional war, and also to become the future army of an independent Namibia.

I spent two days in the base treating those who were sick and collected those who needed to convalesce and go to Nyango. Comrade Nanyemba was beaming with pride and giving me that broad smile of his. My advice was that since these soldiers were to be our future army, why not also organize literacy training, but some felt that they should concentrate on military aspects only. Looking back now, I was right. They could have organized the schooling because now only those with Grade 10 and 12 can be admitted to the army. All the comrades who survived the struggle, those I met at Base 32 and those guerrillas who came out alive, became the Namibian Defence Force (NDF) of today.

Fortunately I never had to use these weapons and since I was working with children, I was extraordinarily cautious. I made sure that they didn't discover that I had weapons in my house. In the centres the only weapon I carried was a pistol in its holster, in the manner I was taught.

Family Planning Services

Since Namibia has a small population, some people were not pleased when I introduced family planning. They wanted more children but in the situation of war, and as refugees, I was conscious that we needed education and educated women for the day we eventually went home. Child-spacing was also important so that we could bring up healthy children, especially under our circumstances as refugees.

I introduced family planning services but this was not welcomed, particularly by the men. They cooked up all kinds of horror stories about the programme, e.g. that it would make women infertile; I was giving them poison; and many other stories I cannot repeat here. But I closed my ears and proceeded with the programme and the women accepted it wholeheartedly. I am convinced that because of that programme we were able to educate many women, who are today serving the Namibian nation. Although we experienced teenage pregnancies I did not introduce family planning for schoolgirls. But, having lived and worked in Sweden with programmes for youth, I wanted to introduce

that same kind of programme for the young girls in the camp. There was a programme they called sex education, which was essentially to teach young girls about how their reproductive systems function. Imagine if I had used the words 'sex education', I would have been lynched and stories against me would have been even more virulent. I was going to be accused of teaching children how to have sex, etc. So I called the programme 'family health'.

This programme was meant to teach the girls how their reproductive systems worked, and once they knew their menstrual circle, they would be able to prevent teenage pregnancies. They would know the no-go time (the rhythm method) and protect themselves, rather than putting them on contraceptive pills. My three girls in my house were also taught the same way. Later, they were awarded scholarships to complete their secondary school in West Africa – The Gambia, Sierra Leone, Liberia, Ghana, and Nigeria. I didn't trust that the mere teaching of timing would work. I thought they were going to be exposed to peer pressure and would fall pregnant, so I put them all on contraceptive pills when they left for school and told them that, boyfriend or no boyfriend, they must take the pill every day.

The girls between fourteen and fifteen years and above enjoyed the family health programme and felt empowered, but little did I suspect that I was empowering some of them to get pregnant. I left one of the senior nurses to monitor the programme in September 1976 while I went to attend the WHO regional conference in Brazzaville. When I came back, I was sure that the training would have worked, and that by now teenage pregnancy would have decreased and would soon be a thing of the past. I was so wrong. The nurse I had left to supervise the programme gave me the grimmest news. The month after our initial training showed an increase in teenage pregnancy. I was devastated and kicked myself for thinking that I knew what was best for the girls. It dawned on me that I should have first conducted a survey to find out why they wanted to get pregnant, instead of groping in darkness. I sobered up and did what the public health course had taught me – to ask 'Why, where, how?' So I drew up an anonymous questionnaire, asking those very questions that I should have asked in the first place before plunging in like a blind bat.

The response I got from the survey was amazing and very simple. It showed that schoolgirls had issues; I will highlight just two. Firstly,

the mothers or pregnant girls were given things like bras, toiletries, etc. Those who were pregnant were also excluded from cooking and collecting fire wood, and did not have to do hard work in the camp. Secondly, it would happen that an important man had promised to marry a girl but the first demand was to show him that she was fertile by having his baby. Conclusion: if all the school girls received the items mentioned, we could have solved the two problems together. Often the girls were lured by the men with small gifts of nice panties and bras, perfumes and whatever else. Had we looked after the girls' needs better, we would have prevented them from being lured by those very items. There was also the issue of poor performance in school which influenced the girls. They felt that if they had problems with their education, it was perhaps better for them to become mothers.

There were also older women who didn't want to have any more children and they wanted family planning. Other younger women wanted education to go to schools elsewhere. We had good children's programmes in Nyango, and a nice and properly run kindergarten, where the children of those who were studying abroad were well looked after. We encouraged women to get an education because, in the future, Namibia would need educated people to run the country. But there were some who didn't want to go to school, who told me that they were giving birth to future soldiers, assuming that the struggle would continue forever. I am sure that this attitude was instigated by the men who, for some unknown reason, wanted to have many children, maybe to prove their manhood.

I had a challenge with one older woman, who already had seven children and didn't want any more, but she was scared of her husband finding out that she didn't want any more children. We had to find a suitable method, so we settled for contraceptive pills. I spent at least three weeks teaching her how to take the pills. When I felt that she understood how to take them, we started the programme. The first month went very well, so I relaxed and gave her the pills for the second month. After only fourteen days she came back to ask for more and I asked her what she had done with the rest of the tablets, since there should have been at least fourteen pills left. She looked at me sheepishly and said, 'Oh doctor, I was afraid the children might see the pills and since they are so small I swallowed them all in one go.' I almost passed

out thinking about the possible side effects and didn't give her any more pills.

We agreed that she must feign something if the husband approached her for sex and I frightened her by explaining that she could have died taking so many pills in one go. Later I found the whole episode very funny. One day after Independence I found her in her village and we had a good laugh about it. I have visited all those women who were in Nyango and it always feels like a second homecoming. It's so rewarding to meet those whom I was with during the struggle; they feel like my family, perhaps even more so than my biological family.

Camp Life

We, as a liberation movement, looked after our people. Many professionals came from their studies and returned to the refugee camps to serve the people. People like comrades Nahas Angula, Helmut Angula, Nangolo Mbumba and Frans Kapofi (who was the camp supervisor), just to name a few, lived and worked in the Nyango Centre. I know it's dangerous to name names because of the risk of leaving out someone, but forgive me, I am naming those known by many people and also those who were living and working in the camps. We provided proper health and educational services which gave us a solid base and prepared us for the future in an independent Namibia. I am not intending to bore you with many details; suffice it to say that it was a great pleasure to serve my nation. I delivered good services, saved lives, trained health workers and kept the children healthy. I worked with equally committed comrades, and we established bonds that remain to this day.

The life in the refugee settlements was work, teaching and planning how to make our people productive, but there was also music. We sang lots of our freedom songs to keep the morale high and were also entertained by our musician comrade Jackson Kaujeua, who wrote and performed the very famous song 'Independence or death, we shall win'.

Every morning we gathered at the parade ground where the news of the day was shared, and the day's duties were announced and groups were divided for different tasks. Schools started on time and so did we at the hospital. In general the centres were not idle; there was always something to do. As the saying goes, 'idleness breeds crime'. Our centres were crime free, with no fighting, no stealing and no sexual

crimes; indeed we were a big family. I must admit that even today in independent Namibia the comrades from the struggle are closer to me than my own family; if and when I am sick or in need of assistance, the struggle comrades are the first on the scene with help.

During our life in the refugee settlements there were serious reports that we, the Namibian refugees were starving and eating grass. This was malicious propaganda – stories put about by the South African media that were meant to frighten our people from joining us, but they failed. The international community, particularly the Nordic countries and The Netherlands, and the Namibia Support Committee in the UK, constantly assisted us with clothing, food, educational materials, and medicines. Life in Nyango felt like home and we tried to live a normal life.

United Nations Institute for Namibia

This was also the period when the United Nation Institute for Namibia (UNIN) was opened in Lusaka, the capital of Zambia, and many Namibian women and men were studying at the institution, which was headed by Comrade Hage Geingob.

I should mention that it was Comrade Hage who bought me a single bed and a mattress when I came to Nyango, because in Dar es Salaam I had been bitten by a very poisonous snake and ever afterwards I was very scared of snakes and didn't want to sleep on the ground. What happened was that one evening on a visit to Dar, I was visiting a friend of mine, Dr Ester Mwaikambo, with whom I had done an internship in 1969-70. Actually she insisted that we accompany her brother to the bus or taxi stop. I followed very reluctantly, and a minute later I stepped on a rattlesnake and was bitten on the big toe of my right foot. We defied all the precautions, ran to her car and got to the casualty department in a matter of minutes. It was very lucky that her house was only a stone's throw from the hospital. There were two Dutch doctors on duty who attended to me very quickly. They pumped a large dose of anti-snake serum into me intravenously. I started to feel my throat contracting, and thought I would die either from the bite or from anaphylactic shock from the anti-snake serum. Fortunately, I had no reaction to the serum but the pain was excruciating as my leg swelled rapidly. I was admitted for two days and later discharged to Ester's house, where I stayed for a further two weeks, with my leg elevated. She nursed me, feeling very

guilty for dragging me to that snake. I came back to Nyango in Zambia and was limping for weeks.

We would sometimes go to Lusaka to collect materials needed for our school and hospital, visit Comrade Hage and relax at his house, or go to visit other comrades, such as Hidipo Hamutenya and NgarikutukeTjiriange, who were also teaching at UNIN. We had many of our colleagues at that institute, and other friends in Lusaka; thus we would come from the centre and relax at their homes, drink beer, eat and be merry. It was indeed a wonderful time together.

I also entertained the hardworking nurses from Nyango. We would go to the nearest town of Koama once a month and on such occasions we would dress up and go to a local bar. I won't go into details, all I want to do here is to illustrate that our refugee centre was not all gloom and doom. I also ran a kindergarten for children and we brought them up in the absence of their parents who were in the war zone or attending schools or universities. I am very proud of how efficiently we, the centre directors, my colleagues in education and all those who were providing services, organized the centre in Nyango.

The Threat of Attack

One day in late 1976, Rhodesian planes flew very low over our centre. We all took cover under trees and houses. The incident happened so quickly that we didn't have time to run further to hide behind bigger trees, so we hid under whatever was close. I remember that we ran out of the hospital with my midwife, Meme Nanghonda, and male nurse Rafael, and took cover somewhere near the hospital. When the planes disappeared we waited a little, and when we were sure the planes had gone we left our cover and planned to evacuate the centre.

A new commander had taken charge at the centre but when the planes came down low he was nowhere to be found. However, as we packed up our medicines afterwards to go into the bush we heard his loud voice shouting, 'Take cover' from across the small stream, on the Zambian side. By that time the Rhodesian planes must have already reached Salisbury (Harare)! We had already taken cover and come out of hiding. I thought it was laughable. When he had heard the planes he'd crossed the small stream and run to the Zambian village to save himself and then, an hour or so later, he remembered that he was the camp commander of Nyango!

We decided to move out of the camp fearing that this might have been a reconnaissance mission and that they may return to bomb us. We moved into the thick forest and stayed there for a week. I left two patients who were very ill in the hospital with guards, but every morning I took a walk over with one of my male nurses, Rafael, to check on them, change their dressings and give them food and medication. The first day we were in the bush, the rain came as we were erecting the tent to serve as a clinic. A baby then decided to arrive and we delivered it quickly without having opened our maternity pack. There was no time; the baby came without warning. We called him Jungle, the name he carries to this day. He is now a tall, handsome young man. One day, long after we returned to Namibia, I was standing in a local shop waiting for my change, when somebody touched my shoulder and I turned to see who it was. He simply said, 'I am Jungle.'

Rebellion

Also in 1976, I was working peacefully in my hospital one day when suddenly we were visited by a group of young people walking around aimlessly. My nurses chased them out, telling them that this was a hospital and not a park. If they weren't sick and looking for treatment they must get out. They left and we had no idea who they were or what they were looking for. However, later we discovered that these were some young people, recent arrivals from home, who were in PLAN and had come from the front. They were confronting the leadership of the movement and one of our senior comrades, the Secretary for Information and Publicity, Andreas Shipanga, was considered responsible for using them to stir up trouble.

Some of these people were intercepted and arrested by the Zambian police and army; we learned after their arrest that apparently they were armed. If it was not for the vigilance of the Zambian police and army there could have been lives lost, but they were apprehended in time.

SWAPO set up a commission of enquiry headed by Comrade John Ya Otto to investigate this issue. I was a member of that commission, together with Comrade Theo-Ben Gurirab. Unfortunately I no longer have the document of the commission's findings, but from the evidence presented to us we found the Secretary of Information to have been the leader of the rebellion. If the Zambian authorities had not acted quickly

to arrest the perpetrators there might have been a bloodbath. I must mention here that Mishake Muyongo, then Vice President of SWAPO, played a pivotal role in containing the situation.

Shipanga and the other ringleaders were detained by the Zambian authorities and spent some years in prison in Zambia and Tanzania. When he was released he formed a new party, which was stillborn.

After this I was convinced that we had seen the back of political intrigues but, as I will explain later, more sinister plots would come our way as the struggle advanced.

Political Responsibilities and International Solidarity

SWAPO Women's Council

SWAPO had organized its first party congress from 26 December 1969 to 2 January 1970 in Tanga, Tanzania. I was elected the Secretary of the SWAPO Women's Council and Deputy Secretary of Health. Dr Iyambo Indongo was the Secretary of Health. The interesting thing was that there were only three women in exile at that time: Meekulu Putuse Appolus, Meme Mukwahepo and me. We were so vocal and were invited to international meetings. People thought that we were a mass organization, yet we were only three women. Meme Mukwahepo was a soldier so she was not with us in Dar es Salaam. We, the SWAPO Women's Council, were the founding members of the Pan African Women's Organisation, which was based in Algeria, and Meekulu Putuse was transferred to Algiers to work in the office of that organisation. I was a doctor and busy with my internship, so we were not always available to attend meetings and, on several occasions, Comrade Ernest Ngarikutuke Tjiriange had to stand in for the Women's Council to attend those meetings.

After the arrival of so many women who fled Namibia during the period 1974-75, I felt that I could hand over the mantle of Secretary of the SWAPO Women's Council and concentrate on health matters. The Central Committee of SWAPO appointed a young, beautiful, woman by the name of Penny Hashoongo to replace me. Sadly, she died soon after, in Zambia.

Africa's Intellectual Giants

One day there was a SWAPO Central Committee meeting organized in Angola, sometime after that country's Independence. President

Augustino Neto was invited for the opening. Meekulu Putuse was in attendance, and so was the SWAPO Vice President Mishake Muyongo. While we were in the receiving line awaiting the arrival of President Neto, Muyongo developed a stomach problem, so I sent my nurse to get some water and anti-acid tablets from my medical bag. Meekulu Putuse was sitting under a tree resting and we stood around in the greeting line. As my nurse, Peter Shinyafa, was bringing the tablets to Muyongo, Meekulu Putuse asked him what he was carrying. When he replied that he was taking some medicine to Muyongo, she informed him that she too had stomach pain and that he must give those tablets to her.

The nurse obliged and went back to fetch more tablets for Muyongo. Comrade Tjiriange, who was standing next to me, said under his breath in Otjiherero, 'Doctor, Meekulu Putuse has hijacked Shinyafa and is drinking Muyongo's medicine.' Certainly when I looked I saw Meekulu drinking some medicine. I found that so funny, but before I could react, there was President Neto already greeting the first comrades in the line. Meekulu Putuse was struggling to get to the welcoming line but she made it. The whole episode was hilarious and I had a hard time controlling my laughter. Then when President Nujoma came to Tjiriange for some reason he didn't give Tjiriange's name, but President Neto recognised Tjiriange and greeted him. I asked Tjiriange in a whisper why he hadn't helped our President and he replied, 'Why did he forget me? I wasn't going to help him to remember my name.' Sometimes we had some funny occasions such as this one, which made life interesting.

President Neto of Angola was a very soft-spoken and unassuming person. On many occasions he would quietly enter the hall while people were waiting for him. His motorcade was not loud. He was a deep thinker. I also found the same behaviour with the Senegalese President, Léopold Sédar Senghor. I was in Senegal in 1974, attending a conference for African and Arab women, and the heads of delegations were invited for lunch at his palace, which was not opulent. He too was soft spoken and quiet. Maybe it is a trend with the thinkers and writers of this world. Both these Presidents were writers and poets. I was privileged to meet these two African intellectual giants.

From that meeting in 1974 I was issued with an official Senegalese passport, which I travelled with till I came back to Namibia and only stopped using it in 1989 when we were issued with the UN Council for Namibia passports, to return home.

World Health Organisation

In the mid-1970s, SWAPO was recognized by the United Nations as the authentic representative of the Namibian people. Some people had an issue with this but had no choice but to accept it. It gave SWAPO greater recognition internationally and enabled us to participate in UN agencies, as observers.

Our representation as Observers to the World Health Organisation (WHO) was initiated by Sean McBride, an Irish gentleman very committed to the cause of Namibia gaining her independence, who was the UN Commissioner for Namibia from 1973 to 1977. I was appointed SWAPO's representative to the WHO. Other liberation movements were also accorded observer status, which meant we could take part in deliberations but had no voting rights. The ANC of South Africa was represented by Dr Feleng and Dr Manto Tshabalala, Zanu PF of Zimbabwe by Dr Herbert Ushewokunze, and the PLO of Palestine by Dr Arafat, the brother of Yasser Arafat. At meetings, we all sat in the back row.

In 1974 I went to attend the WHO Africa Regional meeting for the first time. I had no idea about this meeting; nobody briefed me; but I knew about the poor health situation in Namibia because we were working on a paper looking at the health conditions of our people in the country. When I arrived in Congo Brazzaville, which was and still is the headquarters of the WHO Africa Region, I was taken to the VIP section in the airport with the other delegates.

One elderly Professor from Ghana was intrigued because I was dressed in jeans and looked very young. He came around to where I was seated and asked me whether I was accompanying my father. 'No,' I said and on his continuous interrogation I told him that I was a representative of the liberation movement SWAPO and the representative for Namibia. He later came to see me and asked if I had my speech ready so he could look at it. I had no speech and told him I would prepare one later. 'The meeting is going to last for three weeks,' I said, 'and there is enough time to prepare my speech.' In those days, these regional conferences lasted for about three weeks. Then he stated that since it was my first time, he wanted to brief me. I agreed to listen to what he had to tell me and in his briefing he talked about resolutions that were important, which I must quote in my speech.

'What is a resolution?' I asked him. He missed a heartbeat, and when he had steadied himself he said, 'Child, let me help you with the speech.' I agreed and he drafted the speech for me, which he asked me to go through. I went through the speech but it didn't make sense to me. What had those things he put in as resolutions got to do with the poor health services in Namibia? I wondered. I lost interest in his draft speech. I also didn't understand the meaning of his speech; it was complicated.

In this particular meeting there were only two women: Dr Mutumba Bull, a Zambian doctor, who was married to a British man, and me. Since the liberation movements had observer status, we were only given the floor to speak after member states, on day four or even the last day of the meeting. But I was called to speak on day two. I think the elderly Professor was the one who arranged that I was put on the list of speakers that day. The Director General of WHO, based in Geneva, was Dr Mahler and he attended this meeting. I suspect that he too was curious to hear what this apparently naive, jean-clad young woman had to say. I had the speech which the Professor prepared, but when I was called to speak I forgot about it and did my own thing.

I started with no protocol, no greetings or congratulations to the elected bureau and the honourable delegates (the usual courtesy). I went straight to the jugular of the illegal apartheid regime that was occupying my country and stressed that SWAPO would fight them and defeat them. I talked about the lack of health care facilities in Namibia and how our people were dying because of the lack of doctors and general neglect of patients, and the foreign nurses who treated our people badly. I also talked about the doctors who were operating on people without an anaesthetic (remembering what I had witnessed as a child when one of my relatives had an amputation without anaesthetic in Otjiwarongo). I also recalled our teacher, who died in Otjiwarongo Hospital four days after breaking his leg, because he was never seen by a doctor. After speaking my heart for about ten minutes and clearing my pent-up rage, I finally came to a conclusion. Only then did I remember to thank the chairman of the meeting and the delegates for listening.

As I sat down, I remembered the Professor and had a panic attack, wondering where he was and what he was going to say, because I had not read the speech he prepared for me. But the house broke into loud cheers and applauded. My neighbour tapped me on my shoulder because the delegates had stood up and formed a queue to congratulate me. My

Professor was beaming with pride and congratulated me, saying that mine was a very refreshing speech. It was indeed a stressful occasion but as soon as I started speaking I forgot about the people around me and only when I finished my speech did I remember their presence.

Although I hadn't known what a resolution was on that first day of the WHO regional meeting in 1974, I later became the Chairperson of the WHO Regional Committee for Africa (1999-2000), and President of the 53rd World Health Assembly in Geneva the following year, in May 2000. By then I was very confident and even brought a new style of doing things. Previously people used to meet and start greeting each other in the hall while someone else was talking. The Director General was always late as she scheduled her meetings during the sessions, and on many occasions the meetings would start late as we would be waiting for her. During my Presidency, I stopped discussions in the hall while a delegate had the floor. I also started the meetings on time. But I was changing these things with a smile. It was adhered to and we had a very smooth and memorable 53rd session. Delegates who attended that assembly will attest to it. I addressed the issue of poverty in our countries during my opening remarks as President of the Assembly.

I am telling this story to illustrate that during the struggle you were called upon to take full responsibility and find your own way, not like these days when you go with a prepared speech. Many times you got a message to 'report at the office in Zambia or Angola, you are going on a mission'. Only when you arrived at the office were you told what your mission was and where you were going.

Scholarships

I attended my first WHO Assembly in Geneva in 1975. While I was there, the Minister of Health of The Bahamas gave me a stethoscope. He was an elderly, very dignified doctor. I regret that I cannot recall his name, but thank him. I came to know the people from the West Indies during those conferences and it enabled me to organize scholarships for our health workers and send them to the Caribbean for training as nurses.

I also sent four nurses to Ireland to train as registered nurses. They went to Potiuncula Nursing College in Balinaslore, County Galway, and came back very well qualified; now in independent Namibia they are

very senior workers in our health institutions. I went to visit them in Ireland and they were fine and happy. I liked Ireland and enjoyed their pubs. On completion, only two of these nurses came back to the camps – Ella Ndume and Sofia Nekongo – but the others stayed on.

The word 'struggle' doesn't only connote the military struggle but also emotional and mental struggle. There were some people who through envy or sheer meanness wanted to frustrate others, particularly those in a leadership position. The day I was sending those four girls to Ireland, someone hid the passport of one of them, out of sheer maliciousness. Luckily, I went to the office in the morning to collect the documents because the flight was in the evening. But I only found three passports; the fourth had disappeared. I was so angry that I started cursing anybody who greeted me that morning. Unfortunately the first victim was my dear brother Peter Nanyemba. When he greeted me pleasantly, he was taken aback by my reaction. I said 'Don't greet me and sister, sister me, you people have hidden Ella Ndume's passport and if I don't find that passport by noon none of other girls will go! I will cancel the whole thing.' I walked out. I was really mad. Comrade Nanyemba went to the office and after three or so hours brought me all four passports. I went to the airport with the girls and sat there until I saw them going onto the plane; only then did I relax. The girls flew in the evening and I calmed down. Peace came over me. I also sent two girls to the Bahamas and two to Jamaica, for nurse's training.

Our African brothers and sisters also helped us. We were given places in their schools in countries such as Liberia, The Gambia, Nigeria, Ghana, Sierra Leone, in fact in all of Anglophone Africa. We were also given passports by some African countries and this eased our travel to meetings abroad. I carried a Senegalese passport and I remember Comrade Tjiriange had one as well. He told me a story that one day at Charles De Gaulle airport in Paris, a Frenchman, seeing Tjiriange's passport, started a conversation with him in French, but Tjiriange couldn't speak a word of French so he said in English that he was from Seno-Gambia. Fortunately the plane was boarding so their conversation ended.

I am personally grateful for this assistance and particularly to President Léopold Senghor of Senegal. Unlike Comrade Tjiriange, I spoke French, so I had no problem, but one day there was a Senegalese

man behind me in a queue and when he noticed that I had a Senegalese diplomatic passport he was curious about how I came by it. I explained to him how and why I was carrying that passport and he calmed down. Maybe he thought I was a crook who had stolen the passport or got it through dubious means and was ready to report that I was carrying a stolen passport. Come to think of it now, he should be congratulated for his vigilance.

My Second WHO Scholarship

In 1977 I was awarded a scholarship by the WHO to study Tropical Public Health. I went back to my alma mater, the London School of Hygiene and Tropical Medicine, and completed my post-graduate studies there in one year. The first day in the class we had to introduce ourselves to each other. The first student started to introduce himself, gave his name, said he was very happily married with x number of children, coming from a well-to-do family, and almost every other person followed that trend. At that stage I was getting fed up, thinking: 'who cares about your families?' So when it was my turn I said: 'I am Dr Amathila. I come from the war zone, I didn't come with my gun so don't be afraid,' and I sat down. There was palpable apprehension in the class but in the end we had a good professor and the subjects were very interesting.

We were four African doctors in all – two women and two men, including Dr Makuto from Zimbabwe and Dr Magano from Botswana. The wives of the doctors were wonderful and cooked for all of us during the exams. My friend Abiola from Nigeria was a very nice girl with a sense of humour, so we had many enjoyable times full of laughter. She came with her baby boy. She had a flat in an expensive area of London and we frequently studied there. In general we worked hard, passed our exams and graduated. Life in London was very enjoyable; sometimes we would go to the pubs to relax. I really enjoyed and loved London and I was awarded the Diploma in Tropical Public Health on 28 July 1978. After the graduation each one of us went back to our countries but we have kept in touch to this day. Sadly, Dr Makuto passed away in late 2010. I met Abiola in Namibia once during a conference. I seldom meet Magano from Botswana.

Kassinga

It was at this time that the forces of the South African apartheid regime attacked refugees in Angola at our centre at Kassinga, on 4 May 1978. Much has been written elsewhere about this dreadful attack. Over 600 Namibian refugees, who had just arrived in Angola from Namibia, were mercilessly killed by the South African army. The aftermath was that children who survived the bloodbath at Kassinga were sent to the then East Germany and the Government there assisted SWAPO in taking care of them. This gesture of goodwill was much appreciated by SWAPO.

Many of the children were orphans but some were children of busy SWAPO leaders. A few Namibian women went to stay with the children and keep their Namibian languages and culture alive. The children stayed in East Germany until the fall of the GDR in November 1989.

Reading the USA

I went to the United States of America for the first time in 1979. I was interested in reading books about the CIA and BOSS (the South African intelligence service). I also liked to read thrillers. Now with my experience in Poland (remember my story about the visit to the US Embassy in Warsaw), and with this background of thrillers and stories about the CIA, I was very afraid.

There was a particular American writer by the name of Chester Himes, who wrote *Cotton comes to Harlem* and two other thrillers – *The Heat's On*, and *The Real Cool Killer*. I read them all. I remember the two detectives Ed Coffin and Gravedigger Jones. The stories were mainly about crimes and murders in Harlem. In *Cotton comes to Harlem* there was a movement called 'Back to Africa', run by a conman, Reverend O'Malley, who was collecting money from African Americans who wanted to repatriate to Africa, but the money was later stolen, and lots of murders were committed trying to find it. Ed Coffin and Gravedigger Jones were very tough, stocky and no-nonsense detectives. Ed had a long barrel gun and nickel-plated .38 revolver.

In the other books, I remember the one about a lady who cut open the skin of the goat and hid drugs there and then sewed it up. The other story was about a man on a motorbike speeding through the streets of Harlem. There was a wire tied up between the houses, and as he sped

down the street the wire severed his head and it fell off, leaving the torso still on the motor bike!

I read Himes' three novels and the one I most enjoyed was *Cotton comes to Harlem*. The way people spoke was often hilarious. For example, there was a church lady who mentioned something about 'the communist preacher'. I even saw the movie of this book and one of the actors was Bing Cosby. I lost the other two books. I wonder whether they can still be found; they might be out of print by now. All my books I read during the struggle disappeared in the container during our return to Namibia in 1989. We were only allowed to carry 20 kilograms of luggage, so the books had to be put into a container, which never arrived.

The thickest book I've ever read and very much enjoyed was *War and Peace* by Leo Tolstoy. It took me three months to read that novel and I finished the last sentence on a KLM flight from New York to Amsterdam on my way back from visiting the USA. I was sitting next to a white American man whom I ignored all the way because I was scared in case he was a CIA agent. I was also engrossed in the book, but when I finished reading the book somewhere over the Atlantic, I ordered champagne to celebrate the victory of finishing that big book. My neighbour started a conversation, asking about the book and, when I showed it to him, he congratulated me and also ordered champagne. We toasted each other and chatted and he told me about the works of Mark Twain and the stories of Tom Sawyer and Huckleberry Finn, and encouraged me to read them. I think that Mark Twain's works were compulsory reading in American schools. At Amsterdam airport, this man kindly bought me a copy of Mark Twain's book *The Adventures of Tom Sawyer* and I read it on the plane back to Lusaka. Since then I've read other books by Mark Twain and enjoyed them very much. I remember the story when the two boys got lost in the caves for over three days and the people of the village presumed them to be dead and held a memorial service in their memory. Tom Sawyer's aunt cried her eyes out, but during the memorial service the two boys returned, sneaked into the church and listened to what people were saying about them. After that, Tom Sawyer ran home and hid under the bed to watch his aunt spilling copious tears and only then did he realise how much she really loved him.

War and Peace reminded me of my grandmother and her friends back home, because of the way those Russian women were gossiping and rumour mongering. I am normally strict in lending out my books to people since they never return them and one forgets who borrowed the book. Fortunately I found my copy of *War and Peace*.

When I arrived at John F. Kennedy airport in New York that first time, the people who were supposed to collect me were late and I had to wait in the arrival hall. A burly black man approached me and asked whether he could help me find transport. I gave him one look and decided that this one was a potential Harlem criminal and I walked away with a 'No, thank you.' After that I was approached by a white man who also asked whether I needed a cab or something. Now in Africa we talk of taxis whilst in America they say 'cab'. That word 'cab' frightened me even more. I concluded that this one must be a potential CIA agent. What was this 'cab' he was talking about? I was beginning to worry where my people were when fortunately they arrived. I was in a big hurry to get out of that place! I must have stood out like a sore thumb – an African woman not yet collected and alone is suspect. I revealed my suspicions to my friends and they must have thought I needed to see Harlem to cure the fear and phobia I had about it and cleanse my soul.

The following night I was taken to a jazz club in Harlem. I enjoyed myself so much; people were courteous and friendly. I was their sister from Africa and the treatment I received there as a customer made me feel as if I was the only important person at that moment they served me. Where I come from it is as if you, the customer, should beg for service or you are disturbing them. We spent the night in Harlem and went out from there to have breakfast.

From my experiences during this trip, I learnt a lesson of how friendly and pleasant Americans are. I think from then on I relaxed, stopped my guerrilla suspicion and phobia about spies, and enjoyed people's company, although I was still cautious. I went to New York several times after that and enjoyed myself immensely. I fell in love with New York, and to this day New York remains my number one city. I found Americans very friendly and very helpful. Sorry for my misconceptions. You must blame Chester Himes, author of American thrillers.

Support from Finland and the USA

In 1982-83 I took some Namibian comrades who were blinded in the war to Finland. I have mentioned earlier the battles in Oshatotwa and other places where some of our comrades were blinded, and when they were transferred to Nyango, they couldn't manage on their own and needed constant assistance to walk. I was helped by a Finnish NGO to send them for training in Finland, where they had wonderful training facilities for blind people. I went there to organize a specially adapted course to train our blind comrades to learn how to be self-sufficient and to walk with a white cane. Those who could already read were taught braille. I also sent other sighted Namibians there to be trained as trainers for the blind. I went to visit them in Finland and attended their graduation in 1985.

There was still a problem caring for hearing-impaired comrades who needed help to be able to communicate through sign language. We had a place for them in Kwanza Sul, in Angola, and they were very enthusiastic and liked singing. I was hoping to find a place where we could train them in sign language.

One day one of our senior leaders, Comrade David Meroro, the National Chairman of SWAPO, went to visit this group in Kwanza Sul and as protocol dictates he was seated in the front row. The comrades decided to welcome him with a song but there was total chaos, as the deaf comrades stood behind each other and couldn't read each other's lips and keep time. This meant that the song was concluded by some while others were still singing. Our guest couldn't control himself at the many sounds that song produced. He was laughing secretly and his tears were streaming down. I was responsible for those comrades and I had to find a way to help this group as well. The breakthrough came while I was in Finland visiting the blind students. I read that Gallaudet University in Washington DC offered courses in training deaf people. So it came about that a few years later, in 1985, I made a second visit to the USA, when I took five hearing-impaired comrades from our Health and Education Training Centres in Angola and Zambia, and five comrades with normal hearing, to Gallaudet University in Washington DC.

I had flown from Finland the previous year with help from the Finnish NGO who organized the ticket to Washington, and had met the authorities there and organized a special programme to train Namibians

in sign language. The group of five hearing comrades were to study to become trainers. This was a very difficult trip. The comrades had never been on a plane before so I had to be everything to them, helping them to the bathroom, helping with eating, etc. I'm sure it took about 30 hours from Luanda, Angola, to Washington DC. When we landed in the evening at Dulles airport, the people who were supposed to meet us were nowhere to be seen, maybe due to our late arrival, so I had to find a big car to fit us all in. I found a big limousine driven by a very friendly, large, black man. He took us to the university but it was after midnight when we finally arrived at the campus. The driver didn't just drop us, he ran around to find the people who were by now sleeping, since it was the early hours of the morning. The accommodation was arranged and by the time my students were settled in it was morning.

The driver took me to my hotel, the Howard Hotel in DC. When I asked for the bill he declined, saying that it was his service to the African people: 'A small woman like you taking care of all these men alone and on such a long journey.' He said he felt privileged to help after listening to my story. I remember this kind limousine driver but I regret that I didn't take his address to send him a thank-you note. He also helped to book me in at the hotel. I was very, very tired and slept for more than 24 hours. I was woken by the hotel staff, although I had put a 'Do Not Disturb' sign on my door. They were worried that I was still sleeping. Maybe they thought I was dead, but of course they didn't know how long I had been travelling. The lady in the dining room wanted to know what I wanted to eat and communication became a problem, I with my Namibian accent and she with her American drawl. She asked whether I wanted to eat hash and I didn't understand what that was. The more I asked, the more communication broke down, so I simply decided to stick to what I knew and asked for bacon and egg, bread and coffee.

The next day I was standing outside the hotel waiting for a taxi (or 'cab') to visit the comrades at the university. As I stood there, I felt some movement behind me and as I was trying to figure out what it was, I saw out of the corner of my eye huge feet, maybe size 12, next to mine. I realized there were maybe four pairs of those huge feet surrounding me. My grandmother had taught me it was bad manners to stare at people and I shouldn't raise my head to look, but very carefully I lifted my eyes gradually to look. I could only see the knees. These guys were very tall!

I had never seen such big feet in my village. Later, I was told that these were basketball players. I sometimes think of that first encounter with basketball players when I watch the game of basket, which I like very much.

The next day our Representative at the United Nations, Comrade Theo-Ben Gurirab, came to see the students and took me back to New York once the students had settled in. The students completed their course and I met some back here in Namibia. One of them didn't return; he did very well and was admitted for further study at the same university. I often wonder what happened to him.

Ndalatando, Angola

After four years in Nyango, Zambia, I was transferred to Angola in September 1979. We had a large number of Namibian refugees there – over 35,000 people. I left Lusaka and arrived in Kwanza Sul (Kwanza south), the main centre where the refugees were staying. The camp was situated in a beautiful, green, deserted coffee plantation in a farm called Kambuta, but our people were living in makeshift tents. The SWAPO President, Comrade Sam Nujoma, was very concerned about the health condition of the children and told me that whilst the situation in Nyango was very stable, that in Kwanza Sul needed urgent attention. He ordered me to take charge of the people's health, particularly children who were dying of preventable childhood diseases.

The Angolan Government had recently given SWAPO another site which was a lush coffee plantation in the province of Kwanza Norte (Kwanza north). It was about 15 kilometres south of the town of Ndalatando. A decision was taken to move the children to this place from the main camp in Kambuta and we did so shortly after my arrival. The condition of the children was bad; they had sores all over their feet caused by some insects or parasites. I had no idea what it was, since I had never seen these sores before, but people in the know called them *takayas*. The place had previously been inhabited by Cuban soldiers and when they moved out it was given to SWAPO. When we arrived, the Cubans had gone but they had left a dog, which we inherited. This dog was a symbol for the children who had never seen a dog before. Soon any four-legged animal was called a dog, to the extent that when a comrade from Sumbe brought us some goats to keep for milk for the children, they were also called dogs by the children. One day we slaughtered a goat but to the children it was a dog, and they told President Nujoma when he visited them that Meme Doctor had slaughtered a dog and we had eaten all the meat. The President found the story hilarious and asked me, 'Since when have we started eating dogs?' I was taken aback

by the question and then the President told me what the children had told him. I also used animal pictures when I was checking the eyesight of the children in the hospital and I was amused at their response: every four-legged animal was a dog but this was fine to me, as long as they could see it clearly. Sometime later our dog disappeared and we were told that an old man had eaten it, but I think maybe the dog died from old age somewhere in the thickets of the tropical plantation.

At our centre in Kwanza Norte we had one main house and four other structures. The main house had fifteen to twenty rooms and had presumably been used as a hostel for the plantation workers. We turned that into the sleeping quarters for the children. There was also a big hall, which we made into a school. One of the buildings became the hospital and the other became a house for the supervisors, where I stayed. The last remaining structure was made into a storeroom. The refugees made their dwellings from tents and corrugated iron sheets.

The place needed to be made habitable, so first we put all the children into the big hall while we were cleaning and painting the various rooms. At the same time, the four nurses and I were treating the children, dressing their wounds, and feeding them with high-energy milk and nutritious food. I don't remember which organization gave us children's beds; I think it was UNICEF. The cleaning and painting of the rooms was a mammoth task. I remember that we started very early in the morning and worked till dark because the rooms needed to be completed so we could move the children in. There was a soldier who came from the front, Theophilus Namupala, who was an artist. He was a blessing as I wanted this place to be pleasant and feel like home to the children. I asked him to paint the outside walls and draw pictures on them. He did a fantastic job and when it was finished the place looked so beautiful. When everything was ready, and as the children recovered their health, we moved them in.

One day soon after we had arrived, I went to Luanda to pick up some things and lo and behold there was Monika, a woman I knew from Nyango. In fact, whilst in Nyango I had sent her to Bulgaria to take a course in pre-school education. She had just returned from there that morning. After greeting her I asked her to come with me to the new centre and we left the next day.

We named the centre the Mavulu Centre after Natalia Mavulu, a very brave and hard-working woman with whom I had started the Nyango kindergarten. She died in Zambia in a car accident and we honoured her memory by naming the new centre in Kwanza Norte after her.

Once everything was in place, and the children were better and had started behaving normally, it was time to put administrative structures in place. The population of the centre was about 800 at the start and as time went by it reached 1,000, consisting of 350 women, over 600 children under the age of six, and 40-50 men who had been discharged from the army because of battle injuries or ill health, and who were there to guard the centre. The women were divided into the following groups: surrogate mothers, nurses, cooks, cleaners, teachers, and soldiers who helped the men guard this very isolated place. There was only one road to the centre, which was surrounded by mountains and huge tropical trees, and it was vulnerable, particularly because Jonas Savimbi's UNITA forces were fighting Angolan Government forces in that particular region of Kwanza Norte.

UNITA was one of the three Angolan liberation movements (along with MPLA and FNLA) that had fought against Portuguese colonial rule. When Angola was declared independent in 1975 after the fall of the Caetano regime in Portugal, and the MPLA was installed as the legitimate government of Angola, UNITA continued to fight the new MPLA Government. It was an arduous and bloody war that dragged on for years and cost many lives, until Savimbi was killed in 2002. We were surrounded by that war; the UNITA forces roamed around the countryside, especially in Kwanza Norte, and were a threat to us. We were actually guarded by the Almighty! I must confess that we were not molested by Savimbi's men, even though we were sitting ducks and soft targets. However, unlike what we hear from the media about rebel soldiers going on a rampage of rape and destruction in some parts the world, I never came across such atrocities concerning Savimbi's rebels. They knew of our presence in the area where they were very active, but they left us alone.

The staff of the hospital we established at the Mavulu Centre consisted of me as the doctor, one registered nurse, three enrolled nurses, and three cleaners. There were also six teachers. I appointed Monika as the Supervisor, assisting me with the running of the centre. She shared my house. I was the overall Commander of the centre.

Life in the Mavulu Centre

There's a persistent myth that women can't work together, which I vehemently dismiss. Women have no egos, they do the work assigned to them, period. Only if there are men involved do women quarrel, usually instigated by men, I think. During the five years I lived and worked at the Mavulu Centre (1979-84), I never experienced any problem with the women, such as fighting among themselves, or even quarrelling.

I have found women to be the most responsible and loyal group to work with. My experience at the Mavulu Centre was that we worked as a team. The centre was very clean and orderly. The cooks woke up at 2AM to prepare breakfast for the children and, day in day out, they did their work brilliantly. The cleaners woke at 5AM to clean the surroundings. Sometimes they would decide to do so in the moonlight, particularly when all of us at the centre were required to work in the garden. Before the children woke at 6AM for morning exercises and breakfast, and before the pre-school classes started, the whole environment was clean and pleasant.

Everybody had responsibilities in the centre. The children, who were the owners of the centre, had to make sure it stayed clean. Another responsibility was to show the newcomers where the toilets were, so they didn't defecate anywhere except in the toilets, and kept to the time when teachers lined them up to use the toilets. We, the hospital staff, taught the women and children how to recognise a sick child. Since this was an endemic malaria area, it was very important not to miss a child who developed a high fever. Such a child had to be brought to the hospital immediately for treatment. Therefore, the children were taught that if they saw a child lying in the playground not playing, they had to feel the child's forehead and, if it was hot, they had to carry that child to Sister Martha at the hospital.

The children took their responsibilities very seriously. We had hilarious times when children would haul in a child they'd found lying somewhere in the camp. Five or six children would carry the child to the hospital and announce very loudly that the child had malaria as her/his forehead was hot. But if they were more than six children carrying a screaming child, then that could mean trouble. If a child had defecated on the grounds of the centre, the child would be brought to me or to Meme Monika and it would be reported very loudly that he/she was

found defecating on the playground. This would normally be a new arrival, and after the report that, 'This one has done kaka over there on the playground,' the child would be given a small shovel to pick up the mess and throw it in the toilet, and that child would never repeat the mistake again.

We built very neat pit latrines, which I designed; I learnt that from my post-graduate training in Public Health in London. We built two rows of latrines – one for girls and the other for boys – with ten holes each. I was very proud of those pit latrines. We put in foot rests and good seats so that the children could sit comfortably and not fall in. (I recently read in her memoir how the current Liberian President, Ellen Johnson Sirleaf, fell into a pit latrine as a child.) Teachers would break at 10AM for the trip to the toilets. One teacher would be there to help the children, particularly the small ones, thus we never had any problems. I mentioned earlier how amazing children are; they quickly adapt and learn. There was also a strict medical check done once a month. These medical examinations made mothers very nervous. Each mother wanted her children to look the best, so there was fierce competition. It was also a morale booster and through the practice of strict regular medical check-ups, the children's health and well-being was guaranteed.

When I talk about the mothers, these would not be the actual mothers of the children but the women who had been given responsibility for the children, since their real mothers would be away at the war front, be studying or might have died. Each 'mother' looked after five children.

The centre was very busy from 6AM to 7PM, Monday to Friday. Saturdays were the most pleasant days, because there were no classes and the children could play to their hearts' delight. Saturday evening was disco time. The mothers would wash the children and dress them up in their best clothes and they would spend the evening enjoying the music and even dancing. Both women and children dressed up for the disco which started around 6PM and went on until 7PM for the children; the adults continued up to 9PM. The disco night was popular; our people even came from Luanda and other centres.

Sundays were free and we let the children play on their own. They climbed trees and ate fruits. There were bananas and many tropical fruits like mangos growing in the wild in the fields around the centre. The children also discovered a lime tree that Monika and I had found.

Fortunately for us, the fruit was too sour for the children's taste so it was left alone. However, our guava tree was not spared! Coming home on Sunday afternoons after a day in the fields, the children were so tired and dusty they resembled baby elephants that had rolled in the mud.

We adults also enjoyed our Sundays. This was the day when women washed their clothes, braided their hair, cleaned their dwellings and rested or visited each other's tents. Monika and I used to visit our Angolan friends in the small town of Ndalatando. I had been given a jeep for the centre and I would drive while Monika played the role of bodyguard. We would visit the town to check up on the latest news and the movements of Savimbi's men. On many occasions, President Nujoma visited the centre over the weekends. He enjoyed the company of the children tremendously, and they in turn loved these visits. They played with him, telling him stories about what they did in the centre and giving him all kinds of reports.

My life in the centre was very busy but very rewarding. I was very happy there. Perhaps the children, with their innocence and tricks, made my daily life worth living. They were so innovative, full of energy and very resourceful. We had a drum of multivitamin syrup in the hospital and often the children would come and demand that the nurses give them this syrup saying, 'Meme Sister, we want vitamin.' The best times, when the children showed their pride, were when they brought a sick child to the hospital. They looked and acted grown up and important; they felt they had achieved something by saving the life of a child who had malaria. The public health was rigorous, the centre was spotless, and at the monthly check-up each mother lined up with the children she was responsible for, while I did a full-body check on eyes, nose, general appearance, heart, lungs, skin, weight and height. Generally, the children and adults in Mavulu Centre were a picture of health, and the mothers took care to make sure that their children were not found to have some disease or to be undernourished.

Morobia

At one point, a colleague brought us goats so that we could have milk for the children and also eat meat when needed. I think they were fifteen females and one ram. The children named the ram Morobia but I have no idea where they got that name from, or the meaning of it. Morobia

was the centre of attraction for the children. He was given food; they
played with him, rode on his back, and looked after him. One day the
children came to us with a serious story about Morobia's behaviour. A
big delegation came to Monika. She listened to their complaint and sent
them to me. Their story went as follows: 'Meme Doctor, Morobia is bad.
He is colonising other goats. He's chasing them and wants them to carry
him on their backs. Even the small ones have to carry him, so we're
not giving him our food anymore.' I had a hard time to figure out what
explanation to give them. I sat them down and explained that we needed
more goats and that Morobia was working hard to give us more goats. I
could see on their faces that there was confusion about the story of how
Morobia was supposed to give us more goats, but since there were no
more questions as to where and how Morobia would get more goats, the
story was accepted and Morobia retained their affection.

President Nujoma was also told about the colonial behaviour of
Morobia. I wonder whether he got the gist of that story!

'Embushua'

Children take their responsibilities very seriously. They guard their
property carefully and are most agreeable to work with. Once there
was a SWAPO Political Bureau meeting held at Mavulu Centre and the
classrooms were used for the meeting. The children didn't like this. They
wanted to stay in their classroom when the meetings were going on,
just to make the point that it was their property. One afternoon during
a break in the meeting, Comrade Peter Nanyemba was sleeping in the
hall and the children came in and woke him up. He chased them out
but they told him that it was their school after all and they wanted to
stay there. They called Comrade Nanyemba 'embushua', meaning that
he was bourgeois, because he was tall and big. I was accused of teaching
these children bad manners, but honestly speaking I don't know where
they got that word from. Sometimes people, particularly in our culture,
like to say things in the presence of children, forgetting that they may
stand around innocently but their ears are open and they take in many
things we say.

Visitors

Many visitors were taken to the Mavulu Centre. Local dignitaries, as well as international guests, visited frequently. One day, early in the morning, we received a visit from a Japanese journalist who wanted to see the children. I think he was under the impression that, since it was a refugee camp, there must be lots of children suffering from malnutrition, and when I explained that there was no malnutrition in Mavulu Centre he felt that I didn't understand what he was looking for. So he took out a picture from his pocket of an African child suffering from marasmus and indicated that he wanted to see that. At that time we had around five children in the hospital and I asked the nurses to prepare the children for the journalist's visit. The Sister in charge of the hospital panicked because when she got into the children's ward, she found nobody there. The children were all out in the courtyard joining in the morning exercises with the other children, when they were supposed to be in their beds. This shows that when a child feels well there is no way to keep him/her in bed. We let journalists visit the centre as they wished; in other words, we gave them unfettered access. The Japanese journalist was surprised not to find the marasmus he was looking for. I don't know whether he was sad or happy but I think he was sure that he had seen all the children.

The Mavulu Centre was very well organized. The children were happy as they felt this was their home. I made sure that, despite the war, the children were treated as children and did not grow up in a gun culture. In fact, I was accused of bringing up the children like civilians.

A New Camp Commander

One overcast Monday morning in 1984 an event took place that changed my life. It was my fifth year at the Mavulu Centre. A group of our soldiers came to the centre from the war front and without warning one of them was introduced as the new camp commander. This man started behaving very strangely. Within days of his arrival, he accused me of not training the children as future soldiers, but rather as future intellectuals or a future bourgeoisie. Before I had figured out what his problem was, the very next morning he had poured petrol in our pit

latrines and thrown matches in my beautiful toilets and they exploded. I smelt a rat and felt that he was bad news. Did he want me to teach the children to shoot people? If he wanted that then he was dealing with the wrong person. I was sent there to look after the health of our people and to give pre-school education to the children, not to run war games.

The next thing the new commander did confirmed my negative view of him. We had some men (ex-fighters), who had been discharged from the war front owing to injuries, and we had given them responsibility to guard the centre; they were assisted by some of the women. The commander ordered nine of these ex-fighters to go to Luanda to fetch some items. I had prior information from our Angolan military allies that Savimbi's men were in the area. I always made sure not to expose our soldiers if I had information that these rebels were on the prowl. As President Obama likes to say, you should not put your troops in harm's way. I warned the commander that it wasn't wise to send our men out whilst the situation was not safe, but despite my warning he sent these men to Luanda, displaying the oversized ego of a man ill-equipped intellectually, with no military strategy, but who wanted to show that he was a military man and not a sissy. My worst fear became a reality when early one morning, I think a day after they left, I had a visit from the Angolan military team. They came to give me the bad news that our truck had been attacked and all nine men had been killed. This happened just because of one man's ego.

I must state here loud and clear that I, as a woman, had run Mavulu Centre for five years with 40 men, 350 women and over 600 small children, and never once had we been attacked by any rebels, despite the fact that they knew of our presence. I was very cautious how I moved and Monika and I would visit Ndalatando to seek the latest information from the local military on rebel troop movements; and I took the advice I got from the Angolan military seriously. Above all, I had no ego and no need to prove my bravery. I sought and listened to advice and never exposed our people to any danger. Even our children were trained not to make noise at night and those women, including me, who had a radio, were told not to play music at night, because we had to be vigilant and listen to what was going on around us. If there were enemy movements we would lay low.

In fact, one night there had been a big bang sounding as if a bomb had exploded. One of my military men came running to my house and reported about the sound we had all heard. He insisted that we wake the children and evacuate the centre, but I was of the opinion that in the dead of the night, and with the thick forest, I couldn't evacuate the children and expose them to the possibility of being lost in the darkness or being bitten by snakes. I consulted the women and we all agreed to take up our AK47s and guard the centre rather than risk the lives of the children. The soldiers also agreed; all the adults kept vigil throughout the night; and, lo and behold, nothing happened. The next morning, Monika and I went to the town to check out the situation, but no enemy movements were reported. Later in the afternoon we discovered that the noise had been caused by a huge tree falling down.

Readers may wonder what happened to the children of the Mavulu Centre. Today they are adults: well-educated men and women. I often meet them and usually they are the ones who introduce themselves to me, because I don't recognize them now they are grown up. The funny thing is that when they introduce themselves they use their Mavulu Centre names to make it easy for me to remember them. I feel blessed and honoured when I meet them. Some are in the army, others in one or another government ministry. One day, after travelling abroad, I came back home and was met by an immigration officer in full uniform beaming with a broad smile. He had been one of our Mavulu children. I was so moved and proud, and had tears of happiness in my eyes.

Kwanza Sul

When the nine men were killed I was so angry and horrified I decided to leave the centre the next day and move to our main centre in Kwanza Sul. I was not going to be part of this egomania. Nothing happened to the man responsible since the deaths were regarded as normal war casualties. I didn't make an issue of it either because I wasn't sure what was going on. During the struggle one couldn't always ask questions. One needed to protect oneself during those dark days. From nowhere rumours had started about spies sent by the enemy to infiltrate the SWAPO movement. At one point it got so serious I started fearing my own shadow. So I just packed my jeep and left the centre. Monika came to join me shortly afterwards.

After many years I met this same camp commander in Windhoek and he tried to be very nice to me, but deep down I knew what he did during the struggle. There are such people walking around with blood on their hands.

Anybody who is in a revolution knows there are ups and downs, particularly when you are fighting against a powerful enemy. We didn't escape that, and we had two episodes of internal conflict; fortunately they were both contained and we continued with our struggle for independence.

Morenga Village

After leaving Mavulu Centre I went to work at our main centre in Kwanza Sul near Kalulo. The camp commander was very happy to receive me and I built myself a cosy little house and a school to train nurses because there were many deaths amongst the children. A Finnish NGO provided us with five big prefabricated classrooms and we build pit latrines for the students, in what I called Morenga Village, after Jacob Morenga, one of our Namibian heroes from the war of genocide. He died in 1907 in the Nama resistance against German colonial forces.

It was maybe a blessing in disguise that there was a hospital in the main centre, which I took over, and where we also treated Angolan patients. Shortly after I arrived there I would hear gun shots almost every day. On inquiring who was shooting whom, I was told that it was funerals, mainly of children. One morning I went to the hospital and found lots of 'nurses' in white uniforms. I was informed that these nurses were perhaps not fully qualified which accounted for the high mortality amongst children under the age of five. That gave me the idea of opening a training school for our nurses.

I had learnt early on that, before embarking on the road to any change, it's very important to prepare the final destination, meaning that Plan B must be in place before executing Plan A. Having that in mind, I decided to establish the facility for training first before dealing with those unqualified 'nurses'. I can't stop repeating this philosophy of always having alternatives before acting on an issue that might disadvantage people.

I observed quietly what was wrong and soon discovered why so many children were dying: it was from an overdose of drugs. They were being given chloroquine injections up to 5cc for malaria and, as soon as the needle was withdrawn, they died. In conditions of war there are many rumours and sometimes you need to cover your back by establishing irrefutable facts before you act, otherwise you may be accused of all sorts of things. The steps I was going to take would be drastic and I needed to be careful and do things properly. After I finished the building of the training school, I found a teacher and with the help of some friends, I prepared the curriculum for training enrolled nurses. Once everything was prepared, I was ready for the battle.

I turned my attention to these white-uniformed people, who were about 90 in number. I set them an examination asking very simple questions, such as the range of normal blood pressure, how you treat malaria, what is an antibiotic and what do you use it for, etc. The results I got were such that I dismissed 69 of them who had no clue about the answers. The rest of them, who were trainable, went to start at the nursing school at Morenga Village. The ones I had dismissed went on the warpath, accusing me of colonialism and even of supporting the notorious South African apartheid President, P. W. Botha, who was responsible for our misery. One even said that I was Botha! I realized

that she didn't know who Botha was. I was reported to the Party, but I was prepared for that and I confronted whoever complained with the bare facts. I invited the group of 21 who had passed the preliminary test to enrol in the training programme, and I started in-service training for those who remained in the hospital. Very soon the gun-fire became less frequent because the children stopped dying as the nurses began to learn their work.

There was a very brave comrade, Hivelua, who stood up for me while some of my so-called 'close comrades' buried their heads in the sand. He told the members of the Central Committee gathered there that he had been administered the wrong drugs and had almost burnt his skin because he was treated with the wrong ointment. He urged these 'nurses' to go for training in the nursing school I had started. Some other people related their failed treatment, while others supported the creation of the nursing school. President Sam Nujoma was amongst them, and advised those complainers to go for training. The complaints died quickly; we got busy with the eighteen-month training course and produced two batches of enrolled nurses. I also enrolled one ANC student in the school.

We built ventilated pit latrines of the same design we had used at the Mavulu Centre, but this time they were for my nursing students. The school was well furnished; it had good books, a student's home, a principal and even one foreign teacher. I built my own house with bricks, which I bought from Angolans at Kambuta village. However, although I thought the house was solid, it flooded when the first rains came because the roof sheets were too short and the water just rushed through the roof. Fortunately it was during the morning, so I borrowed a canvas sheet from our storeroom and covered it. After that, I felt I was living in luxury; the house was very comfortable.

Morenga Village was very popular and it was a hub of activity. One day, some comrades visited us and I had cooked food. I asked Monika to dish out for the comrades but she said to me, 'Who is going to wash the dishes? Let's just give them meat on the forks.' So we also had fun in Morenga. I kept chicken on my plot and one day I invited a Danish friend from Luanda, who was working for an NGO. I had promised her a traditional Namibian chicken dish. However, when time came and the children chased the chicken I had earmarked to be sacrificed for that

meal, it escaped into the nearby bush. We had to 'borrow' a chicken from someone else, only for my chicken to surface as we were eating the borrowed one. These stories are for readers to know that we were living as normally as we could in our refugee centres.

One day, President Nujoma called me and told me that a Tanzanian woman had been invited by the SWAPO Women's Council and I should take her to the centre. She helped me train the students, particularly in cooking, as we were running a four-week course. She was very good with dishes prepared from cassava leaves. At the end of that course, I took women to Congo Brazzaville for another two-week cooking course. We had a beautiful garden with local vegetables such as spinach, pumpkins and beans. The nutrition training started from planting and harvesting, to cooking and eating. The training programme was run by one of our graduates from the Food and Agricultural Organisation in Italy. Her name is Meisie, I meet her now and then in Windhoek.

Spy Fever

As always happens in a conflict situation, stories were rampant about spies sent by the enemy and one had to be vigilant all the time. These rumours reached fever pitch in the late 1980s and people started looking behind them and worrying. Who were the spies? Where were they? Who could one trust? It reminds me of a story a Nigerian doctor told me in Libreville, Gabon, when we attended a WHO-Africa Region meeting one time. He had been in Uganda during the time of Idi Amin and he said that even as he slept in his peaceful hotel room, he would jump up every now and then because he was so fearful. Sometimes it would only be a cockroach that was making noise but he would imagine it was an intruder. He didn't even trust his own shadow.

While we were still in Mavulu Centre some years before, we had started hearing rumours of spies who came from home and infiltrated SWAPO. We also heard that some people had been taken by SWAPO to Lubango and been interrogated and detained there. It's always the case that when the enemy smells defeat they resort to desperate measures. They intensify their atrocities, attempt to assassinate the leaders of the revolution, break the resistance from within by sending agitators or criminals to commit atrocities or, as in this case, spread rumours about the presence of spies to confuse people. We had seen all this happening

in other liberation movements. We in SWAPO had already tasted the rebellion that was led by Andreas Shipanga. So it was with trepidation that I realized that we were now again being targeted, because we had intensified the struggle and were about to suffer one way or another for it.

One bright morning in 1988, I had a visit from some comrades from the army. They came accompanied by our camp commander. I didn't know what the visit was all about but one of them, who was apparently a communications expert, asked me about the communication equipment in my house. I was surprised but not alarmed. This piece of equipment was a toy walkie-talkie belonging to Tostao, a boy who was staying with me. I told the communications expert this but he insisted on examining the toy. I showed it to him and explained that the mother of the boy bought this toy in a department store in Luanda. The two boys who used it were both ten years old; one stayed with me in my house and the other one with Monika in her tent opposite my house. They used to have fun talking to each other from my house and Monika's shelter 30 metres or so away.

I was surprised that the so-called communications expert didn't seem able to distinguish a plastic toy from the real thing. I said he could see that this was a toy but he wasn't convinced and confiscated it for further examination. Later I was told there was a rumour that I was communicating with the Democratic Turnhalle Alliance (DTA) in Windhoek. How was I supposed to communicate with a party I knew nothing about and moreover with a plastic toy walkie-talkie from Morenga Village to Windhoek? I recalled the story of one of our comrades, from a sister party, who was accused of urinating on the wall of a corner house in Dar es Salaam. When the magistrate said, 'You are busy urinating on someone's house in Dar es Salaam while your brothers are fighting in South Africa,' he replied: 'Your honour, should I run to the border every time I need to urinate? The border is so big I will not even get my urine across it.' Honestly this was just trying to accuse me of an impossible act. One could be picked up for spying on such flimsy pretexts. So this charade of spying was in some cases made up. It was also used to ostracise some comrades by newcomers to the party to harass those people for reasons only known to them.

Paranoia about spies under every tree reached such a height in the refugee settlements that no one trusted each other. It was fortunate that the end of our lives as refugees was about to come sooner rather than later, with the implementation of UN Resolution 435, otherwise a lot of innocent people might have been accused of spying.

The spy phobia brought much uncertainty and rumours were floating around about who had been arrested, who had disappeared and who was about to be picked up. Life became uneasy in our centres but as I said it came at the dying hours of our stay in exile. I think we survived this onslaught because we worked closely together and every morning we continued holding our parades to keep people informed and also to raise morale. This reminds me of one early morning parade held by Comrade Meroro, our National Chairman. We hadn't eaten breakfast and people were tired. The Chairman went on and on and people started dozing. One stalwart, Comrade Katamila, got up and in order to wake us up he shouted a slogan, 'SWAPO', and we responded with the refrain 'will win'. He followed that with '*Muarara* – Are you sleeping?' and the chorus answered 'Higher', thinking that Katamila had said 'morale'. Those parades also made sure that we saw each other every day and I think they kept up our spirits.

Homecoming

Ohne bright morning in May 1989, a few months after the walkie-talkie affair, I was informed that we should pack our belongings because we were about to be repatriated to Namibia to take part in the elections. I remember I was so engulfed in my work that I didn't feel all that enthusiastic about the news. I had a nice little house and a flourishing garden. I was running my nursing school successfully, and the nutrition classes. These were my two main projects and I didn't want to interrupt them. I knew where I was, but I didn't know where I was going. Anyway, we had to pack our containers. We were only allowed to take 20 kilos of luggage with us on the plane, so all of my nursing school texts, equipment and other books and property went into that container. I was sorry to leave the prefab buildings, my house and my vegetables behind. It's not strange that I felt that way, because I was weary of moving from centre to centre; every time I put down roots I had to move. I had been on the move for my 27 years of exile. I was not impressed with the news that we were moving again, but I had to go.

We left Luanda on 18 June 1989. I was on the first plane with the leadership group that came back to Namibia with the clear and specific mandate to set up an election team and organize our campaign. Comrade Hage Geingob was appointed by the SWAPO Political Bureau to be the Director of the SWAPO election campaign and he was the leader of the delegation. My responsibilities were in health and social issues. Most of us who were later to form the first Cabinet in an independent Namibia were in that plane. What a risk we took, but we had no choice. It makes me shiver when I think of it even now. I knew that if something happened we would all be goners but I prayed that if that was to be our fate, let it happen on Namibian soil and not over the sea or an unknown territory! Human nature is sometimes funny. When I enter a plane I often think 'what if something happens' and I look around to see who is in the plane with me. I had the same thoughts in 1989, although I

didn't share them with anyone, but when the plane reached its cruising altitude I realized that the die was cast – we were going home!

The other passengers were also engrossed in their own thoughts. Perhaps they too were thinking about the same things that I was: 'Are we really going home? Are we going to land safely or will we be shot down?' I was apprehensive but not scared; I just thought that it was better to die on the soil of the motherland if we were shot down. I also felt that the world was watching and the South Africans wouldn't be that stupid to shoot down the plane carrying us.

When the pilot announced that we were entering Namibian airspace, the mood changed, and the passengers became more alert. I think there were no drinks on the plane otherwise we would have toasted this momentous occasion. We started chatting and looking out of the windows. I began to observe how dry our country was. Coming from the lush, green, Angolan landscape, I felt disappointed.

We touched down at Windhoek Airport on a very cold, dry, afternoon; the airport was full with a huge crowd who had come to welcome us; no doubt they were curious about what we looked like. Our SWAPO colleagues Comrades Anton Lubowski, Daniel Tjongarero, Niko Bessinger and many others, who had stayed inside the country, had organized everything, particularly accommodation and transport on our arrival. Thus we were well received and transport was ready to take us to our places. As we were driving to the city, I noticed writing on the tarmac, which read 'Welcome to DTA land.'

I can't describe what I felt. Maybe due to the fact that I was always travelling to different countries I was not overly excited; it felt like the usual journey to another country. Both my grandmother and my mother were dead and I had that void in my heart, but I was happy and pleasantly surprised to see my older mother (my aunt), who was 80 years old, had come all the way from Fransfontein specifically to welcome me. Only then did I feel welcome; I felt that, after all, I had a family to receive me home. This old mother was the second born of my grandmother's four children, with my mother being the last born. Tears come to my eyes as I write about that encounter.

The next day we left for Fransfontein. I had to go and greet my ancestors, which meant that I had to be taken to the cemetery early in the morning. First I had to greet my mother and grandmother and then

my elder brother. He was the one I looked up to, who used to carry me to school when I was small. He too, as well as other close relatives, had died during the many years I was in exile. After the greetings, a goat was slaughtered; I was washed in a specially prepared herbal bath; and some other traditional rituals were performed. I was officially welcomed. This reception made me feel that I had finally arrived home at last.

Before coming back to Windhoek, I took a trip down memory lane, and walked through the village. I visited the people I had known, particularly the old people, and everybody who knew me was as excited to see me as I was to see them. Many of the old folks had passed on, and there were new people in the village whom I didn't know. I also went around to our childhood hangouts. At first, I was disappointed to realize that the Mopane trees I thought were so high and big seemed short and rickety and, coming from Angola with its tall tropical trees, I was surprised to see that.

When we were children we had climbed up a rocky outcrop where a big bird, I think it was maybe an eagle, used to bring hares to her young. We wanted to steal the hares from the bird. I get goose pimples when I think of what could have happened if the eagle had found us there. We could certainly have fallen off the rock or maybe even jumped off it. I think the Almighty protects innocent children! On my return, I couldn't see that rocky outcrop as I remembered it; something seemed to be missing. My sister told me that one large part of the rock had fallen off. I didn't believe her because there were no earthquakes in Namibia to cause the rock to break off but I didn't want to disappoint her, so I just kept quiet.

I was happy to see that the fountain was still flowing and the gardens were still there, albeit in a poor state. The old people who worked hard in their gardens had all passed on and the youngsters had neglected the gardens. There was hardly any sign of wheat, but it was winter so maybe that explained it. I also went to look for the cave where we used to play hide and seek but I couldn't see it through the undergrowth. This time around I was scared and decided that even if I found the cave I was not going to enter it.

In general, I found an old and poorly maintained village. The young people had left and the houses were not well maintained. The church was dilapidated, dirty, and in need of work. I left the village with some

sadness about the state of disrepair. I made a decision that one day I would repair the church if and when I got some money; I would pay homage to my ancestors and the *oumas* who brought me up and honour their memories by renovating the church where we children had so much fun counting their teeth.

I kept that promise and when I got the 25 per cent from my pension after ten years in Government service, I rebuilt the church. I donated an old piano and a keyboard and I pay the woman who cleans the church. She keeps it really clean and today the church is the pride of Fransfontein.

The 1989 Elections

I returned to Windhoek after my visit to Fransfontein and started work. I was assigned to look after the health of our 'returnees' as we were known, and I was informed that some preparations had been made in Katutura Hospital and that wards had been reserved to receive any patients arriving from exile who might be sick and need treatment, and for any malnourished children. Nobody was admitted there on arrival. Our children jumped off the plane; they were healthy; and there were no malnourished children. So the empty wards stayed empty at Katutura Hospital.

I set up a clinic in the SWAPO office and continued what I had been doing in the centres in Zambia and Angola, namely treating our sick people. The local health fraternity welcomed me and we started bridging courses to integrate the nurses who came back from exile. I worked with Ena Barlow, whom I respected very much. She was forward-looking and very understanding. I found her in the Health Department when I became Minister of Health and Social Services some years later and we worked together again. We soon got our nurses registered and they worked alongside the local nurses. I was happy that this included my trainees from the Morenga Enrolled Nursing School.

Election Campaign

I recall how exciting the whole experience of adapting to Namibia again and working in my motherland was. On the other hand, politics were boiling over. Rallies were held in the months leading up to the elections for a Constituent Assembly in November 1989. The SWAPO rallies were jam-packed, particularly when we went to the northern part of our country. The atmosphere was always electric; support for SWAPO was overwhelming, assuring us of an imminent victory.

I was assigned to campaign in the Okakarara area, in the east-central part of Namibia. It was Hereroland and a stronghold of the opposition

parties, the Democratic Turnhalle Alliance (DTA) and the South West Africa National Union (SWANU), so I had a hard time. However, I was Herero-speaking and had ancestral connections there, so it was a little easier than it might have been for others. My grandmother was kidnapped from that area and I had relatives in Okamatapati, not far from Okakarara, who knew me before I went abroad and were pleased to see me back – people like Mitiri Mureko, Vihajo and Salatiel Tjakuva were there. I was received well but I don't think I persuaded the people there to vote for SWAPO. Nevertheless, despite the political inclinations of the people, I encountered no violence, animosity or disrespect from the people in the Okakarara region. I was listened to politely but there was an engrained anti-SWAPO sentiment. The opposition parties were tribally based. Most Hereros belonged to one or other of these parties and referred to SWAPO as an Owambo party. After listening to me they would say, 'We hear what you are saying but we are waiting for our own leaders.' I realized that we, SWAPO, had very little or no support in that region. Of course, the propaganda machine of the DTA supported by the South African apartheid regime was very active and we were portrayed as man-eaters; but my team soldiered on.

The farmers, particularly those of German origin, were a different story; they were very hostile. Their farm workers were warned not to attend our meetings and told they would be observed on television when they were voting and it could be seen for whom they had voted. Some German farms were literally no-go areas. In fact some farmers prevented SWAPO people from entering their farms. One day I was with Comrade Otniel Kazombiaze. We went to talk to the workers of De La Bat tourist camp at the Waterberg Plateau. This camp was run by some young, arrogant, white men and I was told they were former South African army soldiers, now in Nature Conservation uniforms. We were threatened and chased away by those young Afrikaner boys. Those who were running that camp were spitting hatred when they spoke to us. I was convinced that, if it had not been for the presence of the United Nations Transitional Assistance Group (UNTAG), such virulent racists could have killed us.

The 1989 elections took place under the supervision and control of UNTAG but the physical control was still in the hands of the police who reported to the South African Administrator General. By nature and

political leaning, he was opposed to Namibian independence and the whole concept of majority rule and one person, one vote. No wonder some issues threatened to derail the process both of the election as well as the final independence of our country. Those were difficult and dangerous days.

Finally 'D-day' came on 7 November 1989. The rallies ended and we stood in long queues from the early morning and voted. It was an overwhelming feeling to be back home and voting as a black person. I was so proud and thankful to the Almighty who had protected me during the many years of the struggle; thankful that I was still alive and standing in the queue to vote. Everything went smoothly and people voted from 7 to 11 November. There was no tension or fighting; people stood quietly awaiting their turn.

The Results

I remember that Tuesday night of the results vividly. They started trickling in around 9PM. First came the results from small towns in the south of the country, where the DTA was victorious. I had no idea of the size of such towns as Koes, Warmbad, Aus and Stampriet. During those first results, the members of the DTA went crazy. In the townships they were insulting SWAPO, using foul language, saying that we would eat our flag and many bad words I can't repeat. I was very discouraged but deep inside me something was telling me otherwise. Sometime in the middle of the night they stopped making announcements. At 2AM I knelt down, took my mother's photo and prayed, 'Mother, wake up from wherever you are slumbering; I am home, I couldn't even bury you. Wake up and prevent disaster. Please don't allow those of us who fought for this country with everything we have, to lose.' Then I went to sleep.

We lived in a house in Mission Road (recently renamed Dr Kwame Nkrumah Avenue), in what is now the upmarket suburb of Ludwigsdorf, in the east of Windhoek. That whole Tuesday, the white neighbourhood children were teasing us, cycling around and waving DTA flags. DTA members threatened us, using obscene language that blared out from loud speakers in their cars. Katutura was ablaze with DTA flags and the noise from their cars was deafening. It was loud speakers all over, insulting SWAPO. Looking back now, I'm surprised they thought they

would win, knowing that those towns where they had won were very small and wouldn't be enough to change the overall pattern of voting.

The BBC Africa Service woke me up at 6AM with the announcement that when the final results were announced, 'The giants of the north will change the whole results in SWAPO's favour.' Let me take this opportunity to thank the BBC Africa Service of that time, to which many of us in exile listened constantly during the struggle. There was a Ghanaian announcer who spoke beautiful English, with a lovely deep voice; I think his name was Kwame Mensah. The BBC was our lifeline when it came to news every morning in exile. I hope those announcers are still alive.

That announcement boosted my morale. I got up, dressed to kill in a red dress, and went to the office. When I left the house, my neighbours had all but disappeared; their houses were locked and there were no children playing outside. I realized then and there that SWAPO had won, but there was still no announcement. Rumours started at the office but I ignored them and waited patiently for the final announcement, which came around 8AM when UNTAG cars drove past our office with blaring horns. I knew then that my mother had woken up from her slumber. Windhoek burst open, cars honked, people came into the city, running from Katutura to the centre of the town, and it was just euphoria. SWAPO had won, with a substantial majority.

In the process leading up to the elections, 701,483 people had registered; 680,788 cast their votes, equating to a voter turnout of 97 per cent. SWAPO took 57.33 per cent of the votes and 41 seats in the Constituent Assembly. I was one of those seat-holders. The DTA received 28.55 per cent of the votes and 21 seats in the Assembly.

The Constituent Assembly met between November 1989 and February 1990. The atmosphere was exciting and friendly. Most of us knew each other, and many had either been classmates at Augustineum or had studied together in exile. The main task of the Constituent Assembly was to draft and adopt a Constitution, which would allow the country to proceed to Independence. All political parties took part, and all presented their respective drafts. After perusing them it became clear that SWAPO's draft constitution was better developed; therefore all parties agreed that it should be used as the draft on which to base the final Constitution, after discussion and amendment of all issues.

The next step was to appoint a Drafting Committee from the members of the Assembly. The Chairperson of the Constituent Assembly, Hage Geingob, became Chairperson of the Drafting Committee, which had to report to the full Assembly on all points agreed to and any that remained contentious.

Some issues were easily agreed to, such as the name of our country – Namibia – and the territory that comprises our country. Others were difficult and took time and perseverance to conclude. One major issue was the nature of the executive branch of government – whether to have an executive president or a ceremonial president – and also whether to have a single chamber or a bicameral parliament. Another was what to do with existing civil servants and how to bring in those who had been excluded from the civil service by apartheid laws.

The Constituent Assembly did a marvellous job in drafting and adopting a modern constitution that is recognized as one of the best in the world. It clearly guarantees fundamental human rights and the separation of the three branches of the state – legislative, executive and judicial. It decided on an executive president and a bicameral parliament (the National Assembly and National Council). The then civil servants were given security of tenure but it was decided that the public service should be restructured and an affirmative action policy introduced to allow previously disadvantaged people into jobs and higher positions in government. Dr Nickey Iyambo and I were pleased to note that the health chapter we had worked on during the struggle was made part of the Constitution.

Once the drafting was complete, the Constitution had to be adopted by the full Constituent Assembly. All parties were brought on board and this was achieved. The Namibian Constitution was then formally adopted on 9 February 1990. This date is now commemorated each year as Constitution Day.

The major question that remained was what was to become of the Constituent Assembly. Should it be disbanded and new elections held for a National Assembly, or what? The people had already elected their representatives to draft the constitution. There were other practical considerations too. February is a rainy month, and how would we be able to conduct elections again in places like Kavango and Caprivi where the rainfall is high and floods are common? Another election and all

that entailed would have delayed the movement to independence. How could we Namibians tolerate the South African Administrator General Luis Pienaar sitting in 'South West Africa House' and still being in charge? Luckily wisdom and patriotism prevailed, and the Constituent Assembly became the National Assembly and the date of 21 March 1990 was set as the date for Namibia's Independence. After all the euphoria and celebrations, the task at hand was for the SWAPO Party to set in motion the new Government and structures.

One white woman told me later, after Independence, that she had bought out a shop with groceries, fearing a killing spree, and how on the day of Independence she locked herself in her house. However, her husband was out and about and told her to come out to see and enjoy the wonderful atmosphere. Indeed it was very peaceful. During the struggle we had decided that there would be no reproaches or reprisals. We announced a policy of national reconciliation and we have never negated that principle. Since Independence in 1990, Namibia has remained one of the most peaceful countries on the African continent.

A Minister in Waiting

I had been responsible for the health of our people throughout the liberation struggle and I assumed that if I were to be considered for any Government post after Independence, it would be the Health portfolio. I was wrong. I was surprised to be appointed Minister of Local Government and Housing designate. I was very upset about this, because I had no clue about that portfolio and felt I had been cheated. It took five days and a lot of persuasion for me to accept the post. I did so out of respect for President Nujoma, who had trust in me throughout the revolution and in my ability to perform well whenever I was given a task; and also because of my entrenched party discipline. In fact, Comrade Moses Garoeb persuaded me to accept the post by telling me that President Nujoma had decided he would wait for me because he didn't have anybody else who would be able to deal with the myriad of problems in that Ministry, such as many squatters, the lack of housing, etc. Then I thought who was I to let the President wait, and I accepted the post.

I then went to Rundu to visit a Brazilian friend who had been in Luanda during the struggle. Whenever I was able to go to Luanda from the centres, we used to go jogging along the beach together in the morning and buy fresh fish from the fishermen when the boats come in. She had been transferred to Namibia as part of UNTAG to supervise the election and I went to cry on her shoulders. One evening while I was there, we met a South African soldier staying in the same accommodation. He was upset and told us how he felt cheated by his superiors. He explained that after the ordinary soldiers had been sent into the war to kill and destroy the property of people, their superiors were now wining and dining with SWAPO and were ready to hand over the land to them. He was haunted by the eyes of an old man whose *mahangu* fields they had destroyed and he was particularly upset with Roelof 'Pik' Botha, then the Foreign Minister of South Africa, who had

been part of the team negotiating the implementation of the UN Plan that would lead to Namibian Independence.

That visit restored my confidence and I recovered from my disappointment. I came back to Windhoek with heightened morale. I decided to show those who had campaigned against me getting the Health portfolio, claiming that it would be too easy for me, and vowed that I would make this new Ministry a success.

Before Independence, there were municipalities yes, but no department specifically dealing with Housing and Local Government. Moreover, housing was in a crisis, and the need was huge. There were squatters everywhere, in the riverbeds and the graveyards. Municipalities were responsible for the provision of housing in the townships. The people who lived in those houses were renting from the municipalities and paying rent for many years with no possibility of owning them.

Fact-Finding Mission

I decided to visit neighbouring countries to learn what they were doing with their local governments and see how they were tackling their housing problems.

I started with a visit to Botswana, our immediate neighbour. In 1989 there was nothing to write home about there; Gaborone looked like a big village. It seemed to me that Botswana was also just beginning to wake up to the idea of improving housing, so I didn't learn much there. However, I found a Chinese building company which had started to build houses in Gaborone, which I later recruited to come to Namibia.

I also came across a Sri Lankan man in Botswana, Mr Lalif, who was working for a British charity. He told me about a programme in his country through which people got together and built houses. I invited him to come to Namibia and brief us about the programme. I also remembered that my mother and some of her friends used to have a programme where they saved money together and rotated the savings so that they could buy things such as furniture, which they could never have afforded to buy as individuals. The Sri Lankan Build-Together Programme reminded me of that system. I told Lalif my predicament and he promised to come to Namibia to assist in setting up a similar programme.

I then proceeded to Zimbabwe and was received by Dr Makuto, my former classmate from the London School of Hygiene and Tropical Medicine. I stayed with his family for a week in Harare. He took me around the city and introduced me to many people, particularly those in government who were dealing with local government. I was also taken to meet two nurses, Grace Mushonga and Ms Sithole, whom I had known during my refugee days and who used to attend WHO meetings in Geneva. We went round Harare, a very beautiful and clean city in those days, well organized with lovely eating places served by very professional, polite, waiters. The food was divine – good meat and well-prepared vegetables. I picked up a lot of ideas about how to organize local government. I also decided that in Namibia we should avoid having disabled and blind people hanging around the streets begging. In Harare I found many blind and disabled people singing and begging at street corners, and I decided that we should make financial provision in a form of grants for such people in Namibia.

I met many friends from our refugee days, for example Dr Herbert Ushewokunze, with whom I had shared the platform at WHO meetings in Geneva and in Brazzaville. One evening during my stay in Harare, he invited me to his house and introduced his new young wife, a beautiful woman who treated me with great respect. He made a party for me at his house and we ate very tasty traditional dishes and had a wonderful time.

Doctor Ushewokunze became the first Minister of Health of independent Zimbabwe in 1980. We used to meet as refugees at the meetings of the WHO and of the United Nations High Commissioner for Refugees (UNCHR). At one such meeting, a speaker referred to 'the hapless refugees', meaning that we were unlucky people in need of help and sympathy. Dr Ushewokunze asked me to speak on our behalf and explain to the assembly that we were looking after ourselves as refugees and running our own services. Before I could speak the Chairman came over to us and explained that it was important for us to explain the difficulties our refugees were facing. So when my time came to speak I thanked the UNHCR for the great efforts they were putting in to support us, but I dropped the original speech I was planning to give and told them we were looking after freedom fighters and were not useless refugees.

After Harare, my next stop was Nairobi. I like this big city with a vibrancy you can feel in the air. I paid a courtesy call to the United Nations Development Programme (UNDP) office and met a wonderful woman there. I also spent some time at the head office of the United Nations Human Settlement Programme (UN-HABITAT) and was met by people who were excited to meet a Namibian. In contrast to 1969, when I had arrived in Nairobi three days after the assassination of Tom Mboya, this time Nairobi was very calm and business like. Now, after 20 years, it was Pamela, the beautiful widow of Tom Mboya, who received me in her office at UNDP.

Coming from small Windhoek, the sheer size of Nairobi was overwhelming. I visited all building sites in the city and the new buildings in the townships. I was also given a thorough briefing on how their local government worked. I was very impressed with what I saw in Kenya. I found Kenyan women to be vibrant, innovative, hardworking and self-reliant go-getters. There were many programmes the women had initiated without government assistance. I was also amazed by the traffic, the noisy, colourfully painted *matatus*, and the buses, jostling for customers. I was taken to the biggest squatter settlement in Nairobi, which frightened me. I wondered how an ambulance would manage to collect a sick person in that very densely populated place.

I knew I had to go back and deal with the problem of squatters in Namibia, but not on the scale I saw in Nairobi. Seeing their problems gave me the idea of how to resettle squatters in Windhoek and avoid overcrowding. I also visited a children's centre where they told me that they had never seen a Minister before. I left Nairobi with lots of ideas on how to tackle some of the housing problems in Namibia. The new housing units they were building impressed me in particular but the squatter problems frightened and worried me.

From Nairobi I went on to Abidjan, capital of the Ivory Coast in West Africa. I wanted to see the system in Francophone Africa, how they organized their local government affairs, and their housing projects. I also went to Yamoussoukro and visited the Basilica there. Abidjan was a beautiful city. It was the fashion capital in Africa and since I like beautiful clothes I was blown over by the fashions the women in Abidjan were wearing. However, my visit did not bear fruit. I didn't see anything to take home with me for my work, since their style of

buildings wouldn't fit into our environment. Ivory Coast is a tropical country, and their style of housing is very different from ours. Also there is great French influence and the people behave like the French.

Fortunately I could understand French, so I had no problem with the language. I had learned it during the struggle when I was awarded a scholarship in 1980 by the WHO Regional Office and attended the Vichy Language School for three months. Vichy is an academic town in the centre of France. After completing intensive classes there for eight hours a day, I discovered that I had totally lost the use of other foreign languages I knew. I finished the course and went to Sweden on my way back to Angola, and I was dumbfounded and shocked to find that, try as I might, I couldn't speak Swedish at the airport in Stockholm – every word I tried came out in French! I was concerned and thought I had gone crazy. It took me three days to return to normality and to speak other languages. Since that intensive language class I used to go to France every holiday for three weeks to take classes and improve my French. It's a beautiful language, rather difficult when reading because it has many silent consonants. Now I've lost some of it due to lack of practice but I would like to take it up again.

When I visited Abidjan in 1990, I was still thinking like a refugee from the camps and I was oblivious of the overbearing Francophone sense of protocol. I caused the driver I was given by the Government of the Ivory Coast lots of chagrin. I wasn't used to ministerial protocol, so as soon as we arrived at our destination, before the driver came round to open my door, I had gotten out of the car. The driver explained to me that it was his duty to open the door for me, and that when we stopped I should wait for him to do so. I forgot how prim and proper the French style of etiquette is.

I asked the driver to take me to their squatter settlements but he was afraid to do so. He told me that we couldn't go there without police escort. It was inconceivable for him to take a Minister-in-waiting to a squatter camp, so I saw nothing of their squatter areas although I'm sure there are some.

Though I didn't see any squatter settlements, I met Ernest Anjovi, who was living in Windhoek as a representative of the Ivory Coast, but who was on a visit home at the same time as I was there. I had been interviewed on the local TV when I arrived in Abidjan and this man saw

me on the TV, and through that he was able to contact me. I was stealthily window shopping from my car window, and I noticed how well dressed the women were in Abidjan, so when I met Mr Anjovi, I asked him to take me somewhere I could have a dress made for Independence Day. He took me round Abidjan with a lady friend, and we bought material, found a tailor and I had my dress made. Thus I was able to be very smart in a beautiful dress on that very special day, 21 March 1990, when Namibia finally gained her independence.

Ernest Anjovi and I later worked together to organize the Miss Katutura beauty pageant in Namibia (in 1995). It was held in one of the halls in the township and Esi Schimming-Chase won the Miss Katutura title. It was a wonderful event, and many young girls took part, but soon afterwards, some jealous people accused me of racism, saying I had excluded coloured girls from Khomasdal. Most beauty pageants then were still organized, judged and won by whites and there was a lot of racism still. I felt the criticism was really because we were doing something for black Namibians. Ernest was very disappointed and left Namibia because of the undercurrent of hostility and jealousy. He moved to South Africa where he started a very successful music award programme, the 'Cora awards'. Namibia lost out and the Miss Katutura pageant died. Today the winner of that Miss Katutura title is a very confident woman who has become a prominent lawyer and an Acting Judge. I think she succeeded in part because of her exposure and her experience during the pageant. Many of the girls who win these pageants later become very successful.

Return from my Visits

After the visit to Ivory Coast, I came back home enriched, full of energy and with high adrenaline levels to start my work with new initiatives and enthusiasm. I was struck by how poor the black people were in Namibia. In our refugee settlements, we had no crime, no theft and were like a big family. We didn't have a habit of 'autere' (the Nama word for 'give me') but back in Namibia I noticed that families and total strangers would write letters asking for money or other things. As was my habit in the struggle, I would leave some hand cream or a pair of stockings in my drawer in the office in case I needed to change, but I noticed that things would disappear.

Independence Day 21 March 1990

We became immersed in preparations for the independence celebrations, and on 21 March 1990, the colonial flag came down forever. Strangely, I don't remember much about my feelings on that day; I was so excited and euphoric. My dress from the Ivory Coast was beautiful. It had puffy sleeves ,which Namibians referred to as Libertina's sleeves, and it was tight at the bottom as was the fashion then. I had to be helped up the steep stairs in the VIP stand! Since we did not yet have our own guard of honour, the President of Zambia brought his guard of honour to help out. It was a very beautiful ceremony. Many Heads of State and Heads of Government of Africa were present. The Secretary General of the United Nations, Javier Perez de Cuellar, swore in a beaming Sam Nujoma as the first President of Namibia. It was very emotional when the South African flag was lowered and the Namibian flag was hoisted. I watched the expression on President Nujoma's face and noticed he had a special smile, not his usual wide open smile; this one was different. I wondered what was going on in his mind. Before the 21 March we were stateless, but now we were Namibians. We were an independent nation. That's what I was thinking! I don't think any Namibians slept that night; celebrations went on until the next day, particularly in the townships, but it was very peaceful.

Squatters and Street Children

After the celebrations, the real work started. I was now officially appointed the Minister of Local Government and Housing and my Deputy Minister was Comrade Jerry Ekandjo, a veteran of the notorious Robben Island prison during the struggle. There were many Namibians incarcerated in Robben Island and Jerry Ekandjo was amongst them. We hit it off very well right at the beginning and worked well together. The Permanent Secretary was an elderly man and his deputy was a brilliant and beautiful young woman, Naveuje Munashimwe, whom I knew from the struggle. In my opinion that woman should have been made the Permanent Secretary, but in those early days women were not trusted that much, so the men had to lead whether they were able and capable or not. Unfortunately, Naveuje died in a car accident before the end of her second year in office. It was very painful and tragic. I felt her loss in the office for a very long time.

The other appointment was that of the Director of Housing, a quiet but intelligent man, soft-hearted I would say. The British Housing Association seconded Mr Lalif from Sri Lanka to our Housing Directorate to assist us in starting a Build-Together Programme. We appointed a team under the Housing Director to work directly with this programme and I made sure to include women both in the Build-Together Programme and as directors in the Ministry itself.

Squatters

At Independence Windhoek was full of squatters. Some were living in the riverbeds, some slept inside the cemetery, on the gravestones; and others lived under bridges. It was a very painful situation, but having seen the situation in Nairobi, I was confident that we could manage things in Windhoek.

The first thing my deputy and I did was to visit the squatters to see who they were and how big the problem was. We went to the dump site

in Windhoek and met some women who had put white powder on their faces. When we asked them where they got the powder from, they told us it was from the hospital garbage. I was horrified; it could have been something poisonous. We also found some men collecting wires from the dump, and one woman who employed the men to collect copper wire for her. We confronted her about the unhealthy conditions under which these people were living.

When I came home I didn't sleep, thinking and worrying about what I had seen. Next day I phoned my former employer Joe Koep, who was now living in Cape Town, for advice, and told him about the need to move the people. He suggested we find tents and temporary houses for them, as we had done during the struggle. With my experience of the refugee camps where most people lived in makeshift houses consisting of tents and huts, and also following the advice I was given, I was confident that it would work. I decided to house the squatters in tents which I organized from TransNamib.

I got serviced land from the National Housing Enterprise (NHE) and also from the Windhoek Municipality. Before moving the people or even talking to them about our intention to move them, I remembered my philosophy of Plan A and Plan B. Plan A was to persuade the people to move and Plan B was to create facilities for them, because if they agreed to move, we should already have prepared somewhere to take them. I started to build flush toilets and a standby pipe at each plot. I was laughed at for building toilets and not houses but, being a Public Health graduate, I wanted the people to lead healthy lives in which they would at least have clean drinking water and proper sanitation, regardless of whether they slept in tents or houses. Only when that was ready, did we talk to the squatters in earnest.

Namibia, and indeed Southern Africa as a whole, has a history of forced removals – a very ugly history – and we didn't want to use force to move people if they were unwilling to go. That's why we first organized places for each family and they were told to bring whatever they had to put on their plot. However, I established a rapport with the squatters because I spoke to them in the language they understood, as I am fluent in most Namibian languages. We talked to them carefully and secretly, asking them if they were willing to move if we could find places for them, where they would have clean water and flush toilets, and

where they could take their zinc sheeting or other building materials. We would provide them with tents to start off with, and later on build houses on their plots. However, this promise to build houses for them gave me nightmares, because I had no idea where to get the money from to build such houses quickly. If I failed in that promise I would be in trouble and my reputation would be tarnished. But I had faith that I could pull this off. I have never failed in giving what I've promised. I will go to the top of the mountain to get it. In my vocabulary the word 'fail' doesn't exist.

We soon saw that there was somebody driving around in a red Volkswagen, encouraging the squatters not to move. We discovered that this car belonged to a woman who, it was alleged, received money from an organization that supported her in a programme she ran for squatters. The squatters told us that she was urging them not move. If they did so, she would lose the donor support.

After walking many kilometres in the riverbeds and graveyards, and after many hours of secret discussions, we managed to convince the squatters. They agreed to move and we started our secret (or what Americans call a 'covert') operation. We had to be cautious, careful, and very discreet if we were to succeed. This is because Windhoek is a small city and if the story got out, there would have been lots of negative rumours that would have spoiled our carefully crafted programme. There was only one newsman who noticed our movements in the squatter areas, but he missed the mark because he only took my picture and wrote about me walking in my high heels in the riverbeds and graveyards. He didn't know what I was looking for. That journalist was the late Smitie (Hannes Smit, founder and editor of the *Windhoek Observer*).

We approached the Windhoek Municipality for transport; they assigned trucks and drivers, and we informed the squatters of the intended date and time for the move. On the day, the trucks came but parked far away, fearing possible riots or stone throwing, but our secret diplomacy had paid off. The squatters climbed onto the trucks, singing happily, and moved to their new place. When Windhoek woke up to reality, we had long finished the operation to move the people. They were moved to a new township which gained the name 'Tent City' because they were living in tents.

About six months after they moved, I got a lucky break from a French NGO, CRIAA, who provided finance that enabled us to build proper houses for the former squatters. Today the township has changed its name from 'Tent City' to Okuryangava. There is also a clinic there. I couldn't believe my luck. Maybe when one really wants something, the Lord answers your prayer. There is a saying in the Bible: 'Ask and it shall be given.' Today 'Tent City' has altogether disappeared.

Street Children

The next urgent problem was that of the street children. Windhoek was full of them. They lived in storm drains or under the bridges, sniffing clue, smoking dagga (marijuana), grabbing handbags from women, and begging on the street. They would hang around in front of the hotels, to the annoyance of hotel owners and their guests. They were armed with knives and out of control. People were afraid of them. I remembered the family health debacle in Nyango where I had embarked on a project without the baseline knowledge, and decided to do a survey first to answer the questions why, when and who. From the survey, we found that the children were between the ages of 7 to 18, with one 20-year-old boy. We also found that 95 per cent had at least one parent, mostly a mother at home. They were all boys. None of them attended school or, if they did, they dropped out of school early and hung around the streets. Where there were both parents it was a dysfunctional family; either alcohol was involved or both parents were unemployed and didn't look after their children.

That information was crucial to start the programme. I found two volunteers, a young woman and a young man, who risked their lives to work with these children, and an NGO donated a car for the programme. The first thing was to gain the children's trust and that was left to me. I approached them by being a mother to them, speaking in the languages they knew. After that, we got a place where they could come to eat. The local hotels were happy enough to give us meals for the children, maybe not out of kindness, but rather because it would remove the eyesore from their premises, where the children used to beg, and also from their parking lots, and would prevent the tourists being harassed. The two volunteers kept the children busy with new activities. First we fed

them, and after the meals they had classes, learning the alphabet, and to read and count. There were also some games and sports activities. Some were illiterate but others could read. They had lessons in elementary English. Since many were school dropouts we had to interest them in school activities but they very quickly accepted us and trust was built between them and the volunteers. I then approached the local schools, and within one year of the start of the programme we sent 80 per cent of the children back to school. Here I want to thank those schools who took the children back without them having to pay school fees as long as the programme bought them uniforms.

This programme was extended to two other towns – Rundu in the north and Keetmanshoop in the south – but it was not as successful in either of these towns as it was in Windhoek. Perhaps the volunteers were not as committed as the ones in Windhoek, where I kept a close eye on the programme. The mothers of the children were approached and given training in some handiwork and some were given jobs. I took one mother to work for me in order to help her look after her nine children, who were living with her in a zinc house in someone's backyard. The programme was a success. One of these nine children later became a priest, whilst another graduated from the University of Namibia. People may dismiss this success as nothing to write home about but to me, when I think of where these children came from, it was a huge achievement. At least the life of some children had been changed forever and street children became a rare sight.

During the survey, we discovered that the children in Katutura had nowhere to play; their mothers went to work and locked up the houses for safety, and the children were left to their own devices. They often played truant from school and mixed with the wrong crowd, starting to smoke dagga and sniff glue on the streets. Most parents didn't know that the children were playing truant and thought their kids were in school. I remember that when I was young we would abandon school and go snake hunting if we come across a snake track, although we must have actually gone in the opposite direction to the snakes because we never found them. All children play truant at some time, and it depends on what they do with the time they are out of school whether or not they get into more trouble.

After-School Centre

In order to keep children off the streets, I decided to build an after-school centre between Khomasdal and Katutura. I deliberately chose that spot between the two townships so that all children could benefit. I designed the centre myself and the building is standing to this day; I left the original drawing design on the wall there. The idea was to give children a place to play after school where they could do their homework with the assistance of volunteer teachers. When the building was completed, I recruited two Chinese gymnasts to train the children in gymnastics. The volunteer teachers came to give afternoon classes and help the children with their homework. We also created sports facilities – football, netball and a running track. This centre belonged to all children from Khomasdal and Katutura and not only to the original street children. In that way, we removed the children from unsafe streets and gave them a place to play safely while their parents were at work. Comrade Jackson Kaujeua also gave music classes to the children. He was a very gifted folksinger and guitarist, who kept our morale up during the struggle with his freedom songs. Sadly he died in May 2010.

The after-school centre is still functioning today. Windhoek has maybe forgotten that once upon a time, it was swamped with street children but that is now a rare sight. The police have to deal with criminals and drug addicts, not street children.

Urban Renewal

Katutura Facelift

I found that, as Minister, I was required to approve the projects the municipalities were embarking on, so I used that privilege and decided that Katutura needed a serious facelift, and urgently. I told the Windhoek Municipality that I wouldn't approve any request for improvement in the city until Katutura was taken care of. Katutura was a dustbowl and tuberculosis was rampant there. The housing shortage was huge and nothing had been done to improve the condition of the people. There had been housing projects in the 1950s and from 1959 on people had been forcibly moved into matchbox houses there. However, in Katutura and other townships, no new housing projects had been undertaken for 30 years or so.

Katutura needed a facelift and the first task was to tar the dusty streets and provide streetlights. Some of our white brothers had a serious lack of knowledge of their own countrymen and women who are black. When I mentioned the need to provide streetlights for the dark streets of Katutura, they expressed their fears that the black people would vandalize the lights, by throwing stones and breaking the bulbs. Therefore it was suggested that it would be better to install high mass lights that would be too high to be damaged by stones. I replied that anyone who attempted to throw stones at the street lights must be crazy and I hadn't seen crazy people on the streets of Katutura. I can't imagine grown men spending time throwing stones at the bulbs and the children couldn't reach that high. Therefore, I argued, normal street lights should be installed. The township would look nice with normal street lights and people living there would appreciate it. I was imagining living under those large, extremely bright high mass lights, as if Katutura was a huge prison. How would the residents ever sleep?

I didn't create a scene since I knew that these demeaning ideas were the result of the apartheid system that had dehumanized black people

in the eyes of the whites, who have built a picture of blacks as savages, not to be trusted with anything normal, but today white people walk around in Katutura with no problem. I explained my objection to the high mass lights and told them that after the facelift, Katutura's main street would be an extension of Independence Avenue and should have the same street lights throughout.

The work of tarring the streets started in earnest. I sat on the tractor to launch the programme, wearing my high-heeled shoes (this was noticed by one of the newsmen). The work progressed very well and was completed after a few months. There were lots of complaints from taxi drivers who had to drop their customers far away because of the temporary closure of some streets. One business woman was very vocal, moaning that she was losing customers owing to the street closures, and she even suggested that the work be stopped. But I quickly learned that humans like complaining, particularly Namibians who like to complain about anything you do, but once the project is completed, they are very happy. On 'D-day' in 1992, when work had finished, I invited the whole Government and all the members of the diplomatic corps to see the beautiful refurbished township. The police brass band entertained the guests, speeches were delivered, and it was an unforgettable day for me. Each Minister, the Mayor of Windhoek, and members of the diplomatic corps, planted trees all along the Katutura's Independence Avenue. I planted my palm tree in the middle of the roundabout. It's big now and I see it every time I drive to Katutura. The other trees, although still there, show they are not taken care of; some have died while others are not growing as they should. That is the Katutura we see today, which is a beautiful place with lot of businesses. In fact you don't need to go to the city for shopping, everything is now available in Katutura.

Communal Towns

There were big towns in the communal areas that also needed to be developed and for that they first needed to be proclaimed as towns, which was a daunting task. The process of proclaiming a town could take about two years, I was told. Since these towns were built without much planning, there were homesteads dotted amongst the town houses, so we had to draw the town land from scratch. Completely new town planning had to be undertaken if we were to have properly planned

towns. The homesteads had to be moved out, and for that to happen, people had to be given alternative land and places to be resettled and paid compensation. I failed to understand why the process to proclaim a town was so protracted; there seemed to be a deliberate process of go slow. However, we were able to cut out lots of unnecessary red tape and shorten the process of proclamation to six months. During my time as a Minister of Local Government and Housing, most of today's towns in the communal areas were proclaimed and built as towns. People moved out of their homesteads and these towns benefited from big housing projects that followed, such as the Build-Together Programme, and today they are important business hubs.

The Horseshoe Market

My next target was the street vendors. Immediately after Independence there was a horde of vendors, many from outside Namibia, who sat cross-legged on the pavements of what had been known as Kaiser Street, since renamed Independence Avenue, selling their goods, including food. This created unhygienic conditions, particularly with regard to selling food, and made it difficult for people to walk on the pavement. I had seen that behaviour in countries where I lived during the struggle and had vowed that in my country I would make sure markets were clean. Although I had no idea what my position would be in the future I knew that as a doctor that I would play a role in the health sector and would want to clean up the mess in the markets.

Many African countries I've visited have open markets that are disorganized and unhygienic. However, as disorganized as such markets may seem to me, they do create jobs. Nobody talked to me about unemployment in those countries as we hear of it in Namibia. In West and East Africa, the markets provide income for many families and the women are the ones who use them, creating jobs and putting food on the table. This is not the case in Southern Africa, particularly here in Namibia, where alcohol or the culture of shebeens (bars) plays a major role as home-based business. I never saw that in West Africa. Market vendors in other African countries sell everything but alcohol. In Katima Mulilo, in Caprivi, I've noticed that they are selling food, as they do at other border towns. Perhaps the culture in Zambia has an influence on the markets in Katima.

As Minister of Local Government, markets fell under me. I had no idea at first that there were no markets in Namibia but I was happy that I could start with a clean slate. I was ready to execute my dream of a clean Namibia. I wanted to give people in Windhoek a clean, well-designed market. Plan A was to build a market; Plan B was to move the vendors there. I wanted this market to have easy access and a community spirit. The other consideration was that I wanted people to be close to one another. I quietly designed a market and drew up a plan, which I gave to the architect; it was shaped liked a horseshoe. I had an unusual silver ring in a horseshoe shape, which I loved (I bought it in Denmark in 1973). It gave me the idea of closeness and I thought that in a market shaped like that, people could enjoy each other's company and not spread out, which would happen if the stalls were built in a straight line. Municipal services would also be more affordable because the space required would be smaller. The design had two rows of rooms and electricity, with two plugs in each room, so that vendors could have fridges to keep their food fresh.

Once the market was ready in 1993, I went on national television and gave street vendors one month's ultimatum to move to the Horseshoe Market so they could conduct their business in a clean environment, or face being evicted from the streets by the municipality. I was criticised for denying people their bread, by moving them off the streets, but I replied that if they wanted a messy town with unhygienic condition, they must appoint another Minister. As long as I was there, Windhoek would not be a dirty African town. Some people were critical saying that, 'Windhoek does not have the character of an African town.' What does this mean? Should a town be dirty and disorganized to be African? I take that as an insult to the African way of life. The Horseshoe Market came to be called *'outara ua Nepety* – Libertina's market', because I established it.

I still remember a picture in *The Namibian* newspaper of a woman at that time with her baby. It was alleged that I had prevented her from making an income of 2,000 Rand per month selling her goods on the streets. Little did the critics know that I had covered my back by creating better facilities and a healthy, safe, environment with electricity, clean water and sanitation. People in this country like to follow rumours and don't verify a story. They just move on the rumour train, adding

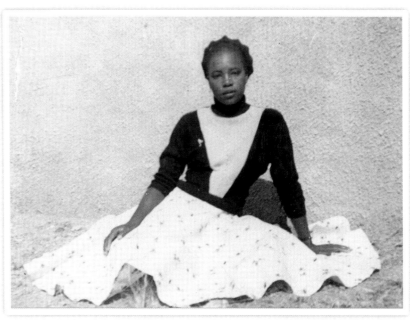

Libertina in 1957 at Augustineum School, Okahandja

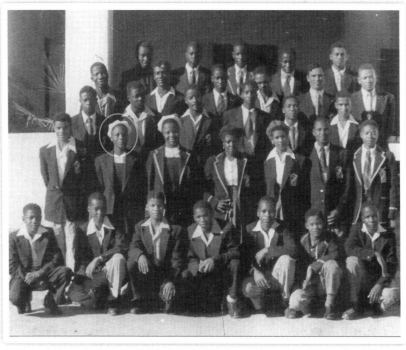

Libertina (circled) with her class at Augustineum

Phillipus Matsuib (left) and Alub Bachman,
Libertina's elder brothers

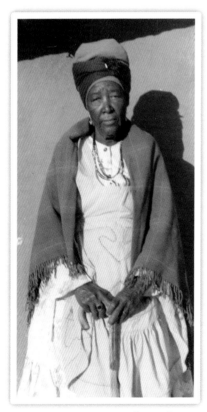

Petrina Murorua, Libertina's
older mother (aunt)

Libertina and Ben Amathila on
their wedding day, 30 January 1970

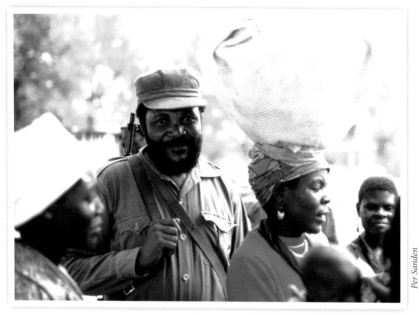

Per Sanden

SWAPO Secretary for Defence, Peter Nanyemba, who watched over Libertina as she passed through Southern Rhodesia in 1962, on her way to Tanganyika

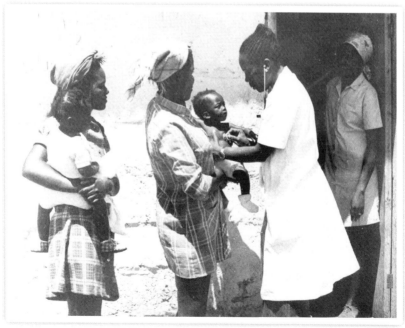

National Archives

Dr Libertina examining a child at the clinic at SWAPO's Health and Education Centre, Nyango, Zambia, late 1970s

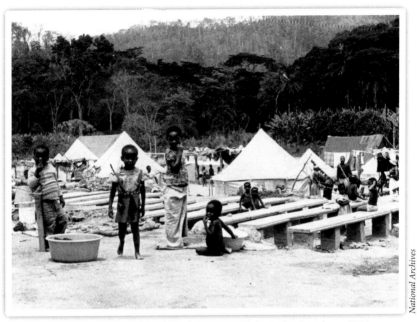

Beginnings of the children's settlement at Ndalatando, Angola, c. 1981

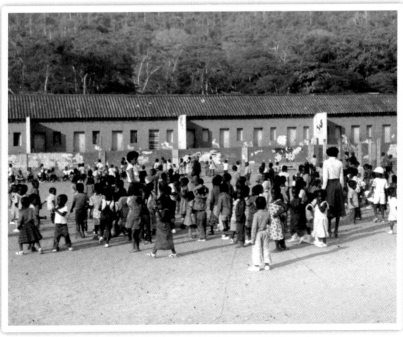

Dormitories at the Mavulu Centre, Ndalatando

Children at the Mavulu Centre

The main house, used as the clinic

The house Libertina built for herself at Morenga Village, Angola, 1984

Libertina (right) and women at the Morenga Village garden

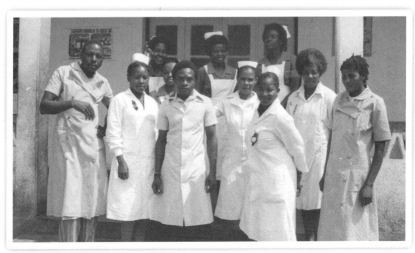

Trainee nurses at Morenga Village

The first sitting of the National Assembly of independent Namibia, Independence Day, 21 March 1990, with Theo-Ben Gurirab, Minister of Foreign Affairs

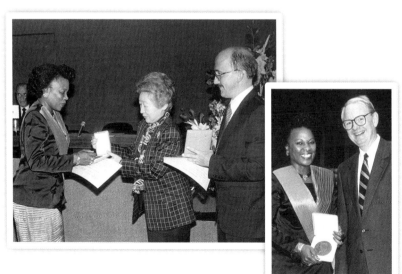

Receiving the Nansen Medal in 1991 at UN headquarters in Geneva, for her work with Namibian refugees during the struggle for Independence

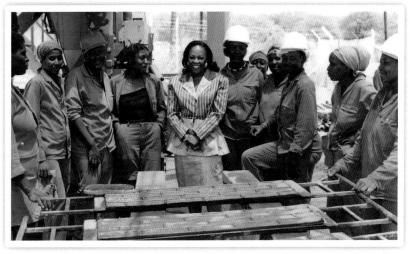

Minister of Housing and Local Government 1990-96, with women members of a brick-building project

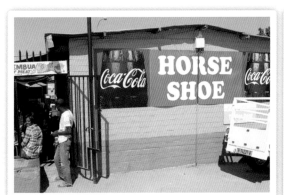

Isabel Katjavivi

Vendors at the Horseshoe Market in Katutura, designed and built by Libertina

Receiving the HABITAT Scroll of Honour awarded for services to housing, at UN headquarters in Geneva, 1993

At the unveiling of the street in Otjiwarongo named after her

Revisiting the hostel in Warsaw, Poland, where she lived as a medical student in the 1960s

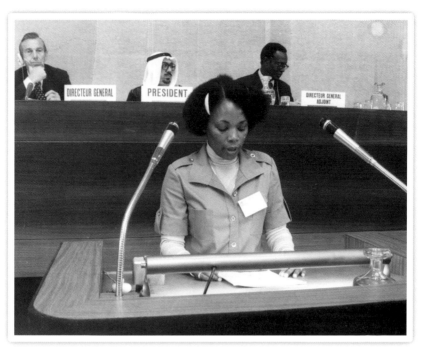

Speaking at her first World Health Organisation Assembly in Geneva, 1975

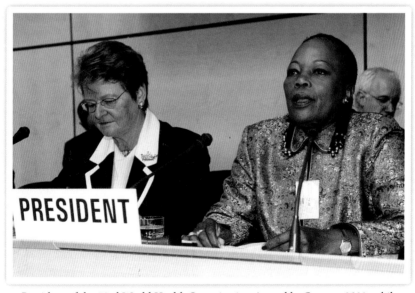

President of the 53rd World Health Organisation Assembly, Geneva, 2000, while Minister of Health and Social Services in Namibia

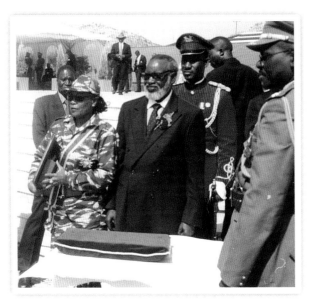

Receiving the Most Excellent Order of the Eagle, first class, from President Sam Nujoma on Heroes Day, 26 August 2002, at the opening of Heroes' Acre

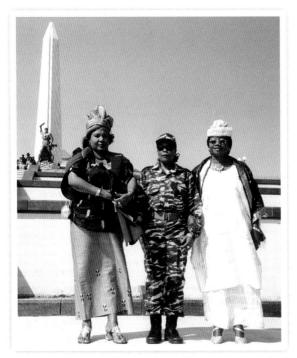

Before the ceremony, with Laura McCleod-Katjirua, Governor of the Omaheke Region (left) and Grace Ushona, Governor of Otjozondjupa Region

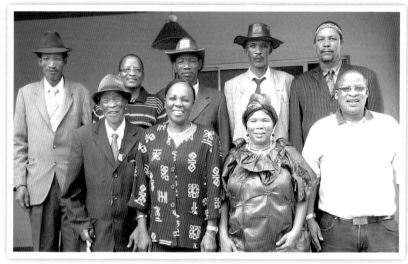

Handover of the Uitkoms Farm to the San people in February 2008.
Back row (left to right): Chief Langman; Chief Royal, member of the National
Assembly; Chief Dawid Khamugab; Councillor Katae, headman of Uitkoms; Chief
Arnold. Front row (left to right): Chief Bobo; Dr Libertina Amathila, Deputy Prime
Minister; Chief Sofia Jacobs; Hon. Moses Goma, Member of National Council

Goats donated to the Uitkoms
Community

With trainees from the coffin-building
project, Hon. Willem Konjore, Minister
of Environment and Tourism (right), and
project organizers, Mr and Mrs Blaauw

Libertina's dream team: (left to right), Aaron Kapere (driver); Thomas Shilongo;
Phillipus Thimoteus (security officer); Jafed Kaputjaza (driver); and Aaron Clase.
Shilongo and Clase supervised the building projects

Camping in Kunene Region while building villages for the mountain
Ovatue and Ovatjimba people in 2007-08

Children at Ohaihuua Village: inside the new school and at play

Accompanying President Pohamba on a visit to Ohaihuua

Gardening at one of the new villages and addressing a village meeting

In traditional Herero dress for the Opening of the National Assembly in March 2005

At the Opening of the National Assembly in February 2008

At a farewell celebration in Parliament Gardens to mark Libertina's retirement in March 2010, with Prime Minister Nahas Angula (left) and Permanent Secretary in the Office of the Prime Minister, Nangula Mbako (right)

*Chair of the Domestic Workers' Wages Commission (2012-13)
with fellow commissioners (left to right) Dr Hilma Shindondola-
Mote (National Union of Namibian Workers), Clement Daniels (legal
practitioner), Uahatjiri Ngaujake (Social Security Commission), and
Veronica De Klerk (Namibian Employers' Federation)*

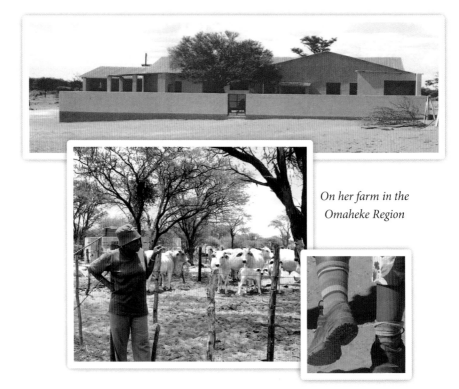

*On her farm in the
Omaheke Region*

further unfounded rumours as the train moves down the line. After the rumours died down, the market became very popular, but nobody came to apologize for that criticism.

The Horseshoe Market is still there and is now a popular eating place and businesses are booming. There are tailoring outlets where people take their material to be made up, and professional and affordable hair salons. I go there to have my hair braided and also have something to eat when I am doing my hair. The place is kept clean and orderly; it has a very pleasant atmosphere and women prepare a very tasty traditional chicken dish. It is a popular meeting place. Nowadays you hear people saying over the radio, 'Let's meet at Libertina's market.' Many people first thought that the market was my own property. What I appreciate is that there are no fights or loud noises. At the market people sit around, having their drinks over the weekends in peace. I think those who have stalls there make a good income.

Rundu Open Market

I targeted Rundu for a market similar to the Horseshoe Market in Windhoek. I found the women there selling food under the trees in the dust and dirt. The Luxemburg Development Agency, LuxDev, was working in the Rundu area and I asked them to assist in building a market with proper facilities. They agreed, and with the Town Clerk, Mr Muhepa, we started building. LuxDev built a well-designed, beautiful and spacious open market, but when it was complete, vendors didn't want to move in. The women continued to sell their produce on the streets but later they were persuaded by the town council, who used veiled threats to make them move. The same rumours that were spread when we built the Horseshoe Market in Katutura were repeated in Rundu, such as that the stalls would be expensive, the women would lose customers, and so on. Later, however, this market became very popular. Today it is a clean and comfortable place to do business. Butcheries are found there and the place is booming.

Saujemwa

I had first visited Rundu in 1991 and discovered this beautiful town with the river snaking at its border, giving a picture of serenity and peace. However, I found the town itself dirty. I visited a school and met the

principal, Comrade John Mutorwa, and we started a cleaning campaign with his pupils. He later became the Minister of Education and is now (2012) the Minister of Agriculture, Water and Forestry.

I also visited the township of Saujemwa, which reminded me of what I had seen in Nairobi, but on a more manageable scale. There were no roads and the huts were built too close together. I asked the same question, 'How would an ambulance reach the sick?' Again, the Town Clerk, Mr Muhepa, and I approached LuxDev to finance roads, water standpipes, and electricity in the streets, and they agreed. When I switched the lights on the first night, the cattle in the kraals woke up and started to bellow, thinking maybe that it was morning. People were very happy that they now had water, roads and streetlights. Saujemwa is now part of Rundu town.

Since our first cleaning campaign, Rundu is now a beautiful town, with many shops and tarred streets. The town is clean and is a nice place to visit, with some good eating places. This shows that Independence has brought visible changes. Many towns in the rural areas have been developed and are now well-organized towns. They have good infrastructure and sometimes I find attractive items there that I cannot find in Windhoek. Banks and big department stores have been constructed and roads are well maintained.

A Clean Capital

I've found that many cities I've visited in Africa are neglected. I don't know whether this is because of the lack of services or that people don't pay attention, or because these are ancient towns that are difficult and costly to renovate. What I've also noticed is the animals roaming around the towns; one finds both cattle and donkeys in town centres. In some towns sewerage is running in canals along the streets. Windhoek is not like this. It has the reputation of being the cleanest city in Africa, and this is largely due to my efforts. I take credit for the hard work I put in to make Windhoek and Namibia in general, a clean place. In this country people don't throw rubbish around. Along the roads you find bins to throw the rubbish in. As for the streets, throwing rubbish is a big taboo.

One day in 1989, Monica Koep and I were driving from Swakopmund to Windhoek. As we neared a bus in front of us, which was carrying an UNTAG contingent, all of a sudden one of the passengers opened the

bus window and threw their garbage out onto the road. I asked Monica to accelerate and we overtook them. I stopped the bus and asked the driver to turn back, pick up the garbage and throw it into a rubbish bin in town. They turned back and we followed them until they picked up their rubbish. I then gave them the thumbs up and we all drove back to Windhoek – me, Monica, the UNTAG team and their garbage!

A couple of years later, in 1992, I had a visit from a French man who came from Brazzaville, invited by a Namibian friend with the idea of opening a night club like those found in Congo-Brazzaville. He started by remarking that Windhoek was one of the cleanest cities in Africa that he had come across and I agreed with him. He told me that, when he got off the plane he wanted to throw away the rubbish he had in his pocket but he found the tarmac very clean, so he decided to wait until he was inside the airport building. Entering there it was again too clean, and since he couldn't find a place to throw away his rubbish he waited until he came out of the airport, where he found a rubbish bin. He told me that it would not be possible for him to put up the kind of night club he had in mind because the place was too organized. I understood him because I knew what he was talking about. Brazzaville is a beautiful city, but it cannot be compared to Windhoek when it comes to cleanliness and order.

Reforming the Legislation

My first visit to meet the Windhoek municipal councillors as Minister of Local Government and Housing was an unforgettable experience. When I walked into the Council Chamber one sunny morning in 1990, I was met by apprehensive white men, all of them over 50 years old. They were uncertain whether they should stand up to greet me or remain seated. I stood in the doorway to see what they would do. I too, was uncertain. One by one they rose from their seats, and when all of them had stood up, I walked in, greeted them and took my seat. There was not a single woman or any black face in that hall except me – a black woman. However, our first meeting ended very well; the councillors relaxed and enjoyed my company. I think the fact that I spoke Afrikaans to them broke the ice, because their whole body language changed as they started to relax. After a briefing, I was given the Municipal Ordinance to study. This contained the laws governing all municipalities. Some of them dated back to the 1930s. They stated that to become a local councillor, you had to be a white male, over 50 years of age and a South African citizen; women were regarded as minors and couldn't buy property, such as a house; and salaries of women were lower than those of men even if they did the same work (this was the general practice in the country before Independence).

I personally experienced the meaning of some of these provisions. One day in Parliament I was sitting next to Comrade Hidipo Hamutenya, when I peeped over his shoulder and saw his pay cheque. On closer inspection, I noticed that his pay was higher than mine. I wanted to know from the Finance Ministry why this was the case. Oom (uncle) Gert Hanekom, the Finance Minister, later explained to me that women were regarded as minors and men as the breadwinners, and therefore their salaries were higher. I'm sure that if I had not been a Peeping Tom, we women might still be regarded as minors in Namibia today! Yet I was buying food in my house and had no knowledge of my husband Ben

buying food alone and buying me clothes. I bought the groceries and my own clothes and also paid the municipal services. I then took up the fight for equal pay for equal work, which we won.

Women's Property Rights

Like other women in Namibia, I also experienced problems taking out a loan to buy property.

During the many years of living in other countries, we learnt how Ministers were sometimes treated. In some countries in Africa, the Ministers stayed in government houses and when they were dismissed they had to move out fast. One particular President liked to dismiss his Ministers while they were away on official trips. As he or she was sitting in the plane returning home, the President would announce with 'regret' to the press that the Minister had been fired. No questions were asked, and no explanation given. When the poor Minister landed at the airport he wouldn't know about the news because he was airborne when it was announced, but he would be told by his driver that he was no longer a minister, that he had no official car and, above all, no house. The driver would drop him at the official residence that day but the next day he was expected to move out.

Having observed that behaviour during my many years of exile in other African countries, I decided that, if ever I became a Minister one day, the first thing I would do was to buy my own house – I would never stay in a government house. So in keeping with that promise to myself, when I became Minister, I started house-hunting. I found a house I liked and I went to the bank for a loan. I was told that if I put down a deposit I could take a loan from the bank and buy a house. During my time in Sweden, I worked as a doctor and earned a good salary, and although we as doctors paid very high taxes, I had saved enough money for a deposit. I went to the Standard Bank and was received by a black manager; unlike the story of the municipal councillors, here at least I was received by a black man!

When I explained to him that I had found a house I wanted to buy and I had come to ask for a bank loan, he looked uncomfortable and asked me where my husband was. I responded that I was not buying the house with my husband's money; I was putting down my own deposit. I asked him why he wanted to know where my husband was, that I had no

time for male chauvinism, and if he didn't want to give me the loan he must just say so. He said nothing but he agreed to come with me to see the house I wanted to buy, so that he could advise me. He wasn't happy with my choice and pointed out some defects in that particular house. With his help, after we had seen over 50 properties, I found a house to my liking that he also thought was a good choice, and I bought it. Ben and I lived there until I moved to my present house in Avis in 1996. The bank manager revealed to me later the agony he had suffered to give me the loan to purchase that house. He had to convince his seniors that if they refused to give women loans, they stood to lose a considerable number of female clients, since women had senior positions in the Government and high incomes. So there again I broke the mould. The door was now open for women to buy properties in their own names and not to go and find their husbands.

Before I left the country in 1962 I knew that many houses in Katutura and other similar townships had been rented by women in their own names. My mother had such a house in Okahandja, but these were still municipal houses. I studied the Ordinance and as time went by I amended the most obvious offending sections, and others I came across along the way. I had the section on property ownership amended first. I was starting a Build-Together Programme and women had to be included in that programme. In fact I wanted to give women priority, so I changed that section as a matter of great urgency. If I didn't change that section of the Ordinance, women stood to lose their houses because they would be forced to register them in the men's names, be it family members or boyfriends, who would undoubtedly kick them out as soon as they found someone else. I brought in a property ownership amendment clause that covered municipal housing, so that women could get their houses without intimidation from men.

Local Government Act

The next very urgent change was the question of who could qualify to be a councillor. That needed the Local Government Act to be promulgated and ratified by the Namibian Parliament, so it was not for simple amendment in the Ordinance. This was a serious undertaking. As Minister of Local Government and Housing, I was required to initiate the first draft known as the 'layman's draft'. I went to the Waterberg

Plateau, the De La Bat camp, the very place I had gone to campaign in the elections where I was chased away by the former South African soldiers-turned Nature Conservation officers. I was accompanied by two women lawyers and one male lawyer. The latter was very knowledgeable because he had been working for the Windhoek Municipality for many years as a lawyer. I found him very patient and he had great tolerance for these hard-headed former guerrillas, two of whom had just come back from the struggle and had no time for discrimination against women in laws favouring men. Our layman's draft laid the groundwork for the Local Government Act as it stands today, and there have only been minor amendments to this Act since it became law in 1992. We did the right thing for women from the beginning, and I feel very proud when I go to the different regions of our country and am met by bright, articulate women mayors of the towns, because that is what the Act has produced. Today we have a female Mayor of the City of Windhoek. Mayors of many towns in Namibia are women. All three coastal towns have women as mayors and these towns are well organized and clean. This shows women's power and potential.

In the layman's draft we took care of women. We put in a clause which gave quotas for women's representation in the council, e.g. where there are 12 councillors at least 5 should be women and where there are 7 councillors, 3 should be women. This means that 30 per cent should be female, but I didn't cite a percentage. I wanted to give the actual numbers to make sure there was no deliberate evasion or confusion. Our draft was sent to the legal drafters at the Ministry of Justice for fine-tuning as was required. Finally it came to Parliament for discussion.

I was surprised to note that some SWAPO brothers showed their true colours by claiming that there should be no favours done for women because we were all equal. No quotas should be given to women, they said; they should stand for elections like their male counterparts. Having lived in Sweden, I had learnt that if you don't create conducive conditions for women, they will never reach the top, particularly in decision-making positions. We can see in some cultures, where women are excluded from decision-making, that men are becoming little kings and they make the country their own property and that of their families.

In Namibia, women are saddled with all the responsibilities of home making, from nurturing their families, working outside the home

to put bread on the table, to working in the fields in the rural areas, while many of their menfolk loaf in bars, holding meetings to discuss irrelevant issues. During the men's absence, the children must be looked after, the cows milked, and all that is left to the women. When and how are women expected to go around campaigning, when they are left with so much responsibility? These men who are talking about equality, who is cooking for them? It is a known fact that, even if both husband and wife are working, very few men will come home earlier to put the pot on the fire to start a meal. The wife comes home and finds the husband reading a newspaper and she has to start the fire and cook. Therefore an enabling environment must be created to accommodate women; places must be left for them to have a chance to be included in the political affairs of their nation. I am convinced that because of the presence of women in the high echelons of decision-making, Namibia is peaceful and progressive. After all, women participated along with men in the struggle for the liberation of the country.

When the Bill came up for debate in Parliament, some male colleagues revealed how chauvinistic they were in reality. Whilst they were paying lip service to supporting the cause of women, the part of the Bill they were vehemently opposing was the quota system for women. After much debate, which lasted almost a month, we finally reached the committee stage. This took place on a Friday morning and then I sneaked back the clause on the quota into the Bill without them noticing. Scandinavian countries have a quota system and in my opinion they have the best governance.

Usually in Namibia we like to go to our villages for the weekend, and any issue coming up for discussion on a Friday is likely to pass through Parliament without much trouble, particularly an item which has already gone through long and tedious discussions. I don't know whether the male parliamentarians were tired or simply gave up the fight, because when the clause dealing with quota system was called out, it was accepted with no objections. I was pleasantly surprised and very excited when the whole Act was passed with no amendments. It was now just a matter of the President's signature and the Local Government Act, giving women a chance to become councillors, was passed.

Later, during the local elections, one town council tried to test me on this quota system and voted for all male councillors (7) while the

women were trailing down the list. I had the law behind me so I simply put a line after the fourth name and pushed up the first 3 women, and then we had 7 councillors, consisting of 4 male and 3 female councillors. One of the women became the first Mayor of that town and performed extremely well. She was re-elected several times. To this day, even after she retired, her town is kept clean and beautiful. That was the town of Tsumeb and the name of the mayor is Meme Susan Ngintinua.

Training Councillors

After the Local Government Act became law in 1992, I undertook a mission to train the councillors, or rather I went to explain the Act to the elected councillors. I was accompanied by Mr Titus Mbaeva, a lawyer in my office. We went to the first town and the morning we arrived there, we were well received. Mr Mbaeva went into the hall to organize the seating arrangements. He then came back to me and said with a grimace that, if we want to get anything done there, we first must start literacy classes since the people inside had absolutely no clue, particularly of English, which we had adopted as Namibia's official language. People were more conversant in Afrikaans but the Government, recalling the serious reservations about Afrikaans as the language of oppression, had made a conscious political decision to adopt English as the official language of independent Namibia. Nevertheless, I went in and greeted the councillors. The Mayor greeted me, saying, 'I have great pressure to vercome you.' I felt Mr Mbaeva's eyes on me but avoided his gaze. I decided to explain in Afrikaans very slowly so that the councillors could follow, and they started to open up and ask questions, and we made some progress. We stayed there for three days; by the time we left I was satisfied that there was some understanding of the provisions in the Act. It's amazing how much Namibians have mastered the English language since those humble beginnings.

Providing Better Housing

The Ministry of Local Government and Housing was created to deal with the serious backlog of housing, and this took up a lot of my time and energy.

The situation was also exacerbated by people flocking to towns in search of work and a better life, leaving their old parents in the villages to fend for themselves. Since not everybody could be employed and the towns were not able to provide serviced land, people ended up in squatter camps. Experience shows that no country has managed to give houses to all its citizens and we had lots of problems to provide shelter for everyone.

Prior to Independence, people had been restricted to their homelands and not allowed to move to towns unless they were contract labourers. With Independence, came the new Constitution of the Republic of Namibia, which in Article 21 Fundamental Freedoms (1)(h) states that: 'All persons shall have the right to: reside and settle in any part of Namibia.' Thus people were now free to live where they wished and many chose to move to the towns in search of work.

Alienation Scheme

People in Katutura and other townships had been paying rent on their houses ever since being moved there in the 1960s, but no improvements were made to their houses. Some needed repairs while many still had outside toilets using the bucket system. When these townships were built, people had been promised that after 30 years the houses would revert to them and no longer belong to the municipality. We had left the country for exile and yet when we returned many years later, in 1989, people were still paying rent to the municipalities. I confronted the municipalities on this issue and it was agreed that the 30-year time period had long passed and houses could be alienated to the residents. Those who could benefit were people who had lived in the houses

permanently for a period of seven years, and whose rates for municipal services were paid up. I approached the Law Society to reduce the transfer fees, which would have been prohibitive if normal rates were applied and would have rendered the programme ineffective. Judges Brian O'Linn and John Kirkpatrick were at the helm of the Law Society then and understood the needs of the people very well. They agreed to help, and reduced the transfer fee to a mere R11 (we were still using the South African Rand then). The cost of the plot with the house was R100 only because I didn't want to make it a completely free gift – people don't respect free gifts. As usual, there were those who were urging some people not to pay the R111. They were arguing that it should be given free. However, many people came on board and in the two-year period of the project we sold around 4,000 houses all over the country.

There was a provision attached to the programme that no house bought through the alienation scheme could be resold within five years. This provision was very important and I put it there in order to protect the old people from speculators. There too were some people who talked to me about freedom and the right of the people to sell their houses as they pleased; they said people should be able to choose what to do with their properties. I shot back and reminded them that freedom comes with responsibility, and if these old people who couldn't read and understand the deals lost their houses, where would they go? Were these other people going to be around to help them? I wasn't going to allow 'freedom of choice' when people, particularly the elderly, were so poor and the judges had helped to almost scrap the transfer fees. Fortunately, this idea wasn't widespread and people were very happy with the programme. After the two years were over, I extended it for another six months and reduced the time of occupation to qualify to five years. Still some people didn't make it. They continued to believe that the houses would be given free and they eventually lost out completely. Today these same houses are sold for N$30,000 (Namibia Dollars) or more.

It was a wonderful feeling to know that people had ownership of their homes and one noticed how they started renovating their homes, extending them, and so on. The programme was popular and there were claimants who wanted these houses but didn't qualify, some who had left their wives long ago who wanted the houses back, and others who

had left the towns wanted to come back to claim the houses. But Plan A was to put in a ceiling and criteria as to who qualified, and Plan B was to sell the houses to those who qualified, so the programme was properly and professionally executed.

Houses in Communal Towns

Funds were also allocated to construct houses in the former communal towns. During my visits to the neighbouring countries I had met a Chinese building company in Botswana and I recruited them to come to Namibia to build about 450 houses in Ongwediva after we had successfully proclaimed the town. The good thing about Ongwediva was that there was already serviced land that had lain dormant for years and there were hardly any homesteads in that serviced area. The Chinese builders came and started with this huge housing project, and they built 450 houses in a year. There was an outcry from town planners and builders in Windhoek and, as usual, lots of bad stories were spread about the Chinese – that they would come with their prison labour and local people would not be employed. One architect told me that the sewerage pipes were laid wrongly and there would be big problems if building projects were undertaken.

However, the builders and construction companies in Windhoek were only interested in building in and around Windhoek. When I wanted to start that project in the hitherto neglected northern communal lands, they had not shown any interest in it, but they cried foul when they realized that the Chinese Building Company was coming to do the work. I ignored them and let the Chinese come, and the doubting Toms were proven wrong. The Chinese didn't bring prison labour but employed our local people. The local people, however, were working as we do, looking at their watches and taking breaks. Chinese workers have none of that; they work through. They worked diligently and built all those houses within a year. Today these houses are called 'better housing'. There was a problem with flooding during the rainy season in some low-lying plots, but that has been corrected.

The Chinese company also built 40 houses in Ondangwa and 50 in Oshakati. The reason that so few houses were built in these two old towns was because they had not been properly planned and there wasn't enough serviced land. After we completed that project and the

people had moved in, some well-to-do people complained that they wanted bigger houses because they couldn't fit their double beds into the bedroom. I promised that if a private company pitched up, I would invite them to build bigger houses for those people who wanted them, but for now that was all I could offer them! The government didn't have money to build luxury houses; that needed private sector involvement. I was very pleased to note that the face of communal towns changed dramatically. People were also very happy. They started planting trees, making their houses beautiful, and even extending them.

Hanova Houses

One morning I received two men in my office – one Nigerian and the other a white American. Our people at the Namibian Embassy in New York had sent them to me because they were interested in undertaking building projects in Namibia. I felt that manna had fallen from heaven onto my lap. I told them there was a huge need for housing outside Windhoek, and if they were really serious they should go to the north. I was aware that my project had used up the serviced plots but there was a lot of land still available in Ongwediva. Moreover, if they serviced the land themselves, they could build any amount of houses.

They did go to the north and they came back and told me they were interested, so we put our hands to the wheel. We helped with the servicing of available land but accelerated the process, which used to take up to two years, to a few months. They got serious with the actual planning of the project and designed a beautiful big show house, a 'Hanova House' as it was called.

These houses were larger and could fit in people's double beds. When all was done, I was invited to the launch of the project and I flew up there with some bankers. We surveyed the plans, I approved them, and we went to the ground-breaking ceremony. The speaker was the Governor of the Oshana Region. In his opening remarks he had some problems with the name of the American, Mark Chiocolante, and referred to him as 'Mr Chocolate'. That was in 1993. People were very excited when they saw the Hanova show house and the houses were bought up even before they were completed. Indeed I am proud of Ongwediva; it developed into a beautiful town.

The concept of a show house is very important and we had one in all the housing projects in order to encourage and involve people. After all it is they who will live in those houses and their opinion is important. They were shown how the houses would look when completed, and before completion the women were invited to make any suggestions or changes they wanted because it would be they who would take care of the houses. So women were instrumental in suggesting changes. The cherry on the cake came when Ongwediva was electrified. Street lights were put in and the town looked very attractive, particularly from the air.

Most of the nouveau riche of the area have houses in Ongwediva and so far it is the most beautiful town in the north. I remember a street was named after me there but the sign was removed when those who had no idea how we worked to make the town what it is today, took over. I am very pleased and thank 'Mr Chocolate' and the banks that supported the project. Indeed Ongwediva is growing every day. It started with a very dynamic, no-nonsense female town clerk who took her work very seriously and dealt firmly with anyone who wanted to undermine her authority. She threatened those who didn't pay for services on time with eviction. She also made sure that the town was kept clean and orderly. Sadly, she died at a young age. May her soul rest in peace. Her legacy lives on and the town is well taken care of by those who came after her. Today it has a private hospital and many beautiful houses with lawns and trees.

Build–Together Programme

There was still a need to take care of those who could never get a bank loan to build a house since they could not afford it. The Build-Together Programme was launched for them. It catered for those who earned N$2,000 per month, or less. As I mentioned before, Mr Lalif from Sri Lanka came to assist us with the financial management of the programme. We registered women-headed families (these made up 47 per cent of beneficiaries) and some families headed by men. We also made sure that rural towns benefitted, as well as the newly proclaimed towns in communal lands.

The loans given were between N$5,000 and N$20,000. Readers may wonder what can one do with N$5,000, but people managed to build a basic unit first and later add to it. The money was not given in one go

but in stages as people progressed with the work on their homes. For example, the first part of the loan was given after the foundations were dug; the inspectors would check the foundations and if they gave the go-ahead, then a further amount of money would be given to enable people to build up to window height. The inspectors would again check the work, and if they approved it, the next sum would be given to reach roof height. The final instalment would be given for the roofing.

As we progressed with the programme, I had a visit from a Japanese NGO that showed interest in assisting us. I requested roofing materials to help the beneficiaries, because these materials took up most of the loan amount. As per Japanese efficiency, the materials arrived very quickly and the beneficiaries were given the roofing material free of charge, once they had reached roof height with their building.

Repayment of the loans started once the roof was on. As usual, the female beneficiaries excelled in repayment. Some families headed by men showed a higher drop-out rate. Either they failed to reach roof height, or even window height, or some (albeit a few) used the loan and bought a cow rather than finishing the house. In one town, we ended up with what looked like tennis courts, since the structures ended at window height. Later those unfinished plots were sold to others and the loans given to those who had dropped out were paid back. The beneficiaries in the communal towns did a wonderful job.

Newly proclaimed towns emerged from the Build-Together programme. People who took the loans worked very hard, added some money from their small businesses, and extended the houses. Women sold *kapana* (small pieces of barbequed red meat popular as a street snack) and used that income to extend their houses. Towns such as Kalkrand, Oshikuku, Ongenga, Omungwelume, Warmbad, Sesfontein and Talismanes, just to name a few, are Build-Together towns. There were also communities who were so enthusiastic that, at the start of the programme, they couldn't wait for the bricks to dry properly and the houses developed cracks! Our inspectors explained to them that the bricks needed at least take eight days to dry, thus people learnt quickly and the problem of cracks was solved. I think that in Phase One of the Build-Together Programme, over 1,000 houses were built.

The programme is still popular and on-going to this day. We had competitions and Otjiwarongo took the first place, followed by Kalkrand

and Grootfontein. The programme covered the whole country. We started in Katima in the north-east, Opuwo in the north-west, and went as far south as Warmbad. I want to pay special tribute and congratulate the communities in Namibia that took part in this programme, thereby improving their living conditions. Women deserve a special mention as they spearheaded the programme. Many of them were making their own bricks. One community didn't adhere to the philosophy of the programme, which is that families and friends should build together. They hired contractors and paid extra money and built only tiny houses because the builders they hired cost them a lot. This was a particular problem in one of our regions where women don't perform well because of traditions.

A Trust Betrayed: the Single Quarters

As my Deputy Minister and I travelled extensively to register people for the Build-Together Programme, we became aware that we had a very serious problem in Windhoek, a terrible eyesore that needed urgent attention. This was the housing complex called the Single Quarters, which had been built to accommodate contract workers. The contract labour system didn't allow the male workers to bring their families. They were housed in dilapidated barracks that were overcrowded and dirty, with sewage running all over the place. The whole area was stinking and extremely unhygienic, not fit for human habitation.

There was an urgent need to do something about the Single Quarters, and quickly, but we were busy with lots of other projects and had neither the capacity nor the manpower to deal with it directly. Thus, we decided in the Ministry to approach the housing parastatal, the National Housing Enterprise (NHE), to take on the task of renovating the Single Quarters. NHE was a statutory body. It had a CEO and a Board of Directors to oversee its work, and its own administration. Thus, we felt it should be able to run the programme itself with funding from the Government. An application was submitted to the Cabinet for approval of the project and the voting of necessary funds to enable this to be done. As a result, a Cabinet resolution was adopted on 26 January 1993 to go ahead with the proposed renovation.

The implementing Ministry was Local Government and Housing, but the project was handed over to be run by the NHE. I was confident

that the project was in competent hands. Following written instructions given by the Permanent Secretary of our Ministry to his financial officer, an amount totalling R5,150,548.97 was paid over to NHE on 25 February 1993 (the Namibian dollar was not introduced until late 1993). The Permanent Secretary was a Board member of NHE and it was he who was assigned to assist in coordination of the project. The Deputy Minister and I helped remove people from the Single Quarters so that the programme could start and the building of individual housing units was handled by NHE.

There is a perception in the communities that Ministers deal with money or payments, but in the system used by the Namibian Government, administrative matters are handled by the Permanent Secretaries. That's why it's not the Minister but the Permanent Secretary who has to write the letter instructing his financial adviser to transfer money. This is an excellent system and effectively shields or protects the Ministers. It's also done this way because the Ministers serve at the pleasure of the President who appoints them, and may be dismissed at any time by the President. Ministers are politicians; we can lose out on politics or be reshuffled, but the administration should remain stable.

The Cabinet and I trusted that the NHE would perform on this project better than the Ministry. It had the manpower at its disposal, so once the project was transferred to them, I didn't worry. I continued to work on the Build-Together Programme and many other local government responsibilities. It never crossed my mind that people might ruin themselves by betraying the trust I had put in them. I always made sure that whatever responsibility I was given, I did my best because it was a trust bestowed upon me and I could never betray it.

Now and then I would check on the progress of the houses being put up but I never dreamt that I would learn from the media of fraud going on inside the NHE. However, unfortunately, greed took over as the project progressed and the CEO, the Director of Housing in the Ministry of Local Government and Housing, the main builder and others were arrested, tried, found guilty in 1999, and jailed for up to five years, on charges ranging from fraud to bribery. Altogether nine people were implicated. It was a very long, drawn-out case lasting almost three years; and as many as 47 witnesses were called. I too was called as a witness and was asked some questions. The main reason was for me to

verify the signature of the Permanent Secretary, Mr Shoombe, on some documents. During the entire investigation, he had repeatedly denied that they were his signatures and claimed they had been forged.

The day after I had testified in court that the signature did, indeed, look like his, Mr Shoombe broke down under cross-examination and, out of the blue, to everybody's surprise, admitted that indeed, he had signed all those documents but that he hadn't read what he was signing.

The documents included agreements to employ unqualified people; payment for work not done; and cheques issued without verification. He had also signed documents brought to him to confirm that a job had been completed, but hadn't physically verified that the work had actually been done. In court documents, it was said that the aim and modus operandi of those involved was to overcharge on the materials and for work not done, and the Permanent Secretary just signed the papers brought to him without question.

If he had acknowledged right from the start that he had signed these documents, the case could have been dealt with and completed earlier, saving money and agony for all of us. I'm convinced that he wanted to get me into trouble, but he failed. His admission liberated me and I wasn't called again. He has since died. May his soul rest in peace.

I was criticised by some newspapers but they don't know how things are done in our Government, and that Ministers deal with policy. The policy I took of renovating the Single Quarters was correct. I'm proud that the most unhygienic and overcrowded place in Windhoek is now history.

I never answered the malicious and baseless rumours that I was possibly having an affair with the CEO of NHE (he was a very young man and a friend of one of my secretaries). I was also building my house in Avis at the same time and a rumour went around that my house, which was built by a very reputable German company, was constructed with the building materials meant for the Single Quarters. A third rumour was that I had a shebeen in the mountains. One journalist went to the mountain to check it out and came back and published the real story and the photo of the real shebeen owner, who didn't even know me. The worst and most baseless and ridiculous rumour was that of the affair. I didn't even think of or contemplate an affair with anyone; moreover I was much too busy! This particular rumour was meant to

destroy my good reputation and I was very hurt. I contemplated suing the newspaper, but later I decided to ignore it. I knew the story was preposterous and I wasn't going to waste my time; I had more important things to do. There's an Afrikaans saying that, '*as jy met die semel meng saal die varke jou op eet*'. This means that if you mix with low life you will become one of them. So I ignored the rumours and continued to work hard.

A similar case happened recently and the CEO of another parastatal is in jail, but this time, the line Minister was not blamed. The heads of parastatals are very senior people, their salaries are even higher than that of Ministers, and they are running statutory bodies with their own budget and have their own boards of directors who supervise them. If they misappropriate some money they should take the blame themselves and take the consequences, and that is what happened to the two bosses of these parastatals. No line Minister should be blamed for that.

I'm happy that after those who were guilty went to jail, a new team completed the Single Quarters project successfully. I'm also happy that immediately when I was informed about the suspected fraud, I informed the then Auditor General to audit our books and those of the NHE. I also urged the Permanent Secretary to call the police to investigate, so that the truth could come out. I couldn't believe that responsible people would steal money given to them for a project. I had a high regard for the Director of Housing, with whom I worked directly, but as it turned out, he was also involved in the corruption. He was the Chairperson of the Single Quarters Committee. I was saddened to find that he was part of the group and he too went to jail.

I want to reveal here that when the two men were appointed to these high posts, as Director of Housing in the Ministry of Local Government and Housing and as Chief Executive Officer of NHE, I had called them both into my office and after congratulating them I said to them, and I quote: 'You are the first Damaras to get these high profile posts, keep your hands in your pockets and do your work.' It's very important to keep your integrity high rather than thinking of making quick money that you didn't work for. You can still make money later but you can never retrieve your reputation once it's gone. However, they paid for what they did: they lost their jobs and their credibility, and served their terms in jail. Let them be allowed to move on with their lives.

Regional Representation

Namibia has a parliamentary multiparty democracy and elections are held every five years. It is not within the scope of this book to describe governance issues in detail. However, suffice it to say that we have elected bodies at national, regional and local level.

At the time of Independence, there was only one house of parliament at national level – the National Assembly. However, the Constitution adopted in February 1990 had already made provision for a second house of parliament – the National Council – that would be made up of regional representatives. First, though, legislation had to be enacted to enable regional elections to that chamber.

Regional Councils Act

The responsibility of regional representation was added to my Ministry in 1992 and the name was changed to the Ministry of Regional and Local Government and Housing. A Delimitation Commission was established to divide the country into new regions as we wanted to move away from the divisive apartheid definitions of the South African regime. The commission was headed by Professor Tötemeyer, a Namibian of German origin. It used information from a Census we had conducted in 1991, looked at patterns of human settlement, and considered many issues. When it had finished its consultations, it recommended thirteen regions with new boundaries between them.

I worked with Professor Tötemeyer in the drafting of the layman's draft of the Regional Councils Act, which followed the Commission's recommendations. The Act provided for the election of 26 councillors in each region, who in turn elected a Governor, and two councillors from each region to become members of the National Council, the second chamber of parliament.

Unfortunately, we couldn't set up the same quota system to take care of women as we had done in the Local Government Act. The draft of the

Regional Councils Act was based on 'the winner takes all' system. When the Act was passed and regional elections were held in 1992, women lost out because there was no provision to support their representation. I think only four women became Governors, out of thirteen regions. Women can't go round campaigning for a variety of reasons, so they stand little chance to make it as political representatives, and they have fared very poorly in National Council elections. In the election of 2004, only seven women were elected to the National Council, with the same number of women being chosen in the last election of 2010. So the situation of women isn't improving, and won't improve, unless some formula is worked out to support them.

The system of election of Regional Governors changed in 2010, and they are now appointed by the President. We were hoping that this would enable more women to be made Governors, but although some of us preached 50:50 equality, the President kept the status quo. He returned the same four women Governors and didn't appoint any new ones.

The Two Houses of Parliament

There is a division of labour between the two houses of parliament. The National Assembly makes the laws and the National Council is known as the house of review. The responsibility of the National Council is to review bills passed by the National Assembly and to amend them or pass them for ratification back to the Assembly.

When the National Council was first established, the Chairperson had issues with this status. I don't know whether it was a question of ego or a genuine misunderstanding. He claimed that, as the house of review, the National Council was the 'upper house' and should be given appropriate respect and status. The duties and functions of the two houses were very clearly explained, but the comrade didn't get it. He didn't want the National Council to be referred to as the lower house and there was some tension between him and the Speaker of the National Assembly because of this. It was a subtle war but a visible one. The issue kept on raising its ugly head but finally it died a natural death.

The first Speaker of the National Assembly was Dr Mosé Tjitendero, a sophisticated, dignified, and able scholar who built a sound tradition of parliamentary democracy. Dr Tjitendero was a very patient man, level headed, and it was a pleasure to work with him. We had very lively first

session of the National Assembly (1990-95). The opposition parties were well represented; the DTA was the Official Opposition with 21 members or seats; but their numbers dwindled after every election. Now, in 2012, they have only two seats in the Assembly. The same goes for most of the other opposition parties, which have only one or two seats today. The exception is the Rally for Democracy and Progress, which is now the Official Opposition, with eight seats.

Dr Tjitendero served the parliament well and efficiently for ten years and retired in 2005. Sadly, he died in 2006. He was given a hero's funeral and buried at Heroes' Acre on the outskirts of Windhoek. I personally miss him a lot. We were planning that when we both retired, we would set up an advisory service facility, so that we could be available to give advice to our people when needed, but with his death those plans fell through. He is sorely missed by those who knew him. May his soul rest in eternal peace.

Traditional Councils Act 1992

The Constitution of Namibia recognizes the valuable contribution traditional leadership makes in our communities. In fact, traditional leaders are part and parcel of the rural communities. They are the custodians of communal land.

During colonial times, many traditional leaders spearheaded the anti-colonial struggle. Some traditional chiefs were beheaded by the German Imperial army and their skulls taken to Germany, along with the skulls of many other Namibians. In 2011, twenty skulls were returned to Namibia and more are to be returned in the near future. Other traditional leaders were hanged by the Germans colonial forces between 1884 and 1915, and we have special memorial days when we visit the graves of our chiefs. The Portuguese must also tell us what they did with the head and the remains of Chief Mandume ya Ndemufayo, who died in 1917.

The country has lost some gravesites of our chiefs. We don't know the place where the remains of the Nama leader, Captain Hendrik Witbooi, were buried. History has it that since his warriors feared capture by the German imperial army, they buried him after his death during the battle of Vaalgras in 1905, and hid the burial site. The area where he was buried is known but not the exact spot. With such history and the sacrifice our

chiefs and *kapteins* have made, it would be unforgivable not to make constitutional provisions for a special Act governing traditional leaders. Therefore, such an Act was passed in 1992: the Traditional Councils Act.

I took part in drafting the layman's version of this Act, as I had done with the Local Government Act and the Regional Councils Act. However, there were difficulties. Some communities were larger than others, since the people south of the Red Line, who had fought the German imperial army, were almost annihilated. Herero Chief Samuel Maharero fled across the Kalahari Desert to Botswana with many of his subjects, and the rest lost their land and were scattered in reserves during and after the 1904-8 war of genocide. The same was true for the Namas in the South. They too suffered great human losses and their population was decimated. We deemed it necessary to come up with numbers of how many people could be taken to constitute a traditional community, in order to cater for ethnic groups with smaller numbers, without formalizing very small communities. We soon discovered that we had a problem. Some groups had fewer than 40,000 people. So we made 30,000 people the minimum number to legally constitute a traditional community. There were also other provisions, such as where there was a traditional leader in a certain community there should not be another chief in the same place representing another community. This provision means simply that if one is from tribe X and one lives in the area governed by the chief of that tribe, then the chief of tribe Z cannot appoint his councillor in the area of Chief X. All those people living in the area of Chief X will fall under his jurisdiction, regardless of what ethnic group they belong to. This clause is, however, heavily contested by those tribes who lost their original land during the genocide and are scattered all over the country.

The people in the northern part of the country, north of the Red Line, had no problem with this system. Their traditional structures were intact and functioning properly, but those scattered by the genocide had huge problems that we are still grappling with as a nation to this day. We found ourselves in a dilemma; thus it was important to bring in the clause stating that where there was already a traditional chief in place, no other chief should be appointed.

The next issue was that of remuneration. The question was, should the Government pay the chiefs or not? We decided that since some or

most of the traditional leaders were poor, the Government had to give the chiefs allowances if they were to be able to function as required.

Once completed, the layman's draft was sent to the parliamentary drafters to put it into legal language and then sent on to Parliament for in-depth discussions, as is required. Many issues were raised and amendments made where necessary. The Bill was then passed.

In fact we made a very serious mistake regarding the remuneration issue and this has caused many problems; it has divided our traditional communities and their unity has been broken. The love of money is the root of all evil, and traditional communities that formed one coherent community before have now split into small groups, each one demanding its own chief, claiming to be a tribe on its own. Before the payment story came up, there was no problem being under another chief, but today we have 49 chiefs, with some still applying for recognition, in a population of only two million people. To add fuel to the flames, the Government recently decided to buy cars for the 49 recognized chiefs, to enable them to more easily visit their communities. This was not a bad move, because chiefs do need transport to reach their communities in this vast country, but it has brought fresh applications for new chiefs to be recognized. I have no idea where this will end. Looking back, I think the best thing would have been to set up a trust fund for each traditional community so that they could look after themselves, and not pay individuals.

Peace and Conflict in the Caprivi

After drafting the law on traditional councillors, it came to my attention that there was a big problem in the Caprivi region concerning the chiefs. While I was working there on the Build-Together Programme, in Katima Mulilo, the capital of the Caprivi, I noticed that there was a serious tribal conflict. Initially there were two chiefs, one for the Masubia tribe and the other for the Mafwe tribe. There was great animosity between them and they were not on speaking terms. I was told that this situation had existed for twenty years. I found it difficult to work in such an environment. Even their subjects didn't regard the chiefs with equal respect. Each tribe respected its own chief and the situation was such that people worked with others of their own tribe and language. This long-standing problem needed a solution. As the Minister responsible for traditional leaders, I took on the challenge.

I invited the two groups through their *indunas* (councillors) and informed them of my intention to find a solution to the problem. I decided this should be done sooner rather than later and I fixed the dates when the discussions would take place. I then made up the team that would help me. I invited Advocate Vekuii Rukoro, who was Attorney General at the time, and Albert Kawana, the Deputy Minister of Justice, who was also from the Caprivi, and the three of us went together to the Caprivi in 1992 to tackle this issue. The chiefs had their own delegations. Traditionally, in Caprivi, the chiefs don't talk in meetings, even if they are present, but are represented by *indunas*. Mishake Muyongo was leader of the delegation from the Mafwe traditional leaders, with some senior *indunas*, and the son of the chief and a senior *induna* represented the Masubia traditional leader.

At the start of the negotiations, I briefed the two delegations separately, to gauge their mood. I explained my mission and asked for their permission to proceed. That took about two days; then I was given the go-ahead. Judging from the discussions I had with the chiefs and their senior *indunas* (in separate discussions), I was sure they all wanted peace.

I felt we would succeed because of the seriousness with which the delegations approached the issue. The two chiefs were present in person. The discussions were polite but serious and I could feel that people were eager for peace. We had come at the right time. The breakthrough came after almost a week. Our peace deal affirmed the recognition of both chiefs by all Caprivians; respect for members of all communities; equal treatment of chiefs and ethnic groups by the Government; and encouraged people to work together regardless of their tribe. The chiefs agreed to the deal and shook hands in friendship, mutual respect and recognition. I stood between them, holding their hands, amid thunderous applause and traditional drumbeats. That was one of the proudest moments of my life. I had brought peace to the Caprivi Region.

I felt overwhelmed when the two chief shook hands and their subjects were dancing. I was proudly flanked by the chief of the Masubia tribe, Chief Mora Liswane III, and chief of the Mafwe tribe, Chief Boniface Mamili the 6th. I had achieved the seemingly impossible task of bringing peace and unity to the two divided tribes. It was a very memorable day. The event is still fresh in my memory as if it happened yesterday.

I must sincerely and profoundly thank Comrades Kawana and Rukoro for their guidance. Without their help I would not be writing about that achievement today. I want to thank the *indunas* on both sides and Mishake Muyongo, in particular, who was instrumental in assisting the team from the Mafwe tribe. He was related to the chief and I noticed that the chief listened to his advice. I also want to thank the *indunas* from the Masubia tribe.

I knew that the two chiefs were willing to make sacrifices to bring peace among their people and to move on with developing their region. I'm convinced that without the go-ahead from the two chiefs we couldn't even have held such a meeting. I thank them both profoundly for the courage they took to make peace with each other for the good of their people.

Unfortunately, seven years after all this hard work and the peace we achieved, the very same Mr Muyongo I've praised, turned around and was involved in an armed revolt to break Caprivi away from the rest of Namibia and form a separate country .

Muyongo had been expelled from SWAPO in 1980, during our years in exile, after being accused of trying to revive the Caprivi African National Union (CANU). He returned to Namibia in 1985 and formed the United Democratic Party, which joined the DTA. He himself became President of the DTA from 1991 to 1998, but he was then expelled for heading a secessionist movement in the Caprivi. He alleges that the 1965 agreement in Lusaka between SWAPO and the then Caprivi National Union (CANU) gives Caprivi the right to become a separate state.

In late 1998, our security forces discovered a training camp for Caprivian secessionists operating under the name of the Caprivi Liberation Army (CLA). Thousands of Caprivians then fled into Botswana, including Muyongo and the Mafwe Chief Boniface Mamili, and were given refugee status there. Some also crossed into Zambia but were returned to Namibia. By the end of January 1999, the population of Namibian refugees at Dukwe refugee camp in Botswana numbered 3,700, consisting of 1,872 men fit for military training, 1,828 women and children, and some unfit men.

This chain of events led to the terrible day of 2 August 1999. We woke up early in the morning to discover that there had been an attack by CLA rebels on security forces and government installations in Katima

Mulilo, including the Mpacha military base, the police station and the Namibian Broadcasting Corporation. Fortunately, the uprising lasted only about 24 hours. Unfortunately, at least eight people were killed. Muyongo issued a statement saying the attacks were 'just the beginning'. He and Chief Mamili were accepted by Denmark as political refugees.

That armed revolt was the shortest in the history of revolts. Thanks to the quick and decisive action of our army, it was quickly crushed. However, it led to the arrest of many people and the trial of over 100 alleged participants charged with treason and murder. This trial is still going on.

Many refugees from Caprivi have gradually returned. However, there are still around 980 Namibia refugees in Dukwe, Botswana. I pray that all of the refugees from Caprivi will return to their motherland and join in the development of their country. I pray also that we have seen the back of armed conflicts. Please let us live in peace. We have come out of a long and bitter war of liberation, and we now want to develop the country for our children. War and armed conflicts are the biggest waste of time, money and human life. We are two million people and we have a functioning democracy. Let's solve our differences at the ballot box, and if you are defeated, please don't start a war; go back to the ballot box next time round and try again. Leave us in peace.

Decentralization Policy

One of the main aims of the 1992 Regional Councils Act was that central government should decentralize some services to regional government level. So it was on my shoulders as the Minister of Regional and Local Government and Housing, to initiate and draft a Decentralization Policy. I invited some experts from Zimbabwe to help me.

With the completion of that draft, I had completed everything I was assigned to do in the Ministry of Regional and Local Government and Housing. I was ready to move on. I launched the Draft Policy in September 1996, made a farewell speech, and left the next day for the new Ministry to which I had been assigned.

This Draft Policy was finalized with very little amendment by the third Minister of Regional and Local Government, Housing and Rural Development, Comrade John Pandeni, in 2008. He told me that since this was my baby, I must assist at the launch. I thought it was gracious

of him to invite me to launch the policy I had initiated earlier; not many people who come after the programme has been initiated and developed will give that recognition to the initiator. It is only those with integrity who do that, and Comrade Pandeni was such a man, a humble man, a veteran of Robben Island together with Comrade Jerry Ekandjo, who was my Deputy after Independence in the Ministry of Local Government and Housing. Sadly, Comrade Pandeni died in 2008 in a car accident. May his soul rest in peace.

Minister of Health and Social Services

I was transferred to the Ministry of Health and Social Services in September 1996 after six years of hard work in Regional and Local Government and Housing. This Ministry was not a new one; it had existed since colonial times but had many problems and lots of unfinished legislation to be rectified. When the outgoing Minister handed to me over twelve files containing unfinished work, I was not impressed at all. I felt I had to start from scratch doing the things he was supposed to have done during the time he had been in office. I felt he was going to rest in my former Ministry, as he had been transferred there and I didn't hand over a single unfinished piece of legislation to him.

During my first week, I learned that patients were waiting a long time to be served in the clinics, because the nurses were having morning prayers at work, which meant that the patients were attended to only from 10AM. I went to one clinic and found that this story was true; the nurses were busy praying fervently while the sick people were waiting to be treated. I called a meeting and told them to stop those church services in the clinics during working hours, with immediate effect. They must wake up early, finish their prayers at homes, and come to work by 7.30AM. That is what they were paid to do. I also told them that prayers are a private matter and can't be imposed on others. The nurses accused me of heathenism. I told those who accused me that, heathen or not, the work that put bread on their tables had priority. I told them they were hypocrites. I remember a preacher called me and wanted an explanation about what I meant by calling Christians hypocrites. So I explained why. When doctors take the Hippocratic Oath and nurses take their Oath of Service, we state that our priority is the health of our patients, and if we let them sit around and wait for their medication all morning, we are not adhering to that oath. The preacher understood.

Of course, he was quoting me out of context; putting words in other people's mouths in order to justify attacking them is a well-known trick.

Before I found my bearings in the new office, some nurses started protesting about overtime for which they were allegedly not paid for the past few years. They went on an illegal strike. What shocked me was the involvement of my own niece who was in the forefront of the demonstration. Well, it was her democratic right. I, in turn, reminded them that they were essential service workers and shouldn't go on an illegal strike, and if any patients died as a result of their strike, they would be held responsible for the loss of life. I also said I would be looking into their grievances when I settled down, but for now, they must go back to work. They did go back to work. I was conscious that they were challenging me as a woman and testing my tenacity, but I wasn't going to be harassed by people who seemed to have forgotten the oath they took. Why had they not taken up this issue with the outgoing Minister who had been there for six years?

Kunene Region

I started familiarization trips round the country and discovered a total lack of health facilities in the constituencies of Kaokoland in north-west Namibia. There was a very dilapidated hospital in Opuwo: the roof was falling off and patients were waiting the whole day to be treated. There was a burned-out clinic in Okanguati, apparently destroyed by a gas cylinder inside the building that had exploded. I was surprised that such a gas cylinder could be there. Before I got to Okanguati, I visited a health post, a rotting prefabricated one, in Ohandungu village, halfway to Okanguati. This was all. It meant that people had no health facilities in the whole of Kaokoland except for the three facilities I've mentioned. There were no health facilities for 200 kilometres and no roads to get to the one hospital. Patients in Kaokoland were at the mercy of their traditional healers, because with no roads it wasn't worth trying to get to the hospital. Thus the Kunene Region was totally neglected, particularly Kaokoland. Public health services like immunization and health education were non-existent.

I decided I would start there, build new clinics in Kunene and renovate those in disrepair. I also trained twelve students from Kaokoland and two from Tsumkwe (in Otjonzondjupa Region) as

enrolled nurses, to work in the clinics under construction in their areas, once they had been completed. I started with the two broken-down clinics. Okanguati was renovated and extended and was made a health centre, because patients came from far away and needed to be admitted. According to the Otjiwarongo document that defined guidelines about where to place health centres in relation to population size and distance from other centres, which was always quoted by senior health officials, health centres could admit inpatients. Ohandungu was built again from scratch into a health centre as well. There was no hope of renovating it as the prefabricated material was rotten. Four new clinics, with a nurses' home at each, were constructed at Otjuu, Otjokavare, Oruvandjai, and Otjimuhaka. The last was completed after I had left the Ministry. During my time, many clinics were built in other regions; some were handed over by the new Minister of Health, Dr Richard Kamwi, who had been my Deputy Minister.

The nurses I sent for training finished their studies at the same time as the clinics were completed and went to work at the new clinics. I mentioned that I also trained two nurses from Tsumkwe; only one completed and was sent to the newly built hospital; the other one dropped out.

During my eight years as Minister of Health, many clinics were put up all over the country. I will not name them all; suffice it to say that when visiting the regions later, I see my name on many clinics, which makes me happy and proud. I also introduced many new health programmes. I will mention those I think made a difference in people's lives.

HIV/AIDS

HIV stands for the Human Immunodeficiency Virus, which infects the white blood cells, compromising the body's immune system and making the body susceptible to any passing bug. AIDS is the Acquired Immune Deficiency Syndrome (a group of symptoms), since as a result of the weakened immune system, the body catches any infection and the patient can die from an illness (for example, pneumonia) that normally would not be fatal, if the immune system hadn't been attacked by HIV.

I had first-hand experience of HIV/AIDS in 1983 while in exile in Lusaka, Zambia. One of our teachers was infected. At that time the disease was under a thick blanket of secrecy. Talking about HIV/AIDS

was an absolute taboo. It was treated as a deadly infectious disease and contact with the infected person was avoided at all times. I vaguely remember from my childhood that syphilis had been treated the same way and the patients were isolated. There was a hospital painted red in the town of Otjiwarongo behind the township, where patients diagnosed with syphilis were kept.

From meetings I attended, I knew how HIV/AIDS was transmitted and that there was no cure. However, there was a talk of a new drug that could improve the condition of a patient. This drug was called AZT. It was the only drug of choice available in the early 1980s. I went to see the comrade concerned and he was very ill. This was a big man but he had lost a lot of weight and was looking grey. I ordered AZT through our SWAPO Representative in London but it was too late and, despite my efforts, the comrade died. Maybe he was already in Stage 4, as I know now, and the drug, which was also said to be toxic, was too strong for him. By the time he died he was so emaciated that people visited him, I believe, not out of sympathy but out of curiosity, to see how he looked. Those who came to see him were genuinely alarmed and frightened.

I was also working closely with the World Health Organisation on HIV/AIDS. It was causing havoc in the community, particularly in East and Southern Africa. People were committing suicide, after being diagnosed with the virus, because HIV/AIDS was regarded as a death sentence since there was no cure. There was also the added problem of stigmatization of those infected and affected by the virus. Such people were rejected and isolated even by their close relatives. People were so confused and it was thought that anything the infected person used, such as cups and plates, was infectious, and if the patient died his/her clothing or even the utensils he/she was using were infected. All those items were burnt. I'm convinced that this stigma was responsible for increasing the infection rate, because those who were infected were hiding the fact and were involved in unprotected sex with many partners. There was a saying, 'I will not die alone.' People were frightened to die alone. Newspapers reported the case of a woman in one African country who infected over 100 men, including lawyers, doctors and businessmen, because she apparently blamed them for infecting her, so she went on a revenge trip.

I distributed a lot of information to the people in our centres about the disease and how it was transmitted. At the time I ordered many condoms and people, having seen the teacher who died of AIDS, used the condoms effectively, out of fear. We embarked on a serious education campaign about the disease, its origin, mode of infection and prognosis. We also introduced the ABC approach to prevention: A for abstaining from sex; B for being faithful to your partner; and C for using Condoms. I have no faith in A and B because these two ideals of behaviour are neither feasible nor adhered to, not only in Namibia but the world over. We read and hear every day how people cheat on their partners.

Condoms are the solution. Although they are said to be only 98 per cent effective, nothing in life is 100 per cent. The churches have interfered with the use of condoms but the priests don't work in the hospitals and see the suffering of the AIDS patients. So we used condoms as a form of prevention in our clinics. I also found that condom use depends on whether the male partner is willing to use them. In many cases they are the ones bringing the disease home. I know there will be denials and criticism about this assertion but I am speaking from experience as a doctor who has dealt extensively with HIV/AIDS.

Within Namibia, I've also found out that there are problems in our traditional communities of how much some men understand about the correct use of condoms. Fortunately the rate of infection is very low amongst the people in Kaokoland. The recent research findings showing that male circumcision has preventive qualities seem to confirm our local experience. The tribes in Kaokoland are traditionally circumcised; they don't use any prevention methods and are polygamous; yet they have the lowest rate of HIV infection in Namibia. They do have a high rate of other Sexually Transmitted Diseases (STDs), but not HIV.

Now the use of condoms has its challenges. The question of how to dispose of them after use was a problem in our refugee camps in exile and children often picked up used condoms that had been thrown away in the yard, and played with them, thinking they were balloons. We quickly came up with a refrain: 'Balloons are red, green and blue and not white.' This had a great effect; children would pick up the condoms, sing this refrain, and understand that these things are not balloons because they were white. Readers may wonder where the men came from at the

Mavulu Children's Centre in Angola. Well, it was a popular place and we had lots of visitors.

There are also funny stories about how different people understand the training of how to put on a condom. There are many hilarious stories when condoms were used as a tool for birth control, before the advent of HIV/AIDS. The nurses who were running the family planning clinics were young and shy African nurses, who would not mention the male organ, so they used a broomstick to demonstrate. When I was an intern in Dar es Salaam there was a story (whether it was true or false I don't know), that in one village each bedroom had a broom and it was used to put the condom on and not where it should be put. A particular villager did as he was told, but the wife continued to get pregnant so he came to complain. He said, 'Nurse, I do as you told me but my wife is pregnant again.' When asked how he had used the condom, he demonstrated by showing how he had put the condom on the broomstick he kept close to the bed. A male nurse was called in to show the villager the correct way to use the condom!

More recently, I remember a male nurse telling me a story while I was working in Opuwo. He said that a man he knew one day asked him for help to put on the condom very early in the day because he had a date that evening and he wanted it to be put on during daylight in advance so he would not have to struggle in the dark! My nurse told me that he explained everything about condom use and also how to use one, even in darkness. I hope that the man has learnt everything about the use of condoms and will not walk around 'condomized'. This is a genuine problem which I had never thought of. How to help those living in darkness with no light? It is high time that condom makers put an extra sachet which contains a tissue and empty small plastic container, so that the used condom can be disposed of; this is my patent.

The cause of HIV and its rapid spread has generated lots of discussion and disputes but people have tried to run away from the real reasons for its transmission. I remember one comrade asking me one day while I was working in Dar es Salaam, 'Doctor, this adicy [AIDS], is it not carried by mosquitoes?' This was a valid question. I think people who live in endemic malaria zones such as East Africa must think of these possibilities and the question should be answered with scientific proof, because mosquitoes don't only carry malaria but other diseases

such as Dengue fever. My answer to the comrade was simple: I said that studies have not yet found mosquitoes to be carriers of HIV.

The politics around the means of infection, and also the relationship between the virus HIV and AIDS, the disease, has confused some people, including some doctors, who think they are separate diseases. I maintain that the HIV virus causes AIDS unless proved otherwise by science. As far as I am concerned it is not a question of HIV and AIDS but HIV/AIDS. The HIV weakens the immune system of the body and in the end the body can no longer fight opportunistic infections because of its compromized immunity; then the infected person gets acquired immune deficiency syndrome (AIDS). Owing to its weakened state, the body easily gets infected by any passing bug and the patient falls very sick and dies. With the discovery of Antiretroviral (ARV) drugs in recent years, AIDS is no longer an immediate death sentence as before, and patients who take ARVs can live productive lives for many years.

When we returned from exile in 1989, I went to talk about HIV/AIDS at our institutions of higher learning; that was over twenty years ago. The students had no idea what I was talking about and were giggling in the hall as I was trying to explain to them how the virus was transmitted. In Parliament it was almost the same. As soon as I got up to take the floor in ongoing debates, there were murmurs of 'HIV/AIDS again'. Despite the scepticism around the subject I soldiered on and spoke about HIV/AIDS everywhere I went. Gradually I got support from my colleagues in Government and also in Parliament, as the stories about HIV/AIDS and the understanding of its seriousness became apparent, and when people started dying, I was listened to. Stigmatization decreased and many infected people came out and informed the nation about their HIV status. These were mainly women; the men still kept their HIV status to themselves.

Launching of the ARV Programme

In July 2003, I launched the Namibian ARV programme. It wasn't easy but I disregarded the stories floating in the neighbouring countries of the toxicity of the ARV drugs. Fortunately these stories didn't confuse our people; they readily accepted the treatment, particularly the women. We also started with the training of HIV counsellors, along with the establishment of the New-Start Centres, where people could go to check

their HIV status and get results quickly and confidentially. These centres were frequented mostly by women. It's still an uphill battle to get the men involved in the programme of testing but the women are very committed. The importance of testing is for people to know their status so as to plan for their children's future. It's not for the status to be known by those not concerned, but for the individual to know her/his status and to seek treatment when the time is ripe if they are infected with the HIV virus. Nowadays, people can live for over twenty years with the disease if they follow the treatment; it's not a death sentence anymore.

I provided 20 out of the 34 district hospitals with ARV treatment. Mother-to-child transmission treatment with Neverapin was also introduced. Pregnant women who were HIV-positive were given Neverapin to take home if it was felt they lived far from the health facilities, so that they didn't miss out on the child's first dose, which should be taken within a few hours after birth.

In Namibia we found that men were reluctant to go for HIV testing and even treatment. Because of their right to confidentiality they couldn't be named, but some went on to marry young women even after the death of their spouses, knowing very well that they had tested positive and that their first wives had died of AIDS. I wonder how and whether this disease will ever be conquered. The stigma is still there, but not as much as it was before the success of ARV treatment. The ARV treatment has improved the prognosis of AIDS. However, we still have an increase in teenage pregnancy, which means that young people are involved in unprotected sex and are ignoring the threat of HIV infection. What still worries me is that the HIV/AIDS-free generation we are advocating and dreaming about will not be realized during the next ten or even twenty years as long as the youth ignore the dangers of unprotected sex.

Cardiac Unit

A frequent cry for help came from mothers who had very sick children who couldn't be treated in Namibia. This was mainly children affected by heart disease. Operations to correct defects such as mitral stenos could only be done in South Africa at very high cost, which our mothers couldn't afford. Namibia didn't have its own cardiac unit and patients suffering from heart ailments were sent to South Africa. There was constant call for donations to cover the costs of sending patients with

heart ailments to South Africa, with families asking for assistance from the public. This situation troubled me and I was constantly thinking of how we could set up a cardiac unit in Namibia to deal with this problem. It was not only children; we had a Member of Parliament who had to travel up and down to South Africa for cardiac review after undergoing a heart bypass operation, and the cost involved was astronomical. If we had our own unit, at least visiting doctors and an in-house cardiologist could take care of this MP and other patients.

I started to look around for help and went to India, where I was told that they had a first class private cardiac hospital in New Delhi. I went to visit that hospital. It took good care of all heart patients. With the assistance of our High Commissioner to India at that time, His Excellency Joel Kaapanda, we managed to get a professor who came to Namibia to assist in setting up a cardiac unit. The second floor of the Windhoek Central Hospital was renovated and a Cardiac Unit was built, complete with the 5-bed ICU downstairs; I chose bright colours in which to paint the inside walls, to improve the mood of the patients.

During a meeting in New Zealand hosted by the WHO in Christchurch, I exchanged views with the Kenyan delegation on the health services in our countries. I mentioned to them our problems, the lack of a cardiologist, and also the difficulties we were facing to find equipment and suitable manpower to run the cardiac unit that was soon to be completed. They told me they had a very good cardiac unit in Kenyatta Hospital where they even performed heart bypasses. They invited me to visit and I did so. I attended three heart operations performed by young Kenyan doctors. I was very impressed and felt that we could benefit from them and send our patients to Kenya at a fraction of the R100,000 it cost to send them to South Africa.

There was also a need to train nurses to care for cardiac patients. We agreed with the team at Kenyatta Hospital that we would send twelve nurses from Namibia to be trained in a special course, to run our new Cardiac Unit. We also agreed that, when the Unit was ready, we would recruit one of the Kenyan cardiac surgeons to assist with the operations, and we team up with Kenyatta Hospital for more complicated cases.

In the meantime, we agreed to send our patients to them for operations. With assistance from Kenya we sent 49 patients, both children and adults. The operations were successful, and the patients

came back home. Because of lack of aftercare, some of the elderly patients died later, which made the need for a local cardiac unit even more urgent. However, there were intrigues going on. Some people wanted to continue with the South African connection. I have no doubt that doctors from South Africa from the Groote Schuur Hospital in Cape Town are excellent, but so are the young doctors I met in Kenya and I had seen them in the operating theatre. These doctors were also attached to hospitals in Britain; they were professionals, equal to any others.

I want to congratulate and thank the team of young Kenyans doctors who operated successfully on the Namibian patients we sent them and to Kenyatta Hospital for its generous assistance in training our special cardiac nurses. I am eternally grateful.

The idea of putting up a cardiac unit in Namibia was not received favourably by some private doctors. The objection even went as far as parliament, when the MP I was struggling for gave a speech prepared by these doctors, disputing the viability of a cardiac unit in Namibia. It was said that Namibia couldn't afford a unit because it was costly. Even the cost was calculated in that speech. I thought it wasn't proper for one of the people for whom the unit would be beneficial to stand there and speak on behalf of those whose prime interest was to continue receiving Namibian patients at a prohibitive cost. However, owing to the respect I had for the colleague, I only explained why I thought it important to have our own unit. I also explained the psychological benefits for the patients, namely that they would be in their home environment, their healing process would be closely monitored, and the families would benefit financially because they wouldn't have to fly elsewhere for check-ups.

In spite of this resistance, we completed the Cardiac Unit. Dr Shangula, who was then the Permanent Secretary of the Ministry, undertook the hunt for a cardiologist. He went to the Soviet Union, where he had been trained, to recruit a cardiologist, while I hunted for equipment to furnish the unit. However, we met lots more obstacles. There were complications on the equipment side when one of the European countries promised to provide the equipment, but the transfer was blocked by their banks. The Russian doctor recruited by Dr Shangula came but was rejected by our health fraternity as not suitable, because he

was a thoracic surgeon and not a cardiologist. We then tried to recruit a Namibian doctor who was living and working in South Africa, but there were problems getting him registered in Namibia. So we were stuck. In the meantime our nurses had gone to Kenya, completed their training, and come back home.

The Presidential and Parliamentary elections were fast approaching. After the new President, Comrade Pohamba, was sworn in in March 2005, he appointed his new cabinet. I was transferred and appointed Deputy Prime Minister. Dr Shangula was sent to the Ministry of Wildlife and Environment, to be Permanent Secretary there. Thus we didn't open the Cardiac Unit. I was very sad I couldn't bring the project I had worked for so hard to fruition.

The Cardiac Unit was dormant for three years after we left and was opened with elaborate fanfare on 5 August 2008. President Thabo Mbeki and Dr Manto Tsabalala were invited, but Dr Shangula and I, who had pioneered the project, were forgotten. Fortunately the main speaker, His Excellency President Pohamba, remembered my work in establishing the unit because he was a Cabinet Minister when I was fighting to establish the unit, and he thanked me for the pioneering work in establishing it.

One day recently, I read in a local magazine how one of the doctors claimed fame for what he called his proudest moment, for having established the Cardiac Unit. I called him and told him I was still alive and he shouldn't delete me from my own history. He claimed he had been misquoted.

They have, as I suspected, returned to the status quo, and signed an agreement with South Africa. I have no problem with that.

I spent eight and a half years, from 1996 to 2005, in the Ministry of Health and Social Services. I worked hard in establishing many health facilities in the country, particularly the ones I established in Kaokoland. I am very happy to note that these clinics are well looked after. When I was in Kaokoland last time, I saw Oruvandjai and Otjiuu clinics and I also visited the two health centres, which are in good shape. These facilities are fully utilized and are serving the communities well. What is still needed in Kaokoland is to train more nurses so that the clinics aren't closed when the nurse goes for training as I noticed in Epupa Clinic. Such remote clinics should have two nurses assigned to them.

During the struggle, I saved many people's lives. Sometimes I meet some of my former patients whose lives I saved and it makes me very happy indeed. It is so important to work with patients who appreciate and follow the treatment, and get cured. Occasionally, there are patients who waste the doctor's time by not adhering to his/her advice, particularly the meat eaters with their gout and diabetic patients who don't want to follow their diets.

Failed Attempt at Democracy

As the 2004 elections loomed – our third since Independence – SWAPO was faced with a severe test of its own internal democracy. We needed to elect a new presidential candidate to take over from the Founding Father of the Namibian Nation, Comrade Sam Nujoma, who had completed the constitutionally allowed terms of office as President of the country.

We felt that we must do things according to the democratic principles we preached at every occasion. Three SWAPO candidates stood for election within the party; the victor would be the SWAPO candidate for the Presidency of Namibia. Those three candidates were: the SWAPO Vice President Comrade Hifikepunye Pohamba, Comrade Nahas Angula, and Comrade Hidipo Hamutenya. Comrade Nahas Angula asked me to support him in his campaign and I readily agreed. I had worked with him in the refugee settlements in Zambia and Angola for over sixteen years, so I knew him as a committed and hard-working person. We had to introduce our candidates to the nation at the SWAPO Extraordinary Congress called for this purpose in May 2004.

The first candidate, Comrade Pohamba, was introduced by President Sam Nujoma as his choice, with a very long, elaborate, and glowing curriculum vitae. I was the next, and introduced my candidate, Comrade Nahas Angula. I did a good job and also outlined the true history and achievements of Comrade Nahas. The last candidate was Comrade Hidipo Hamutenya, who was introduced by Comrade Dr Mosé Tjitendero, the Speaker of the National Assembly, an honourable and respected man.

The outcome of the election shocked me because the election campaigners of Comrade Nahas had made me understand that we stood a good chance of winning, but we were defeated. I was under the impression that all was fine, but our candidate was knocked out in the first round. I was shocked. The two remaining candidates, Comrades Hidipo and Pohamba, had to go for a second round of voting. This was

done immediately; there was no time to even caucus within our team to discuss the way forward, so each one voted as she/he wished. Comrade Pohamba won by a huge margin and became SWAPO candidate for the Presidency. In the presidential elections in November 2004, he won 76 per cent of the vote, beating all six opposition candidates by a large margin. On 21 March 2005, he became His Excellency President Hifikepunye Pohamba, President of the Republic of Namibia.

At the time of our SWAPO party Congress, I didn't think we were doing anything wrong. I thought we were doing this as an exercise in democracy, since we claimed to be democrats, and this process would allow Namibians who aspired to high office a chance to test their popularity. The aftermath shocked me greatly. People who had supported candidates other than the one of the outgoing President were ostracised and called names. The hostility that followed the SWAPO Congress continued long after the inauguration of President Pohamba, and saddened me. I couldn't understand why so much hatred ensued. I thought at the time that it was a good move to give people the opportunity to make their choice.

The system of designating the sons or daughters of presidents to be the next President is not acceptable. We read, for example, that former President Hosni Mubarak of Egypt, and former President Ali Abdullah Saleh of Yemen, were intending to appoint their sons as their successors. I don't think the presidency should be treated like a monarchy. It should be open to any citizen who deserves the position. The President is not only going to serve his family but is President of the whole nation. The sons and daughters of sitting Presidents, like everybody else, must stand for election. If they win, that is fine, but they must not be treated like the sons or daughters of a monarch with succession rights. God didn't make them the chosen few; therefore they must get a mandate from their people. I am also a staunch supporter of a time limit for the presidency, which must be adhered to. I still feel that the system we tried in Namibia is fair. However, the backlash from the SWAPO elections in 2004 was very traumatic.

The negative aftermath had serious repercussions. Those of us who supported Comrade Nahas Angula were not openly ostracised but the supporters of Comrade Hidipo Hamutenya were. Comrade Hidipo left SWAPO and formed his own party in 2007 – the Rally for Democracy

and Progress (RDP). Some other SWAPO members joined him. Others didn't join him and remained members of SWAPO but, despite that, they were called hibernators and suspected of supporting the RDP in secret. Friends became enemies, and the situation went from bad to worse. We failed to handle the situation properly.

President Pohamba was nevertheless inaugurated in March 2005 with gusto and fanfare. It was a very beautiful transfer of power, the most moving part of the ceremony being when the guard of honour went over to the new President and the outgoing President moved to where the incoming President had been sitting. After the ceremony, outgoing President Sam Nujoma left in a normal car and President Hifikepunye Pohamba moved away in the presidential motorcade. If only every handover of power were that peaceful across Africa, we would be a winning continent!

After everything was done and the celebrations were over, it was left to the new President to appoint his Cabinet. I was thinking that if I stayed in the Ministry of Health and Social Services, I would be able to complete the establishment of my Cardiac Unit and also continue with Antiretroviral (ARV) coverage of the remaining hospitals. I was wrong. I was sent to a dormant office – that of the Deputy Prime Minister. President Pohamba appointed Comrade Nahas Angula as the Prime Minister. Apparently (unknown to me at the time), people were insinuating that there must have been a deal with Comrade Nahas and me for us to be appointed to these high posts if we supported Comrade Pohamba's candidacy in the second round of voting at the SWAPO Congress – some kind of you scratch my back and I'll scratch yours arrangement. I swear there was nothing like that; at least I had no idea of any such deal, and I also don't believe that anything like that happened. As I explained already, there was no time for a caucus let alone for making deals.

Another Transfer

I was very upset to be transferred from the Ministry of Health because I was hard at work on my programmes. The Cardiac Unit was very close to my heart and I wanted to make it functional but was denied the chance to do so by my transfer. The other programme of huge importance was the HIV/AIDS programme, where I was involved with rolling out ARV

treatment. However, Ministers are appointed by the President and serve at his pleasure, so you can't convince him to let you finish what you are busy with. I also think that the mentality of 'Let me finish what I am doing,' is what causes some Presidents to want to stay in power for their entire life, because there will always be things you didn't finish. It's healthy that somebody else can come in, with maybe a better or fresh idea to finish what you left behind. You can also not refuse an assignment given to you by the one who has the power to transfer you. You are told to start with your new post with immediate effect; no reason is given, no questions asked, and no answers given. So, upset as I was, I packed up my things and moved.

In my case the door that opened help to change the lives of many marginalized people. I know that some people dislike the word 'marginalized' but we can't hide the fact that there are Namibians living on the margins of existence. We saw them on our television screens, so what else am I supposed to call them? The important thing is, that once we discovered how some people struggled to survive, our Government took action and, as I will report, their plight is being dealt with.

Deputy Prime Minister

When I moved to my new office, there was no handover and I found no documents to work on. The terms of reference of the Deputy Prime Minister were to assist the President and the Prime Minister with their duties. I felt dejected; with such terms of reference I could as well sit in the office and twiddle my thumbs, read the newspapers, or come to work only when I was needed. I started wondering what the office was supposed to do, and what was the need for it. I felt I had been put on early retirement. Actually I was secretly planning to rather take my retirement then and do something else, instead of sitting idle in this office. When I shared my frustration with a friend, he said: 'Doctor, I know you will find something to do. Give yourself a few days.' I did exactly what he suggested and indeed quickly found plenty to do.

The Prime Minister, Nahas Angula, and I had worked together and knew each other very well. I respected him and he respected me. He called me into his office and informed me what our responsibilities were, and asked me to chose what I wanted to work with, for example, which Ministries I would like to supervise. After studying the Units and also the Ministries, I decided to take the following: the Ministry of Regional and Local Government, Housing and Rural Development, and the Ministry of Home Affairs; these two were not new to me. The Public Service Unit was new to me but I found the topic interesting. I also chose the AIDS Unit, the Disability Unit, and the Public Service Unit, in particular dealing with the African Charter for the Values and Principles of Public Service and Administration. Since we don't have a Minister of Public Service and Administration in Namibia, this function fell under the Prime Minister's office and I was responsible for that department.

Public/Civil Service and Administration

A month or two after taking up my office, I attended a conference of African Ministers of Public Administration in Addis Ababa. I was a

bit confused and I had no idea what was going on as I had received no briefing from those who attended such meetings before I came on board. I was in the dark, but I got the conference documents and started to follow what it was all about. I met the South African Minister of Public Service and Administration and she helped me by explaining the origin and work of the conference.

Within the framework of the 5th Pan African Conference of Ministers of Public/Civil Service of the Africa Union Commission, Namibia had been assigned the task of chairing the Africa Public Service Day Subcommittee and the Office of the Deputy Prime Minister was assigned that responsibility. The Africa Public Service Day emanates from the declaration of the 1st Pan African Conference of Ministers of Public/Civil Service held in Tangiers, Morocco in 1994. The Ministers agreed that 23 June should be celebrated each year as Africa Public Service Day (APSD), to recognize the 'value and virtue of service to the community'. As such, this day had now become an entrenched event on the Africa Union Commission calendar. Namibia held two annual national celebrations and hosted one biennial continental celebration, where many African Ministers of Public/Civil Service descended on our country.

I worked closely with the dynamic Minister of Public/Civil Service of South Africa, Mrs Geraldine J. Fraser-Moleketi, and the UNDP Resident Representative in South Africa, Scholastica Kimaryo. It was such a coincidence and a pleasant surprise, because I had met Scholastica in Tanzania when I was an intern there. These celebrations were not just for fun; they had serious themes for discussion. I remember the following themes: 'Building an Ethical Public Sector for Improved Public Service Delivery in Africa' (2006); and 'Promoting Good Governance with Emphasis on Anti-Corruption' (2007). I believe these APSD celebrations are necessary to improve service delivery to our communities and we learn from each other through the exchange of ideas. It's also during these celebrations that we have the opportunity to thank the hardworking civil servants who work tirelessly, sometimes under trying conditions. The countries hold their own celebrations for one week in their countries, dealing with specific issues concerning their public servants, and we all celebrate the main theme for discussion

together on 23 June each year. During the continental celebration in Namibia, we managed for the first time to have teleconferences with Ministers in different countries. It was difficult because of the time differences (the continent is large with 52 countries and different time zones), but we managed to talk to each other. I was very impressed by the high level of discussions amongst the Ministers of Public Service from African countries; it was very informative.

Namibia hosted this celebration successfully. We made it a point that our uniformed men and women attended so that they felt part of the service personnel who serve their communities. People should feel free to approach our uniformed force in times of need, and likewise the uniformed forces are duty-bound to assist the people. The Ministers who attended the celebrations were impressed by our inclusion of the military; some told me they would emulate that example. It's important that the military know that their uniform must not be used as a passport for harassment but that they are protectors of the people. In some African countries, the soldiers harass the local populations and generally regard their uniform as a passport to commit atrocities with impunity. We read about rapes and looting committed by uniformed forces in some countries. Thus, by including them as part of service personnel, they feel duty-bound to serve the public.

In Namibia I am immensely proud of our military, who take part in service delivery during floods and wild fires without harassing the communities; they are protectors of the people and their properties. One feels safe in their presence. I am appalled by reports I read in the press that soldiers are feared in some countries because they are not protectors of their people. We are lucky in our country. We have kept the struggle discipline. The PLAN cadres were exemplary and they've upheld that honourable stance. Let's keep it that way. My experience is very different from what I read in the book *This Child Will Be Great* by Her Excellency Ellen Johnson Sirleaf, the President of Liberia (who succeeded in being elected for a second term), about the behaviour of soldiers in her country. I was horrified to read how ill-disciplined soldiers are in some countries. In Namibia we have no such experience, maybe because we fought the guerrilla war and brought that experience to the national army.

The German Special Initiative

As I mentioned earlier, Namibians have fought many colonial wars. Our forefathers took part in these wars and every year we make a pilgrimage to the places where the major battles took place and pay homage to the fallen heroes and heroines.

In August 2004, in Okakarara constituency, we held the 100-year commemoration of the Battle of Ohamakari (near the Waterberg), between the brave Herero warriors and the German Imperial army. The German Government sent a delegation to the commemoration, led by the Federal Minister of Economic Cooperation and Development, Ms Heidemarie Wieczorek-Zeul. The Minister made a very important statement and declared: 'We Germans accept our historic and moral responsibility and the guilt incurred by Germans at that time.' She stated that the massacres committed by German colonial forces in Namibia were equivalent to genocide and apologized for them – the first time that a member of the German Government had done so. She promised continued economic aid for Namibia but ruled out paying compensation. However, the following year, Minister Wieczorek-Zeul spearheaded a German Special Initiative to give 20 million Euros over a period of three to five years for development projects in the Namibian communities that had 'historic ties' with the German colonial government, and to whom the German Government felt a special moral and political responsibility because of the wrongs done to them. They named the Hereros, the Namas, the Damaras, and the San as the communities that would benefit from this Initiative.

In February 2006, the President assigned me to go around the country to explain this Initiative to the people concerned and get their opinion and views. He didn't want to impose the Initiative on them but he told me that if they accepted it, I should ask them to propose projects and put them in order of priority.

The main communities to suffer at the hands of the German imperial forces were the Hereros as well as Namas, Damaras and the San people. The Hereros suffered the most. As well as their loss of land and property, it is estimated that over 80,000 Hereros were killed. The German Government, although recognising that atrocities were committed, refuses to recognize that this was genocide. However, the German Imperial Army General von Trotha signed a written extermination

order in 1904 ordering the killing of the Hereros, including women and children, and Namibians see this as genocide. My task was not easy. The affected groups felt that this allocation of money did not came out of genuine concern but was meant to avoid Namibian demands that the German Government pay reparations like those they have paid to Israelis after the Second World War. The Hereros in particular were furious with the Special Initiative and saw it as a ploy by the German Government to avoid talks about reparations. I had a hard time to convince them that this was not meant to be reparation money but was indeed a 'Special Initiative'. They were also not happy with the 20 million Euros to be shared amongst the various ethnic groups. They called it peanuts and some vowed to continue to fight for genocide reparations through international courts.

I had a hard time to explain the Special Initiative to people and also a hard time from the weather: it was raining heavily. First, I explained that I was not representing the German Government; I was a messenger sent by our President who wanted the people concerned to be informed about the Initiative and to make informed decisions about it. I also explained that they were under no obligation to accept the assistance. The other explanation to the Herero community was that this money was not part of any reparation money they were requesting and that they could continue with their bid for reparations. At the end of the day, all the communities accepted the Initiative. However, the Herero-speaking communities accepted grudgingly. During the discussions, I told people they must prioritize the projects in order of importance and give not more than five projects, and we worked together on the projects and their priorities.

I travelled for over three months to reach all the affected communities. I remember how it rained. February is in the middle of our rainy season. Sometimes the roads were so bad that we could only drive at 20 kilometres per hour, but finally we reached our destinations. This trip lasted from February to May 2006. It was a physically and mentally exhausting time. We had to travel with our tents, pots and pans but, despite those difficulties, I managed to visit all the communities. It was also sightseeing, in a way. I've travelled a lot in Namibia and it was good to see and listen to the people. Sometimes I had to ensure that their requests were feasible. Some communities asked for things

the Government was already busy providing, or projects that would cost more than the monies earmarked for the entire Special Initiative. I am multilingual so I needed no translation, and I think that people accepted me with open arms because I could address them in their own languages.

I completed my task, compiled the report, with the project proposals put forward by the people, and gave the report and recommendations to the President. He in turn gave the responsibility of implementation of these projects to the Director General of the National Planning Commission (NPC). Unfortunately, the Director General who was in the office that time did little for this project because he was dealing with a huge American grant programme – the Millennium Challenge Account – and implementation of the Special Initiative projects stalled for more than three years until a new Director General of the NPC, Professor Peter Katjavivi, was appointed. During his time, things started moving. However, not all the programmes have yet been implemented.

Some people have questioned whether the San people were also affected by the genocide. One of my uncles suspected that it was me who had included them. I didn't respond to those questions but I knew it was right that they had been included because they had also been killed in the colonial wars with the Germans. However, I assisted the San communities to request cattle and housing, because they had nothing. I worked with the Ministry of Lands and Resettlement for the Government to buy some farms in order to resettle landless San people who were scattered all over the country, and I advised the San that it would be helpful for them to ask for projects that would enable them to build houses once they got their farms.

I helped with a request for cattle for the San people, hoping that by the time the cattle came there would be some resettlement farms for the San and they could share the animals. I was privileged to receive 200 head of cattle for the San people in Skoonheid in eastern Namibia. The reason we made a request for the San in Skoonheid was because it was the only San settlement at the time when the Special Initiative started. I was thinking that by the time the cattle came to Skoonheid, other newly created settlements could share some of the cattle, but this didn't happen. I was appalled and disappointed when the San people at Skoonheid refused to share the cattle with other San in the same area.

Their headman was very unreasonable; he wanted all the cattle to be only for his people. However, Skoonheid couldn't sustain the 200 cattle because of poor grazing there. Besides that, they had already received more than 12 cattle from the Government before the Special Initiative was born. I hope that the 200 cattle that are still outstanding will be shared equally with the rest of the San people who did not get anything, now that there are at least five new farms, bought for the San people by the Government.

Marginalized San Communities

After completing my assignment of the German Special Initiative, I wondered what I would do next. I didn't have long to wait. One Opposition Member of Parliament, Honourable Moongo, asked the Prime Minister the following question: was the Prime Minister aware that a San man had died of hunger in one village (he named the village) and if the answer was 'yes', what was the Prime Minister intending to do about it? The Prime Minister was out of Windhoek on the day his answer was expected so I, as Deputy Prime Minister, had to answer that question. I hadn't heard about the person who had apparently died of hunger, so I simply said that I didn't know but I would investigate and come back to the House with the answer.

'San' is the name the Namas use for people who are gatherers (referred to in colonial times as Bushmen or 'boesman'). In Otjiherero they are called 'Ovakuruvehi' (the ancient people of the land), or 'Ovakuruha' in short. In Botswana, the San are called 'Masarwa'. Traditionally, the San led a nomadic life as hunters and gatherers across southern Africa. However, their ancestral hunting grounds were decimated by other communities, and they were specifically targeted and even hunted by white European settlers. They have sometimes compensated by hunting cattle and this has brought them into conflict with other communities.

There are ten San sub-groups in Namibia:
1 !xo; led by Chief Sofia Jacobs
2 Ju/'hoansi; led by Chief Bobo
3 !Kung; led by Chief Arnold
4 Khwe; no Chief yet
5 Haillom; led by Chief David

6 Khoe; led by Chief Langman
7 !Xu (Vasekele); Ohangwena Region
8 Nharo; Tsumkwe West
9 /Nu-//En; Omaheke Region
10 /Auni; Hardap Region.

As this book went to press in July 2012, Chief Arnold sadly died after a car accident. His successor has not yet been appointed.

I don't have a breakdown of the numbers in each group but altogether they number some 30,000 San people in Namibia, mainly in the following regions: Omaheke, Otjozondjupa, Kavango, Caprivi, Ohangwena, Oshikoto and Omusati. They are also found in towns and are scattered here and there throughout the country.

The traditional hunting and gathering grounds of the San people have become inaccessible. Farmers fence off the land, and in some instances they hunt the wild animals from which the San survive. So the San, not having any other source of meat, since they do not own cattle, are accused of stealing other people's cattle. Most San are poor and marginalized but are not thieves in general. Occasionally they may kill somebody's cattle, but this is rare.

Fact-Finding Mission

I went to the President and told him about the issue raised in the National Assembly, and what I wanted to do. I thought the best thing would be to visit all the regions where the San people are found, in order to answer that question. So I asked for permission to travel around the country to investigate the condition of the San communities. The President readily agreed for me to go, to compile a report and come up with recommendations.

Once Parliament went on recess, I started my trip. First, I wrote to the Governors of all thirteen regions to inform them about my trip and asked them to make a programme for me to visit their respective regions, particularly those who had San people in their constituencies. I left for the regions in September 2006 with my delegation, which consisted of my two drivers and one security officer. We were aware that there were no hotels in some places, so we travelled with our own tents, and our pots and pans.

The first region we visited was Omaheke, where we were well received by the Governor, Ms Laura McCleod-Katjirua. She gave us a thorough briefing about the region and, in particular, the situation of the San communities there. The next day we started our visits to different villages, accompanied by her and her officials. Though I was born in a village and knew how people lived in villages, I didn't expect to see the utter poverty we witnessed there. Wherever I went, the San people were destitute. They were living on the margins of existence.

At Independence, we inherited eleven ethnic administrations that had been set up by the divisive South African apartheid system, but there was never any San administration and, unknown to us, the San lived in what I can frankly term a slave-like existence amongst other ethnic groups. They were working without pay; most of the time they were given a pint of local homemade brew in recompense for their labour. First of all, the South African colonial regime that had occupied Namibia, and against whom we had waged the war of liberation, used the San people as trackers to look for the freedom fighters, and introduced them to alcohol, thereby destroying their souls. Their spirits were completely annihilated; they were forced into the position of serving the South African army; and when they got paid they spent the money on alcohol. One white man told me that after they were paid the San men would drink themselves into oblivion, and some actually died. After drinking, they would lie in the sun and some would die owing to the immense heat – probably from dehydration and heatstroke. Their families were stone broke and lived in utter poverty at the time I visited them. Despite all this misery, I noticed that they kept their families together in that horrendous poverty.

During the implementation of UN Resolution 435 in 1989 that led to our first fair and free elections, the South African army left Namibia. Realising that Namibians were about to return from exile, and under the pretext that an incoming black government would kill the San, they took some San men who had been their trackers back to South Africa with them. These San men left their families behind in destitution in abandoned South African military bases in Namibia. I think the South Africans took the able-bodied San men and I often wonder what happened to them. It reminded me of the end of the Vietnam War, when the defeated Americans took some Vietnamese soldiers along and

left others when they were departing. I watched how some Vietnamese people were climbing and clinging to the American helicopters as they evacuated their headquarters in Saigon, and were pushed off by the American troops. Some Vietnamese who had worked closely with the Americans were taken along, but most were left behind. The same thing happened to the San; some were taken by the army to South Africa but the rest were left behind with no assistance.

When I got to these abandoned bases I found the San starving, and I suspected that the question asked in Parliament might be true. Alcohol abuse was also rampant. I realized I must schedule my visits and meetings for the morning; if I started in the afternoon, nobody was ready to listen because women as well as men were intoxicated. It seemed to me that the San people had given up living and were only existing as long as the sun rose and they happened to be alive that day. I also wondered where and how they got alcohol from in the state they were in; they were unemployed and had nothing to eat, and many children didn't go to school. I came to learn that shebeens belonging to the locals were mushrooming in or close to those bases, so alcohol was easy to find.

After Independence, the San worked as labourers amongst the other tribes with whom they lived. Some worked on various farms, moving from farm to farm, their children in tow, and in such a situation the children never went to school. Thus 95 per cent or more of San people are illiterate. Adults aren't able to count their money and are cheated by unscrupulous business people, so the situation is dire.

I also found that sometimes the parents didn't know where their children were because other people had taken them on the pretext that they would send them to school, but instead they used the children to work for them. Some of those people never returned the children and I was so appalled, particularly by the disappearance of the children, that I threatened one man that if he didn't bring one boy back to the parents, I would have him arrested. I found the sister of the boy and put her in school in Windhoek with a good family who knew the child's mother, but until I retired I didn't find the boy. There was no point in arresting the old man who had 'sold' the child because he claimed to have lost contact with the person who took the child. I left the matter in the hands of the Governor of the region to pursue this case.

Identity Documents

A big problem was that the San people had identification cards given to them by the South African army and had been issued with birth certificates with the wrong dates of birth, given randomly, regardless of their real age. So we found that the very old were listed as being 30 years of age, according to their cards. In other cases, we found that a child was given almost the same age as its mother. At least an estimate could have been done based on appearance, and surely an old woman could be seen to be at least 50 and not 30? So when I was travelling around I was struck by how disadvantaged the San people were, in all respects. They had no Namibian national identity documents and none of them received monthly national pensions because they had been identified as being under 50 years old, while the national pension money starts being paid at 60 years.

Many San elders missed out on national pensions and other benefits, and this situation would have continued if Hon. Moongo had not asked his question in Parliament, which prompted this investigation. Thank you, Hon. Moongo.

No Coffins

Another very sad story was that San people were buried in plastic bags because they couldn't afford coffins, and where some municipalities didn't allow burials in plastic bags, the remains of the deceased stayed in the mortuaries for months. I found some whose bodies were forgotten in the mortuary for a year, yet I knew that there was a policy that if the body was not collected by relatives after three to four weeks, it must be buried by the local municipality. Another reason why bodies remained in the mortuaries was due to lack of transport; the San people were unable to collect the remains of their loved ones since they had no money and couldn't afford to hire a car to take the body for burial. A further reason was that ambulances don't carry corpses, so even if the patient had initially been taken by the ambulance to the hospital and then died, her/his remains could not be taken back by the ambulance. There was also another serious problem. Because of the frequent lack of a proper known address, information about people dying couldn't be sent to their relatives, and since they couldn't be contacted, the bodies remained in the mortuary. This was a Catch-22 situation.

Donations and Dependency

It was a daunting task to solve the many problems of the San people. Besides being poor, it seems to me that the San people had given up on any prospects of improvement and were either not able or not willing to help themselves. It could be that the conditions under which they lived had made them lose all hope in their lives.

As I mentioned earlier, the San who didn't go to South Africa were left in the army bases to fend for themselves. They had no possibility of feeding themselves and lived from hand-outs given mainly by the churches. Nobody seemed to have heard of the Chinese proverb, 'Teach a man to fish rather than giving him fish.' Thus, those who were giving assistance continued to feed the San, with no possibility of the San ever being able to help themselves. They developed a serious dependency syndrome and sat around waiting for hand-outs. During our discussions, the San reported to me that there were those amongst them who had a tendency to sell anything they were given, in order to buy alcohol. In one of the regions I was also told by concerned neighbours that people from other ethnic groups wait around to buy the things given to the San immediately after any donors have left.

However, there were some organizations, for example the Ombili Foundation, and some churches, which were doing commendable services for the San people. The Ombili Foundation had created the best facilities I saw during my investigation.

Schooling

The Roman Catholic Church was running a beautiful school in Omaheke. The Dutch Reformed Church also had programmes in Tsumkwe and surrounding villages, where the majority of the San are settled. However, despite these efforts, San children dropped out of school at an alarming rate, mainly owing to the nomadic behaviour of their parents who travelled round the farms, regardless of the school programme. I found that most San children only completed Grade 5 and very few reached Grade 7. The dropout rate was almost 90 per cent. There was a feeble attempt to put them in hostels but these were inadequate and not worth mentioning and, moreover, the parents had no money to pay for the hostels. They were required to pay N$200 per annum but this was out of the reach of parents.

I thought at first that the parents were not keen on their children's education but as I listened to them I realized that it was not a deliberate move but because of their dire situation and hunger that they had to travel around. I put myself in their situation and realized that if I were living in such terrible conditions I would be visiting relatives to get some food to eat. What would the children eat and what future would there be in school if I was living in grinding poverty? Thus, as the parents went up and down they took the children along regardless, and they missed school. There were also some children who never attended school at all – these were the children of farm workers whose parents were very mobile, moving from one farm to the other. There was an attempt by some farmers to put up schools on their farms for the children of their farm workers and other workers in the neighbourhood, but again the schools only went up to Grade 5.

On most farms there are no schools and if the children want to stay in school they have to stay in hostels far away. Some good farmers help to transport the children of their workers to school, but after Grade 5, the children usually drop out. Even where I found community school hostels, the San children were seriously disadvantaged because the parents were required to pay N$200 and the conditions in those school hostels were appalling, to say the least.

Land

The San are the first people of this land; we see their engravings and paintings in our mountains all over the country. They should not live on the edges of the road and squatter shacks in towns. We must give them a place they can call home. They are living on other people's farms and can be kicked off there arbitrarily with no compensation and dumped on the edges of the main roads. I found some living in a disused swimming pool in one of our towns, in untold misery. They had been told to leave their farm work to join a so-called development programme that was supposed to help them, but when I went there I found total destitution. Those who were running the programme were so obese they could not turn their necks, while the San people were starving.

If we are to succeed in improving the livelihood of the San and their ability to feed themselves, and send San children to school, they must be given land they can call their own. Most other Namibians, however

poor or rich they are, have villages they call home where they were born or grew up, where they go to spend their holidays and where they are buried when they die. The same must be provided for the San people. Only then can we expect that they will settle down and feed themselves. Once they have land there should be no excuse for them to continue living on hand-outs.

Recommendations

After completing my three-month trip, I wrote a long report with the findings and recommendations the President had asked for. My first and most important recommendation was that, in order to tackle the San problem head on, we needed to make exceptional efforts to fast-track the development of the San communities, by creating a special programme dealing solely with their problems. My second recommendation was that this programme should be treated as urgent and given special Government funding. I named the programme the 'San Development Programme'. The Cabinet endorsed this name. However, some members of Cabinet questioned the validity of singling out the San when there were other poor people in the country. The same argument was used as with the special quota for women that I discussed earlier. Others argued that there were other poor people, so why was it only the San who should benefit from a special programme? I replied that yes there are poor people, and even some whites are poor, but there is a difference between individual poverty and collective tribal poverty.

We should be concerned as a nation by the situation the San people are in and not come up with irrelevant excuses for scoring political points. I stand by what I wrote because that is what I found. I didn't cover up anything because the reason I travelled around the country was to discover the truth so that the Government could solve the problem of the San people, based on correct research and findings. I told those who were disputing my findings that they depicted the true living conditions of the San as I had found them. I was also accompanied by the media to record the findings. His Excellency the President gave me a full mandate to investigate and recommend what should be done, and I did just that. The South African army is the culprit. They destroyed the San people, but we have to salvage what is left of them. Now it's the responsibility of the Namibian Government to uplift them; they are our brothers and

sisters. Fortunately most of the Cabinet members were supportive of the proposed programme and it was agreed upon.

The first task was to assist the San people with food, and I proposed that there should be a dedicated programme like a drought relief programme, until the San could feed themselves. This should not be a haphazard provision but be organized properly and sustainably so that food is given periodically, while we make projects to teach the San how to fish (i.e. to become self-sufficient).

The second programme I proposed was to develop a training programme to make coffins. The San are very dexterous people and they could learn quickly how to produce coffins, so that no San person should ever again be buried in a plastic bag or lie in the mortuary for months on end.

Education Solutions

One outstanding school for San children was the Huigub Primary School near Tsintsabis, supported by the Lions Club of Germany and run by Namibians of German origin. I was invited to visit this school, and when I arrived, I was told a very sad story of a child who had gone missing and his body had been recovered on the neighbouring farm a week later. After school on a Friday, the child had got lost on the way home to the farm where his parents were living. It was during winter, when it's dark by 6PM. The school principal explained to me that children had to walk between 12 and 14 kilometres to go to their parents every day, because there was no hostel at the school.

I was so saddened by this news that I approached the Lions Club of Germany, through the Ombili Foundation, for assistance to put up a hostel at Huigub School. They very generously agreed to build a hostel for the school during the course of 2008. This is an outstanding facility and includes a hostel and dining hall. The school principal, Tate Shilongo, and I were invited to the official opening in 2011 and felt very privileged and happy to reach this milestone of helping to provide such a beautiful and comfortable facility for the San children.

I remember how distressed Tate Shilongo was when he had started that school many years ago with 20 plus children, and it was a milestone for him to retire and see the fruit of his labour. The school has over 200 children now. For me, it was a huge satisfaction that I had helped to save

the lives of the children by arranging for the building of that wonderful hostel funded by the members of the Lions Club. I am eternally grateful to them; no child will now die walking to their parents owing to the lack of a hostel.

I am convinced that without education, we will never turn around the lifestyle of the San people; so education of the San children must be amongst the top priorities. If we give education to the San children, they will help their parents and break the stalemate. So 'education, education, education' is the salvation of the San community.

Today there are many more San learners in schools than ever before. Various new schools have been established through my initiative, such as Berg Aukas Project School, Auns Project School, Uitkoms Project School; and several kindergartens and pre-schools in Uitkoms, Okatjoruu, Corridor 17, and Makaravan in the Caprivi Region. The teachers are paid by the San Development Programme. You can read more about this in the next chapter.

In early 2009, we launched the campaign for San learners to enrol at the Namibian College of Open Learning (NAMCOL), so that those who drop out could have another chance and rewrite Grade 10. Invitations were sent to the regions to find ten such children from each region. This project is generously funded by Icelandic International Development Agency.

The next programme was to assist children to stay in school by helping to pay their school fees and by giving scholarships to those who reached Grade 7. Later, during the Implementation Phase, we came up with the motto 'San children back to school and stay in school.' The San Development Programme pays the school fees for the children, including tertiary education.

The San Development Programme

I put a team together in my office to start the San Development Programme, and the Government allocated it a budget of N$400,000. The first priority was to find farms for the San people because it was no use giving them assistance in the squalid conditions they were living in, because everything would be wasted. Food was also needed urgently before the dedicated programme could start. We started to make food available while seriously looking for farms.

Uitkoms Farm

It was a lucky break that the Ministry of Lands and Resettlement, headed by my former Deputy Minister of Local Government and Housing, Comrade Jerry Ekandjo, had bought a farm in the Otjozondjupa Region for resettlement a year before the San Development Programme started. This farm was still not allocated to any resettlement project. I got wind of it and I quickly rushed to see that farm – Uitkoms. Unfortunately, the day before I arrived some people broke in and removed various items, even though someone was guarding it. Uitkoms was a beautiful 6,400 hectare farm, very suitable for resettling the San people who were squatting in the Omatako constituency, in the empty, old swimming pool at Okahandja, and along the roads in an area of Otjozondjupa. I got back to Windhoek and told the Minister about my visit to the farm, about the break-in, and the whole story of the plight of the San people in the region. I impressed upon him that the farm would be very suitable for resettling those landless San people. Shortly afterwards, he agreed to hand over that farm to the San Development Programme for the purpose of resettling landless San people. I was immensely grateful and quickly,

before others got wind of it, resettled 53 families there, consisting of 306 people, using my old style of covert operation.

As I mentioned, these people were the ones who were hanging around the roadside, and those who had been lured with false promises and dumped at the dry swimming pool in Okahandja, to fend for themselves. I must thank the Municipality of Okahandja, the Councillor of the Omatako constituency and the then Governor of Otjozondjupa Region for the assistance they rendered the San Development Programme by providing transport quickly, which enabled us to move the people out of their misery. They were very eager to move and, within two days or so, all of them were moved without a problem. We put them into tents temporarily, not knowing how long they would be in them and praying for a miracle.

So another 'Tent City' was erected, this time to house the San families at this very beautiful farm. The neighbours, mainly white farmers, were horrified, to put it mildly. They had serious issues with me for resettling the San people there. The same stereotyping attitude was at play. The farmers accused me of total ignorance about the Bushmen. 'Do you know the Bushmen?' they asked me. 'They will steal our cattle and hunt our game,' I was told. After they had let off their anger and frustration, I asked them a simple question and I was unusually calm. I said, 'These are Namibians like you and me, where do you want me to take them?' I told them that the farm was given to the San people by the Government and they were here to stay. I asked them rather to assist the San, their new neighbours, with the skills they have, in order to prevent them from doing the things they had just talked about. The younger farm owners and their wives were not as virulent as the older ones. In fact one young man committed himself to help. He offered to employ some of the San people on his nearby farm and assist the project in any way he could.

When the meeting was over I thought I was finished, but the very next day some black people from a communal area in the region came very early in the morning to tell me that they had mineral rights on that farmland, which had been given to them by the Ministry of Mines and Energy before the farm was sold to the Government. I told them that when the farm was given to the San Development Programme, no mention had been made, either in writing or verbally, about any mineral rights issued to anybody and that there would be no mining

on this farm: 'Over my dead body,' I said. It became a tense political issue, which generated a very unpleasant atmosphere, while discussions with the Ministry of Mines and Energy dragged on. Some officials in that Ministry seemed to know nothing about the issuing of the mineral rights.

I was also told by the Ministry of Lands and Resettlement that when the farm was bought, there was no such discussion about mineral rights of any individuals, and it seemed to me that, since this was such a beautiful farm, people were taking chances. The handover of such a farm to the San was painful for some people. I kept hearing the old prejudiced statements: 'She doesn't know the Bushmen. How can such a beautiful farm be given to the Bushman? They will just waste the land, and nothing will take place on this farm.' But I stood firm, the project continued and we started with the building programme.

An anonymous donor appeared on the scene, just as I was wondering how long the tents would last. The weather was battering them with rain and strong winds and they were already showing signs of wear and tear. This Good Samaritan was Swedish and he donated N$500,000 to the project. It came at the right time. We decided to use that donation as seed money to start the construction of houses, because the Government funding of the whole San Development Programme was only N$400,000 and we could never have managed to start building houses with that limited allocation. The tents would not have lasted another six months, and we reckoned correctly that if we embarked on the housing programme with the San people making bricks themselves, and I used my skills to design and plan the layout, the costs would come down. The San people were given training in brick-making and I did the planning and house design. We then only needed to buy cement. We managed to save money to build these houses without paying fees for an architect or planner; I took that over and no extra money was needed to pay me. When I had earlier asked our housing parastatal to do the layout plans for us, they asked for money the project didn't have, so I decided to do the planning and layout myself. I recall how I asked one of my officials, a very tall fellow by the name of Thomas Shilongo, who was 1.8 metres tall, to lie down on the ground so that I could measure the length of the veranda because I couldn't find my tape measure and I needed the width of 2 metres. I had great fun working on those houses!

We started with the brickmaking programme. There were ten San people who were trained on the job in bricklaying and as builders. This group included five women and two of them excelled and became serious builders. We employed one supervisor to make sure that the bricks were properly made and dried out before use. I remembered my former bad experience with wet bricks by over-eager participants in the Build-Together Programme, so I was very strict with how the bricks were treated, because there could be no room for wastage. The San people themselves, assisted by the supervisor, built their farm, and it soon became a small town.

These were simple two-room houses and didn't need the skills of an architect to design and plan the layouts. We only had to pay for the instructors who trained our bricklayers and builders and we gave small stipends to the workers. They needed things like soap, Vaseline for their cracked hands as they worked with cement, and some other items. We didn't even have to buy bricks because we made our own. The only cost we incurred was to buy cement and other building materials.

The Ministry of Defence put a truck and a driver at our disposal to transport the building materials. The Directorate of Emergency Management in the Office of the Prime Minister helped us with food for the population of the Uitkoms Farm. When we resettled the people, we borrowed tents from the Ministry of Defence as well as from the emergency unit. The Government gave us another N$400,000 to add to the money donated by the Swedish donor and we completed the whole project in about 18 months.

We built 36 houses for the community, a big school to cater for pre-school, Grades 1, 2 and 3, an office for teachers, houses for four teachers, a house for the nurse, and an office building for the small town. All in all, the whole housing project cost approximately N$1.5 million; a huge saving. The private sector came to contribute, led by leading businessman Mr Sidney Martin and his colleagues, who built a clinic for the community of Uitkoms. We built the house of the nurse, one dry toilet for the nurse and two dry toilets for the patients, male and female. We engaged the Otjiwarongo Clay House Project to build dry toilets and a shower for each house. The houses only had two rooms but they were large; the idea was to allow for partition since San people have large families.

Other ministries also helped, for example the Ministry of Energy provided electricity through its Division of Rural Electrification. The Defence Ministry gave free transport; the Ministry of Health assigned a nurse, and the Ministry of Education assigned teachers. The project became a resounding success. The neighbours, who had been sceptical, relaxed and the San people showed the nation that they could be responsible and productive members of society.

I am immensely proud of that project and of the San people who showed those who were insulting them and me that they were quite wrong. I invited the donor who trusted me with his money to visit the town to see for himself. I am immensely grateful for his timely assistance. I also thank other donors: the private sector led by Mr Sidney Martin for building the clinic, Mr Peter Koep for donating a deep freezer; and those who donated animals. Sidney Martin gave two milk cows, Mr Tjihero gave a Brahman cow, President Pohamba donated a cow and I donated a boerbok ram: 'Charity starts at home.'

President Pohamba was invited to officially receive the completed town and to hand over the houses to the owners. He was elated and couldn't believe what he saw. He wanted to know how much the project had cost, and when I told him, he couldn't believe the savings we had made. I was a proud town planner and architect! It was a very memorable day. All the San chiefs were invited to the handover ceremony. Some of them met 'lost' family members at that celebration. Because of their nomadic lifestyle and the fact that the San can't read and write, some families had lost contact with each other. They had thought that their relatives were dead and it was a surprise for them to find each other. There was such a happy reunion. They couldn't talk enough with their families, so they decided to stay overnight and continue to share their stories. The development of the San settlement at Uitkoms farm enabled these families to finally meet again.

This was really a festive day. The teachers organized the school children, who recited poems in praise of the Government and of those who had worked hard to provide a school for them, and me in particular, for being there for them. The visiting chiefs made very moving speeches and encouraged their subjects to take care of the farm. The nearby school sent their pupils to assist in serving the guests at the banquet. These were San learners from that school and the girls looked very beautiful.

The population of this settlement have become very proud owners of their small town. When the handover was done, the settlement was televised for almost a week. There was one malicious person who couldn't hide his dislike for the achievements of the San people. This person urged the television to stop showing Uitkoms but the television went on to show the beautiful farm for days on end and what the San had made of their town.

People have since planted flowers and made the place beautiful; the school is growing, and the clinic is serving the population well. The nurse is one of my San trainees who completed her enrolled nursing training just as we were completing the housing project, so, after a period of internship she was transferred there. She is supervised and supported from Okakarara Hospital. The school has a principal and all the teachers are female and, as usual, they are working hard. Many people are astonished to see that little town, and I think they have respect for the San people now. I am very proud of my achievement and my hard-working officials. I am very proud of the San women and men who rose to the task and shamed those who were insulting and degrading them as being nobodies. They stood up to the challenge and showed the nation and the world that they are capable of performing, given the opportunity. I am eternally grateful to the Swedish gentleman who contributed such a large amount of money to the project, for his trust in me that his donation would be used for a good cause. Thank you.

This beautiful place was not supported by all, however. There were those who were jealous of the Uitkoms success story and one Sunday, in broad daylight, the solar panels, which cost the project some N$48,000, were stolen. I think that it was with the connivance of some of those inside. When people are poor and deprived they can even sell their own grandmothers, and I think the man assigned to guard the solar panels must know something about their disappearance. He should have been on duty that day but he left the place and was socialising elsewhere, so there was nobody on guard. I was so dejected and upset that I left the farm without a solar pump for six months. I only had it replaced because the clinic needed water. How can someone be so callous as to steal from the poor and how come the poor fail to appreciate when something is given to them to improve their livelihood?

After we had established the Uitkoms settlement, I approached the Women's Action for Development (WAD), an NGO run by the dynamic Ms Veronika De Klerk. She spearheaded the training programme in Uitkoms, where one group was trained in bread making and others in sewing and computer training. Those who were trained in sewing became very good and are making school uniforms. The bread makers were also very successful and made very tasty bread.

However, there was a major problem as they didn't know how to administer their money. Even before they bought bread flour to make more bread, they had shared the little income they made between themselves and I had to always buy the flour for them, since we needed to eat bread when we worked there. We asked the NGO to come back and train them again in management skills, and how to save money. Unfortunately, I didn't see any improvement to write home about, because as soon as we left, the situation went back to square one. I feel that if we had only had women to run the project we would have been successful. I found that the San men dominated the group, and the one who had made himself the supervisor of this programme kept the little income in his name. I think the situation has improved but only slightly. The team of uniform makers, which was made up only of women, fared better; they made really nice school uniforms. My office donated the material and again WAD sent the trainer and gave the San some sewing machines. That project is still doing very well. As I write I am smiling, thinking of one of my colleagues, who will say that it's typical of Doctor Libertina with her thing about working with women, but it's the truth. I am also happy to have only female teachers. I know the children, particularly the girls, are safe and children are receiving the best education because the female teachers are mother figures and have the interests of the children at heart.

I am very pleased with the progress at Uitkoms; it shows that the San people have lived up to the Chinese proverb 'Don't give a man fish, but teach him how to fish.' Truly the San community in Uitkoms has been taught to fish and they are fishing.

Land for the Haillom

After we were given Farm Uitkoms for resettlement of the San in Otjozondjupa Region, the new Minister of Lands and Resettlement,

Comrade Alpheus !Naruseb, bought farms in the Oshikoto Region on behalf of the Government, and handed over four of them to the San Development Programme for resettling the Haillom – the San group who originally came from the Tsumeb/Etosha area.

History has it that before the arrival of Europeans, the Haillom group lived around Lake Otjikoto because there was no water in Tsumeb. The area was dominated by a 12-metre high malachite hill, which the Haillom guarded with bows and arrows to prevent anyone from stealing the copper that was found there. When traders came from Owamboland, the Haillom would carry the ore from the hill to Lake Otjikoto to trade. They didn't smelt the copper ore themselves but bartered it with the Aandonga people who walked from Owamboland to collect the ore. On arrival, the Aandonga would light a fire to report their presence; once that fire was lit, the San knew that the traders had arrived, the Aandonga would display their goods under a tree, consisting of axes, hammers, knives, spears, arrow heads, pots, tobacco, salt, and green glass beads (from Angola). The Haillom would place their goods nearby – copper ore, ostrich eggs and sinew strings – and exchanges would take place. It is said that after business was finalized, the Aandonga people would immediately make a fire and smelt the ore on termite mounds, and then carry the smelted copper back to Owamboland, in baskets made from Makalani palms that they had brought with them.

With the arrival of European colonizers in the 1880s, the Haillom lost their land, and much of it was turned in 1908 into the huge wildlife reserve, the Etosha Game Park, which included the Etosha Pan. The Haillom had to then move into the towns of Tsumeb, Otavi, Grootfontein and Outjo, often as squatters. After Independence, the Namibian Government bought some of the farms surrounding Etosha from the whites who owned them, and gave the land back to the Haillom group. This means that the land that had originally belonged to the Haillom was returned to them. The Government thus implemented one of the recommendations I made, namely that of land acquisition for the San people.

The Haillom group of San are strong and very hard working. They were not used as trackers by the South African Defence Force and didn't have a 'hand-out' mentality. In fact, when they lost their land, they moved into the adjacent towns and worked in those towns like

everybody else; they are thus used to work. They manage their lives well and are not dependent on alcohol either.

Once the farms were given to the project, we worked fast and resettled the Haillom onto two of them – Seringkop and Mooiplaas. The other two farms were not yet ready for resettlement. With experience from our successful work at Uitkoms, we found it easier to deal with this group and within fourteen days we had resettled 545 households on the two farms. The Ministry of Education acted quickly and a school was built on Seringkop; the hostel is in the planning stage. Fortunately these farms are close to each other, a matter of 15 to 20 kilometres distance apart, so the school will cater for both farms. However, a hostel is very necessary so that children don't have to walk a long distance to school. This area is close to the Etosha Game Park and sometimes wild animals may escape from the park, so precautions need to be taken to protect the children walking back and forth.

The Haillom got busy with constructing their own dwellings the moment they received their farms. My office helped with the demarcation of the plots and also with the gardens. The Ministry of Agriculture sent an Extension Officer who assisted with the garden project. What was missing was a hostel and electricity. The electricity lines are only one kilometre from the school, so I had a word with the Minister of Mines and Energy about it before I retired, and hopefully that will be extended to these farms. The garden project was very successful and produced enormously big onions. The women sent me some from the first harvest of onions, which I had helped plant. They also produced other vegetables and are selling them to the surrounding lodges. I'm very impressed by their entrepreneurial spirit and hard work.

The Government has, within the short period of four years since the start of the programme, dealt in part with the land question. However, the San in the Omaheke Region still need at least one or two farms. Many of the farms in that area are owned by whites and have become outrageously expensive, so it will take a while and perhaps a change in legislation to acquire farms for the rest of the landless San in the Omaheke Region, who have no place to call home.

The San from the east have Tsumkwe as their town and many surrounding villages. Tsumkwe is growing: there are schools and a hospital and even a petrol station which recently opened there. We

have also undertaken training programmes there and the San have been supported with donated livestock. A donor organization has also built a hospital, so the life of people in Tsumkwe is gradually improving. People are settled there. What is needed now is continued support. The long gravel road (over 250 kilometres) is dangerous and needs to be tarred; and provision for cellphone network coverage in the area is urgently needed.

Identity Documents

The Minister of Home Affairs, Rosalia Nghidinwa, is a lady of action. When I reported to her the plight of the San people and their lack of national identity documents, she offered to send her team to all the regions where the San people are found, to register them so that they could be issued with documents. We were aware that most San people don't know their dates of birth, so efforts had to be made to make an approximation, and distinguish those over 60 years of age from those under 60, so that those who qualified could receive their old-age pension. Minister Nghidinwa's team, as she promised, went around the country, registered most of the San people, and issued them with national documents. Today those who are over 60 are receiving their pensions.

I also introduced an adult education programme to teach the elders to write their names and to count their pension money, because many were badly cheated by some unscrupulous business people and shebeen owners because they couldn't count their money. This was an unusual programme, where I was assisted by UNESCO. After three months, most of my graduates – the pensioners – could differentiate between the red 100-dollar bill and the browny orange 20-dollar bill. I put the pensioners in graduation gowns on the day of their graduation, which the Prime Minister, Nahas Angula, found very amusing, but I told him that I wanted to make a difference in their minds and also to show off to encourage others to follow their example and learn about their money. I think such courses will improve the quality of life of the old people if they can control their money and be aware of what things should cost, instead of being robbed by the shop owners. The pensioners would give a 100-dollar bill for something that only cost about 10 dollars, and would get no change back. Those who went through the course are wide awake

now and know the difference between 10-dollar and 100-dollar bills. I must tell you how important and proud they felt on the day of their graduation. There was one particularly sharp old lady who came out top of the class; she was a no-nonsense woman and I was very proud of her. The old men struggled more and I think they continue the usual habit of depending on their wives to learn; they made little effort. I teased this old lady and told her that she should open a small shop because she was such a quick learner and outperformed them all during the practical test, counted her money correctly, and gave the correct change.

The other remarkable development is that the San people have their dignity restored, they no longer walk with their heads bowed, and they demand what they perceive as their rights. There is support for the programme in Namibia. The private sector, and individuals as well as NGOs, have joined the programme. I think that the San people will undergo a visible improvement in their lives sooner rather than later. Of course they are still poor, but they now feel more included in Namibian society. The Government is working hard to take them out of grinding poverty but this will take time.

Campfire Stories

When we worked on these programmes we used to travel by road and stay in tents. I had my two drivers, one security officer and two officials with me. We all stayed in tents but there were those amongst us who snored at different decibels and pitch, some who were altos and others who were baritones! I'm very sensitive to night noises, particularly snoring, but fortunately my security officer, who put his tent next to mine, didn't snore. We carried our pots and pans, food and firewood with us, and appointed cooks from the communities we visited. Otherwise I might have had to teach them how to cook or even be the cook and I didn't have the time for that! In the evening, we sat around a big fire and told stories. Some of the team members were gifted in storytelling and were full of hilarious stories. They had a great sense of humour and the evenings were pleasant.

One evening around the fire, one of our team members told us a story that he swore was the holy truth. The story was that a San woman's child, three years old, had passed away and was left for over three months in the mortuary, as the mother had no money to buy a coffin to bury her

child. The owner of the farm where the San woman worked was an old man. After a while, he became sick and he died in hospital. His body was kept in the same mortuary where the child's remains were. When the time of the funeral of the old man approached, the child's mother (let's call her Maria) was sent to the mortuary to prepare the body of the old man for burial, dress him, and put him in the coffin. She cried so much as she was preparing the body that the mortuary attendants were flabbergasted and couldn't understand why she should be so upset about the old man's death.

Maria reluctantly told them that her own child's body was in the very same mortuary, and she hadn't been able to bury her because she couldn't afford a coffin. The attendants came up with a plan to help Maria bury her child. They simply put the body of the child in the same coffin as the old man, placing it down between his legs, because during the viewing of the body before burial, people only see the face and upper body. So the old man was buried with Maria's daughter between his legs. At the funeral, Maria again couldn't control herself and cried inconsolably. The widow of the old man said to Maria, (and I must say this in Afrikaans): '*Maria stop tog met huil, die oubaas was siek en hy is nou hemel toe* – Stop crying because the boss has gone to the Lord; he was a sick man.' Maria responded: '*Ek huil oor dit tusen die bene van die uo baas* – I am crying over that thing between his legs.'

As we all know there is only one thing between the legs of a man. Maria was suspected of having had a long-standing affair with the boss to the extent that she was crying over 'the thing between his legs' even after his death, and she was kicked off the farm. The good thing is that the widow didn't insist on knowing what Marie meant, she was so angry about her cheating husband. '*Nog met a boesman meid* – and with a Bushman servant!' she said. Had Maria mentioned what was between the legs of the old man, they would certainly have removed that 'Bushman child' from the coffin and thrown away the body.

Making Coffins

The story was funny but it was also sad, and it said a lot about the realities facing the San. We started a project to teach San people how to make coffins. There were many unpleasant challenges. I wanted somebody with carpenter skills to teach the young San men to make simple coffins

but there was an assumption from those we approached to help that there was lots of money to be made out of this. Fortunately, a couple who owned a small coffin-manufacturing business came to our rescue, and Standard Bank donated N$70,000 for us to train fifteen young San people (five from each of the three regions of Omaheke, Otjozondjupa and Oshikoto). This reputable company, run by a young Afrikaans-speaking Namibian couple, not only trained the San in coffin-making but also in how to behave appropriately when serving bereaved families. Since some of these students had never seen the sea, the couple also took them to the coast during long weekends. They trained fifteen young students who, after a brief period of cultural shock, adjusted to the new environment, started to work very seriously, and built excellent coffins that even other communities benefitted from. The trainers were very pleased with the fine workmanship of the students, and so was I. Actually when it comes to craftmanship, the San have excellent capabilities. They are master artists, as we can see from the rock paintings in Namibia attributed to them.

At the completion of the two-month programme, each trainee was given a toolbox with all the equipment he needed to start with, and materials for ten coffins. The idea was that each trainee would make ten coffins and sell them in order to purchase new materials for the next batch of coffins. Since it was their private project, they were also advised to make a small profit for themselves. I regret to say that the dependency syndrome kicked in and the trainees gave the coffins to people without insisting on payment, because they assumed the Government would provide more materials. It took some time and agony from my side to drill into their heads that this was their project and that they were expected to make money from it; the Government couldn't give them materials, they needed to buy them for themselves. The couple who did the training continued to support the young San until they could stand on their own two feet, but it was an uphill battle. It took some time but slowly the young entrepreneurs started to make some headway.

The regions were told to take ownership of this project so that they could buy coffins from these trainees and make sure that in case of the death of a poor San person they could give the family a free coffin, but all others must pay. When I was Minister of Health and Social Services, I had made a special programme to provide funeral benefits for pensioners

and the San pensioners also benefitted from that programme, so the coffins were only free for San people who were destitute and under the age of 60.

These coffins were much cheaper than the normal commercial ones, they cost only N$800, whereas other coffins cost between N$2,000 and N$20,000. Of course the quality was different, but a coffin is a coffin. Some Regional Councils defaulted on payment; one region took nine coffins and never paid. The arrangement had been for them to buy and pay for the coffins. Thus my office had to intervene with some assistance in the form of providing more materials to the coffin makers.

Sadly, I am informed that this project has collapsed. Two of the trainees from Rundu have died; the rest of the group disintegrated and the project collapsed. It's a great pity. The project should be revived because it was helping the poor.

One afternoon during the coffee break at the National Assembly, I was sitting with some Members of Parliament, when one of them told a story about a relative who passed away and that he told the family to buy one of Libertina's coffins. I was taken aback; I didn't realise that these coffins made by the San were dubbed 'Libertina's coffins'. This was like the Horseshoe Market in Katutura that came to be called 'Libertina's Market'.

I'm convinced that the lack of education of the San has a role to play in the problem of sustainability of projects and also the dependency syndrome, but I am hopeful that the new generation will perform better as the education of the San progresses.

Bee-keeping

One morning I received a call from the Kenyan High Commissioner to Namibia. He told me that he had two visitors from Kenya, who were flying back to Nairobi that afternoon, whom he wanted me to meet before their departure. He informed me that they had a project which he thought might be suitable for the San people. I quickly rescheduled my morning appointments and asked them to call in. These two men had a bee-keeping project and were producing honey. I was very impressed and told them to please come back and train our San people. One of them did return and we trained three groups of people. When the training was completed, the project was launched and each group was given their

own beehives and all the necessary equipment. We ordered the beehives from Kenya. After a month or so, I went to visit the projects and I found the two groups from Caprivi excelling and producing honey. A woman trainee in one of these groups was the first one to produce honey after training, and when I visited she gave me a jar of her honey. There was also a group from Omaheke but they told me that their bees had flown away. I think they just lost interest. How come other people's bees hadn't disappeared? Honey making can be profitable if it is properly supervised and people in villages could make a living from it. I thank the Kenyan High Commissioner for alerting me about the existence of such a project, and I urge our people to continue with it.

Education

Education of the San children was an absolute priority and took a large chunk of the money from the San Development Programme's budget. The government topped up the fund in the second year and made it N$800,000, and we enrolled five San students in the Polytechnic of Namibia and four in the University of Namibia. We placed 40 San children in various secondary and high schools. I concentrated on children's education because it's important that the young generation move away from the dependency mentality of their parents. Although I haven't made a survey to see how the school attendance rate has improved, I am informed by people I meet that there is a marked improvement and that more San children are now in school. I am also happy to note that the parents encouraged their children to go to school in Uitkoms while I was working there. The project paid for those children who were in Grade 7 to continue with their secondary education.

Four San students graduated from the Caprivi College of Education in Katima Mulilo in 2010 and two more graduated in 2011. We also trained over ten enrolled nurses, one of whom is in charge at the clinic at Uitkoms. I can't claim that the problem of students dropping out is over, but there is definite improvement. If the 49 children I left in primary school at Uitkoms complete their schooling, there will already be many who will proceed to secondary school, God willing. That is already a sizable number of educated San who will complete high school, and some of them will hopefully go to university.

I must admit that although lots of work and efforts are put into their education, the San, and particularly the males, have a tendency to walk away from their training and work. In 2009, we sent fifteen young men from Uitkoms to a Youth Training Programme in Rietfontein, but I'm told that only five remained in 2011; the rest dropped out. Unfortunately, the young boy whom I struggled to put in a good school and who was employed by Namdeb sorting diamonds, earning N$8,000 a month, left the job to babysit his girlfriend because of jealousy. Now he is roaming around unemployed. I'm told that the girl left him because he was no longer earning the N$8,000 and he is now looking after someone's cattle. I pray that the next generation will be more serious and work hard and improve their lives by staying in school and getting a better education, thereby improving their living conditions and those of their families.

Inclusion of San in Education and the Workplace

I have sometimes been accused of destroying the culture of the San by sending the children to school, thereby changing their lifestyle and the culture. But when I ask such accusers whether they will give up one part of their farms to the San people to practise their culture of hunting, the answer is always a resounding 'No.' I'm convinced that advocating keeping the San in the *oerwoud* (forest) will kill them off slowly. It's also hypocritical to think that some people must stay in their simple shelters and not develop, while others are enjoying clean water and proper housing. Let's concentrate on educating the young San children so that they can also earn the fruits of independence, like every other Namibian. 'Forward ever, backward never,' is the motto of our Founding Father, President Sam Nujoma. The Government must and is doing its best to take the services to every Namibian and will not keep members of some communities hamstrung in the name of preserving culture. What culture is that – the culture of hunger, poverty and ignorance?

I'm aware of the cultural shock the San must suffer, but there is no open land for hunting and gathering of wild fruits nowadays; the farmers have fenced off their land and they have claimed the ownership of the wild game. The world is moving into the computer age. Until when are the San people expected to continue to be hunters and gatherers? The San need to realize that the life of yesterday is probably gone for good. This is the era of 'facebook' and San children should also

join in. Government and the private sector should assist them to make the transition from the hunting to the computer age. The San are very clever and will become good computer specialists. The good things in their tradition, such as their unique dance and hunting skills, must be encouraged, but as a tradition rather than as a means of survival.

As Deputy Prime Minister, I also advocated a policy of inclusion of the San in the workplace and in Government Ministries. In keeping with that philosophy, and also the maxim that charity starts at home, I appointed two young San men in my office to work as what we call institutional workers. In the end, I was left with only one, as the second one was dismissed for disorderly behaviour and alcohol misuse. I also recruited a young San woman at the same time; she is still working at my former office. I think if we can encourage more women to work in Government Ministries, we will see changes in the life of the San more quickly since the women, as usual, are more responsible. Many San workers just walk away from their employment, sometimes because of women. However, I guess we must be patient since they have lived from hand-outs all their lives and they often go back to the hand-outs. 'Why work if parents have a pension and Government provides food?' seems to be the mentality. I've noticed that this behaviour is common amongst some of the San from the east, since they were used by the SADF, introduced to alcohol, and suffered a breakdown of their culture and society. I haven't noticed this amongst the Haillom group of San.

There is generally a phenomenon in Namibia that women tend to do better than men, even with issues like HIV/AIDS testing at our New-Start Centres. Women are more committed than men. This, I believe, is partly because of the way we bring up our boys, telling them that, 'men don't cry, men are tough and should not be sissies.' However, we ignore the sensitivity of boys as they are growing up. The UN and other donors rightfully concentrate on the education of the girl child and we don't think of boys' education, so often the boys aren't given attention. However, these girls will have to get married one day to their age mates, and if we neglect the boys of their age group, who are they going to get as husbands? It will be a problem in Namibia. It's no wonder there are so many rapes and so much violence against women and children, because the boys are left out of our programmes and continue with their chauvinist behaviour. At the end of the day, they are the ones who are

filling up the prisons and joining prison gangs to prove how macho they are. In Namibia, girls form the majority of students in almost all school grades. However, any time a female is appointed to a new job the first questions asked are: Who is she? Who knows her? Can she do the work? When it comes to males, it's taken for granted that they will be able to do the work, but at the end of the day, the female outshines the male. There is an increase in violence against women in the homes because the men feel their role as breadwinners and as head of the home is usurped by educated and employed women.

San Traditional Leaders

Today the San have their own chiefs who speak on their behalf in the languages they understand – I am very passionate about people keeping their mother tongue. We helped to enable five chiefs to be recognized as San traditional chiefs. One is a woman, Chief Sofia Jacobs, a very outspoken, dynamic and hardworking woman, who is changing the whole scenario of women's place in the society. She has been very vocal in advocating education for her people, particularly the children. This woman has brought respect to her people. In 2011, another woman was elected chief of the Ovambanderu community. This is a very welcome phenomenon. I can imagine these two women chiefs working together. They will make a big impact because they are in neighbouring constituencies.

Two of the San chiefs – Chief Sofia Jacobs and Chief John Arnold – went to the United Nations Conference of Indigenous People, in New York. What an experience! I was told that the woman was a performer; she was accompanied by my official and spoke very well through the interpreter.

The future of the San people worries me. The Government must not abandon them. The San Development Programme needs to continue for at least the next ten years. The future is in the hands of the children who are now in school, so that when they are 20 and 30 years old there is a likelihood that the life of the San will have visibly improved. I also worry about the alcohol and drug abuse taking its toll on the young men aged 20-25. More projects need to be developed to keep the young men busy. I have encouraged music to be introduced in San schools and I notice that they are good at it, and that is one programme that

needs support. Teenage pregnancies and early marriages are other issues that need attention (this is also a problem amongst other marginalized communities). Until we build capacity and educate women, the changes we are aspiring to will elude us, because women are the pillars of any community or society.

Mountain Folk in the Kunene Region

The Kunene Region, particularly Kaokoland, is pristine, with unspoiled forests, and some of the most beautiful mountain ranges in Namibia. The Zebra Mountains stand out in my opinion. To complete the scene, the great Kunene River flows, forming the border between Angola and Namibia, and cascades down at one point in the stunning but frightening Epupa Falls.

It is one of the safest areas in Namibia, where women can walk by themselves from village to village; when darkness comes they make a fire and sleep in the open. The people are very friendly, handsome, tall and strong; they walk many kilometres on foot, or occasionally they may ride donkeys. The women are strong-minded with their own views; in meetings they speak out on issues and make their points, and their opinion is respected.

Most of the people of Kaokoland are nomadic pastoralists. They consist of loosely connected groups – the Ovahimba, Ovatjimba, Ovatue, Ovazemba and Hakaona. They resemble the Masai of Kenya, who are also nomadic pastoralists, inasmuch as they live in a very traditional manner. They wear no Western clothes and, until recently, the men walked around in loincloths, with their buttocks bare. It's only relatively recently that they've started to wear cloths around their hips. I explained earlier that my maternal grandfather was from the Ovahimba tribe. Since he was in the Second World War, he wore Western clothes, but when he died his tribesmen came to the funeral wearing traditional loincloths.

Similarly, the Ovahimba women are bare breasted and wear skirts made of cowhide. The Ovahimba, Ovatjimba and Ovatue women rub *otjize* on their bodies, as a form of decoration, and to protect their skin

against the sun, the wind, and the winter cold; and they have beautiful smooth skins. *Otjize* is made from a mixture of animal fat and reddish ochre powder. The Ovazemba and the Hakaona women use fat mixed with herbs rather than ochre, which makes their skin look blacker.

Generally, the Ovahimba tribes are not regarded as marginalized, since they are often wealthy pastoralists with large herds of cattle. However, the Ovatue have been treated almost as slaves by the Ovahimba and they moved into the mountains to escape this. It is the Ovatue people whose lives I became involved with.

In the first half of 2006, a story was broadcast on national television showing starving people from the Kaokoveld. We learned later that these people, unknown to the Government, had lived in the mountains all their lives and came down only because of starvation that had been caused by prolonged drought. There was no food in the mountains; they were surviving on honey, wild fruits and small animals, but even the wild fruit had disappeared. Later, they told me that they used to plant their millet in the mountains but due to the lack of rain their crops had failed. People may wonder how people can plant on the mountains; well, they can. The mountains in that part of Namibia often have unusual flat summits and one could even construct a town on some of the mountain tops. In the crevasses of these mountains there are also fountains, so people can live in the mountains peacefully, as long as the rains come. During the drought, however, the crops will wither and, as happened this time, people can starve.

President Pohamba was visibly shocked that after twenty years of Independence we apparently had people living in the mountains whom the Government didn't know about. He flew to the Kunene Region to see for himself and to speak to the people and learn first-hand about their situation. On his return, he called me in and requested me to take care of these people under the San Development Programme. He gave me full executive powers to deal with the situation. I was told to resettle them on land and construct houses for them. He put emphasis on 'houses', not tents as is my habit when I resettle people before I build houses for them. The Government immediately earmarked N\$3 million for this programme. There was a team headed by the Secretary of Cabinet that was responsible for purchasing building materials and providing water

by drilling boreholes. My responsibility was to find land, resettle the people, and build houses for them.

I left for Kunene with my trusted team of two drivers, my security officer and three of my officials. We also recruited two young women, school leavers from Okanguati High School in Kaokoland, as volunteers to help us with the cooking. We had our pots, pans, food, and firewood in tow, and since it was very hot, one of our more enterprising team members, Aaron Clase, found a gas fridge for us. We settled in the town of Okanguati in the house of the Agricultural Extension Officer there, and started the hunt for suitable land. I wanted land where there was a river and also in the vicinity of the mountain where the people came from, to keep the same environment. The first area we visited was in the beautiful Zebra Mountains, east of the small town of Okanguati in the Epupa constituency.

I had a very tough time with the chiefs or headmen of the areas where I needed to resettle the people. In Namibia, according to the Constitution, all communal land belongs to the Government and the chiefs are custodians of the land. Therefore I needed their permission to settle people on the land under their jurisdiction. They regarded the Ovatue as low-class people; they even referred to them as 'Ovatua', a derogatory word in Otjiherero, something almost like 'Kaffir' in Afrikaans. As I came to know them and listen to their stories, I decided to change the name being used to describe them from the derogatory 'Ovatua' to their rightful name, 'Ovatue', which means sharp-minded or brave people. The other problem was that the Kunene Region was a stronghold of the opposition parties, particularly the DTA and UDF. As a Government Minister and a member of the ruling party SWAPO, I was looked upon with suspicion but I was lucky because I am Herero-speaking and needed no interpretation. I was also given full authority by the President to speak on behalf of the Government, and I decided I would take no nonsense from any of those chiefs, their headmen, or local politicians. I decided that, for the sake of these poor people, I would use my authority to the maximum to get what I wanted. I wasn't going to allow anyone to dictate to me where I should resettle the people, so I looked around for suitable land, with the priority being that water should be available.

I told the local chiefs that according to the Constitution, Namibians have the right to settle anywhere in the country. I also told them that I was being courteous and polite by asking them for a piece of land and that I would only accept land where there were rivers so that people had drinking water whilst waiting for a borehole to be drilled. I also informed them that our work would be to their advantage because, if the Government resettled these people, services such as clinics and schools would be built and clean drinking water would be provided, and this would also benefit other people living in the area.

The chiefs and the headman started to listen and Chief Horo, the senior chief of Otjidanga, was convinced. Despite objections from his headmen, he told me to go and look for a suitable place to settle the Ovatue people. He also told me which area was occupied and which was not. I had already looked around and told him which area I preferred – a lovely area with a view of the stunning Zebra Mountains. The place I wanted to settle the people was Otjomuru, situated between Otjidanga and Otjikondavirongo, a beautiful place facing the mountains, on the banks of the great Okanguati River. Pools of water exist in certain parts of the river all year round and the place I wanted was where the river had water. It was very important that water be available since, as we all know, 'water is life.'

Fortunately this area was not occupied, so it was allocated to us. There was a small outpost there with one family who were also Ovatue. This particular family lived on that outpost and only went into the mountains to collect honey or wild fruits. Unlike the other Ovatue, they had goats. They didn't stay in the mountains because the husband was suffering from what I later diagnosed as asthma; I then treated him and he got better. He is still alive as I write this story. Unknown to me, this area was where the Ovatue had originated from. It's strange how I picked that place without knowing that they had come from there a long time before going into the mountains. The headman gave me a place close to this outpost to settle the Ovatue, and the family at the outpost welcomed their kith and kin with open arms.

I immediately informed the Office of the Secretary of Cabinet about the new place, and building materials arrived soon afterwards. We moved out of our house in the small town of Okanguati, to our new settlement a little further east, and into our tents.

Otjomuru Village

I started to design the layout of the houses using the prototype house from the National Housing Enterprise (NHE). These were very simple one-room houses made from corrugated zinc sheets. The layout was such that no house would look out onto another. I also made sure that there was enough space at the back of each house so that people could put up their traditional structures if they so wished. The corrugated zinc roof sheets were suitable for building in the mountains. They were easy to put together and only needed poles on which to attach the roof. Each house needed 13 poles and 36 zinc sheets and we could construct two to three houses per day, depending on the hardness of the soil and how many holes we are able to dig per day; if the place was very rocky, it took longer. Sometimes digging the holes was very hard, as it was a mountainous area. As usual, I did the lay out and joined the builders to dig the holes to put up the poles. We appointed a Red Cross volunteer who had experience in how to erect those types of houses; we were the *handlangers* (assistants).

I also became the village doctor because there were no medical services anywhere nearby. I treated patients in the morning and joined the building teams after seeing the patients. I had my group of diggers – teenage boys – and they would let me dig for a short time and then form a queue to take over digging one after the other. We decided to dig one hole at a time. They had to be deep enough to hold the poles because we didn't use cement to strengthen all the poles, except for the ones at the corners. It was such a pleasure to work with those boys. They also enjoyed working in my team; nobody absconded from work until break time. They would tell me stories about what was happening at the moment and who was stung by bees during the honey collection, and how to behave with the bees so as not to be stung. Our cooks would prepare food for the teams and we would all eat together under the trees.

We built sixteen houses for the families. We also constructed a clinic and a school, two houses for teachers, and one for the nurse. The drilling team came and sunk a borehole close to the river bank. The water was plentiful and very sweet. The team provided a solar pump, to pump the water, and we constructed a house there for the caretaker who would guard the solar panels. This system is very economical, because after the initial cost of the solar panels there is no operating cost. However, it's

not theft-proof, as we discovered at Uitkoms. The only way is to guard the solar panels 24 hours a day.

We also fenced one hectare of land to make a garden. It was important that people started planting as soon as the rain started so they could feed themselves and not get used to depending on the feeding programme from the Emergency Management Unit in the Prime Minister's Office. We hired a local businessman who came with a tractor to plough the garden. The people were given seeds and tools. A very hard-working Agricultural Extension Officer showed them how to plant the crops.

A very efficient man by the name of Faris Karutjaiva was assigned to us by the Ministry of Gender and Child Welfare. He helped us with the distribution of food and the purchase of items such as three-legged pots for cooking on an open fire, plates, utensils, cups, and 20-litre water containers to store the water. At the start, the Ovatue people drank water directly from places they dug out by hand in the river. That's how they used to get water. They would also cup water in their hands to give to the children to drink. They hadn't seen cups, water cans, or pots before.

The building of the houses only took two weeks and people moved in as soon as they were ready. We had three young women to cook for us, and they became very handy in assisting the men and women in the use of the new utensils and showing them how to cook mealie meal in the three-legged pots. The project provided the food: maize meal, cooking oil, beans, and tinned food. The first day of cooking with these pots was very funny as the women who were cooking mealie meal took the whole 500ml bottle of cooking oil and poured it into the pot. Our cooks came to their aid to show them how to do it and within a short time they learned how to cook beans, mealie meal and other foodstuffs they had been given.

I brought medicines from Opuwo Hospital to treat the sick and it was a lot of work for me to supervise the building and treat the sick at the same time. I had no nurse to help me, so I trained our three school-leaver cooks in basic first aid and how to treat simple common illnesses. These girls were Grade 12 school leavers. They started to count the tablets and put them in small sachets. I taught them to dress wounds and about general hygiene, so I had 'nurses' to help me. Today, these volunteers are qualified enrolled nurses.

It was cold in Otjomuru and although the Ovatue people wear only traditional skins, I used my own money and bought the women some warm shawls, and some shirts for the men. I was cold and wore a warm shawl and a coat and I felt embarrassed that I was wearing warm clothing and sitting in front of them, whilst watching them shivering in the cold. I was also aware that I might be accused of changing their culture or interfering in their lifestyle by giving them clothes, but I went ahead anyway and gave them clothes to keep them warm. We also received donations of clothing from a clothing company and I distributed those to the people. Again I was told off by people who were not Ovatue for changing their culture. I ignored their comments. As usual, they were talking without knowing how cold it was and how people's health was negatively affected by the cold. The children were always coughing and shivering, while the women walked bare breasted and the man with bare buttocks. I had to treat lots of colds because of the weather, so I decided to give them clothing and the bed sheets that a hotel had donated to us. Immediately, there were fewer colds. The women were happy to cover themselves with the bed sheets to keep warm. I must say that people were happy; nobody made any negative remarks about wearing clothes. I wonder whether we are not compromising the health of people, particularly the children, under the guise of tradition. After I provided shawls, the people felt warm and their coughs and colds disappeared.

A word about the children: the tribes in Kaokoland take good care of their babies – they are so cute and round. I was tempted to pick them up but since they are usually shining red from the *otjize*, I knew I would become red if I did so. I was also afraid that I might drop them as they were slippery from the *otjize* lotion. When I was Minister of Health, I visited Opuwo often, and there were always two weighing bags for the babies – one was red and the other was colourless or black. The red one was to weigh the children of the Ovahimba who use *otjize* and the other for children of the Ovazemba tribe, who don't use it. I was advised to use the mixture and I did use it on my face when we were building the villages. Since fat was not available, and because these people had no animals, I bought them Vaseline out of my own pocket to mix with the ochre. All the donated items, whether bed sheets, curtains or blankets, became red within a few days, but I was happy that the people were

warm and told them that it didn't matter that the white bed sheets were red as long as they kept warm.

The Safari Hotel had donated hundreds of bed sheets, pillow cases, curtains, and old carpets. These items came just at the right time and we distributed the items to people on all our newly acquired farms, to San Development Programme beneficiaries and school hostels, and to the new villages we were building in Kaokoland. I thank them for these donations. They were extremely useful and timely. The Chinese business community in Namibia also donated new mattresses and beautiful warm blankets during the month of June, and they too came at the right time. The San and the mountain people benefitted. The programme was well supported by many private companies, and I apologize that I can't name them all here. I just want to thank them for their contributions, and to inform them that they saved marginalized Namibian communities from the cold. In fact many children could have succumbed to pneumonia and died had it not been for these generous donations. I distributed the mattresses and blankets to the school hostels where children were sleeping on the bare floor and that was very much appreciated by the school children.

The teachers at the Otjomuru school were volunteers, Grade 10 and 12 school leavers from the Kunene Region, who had the same traditions and language as the Ovatue people; some of them were themselves Ovatue. The Ministry of Education appointed one qualified teacher to each of the schools in the three villages we built. The Director of Education in the Kunene Region was a wonderful woman, and as soon as the Otjomuru school building was completed she came with furniture for the school – chairs, benches. etc.

After we completed our work in Kaokoland and built three villages, Otjomuru became the star and won prizes as the best-run village. It is well organized, with committed people who work together.

Otjikojo Village

The next village to be developed was in the Otjikojo constituency. It is far from Otjomuru and Okanguati, in the west. It has no spectacular scenic mountains or any large river nearby but we wanted to settle people near the mountains they had lived in.

A small community of Ovahimba people lived around Otjikojo and there was a borehole provided by the Government, albeit poorly maintained and often lacking the diesel to fuel the water pump. Here I had no problem with land. The young headman gave a small piece of land near the existing homesteads for us to settle the mountain people and, unlike the first village where we had only Ovatue, here we had Ovatjimba and Ovatue. This place had a very bad road; in fact all the villages in Kaokoland had very poor roads, just made by cattle and occasional cars. Since those who lived in those areas had no cars, no attempt had ever been made to make better roads. Generally people living in Kaokoland walked from place to place, which is why one rarely finds obese people, suffering high blood pressure or diabetes, there. One doesn't see men with potbellies either. I can safely say they are generally very healthy. When I was Minister of Health and Social Services, I built lots of clinics in Kaokoland and I remember that one small clinic was later made into a school because there were not enough patients visiting the clinic on a regular basis to keep it going.

At the beginning of the programme in this village, we had to buy diesel for the water pump in order to get water for our settlement. Later, whilst we were in the middle of the construction, the team came to drill for water, but the first borehole was dry and the second and third boreholes were very far from the centre. One was 10 kilometres away and had water but the distance was problematic. The other borehole was about 2 kilometres from the centre but had very little water, so we still made use of the old borehole. After people had moved in, another attempt was made and drilling resumed; this time sufficient water was found in the dry river bed, 7 kilometres from the centre, and a pipe was laid to bring water from there.

We spent over a month in this centre. In the first phase, we built 25 houses, a clinic, a school block, a house for the nurse, and one for the teacher, a storeroom and three houses for the guards who guarded the solar panels at each borehole. I worked both as planner and designer of the layout of the houses, using the same prototype.

Again, we fenced one hectare of land, ploughed it, and used it as a garden. This was very important because at the end of the day the people had to feed themselves. Pots, pans, cups, utensils and water containers were given to this centre as well. The Agricultural Extension Officer came

again and with his help and training, we planted vegetable, mealies and beans with the people. Unfortunately, many villagers planted tobacco after the first harvest instead of food crops.

The Director of Education provided school furniture. My team of three cooks-cum-nurses once again taught people how to cook and how to use the equipment, and helped in the clinic; by this time they were competent in sorting pills and could dress wounds on their own. Three drivers and a truck were assigned to us by the Ministry of Defence and we worked with this well-disciplined and hard-working trio until the whole project was completed. One of them was a beautiful woman driver.

In this village, there were many sick people because of the very cold weather and the bedding we received from the Safari Hotel was very helpful. The scenery of this village was not all that beautiful but that's what we got, so we had no choice. The community was also diverse; there were two different groups, the Ovatue and Ovatjimba, with more Ovatjimba than Ovatue. Unlike Otjomuru, these people had poor discipline and there was an alcohol den nearby where they went to drink. Alcohol was not allowed in our new villages, but Otjikojo was near another village where alcohol was sold and the younger men went to drink there. The alcohol was brought in a rickety car to the house used as the bar. Since members of two tribes were living there together, there were some misunderstandings and the alcohol consumption and a lack of discipline made this place difficult to run. One night, when the young men came back from drinking at the bar, one man fell on the glowing red coals of the fire and sustained horrific burns to his left leg. My newly trained nurses dressed his wounds until he was well. I warned the villagers very seriously about alcohol misuse but I heard later that this same man fell in the fire again. This time I was not around to treat him, and he was admitted to the Opuwo District Hospital.

Since there was a solar panel for the boreholes it was easy to provide electricity to the school and the clinic. The Ministry of Mines and Energy installed electricity in the houses of people as well as in the school and clinic. The day the lights were switched on, the people gazed at these stars in their houses, with awe and amazement. They had a big party, singing and doing traditional dances, and the village was ablaze that night. People thanked the Minister of Mines and Energy,

Erkki Nghimtina, profusely, when he came personally to hand over the electricity to the people, telling him that they would no longer be sleeping in the smoke because now they didn't need to make fire in their houses to give them light at night.

President Pohamba wanted to officially hand over the first houses to the people but the presidential helicopter couldn't land at Otjikojo because of the soft sand. So I was authorized to do the handover on behalf of the President. I invited some of my colleagues, the Ministers, to the handover ceremony. They all came and were shocked at the state of the road, and wondered how I had managed to stay for over a month travelling to and fro on such a road. 'Well,' I joked, 'I am an old freedom fighter!' After the first phase was completed, we went back to build ten more houses to accommodate a group of people who had missed out earlier because they were not present in the area when the transport came to collect them. The Ovahimba people are nomadic and like to move around.

The school rapidly filled up and we had to construct an additional classroom block. The Ministry of Education came to furnish them. What was impressive in all this was the fact that the children, who at first couldn't even say 'Good morning' in English, could sing the national anthem in English when the President came to visit a year later. By then we had found a place with a hard surface where his helicopter could land.

The programme also gave goats and cattle to the people. These people had no livestock, so the Government decided that we should buy some for them. The people of Kaokoland are pastoralists and cattle represent wealth and culture; they give people their soul and importance in that region. Without animals you are nobody. Traditionally, milk is the staple drink but meat is rarely consumed. Cattle are slaughtered mainly for occasions such as weddings or funerals. Thus, when a cattle baron dies, people stay on long after the funeral to eat meat. Our team undertook the process of buying animals from the local farmers in the areas where we were building the villages. Each person was given three goats and a cow. We bought the goats and distributed them first while we waited for the cattle. We also bought five rams per village. The bulls and rams were shared by the village. This was done in all three villages we built.

In Otjikojo, some villagers sold their goats to buy alcohol. This was done by the men without the knowledge of the women, who reported it to me during my subsequent visit. Those who had sold their animals lost out when we distributed the cattle later. Buying cattle was problematic, since the farmers were not selling cows but only heifers, which would take two years or so before they could produce a calf, meaning that the people would have to wait a long time before they could drink milk. However, we bought the heifers because there was no other choice, and we wanted to support the local farmers. Some people in Otjikojo again must have sold their animals, because they claimed to have taken their cows to the mountains to graze and I never saw one cow in that village up until the time I retired. A decision was taken that those who had sold their livestock would be excluded from any future donation of animals. Someone told me the other day that they are now crying when they see people in the other two villages milking their cows, and regretting what they did.

When this village was completed, I was so exhausted that I went back to Windhoek to rest a little and recharge my energy, and also to attend Parliament before tackling the building of the third and last village. The President had started asking where I was, forgetting that he had sent me out to the mountains. Since the Prime Minister was in attendance, I could do my work in the mountains and finish. However, it was important that I stay abreast of the issues in Parliament and contribute to the debate. So I stayed in the capital for over three months.

Ohaihuua Village

The next village we went to was Ohaihuua in the Epupa constituency, which is 5 kilometres from the great Kunene River and 15 kilometres east of the Epupa Falls.

The Kunene River is home to crocodiles, so one has to bear that in mind and watch out for them. At Epupa Falls, the water of the river crashes onto the rocks below and roars like a lion. The rocks on the banks are also treacherous. They can be very slippery and if you aren't careful, you can fall into the river. The names of those who have fallen in and disappeared are engraved on a big tree in front of the Falls. I can safely say that almost every year somebody falls in there – usually a visiting tourist who doesn't heed the warning signs. I think the lodges

on the bank of the river should do more to warn their clients about the dangers of the innocent-looking rocks. If you fall in, nothing and nobody can rescue you; people wait downstream to collect the body. When I was there, I never went close to the Falls themselves. I stayed on the rocky bank in the safety of the trees.

Ohaihuua was the last village in our resettlement programme in Kunene Region. This time I didn't negotiate with the chiefs for land. When the Ovatue people in the area realized that other Ovatue had been given places to stay, they moved down from the mountains to occupy Ohaihuua, which was where they had originally come from. When the Ovahimba men discovered that the Ovatue and the Ovatjimba had moved to Ohaihuua, they claimed it was their land and threatened the Ovatue, telling them that they must move out or blood would flow. The group of Ovatue people refused to move, saying the place was originally theirs; in fact there are even old graves of their ancestors there. There was a lot of commotion at this village, so I stayed in Windhoek waiting for things to calm down. The Ovatue claimed that the village was their ancestral land and that during the Namibian and Angolan liberation struggles and the civil war in Angola, their elders had fled into the mountains, while some others went to Angola. Now they had come back to their village of origin and stated that they were going to stay put. They were ready to fight and die for their land. The residents of Ohaihuua didn't welcome them, so there was a clash and the police had to be called. If the police had not intervened quickly, there might have been a minor tribal war.

I waited until the dispute was over and when the mountain people had seemingly won the argument, I moved in with my usual team to start the building process. No wonder there was so much hullabaloo over Ohaihuua. It is a lovely spot on the bank of a big river called the Muhongo, a tributary of the Okanguati River, which is lined with palm trees all the way to the Kunene River. Right opposite, there is another river from Angola that also drains into the Kunene River. This river is dry through much of the year but has lots of water during the rainy season and never actually dries out completely. Although it is not perennial, pools of water are retained in some places and if one digs by hand, water isn't far from the surface; that is what sustains the mountain people.

Our advance team had gone to Ohaihuua earlier, led by the enterprising Aaron Clase and the hard-working Thomas Shilongo. Faris Karutjaiva, who was responsible for food distribution, had brought some food for the people. We stopped first at Epupa Falls, to enquire about how to get to Ohaihuua and how far it was. We were told that the place was 15 kilometres from the Falls. The road there was atrocious, to say the least. I had my two well-trusted drivers but on that day I wondered whether we would reach the place. We drove along the Kunene River, lined by palm trees, for 5 kilometres, and then branched off onto the mountain path. The river was so amazing that I forgot my fear of crocodiles and enjoyed the scenery, but when we took the mountain path it was so bad the car was leaning over to one side, and sometimes it seemed that we were about to fall into the ravine.

My excellent drivers drove slowly but surely, remaining calm and controlling their cars. I had undergone a back operation in 2006, so they were very careful when we drove on those terrible roads. Finally, we reached the place. It had taken us one hour to drive 15 kilometres! We were greeted by a sight so beautiful that I was blown away – a huge river, lined with olive green palm trees. We were able to cross the river and were greeted by our advance team. A spot was cleared where we could erect our tents; my washing place was constructed with palm branches and a make-shift toilet was built with the same materials. I felt very relieved to have arrived after that gruelling journey. We made tea, and tea has never tasted so good to quench our thirsty and tired bodies and souls! We put up our tents on the bank of the river, which gave us a very cool breeze at night. The next morning the people came to greet us; they looked emaciated.

There had been a cholera outbreak in the constituency of Epupa and some members of this village were infected and had been hospitalized in Opuwo before our arrival. I was told that three people had died of cholera. Thus the first thing to do was to provide clean water, even before we embarked on the housing programme. It was very important and urgent that safe and clean drinking water be provided, and very quickly. The Office of the Secretary of Cabinet acted very fast and a borehole was sunk, so the centre had a good supply of potable water. I started immediately with health education to teach the children and adults not to drink water from the river but only from the tap. Often I would hear

the children talking loudly, telling each other not to drink water from the river because it had a disease. I have, during my many years of working with children, learned that if you want to achieve results quickly, teach the children. They will take responsibility and even remind the adults of what they are told. There were a lot of children but we didn't detect malnutrition as these communities look after their children well and this was evident in Ohaihuua as well.

The local people kept a respectful distance and didn't disturb us, but they made it a point to visit us early in the mornings to greet us and enquire about our well-being and how we had spent the night. It is African tradition that people come round to greet you in the mornings.

We started the same programme we had implemented in the other villages. I did the planning; we demarcated the area where houses would be put up and other facilities, including the school and clinic. This was a truly beautiful place, so I designed the houses to be built on the high ground. We started digging but we encountered very hard, blue, bedrock and had to move some houses to a different place. Everybody was involved as elsewhere: the women, men and even children. Here there was no alcohol, so people worked and didn't abscond. The young men were strong and did most of the digging. I too had my teams made up of teenagers, who let me dig for five minutes and then would take over, saying, 'Mama, it's enough for today, we will continue, take a rest.' I was actually there to encourage them. I wasn't able to do serious digging because the ground was very hard, but the people appreciated my being amongst them and working with them. In the morning, I worked as a doctor, treating my patients at my tent under the big tree, because there was no building as yet; everything was under construction.

The good thing was that this community had strong leadership and was well-organized. The two communities, the Ovatue and the Ovatjimba, each had their own traditional leaders. The Ovatue leader was a woman and the Ovatjimba leader was a man. We enlisted the people themselves to build the houses assisted by us. That is my philosophy, so that people own their places, and don't sit around and employ Government builders. It worked everywhere, from the San programme to the mountain people, otherwise they would think that the village belonged to the Government and not to them. In life, people respect what they have produced with their own hands.

It took a long time to construct the houses; the digging was very hard but we had enough manpower. We worked there for three months, including during the rainy season. Since we had put our tents on the other side of the river, we crossed it on foot, but cars couldn't get across. We didn't think of the possibility of a crocodile coming downstream with the river but that particular river had no crocodiles, otherwise the communities would have warned us. They also crossed the river with us. This river flows into the great Kunene 5 kilometres further downstream. One other big river flows into the Kunene from the Angolan side and these two rivers enter the Kunene River at the same place, opposite each other. It is a spectacular sight.

I used to walk to the Kunene River almost every weekend, accompanied by one of my drivers and some young boys. These youngsters, though they were barefoot, would outwalk us easily. Most of the people didn't wear shoes and their feet were hardened. We had shoes and hats while they were barefoot with no hats but they never complained of any tiredness, while we returned with our tongues hanging out from exhaustion. They are truly amazing people, and since they have oral tradition they can sometimes argue their point until they convince you to come round and see their point of view.

I also often walked to the border post between Namibia and Angola, where many people crossed between the two countries. I reported my presence in the area to the police as was required, and we would sit on the river bank on the Namibian side of the border. Sometimes the Angolan border police would come over with their canoes to visit the village. They would invite me to their side but I was scared of the crocodiles, so I never went to visit them; I also didn't trust their boats. What if the canoe capsized?

We constructed 36 houses for the community, a clinic, two school buildings, and a house for the guard to watch over the solar panels, a store room and the house for the store room supervisor, two houses for the teachers and one house for the nurse. The school had a choir and we organized adult education classes. A football field was also laid out behind the houses. We had fun as well; in the evenings we made a bonfire and sometimes we would buy a goat, have a braai and tell stories. In the evening, community members would also have traditional dances.

The young men loved to play football after work. We received a donation of soccer balls and the men organized themselves into a serious team and crossed into Angola to play with the Angolan teams. I can't say whether FIFA rules were applied but it looked like real football to me.

One day the boys were practising on their newly cleared soccer field, when our enterprising Mr Clase decided to join the game. I had a foreboding and for some unknown reason I looked for him and was told he was playing soccer with the boys. I was so worried that I sent a child to run and call Clase for me, and I explained to our driver that those boys never wore shoes and their feet were so hard, they might break Clase's leg. I swear it was less than five minutes later that Jafed came running to collect the car because Clase had been injured. 'Clase has broken his leg,' he shouted. It turned out that he had actually dislocated his right knee cap, but that was just as serious. I was angry but felt very concerned about the injury. I ran to the clinic and quickly we put Clase's kneecap back in position and bandaged the knee, gave him painkillers and took him to his tent.

I was tempted to lecture Clase and tell him never to take such a chance again, but I knew I didn't have to tell him this; he was in pain and soccer was over for him. I also wondered whether the boys played according to any rules or was it just a question of kicking the ball? Clase himself couldn't remember how he got the injury. Perhaps he might have turned quickly causing him to dislocate his kneecap.

The community was very concerned and the children came every day to visit their 'Tate' (father) Clase. The children adored him and his tent was always full of children, putting ointment on his leg and bringing him food and water. There was also much amusement at his pale skin and some of them would touch his skin with curiosity, but as time went by they got used to his colour. The other issue was the language the children spoke. How they communicated with 'Tate' Clase, who is Nama-speaking, I don't know. However, Clase learnt a few essential words in Otjiherero such as *eta* (bring), *omeva* (water), etc. Later he was operated on in Windhoek and he has fully recovered, although it took some time.

The village of Ohaihuua was impressive by the time we had finished our work there. The Ministry of Mines and Energy provided the electricity the same as in the other villages and when arriving there at

night it was a beautiful sight. We made a garden, ploughed the land, and the Agriculture Extension Officer came once more with seeds and taught the people to plant maize, beans and other crops. For reasons unknown to me, these communities like smoking tobacco, as do the San people, so they were given a small area to plant their tobacco. The garden produced a lot of maize and I was also given sweetcorn and pumpkins, the sweat of their labour. They were very proud to show off their skills.

We also provided cattle and goats to the village and the people formed teams to herd their animals. Today, this community are proud owners of cattle and goats that have reproduced, and they are milking their own cows. The last time I visited Ohaihuua, they slaughtered a goat for me. They are so enterprising that I forgot that these are the same people who were starving. Today there is no difference from their Ovahimba neighbours; they have their cattle and small stock. They are looking after their animals well and the animals are increasing every year.

The most wonderful thing was how fast the children learnt. We had young and very committed volunteer teachers, all of them from the region, which was a blessing.

A year after the establishment of the centres, the President was invited to come and officially hand over the three villages to the people in June 2008. We made arrangements that the handover should take place in one village. We invited the President to Ohaihuua, which he hadn't seen before. We invited about twenty people from each village and organized prizes to be won in competitions for the school choirs and for traditional dancing. President Pohamba couldn't hide his surprise and satisfaction at what he was witnessing, at what he was hearing and seeing, these children singing the national anthem in English. Everybody looked smart and the atmosphere was electric.

Among the volunteer teachers, there was a music teacher and he taught the children songs, including a rousing hymn called 'Jerusalem'. It brought tears to my eyes, looking at the children in their traditional wear, singing with such enthusiasm and with lovely clear voices was too much for me. I also play the trumpet, so I appreciate music. In the competitions, Ohaihuua village won the prize in songs, whilst Otjomuru village took the prize for traditional dancing. It was a day to remember.

The women of the village arrived in their traditional skirts made of cowhide, with their bodies shining red from meticulously applying *otjize*. It was a day of dancing, eating and having a good time. The babies were also shining red, with their round fat bodies. I was very proud of what we had achieved. The President stayed as long as he could and only left when the pilots politely informed the protocol people that it was time to go, otherwise it would get dark and the helicopter couldn't fly then. The party continued into the night with dances after the President had left.

The President loved these villages so much, particularly the village of Ohaihuua, and he visited all the villages several times. I also love Ohaihuua, situated on the banks of the river. In Namibia we don't have perennial rivers except for those that mark the borders with our neighbours – the mighty Zambezi between Namibia and Zambia, the Orange between Namibia and South Africa, and the Okavango River that defines the border with Angola and then crosses the Caprivi Strip into Botswana. Thus, when I find inland rivers that still contain water, such as the Chobe, the Okanguati and the Muhongo, I find peace of mind. We erected our tents on the banks of the Muhongo River and the cool breeze coming off the river was so relaxing, better than taking a sleeping pill. The children played in the river and they passed my tent looking dusty, and always made sure to have a bottle of tap water with them because they were told never to drink water from the river because it had a disease. They would greet us politely and lovingly. I really appreciate our culture as Africans. The culture of respect for elders is so embedded, but I am worried to see the trend of disrespect for elders that is creeping in slowly amongst our youngsters.

I didn't walk away and leave the Ovatue and Ovatjimba people alone after the completion of the programme; I visited them as often as I could. The same was true for the people in the San Development Programme. The people were new to the lifestyle we had created for them and needed to be assisted and supported. I can say with my hand on my heart that they are now independent and are looking to the future with confidence. The Government still maintains programmes to assist them, and it is too soon to stop. We continue to encourage them; the schools are filling up with new arrivals, and adults are also attending the adult education classes. What is needed now are proper school buildings with bricks

like other schools. The zinc sheeting should be replaced with proper materials and a brick hostel and houses for teachers should also be built so that the children can receive good schooling. The three villages also need good roads.

Otjijandjasemo Village

I thought I was now finished with my work in Kaokoland and was on my way back to Windhoek, planning to go to a lodge somewhere else in Namibia to take a rest. However, when I came to the small town of Okanguati on my way to Opuwo, I was asked to go and see some San people who lived just 3 kilometres west of the town; I was told they were really in need of assistance. I was surprised to hear there was a community of San people in Kaokoland, in the same constituency of Epupa where I had spent almost a year working for the mountain people, but I went to see them and confirmed that they were, indeed, San.

There are numerous stories of wars in Kaokoland waged by different tribes. A famous warrior chief known for cattle rustling in the area was Chief Vita Tom. I'm told that he travelled with a group of San people, who were raiding other people's cattle for him, and he also had several San wives. Sometimes he was called 'Oorlog', from the Afrikaans. In the beginning I didn't realise where that name came from because instead of saying 'Oorlog', the Ovahimba were calling him 'Ororogo' and that confused me. However, an Afrikaans-speaking headman, Johannes Raider, told me the correct name in his pure Afrikaans, and explained that it is a direct translation of his name 'Vita', which means war.

The story about Chief Vita Tom needs another book so I won't dwell on him here. Suffice it to say that when he died, his offspring settled in the village of Otjijandjasemo, near Okanguati. The Tom family was one of the well-known houses of Herero chiefs. I thought they were Ovahimba or Herero men and women wanting to benefit from the Government's San Development Programme, but that was for destitute San people, not for rich Herero tribes. I knew the Chief Tom of the time when I was dealing with traditional leaders as Minister of Regional and Local Government and Housing. I never suspected then that he was San but at that time I knew little about the San people.

I went back later to Otjijandjasemo to talk to the people and understand how they got there. I was told that they were servants and

some wives of the old Chief Vita Tom and they had travelled with him on his trips when he was raiding cattle. When the chief died they had settled at this village, and the Chief Tom I knew, of the Tom royal house in Kaokoland, was one of Chief Vita Tom's sons. His mother was one of the San wives. The Chief of the San in Otjijandjasemo was Zuzet Tom, who happened to be a brother to Chief Tom. He resembled Chief Tom, so there must have been a close blood relationship. Both of them had San features and stature, and Chief Zuzet Tom told me that his mother was a full blood San woman and his father was the old Chief Vita Tom and that Chief Tom was his brother. The family tree is rather complicated but that's the story I was told. The important thing was that I was convinced that they were San people. Their physique was unmistakably San, so I included them in the San Development Programme.

I knew Chief Tom very well but had no idea that he had this fascinating background; I only discovered it after his death at the ripe old age of 80 years. Had I known, I would have questioned him thoroughly to get the proper history. The San have been looked down on, so to tell people that you are San is perhaps not easy – people don't want to be stigmatized.

When I went to visit Chief Zuzet Tom at Otjijandjasemo, I found a Herero man with him who apparently didn't know that Zuzet was a San on his mother's side. When Zuzet told me of his origins and mentioned that he was an Omukuruha (the Otjiherero term for a San person), the man appeared to be shocked because he said, '*Tjii nanguari ovomukuruhe ree* – Oh, so you are a Bushman.' I found it very strange that here was a man claiming to be related to Tom, yet he didn't seem to know the origin of Zuzet Tom.

Namibia is one of the African countries where oral history is still the order of the day, so you believe what people tell you about the past. There's no historical accounts written by our own people before the mid-twentieth century, since very few, if any, of our people could read and write. What you may read is what the Germans have written during their occupation of the country to glorify and justify their colonialism, and often that history is distorted. We are losing our history as the older people die out. Very often I found people with light complexions deep in Kaokoland and wondered how they had got there. I was told that the

Nama warriors also went to Kaokoland to raid cattle. Maybe they went there after dropping my grandmother in Fransfontein, who knows?

We purchased some goats and cattle for the people from Otjijandjasemo, while the Directorate of Child Welfare at the Ministry of Gender Equality and Child Welfare planned to build a kindergarten for the village because there were so many children there who needed to attend pre-school. We didn't construct houses for them since they were already settled in the village and had houses. We did want to drill water for them because there's a hot salt-water fountain there and people and animals can't consume that water. A borehole was drilled but the water was still salty and the attempt to find sweet water was abandoned. The decision was then taken to bring piped water from the town 3 kilometres away. However, by the time I retired that project had not yet started.

I travelled a lot in Kaokoland at the time we were building the three villages, and also tried to find the village from where my grandfather originated, but I failed in that mission. I regretted that we grew up at a time when 'children should be seen but not heard', so one couldn't ask questions. I also think we grew up in an era of limited knowledge. I realize now that I should have asked my grandmother about her life history but I was too naive at the time. Unfortunately she is no more; the same with my grandfather, but he died early when I was only nine years old. There's a rich history of Afrikaners who migrated from South Africa to Angola and then came southwards again and settled in a place called Swartbooisdrift in the eastern Kunene Region. They have descendants in Kaokoland. There are some Ovahimba and Hereros with surnames such as Raider, Langman, Hartlief, just to name a few, but I won't go into detail about that history. I just wanted to explain where the Afrikaans language comes from in Kaokoland. The Headman Raider spoke Afrikaans fluently and so did his sister. I think his family had white blood. I won't include that history in my story but my grandmother often mentioned their presence in Fransfontein during their great trek from Angola. Maybe that's why she didn't like Afrikaners and warned us as children to run away when we heard the sound of a car, because she said white people stole children.

Lessons Learnt

There's no tradition that keeps people in destitution; it is poverty and ignorance that do that. Therefore, every Namibian needs and deserves a better deal. People shouldn't be left in the mountains in desperation under the assumption that this is their way of life or their choice, as people who live in comfort sometimes say. I've learnt that everybody can prosper, given a chance. The children of our different communities and tribes are equally intelligent, and the story of how short one's nose is should not be applied to anyone. As human beings, we are the same, regardless of what colour we are, and what we wear, or don't wear. The bottom line is that we all need services: clean water, food, and a roof over our heads. Our children must be given education and we must all be provided with health services.

Providing Education

Because of the many cattle and small stock, goats and sheep, which are the livelihood of the people in Kaokoland, and the fact that often the older children are in cities looking for work or studying and working, the younger children between the ages of six to fifteen years are often left to herd the cattle and goats. Therefore, people have resisted the removal of their children to faraway places for schooling. In order to educate those children who look after the animals, Government has created so-called mobile schools, where the teachers follow the children, but this type of school is ineffective. I discovered on my last visit to Kaokoland that the parents of children at those schools have also realized that this is not working, and they are now demanding that proper schools be put up in their villages. The programme for the Ovatue has ignited the desire for similar programmes in other villages in Kaokoland. On the last visit I made, by invitation, to remote villages in the western corner of Namibia close to the Namib Desert and the Atlantic Ocean, the people were even asking for adult education. They told me that they want to be

able to count their pension money and write their names, like the San people who had been through our special classes. In all three villages, we hired a teacher to teach adult education classes as well, and found the enthusiasm amongst the adults overwhelming. The female traditional leader of the Ovatue community in Ohaihuua was the star student. We recruited amazing volunteer teachers who stayed with us and taught the children under those basic conditions, without complaint.

Health Services

The provision of health services remains a challenge in Kaokoland. Owing to its remoteness and lack of road infrastructure, there are many places where the health services have not reached the communities. There is resistance to immunization of the children and until 2010, when the Epupa constituency was hit by a measles epidemic, it was hard to get people to understand the need to vaccinate their children. Since it was a 'virgin' community, the measles epidemic was severe, and both children and adults were affected. Because of that outbreak, some children and adults were later immunized against measles. I think that with ongoing health education the communities will gradually realize the importance of immunization.

One day while working in Otjikojo, I was called to another village nearby where a young woman was bleeding profusely after giving birth. She was attended by a group of elderly women, as is traditional. They had helped her deliver the baby but she was bleeding heavily after delivery. The hut where she delivered was very small and very hot because there were burning hot coals inside. I almost fainted from the heat when I entered. I worked fast, asking them politely to remove the fire so I could breathe. I also asked for a cloth to clean the young woman but they had none, and I cleaned the blood with a skirt I took from the local teacher who had come to fetch me. I came with one of my 'nurses', and by using our sterile maternity pack I was able to stop the bleeding. I then put the new mother on antibiotics. One old woman, the 'midwife', was very grateful and asked me whether they could now apply the traditional herbs. I told her that we must first wait to see how my medicine worked and later if she bled again they could apply the herbs. I was sure the mother had stopped bleeding and I thought to myself, 'Bravo, modern medicine has triumphed!'

The following morning I came by to check on the patient and she was sitting outside the hut holding her baby. Only doctors will know the feeling you get when you have saved a patient's life under such dire circumstances. If there had been no doctor, what would have happened to that young woman who was already losing a lot of blood? Maybe one life lost is seen as regrettable by those people living under such difficult conditions, and it will be ascribed to the will of God or some witchcraft. But it would haunt me because that one death is unnecessary and must be prevented, and I'm glad I was able to prevent it.

The inhospitable terrain in Kaokoland makes providing a proper road network a mammoth task, but until this happens there is very little the government can do to provide services such as potable water and health services to the people in these remote mountain. During election time, helicopters and mobile polling stations are used to enable people to vote, but when it comes to taking health services to the people there are no helicopters. In the developed world there are air ambulance services for remote areas – I'm thinking of countries such as Canada – but we have none of that. We have difficulties providing enough ambulances on the ground, let alone an air ambulance service. Maybe this region should have a flying doctor service, like in Lesotho.

Tradition and Modernity

We finished the programme in Kaokoland on a high note, particularly observing the satisfaction of the President at the work of my team and my ability to pull off the programme with such success. He told the Governor to make a plaque with my name on it so that future generations could learn and honour the work I had done for the people who were found in the mountains. The Governor didn't do that, though (maybe because he belonged to the opposition party).

I had a visit from a Kenyan Minister who was full of praise for the Namibian Government's efforts to deal with its marginalized communities and include them in mainstream development. According to his assessment, Namibia is one of the first African countries to do this.

There were unscrupulous politicians who, for their own misguided political reasons, were urging the people to go back to the mountains, telling them that it was their traditional way of life to live in the

mountains. These politicians seemed not to know that these people had run to the mountains to avoid harassment from their rich and prosperous Ovahimba neighbours and also to get away from the wars of the past. I, on the other hand, had been given specific instructions by President Pohamba to make sure that these people didn't go back into the mountains. Their children need to go school, and as an independent nation we can't keep our people in the mountains to continue suffering, after having found them. They can go to collect the honey in the mountains but should come back home again and their children should continue with their education.

I see red when people mix poverty and tradition. The excuse that traditional communities mustn't be disturbed from their way of life is, to me, the worst hypocrisy. In many instances, that so-called way of life isn't conducive to people's well-being. I want those who say people should go back to the mountains to go and see for themselves how those people's lives have changed for the better. Tell them today to go back to the mountains, and I think they will chase you away. The people in these villages have settled down, the cattle and goats have multiplied, and they have planted their gardens. The children are in school and adults are learning to read and write. They have clean water and health facilities. I've also noticed that some of the men have abandoned the 'bare bottom' style and are wearing shirts and trousers. My experience of working with traditional communities has taught me that they also want to enjoy the things in life that the rest of us enjoy. Many are hamstrung by tradition and would abandon unproductive and harmful traditional practices were it possible. Many harmful traditions die a natural death as people start to travel and I'm sure they are going to die more quickly owing to the internet and facebook, which have made the world one big village.

I asked the mountain people how they had survived in the mountains and what they had eaten. They told me that their food was mainly honey, small wild animals and wild fruits. The difficult time was when it rained. Although they used the branches of Mopane trees to build structures as a protection from the rain, they often got soaking wet because the branches were inadequate. What they appreciated most about their new lives was that now they only heard the raindrops on the roofs of their houses, but they didn't get wet.

My Team

When we completed the programme, I commended my three drivers, assigned to us by the Namibian Defence Force, to the generals, and they were given a higher rank and medals to go with their new status. These drivers had been extraordinary, and were always ready to serve. Sometimes building materials were needed urgently and the drivers would drive all through the night if need be and bring the materials the next morning, and they never complained about the atrocious roads. I was very pleased that these hard-working and highly disciplined drivers got the recognition they deserved. I sometimes asked them to find something in my handbag and I don't do that with anybody else. As we travelled around the country, they looked after the tents and made sure that everything was in order. The security officer was new. I only got him when I became Deputy Prime Minister; I had nobody to guard me when I was a Minister. He was also very good and got used to us quickly. I noticed that he ate very little and was very lean but strong.

One day my security officer, Phillipus, told a story around our bonfire of how he ran into a Chinese shop to buy an umbrella because it was raining and when he ran out of the shop and opened his new umbrella, it collapsed. He ran back to the shop and said to the man from whom he had just bought the umbrella, 'Look at your umbrella. I just bought it from you and it has broken.' The man answered, 'Umbrella not for rain, umbrella for sun.' We were in stitches and forgot to ask whether he got his money back. Thus I had a very good team, and everybody knew what to do.

Phillipus saved my life one evening. There was a dangerous fugitive in Kaokoland, who had escaped from prison in Angola. He was said to have committed a serious crime and was being transferred back to Namibia, since he was a Namibian citizen. This man was alleged to have attempted to rape women in the Epupa area and he was hiding in the mountains. He was sighted in different areas and the police in Opuwo were hunting for him day and night. People in Kaokoland were so afraid of him that they were saying he had magic powers to make himself invisible and the police couldn't arrest him because he was protected by witchcraft.

One night I was asleep in my tent while most of the people were watching the traditional dances, as they were practising for the handover

ceremony. Unknown to me, Phillipus was guarding me; he didn't join the people at the dance rehearsal. He saw somebody walking in the riverbed in the direction of our tents. It was a dark night, and I don't know how he saw this guy, but he fired a shot and the man ran away and disappeared in the mountains, leaving his cap behind. The next morning the police came to our place to take the report and they recognized the cap as one that belonged to the fugitive prisoner. Later, he was rearrested in Angola. I think this man might have known something about where we were staying, and who knows what could have happened to me had my security officer not been vigilant? I think my security officer also needs recognition for his bravery and discipline. I'm not sure how many security officers would guard a sleeping boss while those interesting dances were going on and everyone else was watching them.

Later, when I went to a funeral of one headman in Ohaihuua village, I was told that this former fugitive now lives in Angola, is married and has stopped all his criminal activities. He apparently told somebody that he only wanted to steal the meat that was hanging on the tree in front of my tent; he wasn't coming to harm me although he knew I was there.

My office staff and those I was travelling with were also great, hard-working and well disciplined, so I had a marvellous team to work with. That's why we succeeded in doing wonderful work. In Namibia people say, 'you are paid to do the work.' Yes, but you are not paid to die, thank you! So many are paid, but do they face the dangers, do they travel on bad roads and compromise their night's sleep and health? I don't think so.

Empowerment

When the project was finished, we all returned to our places of work. Readers may wonder what happened to the volunteers. There were four teachers who volunteered to work with the programme for four years. They worked so hard and were awarded scholarships to study further, and they graduated in 2012 as qualified teachers. I'm proud of these young people and happy that I made a change in their lives. If it were not for this programme, they would still be unemployed or have ended up on the streets, where I found them. We awarded them those scholarships to thank them for their hard work and commitment to stay for so long in the remote area. I'm convinced that they will make good teachers.

Two of the three nurses went on for training at the Nursing College in Onandjokwe and one went to Otjiwarongo Training Centre. I'm pleased to report that the two from Onandjokwe graduated in 2011 and were awarded the Diploma as Enrolled Nurses. I was privileged to be invited to this occasion and asked to make a motivational speech, which I very happily did. When I saw them coming forward to receive the certificates I was in tears, which I struggled to hide from the newsmen, because if they saw me crying they would concentrate on my tears and forget the graduates who had achieved this milestone in their lives. Our programme paid for their education because their parents couldn't afford it, and since they had worked so hard in the remote mountains, even if they came from there, they deserved our support. Not many young people will sacrifice their lives to work in remote mountains with such commitment and discipline. Without this programme, they wouldn't have had this opportunity to become enrolled nurses, so it was my input to train them and their hard work that enabled them to qualify and be admitted to these reputable Nursing Colleges.

These nurses promised to go back and serve their communities in the villages where they were working. I didn't make a written agreement with them but I was confident that they would honour the verbal agreement we had made. As I am writing today, I'm informed that one is working in Opuwo Hospital and the other one at Epupa Clinic. It was a privilege and honour to serve these disadvantaged communities and although I have retired I will still keep an eye on them, particularly the education of the children.

Today those communities from the mountains have clean water and a roof over their heads. The children are in school and, who knows, after ten to fifteen years they will have doctors and teachers from amongst their own children. I'm convinced that these people will achieve great heights because they are eager and hungry for education. This programme for Kaokoland needs to continue to give support for the foreseeable future so that people can reach their goal of being mainstreamed in the development of the country and catching up with the rest of the Namibian nation. Already, Otjomuru is developing into a model village. Ohaihuua, the largest of the three villages, is also coming up. The school will grow faster as soon as the teachers who are undergoing training return after graduation in 2012. Already that school was showing

positive signs of becoming a good school. I'm sure that within the next ten years it could become a secondary school. The people of Ohaihuua have already greatly improved the road, but it will need serious further work. It must have a proper bridge, which will cost millions of dollars, because we still have to cross the big river. I have experience of crossing that river and I was never sure how it would be from one day to the next. During the rainy season it is absolutely impossible to cross, and without a bridge people in those places will not be reached.

Although building a bridge will cost a lot of money, one day (maybe when we discover oil in Namibia) we must do it. Maybe for now, the best solution is to build a secondary school in the Epupa constituency for the children of all three villages, for when they complete primary school. One problem I discovered when we put up schools in these villages, was that children in other nearby villages wanted to attend these schools as well, but since there was no hostel it was difficult for them to come to the schools. So there's a need to build hostels and provide food for children, and also to make sure that they are taken care of properly in those hostels.

The future of the mountain Ovatue people is promising. They are hard-working and eager to learn. They want adult education and have shown how seriously they take life. Their animals have multiplied. The schools are filling up. However, there should be serious concerns about how the girl children are protected. I have sadly noticed that promising schoolgirls have fallen pregnant, and that must be stopped as soon as possible. Education of the girls is what will liberate these communities from poverty and marginalization, and their education must be protected by all means. Those who impregnate schoolgirls should be punished and early marriages of girls younger than sixteen should not be allowed. I dismissed two teachers who impregnated three schoolgirls there. I was furious and wanted everyone to learn that this irresponsible behaviour was unacceptable.

Looking Back
and Looking Forward

Serving the People

I was interviewed on Herero Radio one day by a young journalist who was of the opinion that I wasn't behaving according to my status as Deputy Prime Minister, and that my pre-occupation with the marginalized communities wasn't what I should be doing. Actually, he accused both the Prime Minister Nahas Angula and me of bringing down the status of the Office of the Prime Minister.

My terms of reference as Deputy Prime Minister didn't include the marginalized communities but stated that I was 'to assist the President and the Prime Minister in their duties'. They also stated that I was to serve the President and do what he assigned me to do. Well, I was assigned to take care of the marginalized communities: take care and assist the mountain people, find a place for them to come down, settle them, and make sure they didn't go back up into the mountains again. This was what the President had asked me to do. Moreover, I am convinced that it is the responsibility of the highest office to take care of its poor, to take a lead in solving the problems of those people and not assign them to Ministers who have limited powers.

Unknown to the journalist, and to many people, I acted on three occasions as President of the country, during the absence of both the President and the Prime Minister. On two occasions, this was for 24 hours and on the third occasion, for 48 hours. Twice, I had to deal with serious problems.

One time when I was Acting President, there was a serious skirmish in the Aminius constituency in the east, and someone was shot dead in a dispute about who should be appointed as the Traditional Councillor of the constituency. I intervened quickly and used my negotiating skills;

otherwise more blood might have been shed. I solved that problem quickly and quietly. I want to express my appreciation to the chief who listened to my advice and returned to his place, because he was on the way to confront those who were appointing the councillor.

The second crisis was when the 'Struggle Children' discovered that the President and Prime Minister were both away and I was the Acting President. These are children who were born in exile, some of whom are unemployed and angry because they feel the Government should be looking after them. They came with their suitcases to occupy the parliament building, but before they had made themselves comfortable, I had them removed.

It was in my terms of reference that I should act on behalf of the President or Prime Minister in their absence and I did that effectively, without publicity. Whenever I had to act, I didn't publicize my presidential status; I shouldered my responsibilities quietly with no fanfare. I don't believe in ego and I don't have one. I am a servant of the people. All my life I've looked after the poor and the needy. I will tell Riz Khan, the television journalist who likes to ask people he interviews how they want to be remembered, that I want to be remembered as 'the servant of the people'.

Deciding to Retire

After I set up my three villages for the mountain people, I felt that the time had come to call it a day. I felt I had reached the pinnacle of my active contribution. I was physically and mentally tired and was wondering what more I could do. I had a farm that I had neglected for a long time and it was calling for my attention, so I decided to retire after twenty years of active service in government. I also needed to look after my back, which had suffered from bumps and shakes on those bad roads in Kaokoland.

In 2008 I went to a conference in Bamako, Mali, and there I met a very young Deputy Prime Minister who was only 35 or so years old, younger than my daughter. I felt so old and wondered what to say to this young counterpart; what would we discuss? I then decided that the time of my cohort was over. I must give room. The young people should be empowered and we the elders should give way and allow them to take over. We need only to make sure that we give them all the

support they need but give them room to run the affairs of government. After all, this is the computer age and my cohort doesn't understand the new technology. The most important objective of my age group was to liberate the country and to establish a solid foundation for our independent Namibia, and that we have done. Let the young people come in and fight the economic struggle, which they understand better. They have a better education and understand computer science better.

As time went on and some former Ministers either lost in elections, retired, or died, members of my cohort have slowly disappeared. Our Tanganyika group, who had worked together in Dar es Salaam, has dwindled. Some of them have also made new political parties or joined them, and only three of us remained in Cabinet. I began to loathe sitting in Parliament, particularly when I was working in Kaokoland. I was in the Parliament when there were important bills to be passed. As a Minister with various portfolios, and later as Deputy Prime Minister, I had enjoyed excellent working relationships with everybody. The younger Ministers were respectful and I enjoyed the camaraderie, but I missed the Tanganyika group.

It had been a pleasure to wake up in the morning to go to work. I was passionate about what I was doing and enjoyed every minute of it. I had competent office staff, in both my Ministries and also as Deputy Prime Minister, but if I thought someone was not pulling his/her weight, I would release them because there was no time to waste, I had so much to do. However, meeting the very young Deputy Prime Minister in Mali and the fact that I needed to rest and take care of my farm before I was too old to work, were factors in my deciding to retire. I had really worked hard and it was time to take a rest.

Looking back, I must admit that I was more of a worker than a politician; however, the politics gave me room to manoeuvre. From day one of our Independence, I was in a position of power as a Minister and my five years as Deputy Prime Minister had enabled me to do things my way without being hamstrung by a boss to report to, except to the President, the Parliament during budget debates, and through parliament, the nation. As a Minister you are appointed to a certain portfolio. You're not told to do this and that; it is your responsibility to serve the people to the best of your ability and I enjoyed that. It was left to me to run my Ministries to achieve the best results. I was fully

involved in the working of my Ministries. I didn't sit around waiting to receive reports from my directors; I was always working with my team and would travel around the country to check on my Ministry's work, meet communities, and listen to what they had to say. I think there is no corner in the country I haven't visited during these past twenty years.

I decided that I would retire at the end of my term on the 20 March 2010. I would enjoy the freedom for which I had fought for so long. I was in the struggle for fourteen years, living and working in the refugee camps from 1975 to 1989, running kindergartens and keeping the children happy and healthy. I also looked after the young girls and, although I didn't know their parents, I was as protective as a hen. Sometimes people interfered in my work, particularly when I was running family planning programmes. All kinds of rumours were spread, such as that I was making the women infertile, and the young women would not have children. Put together with my 20 years as a Minister, all in all this was 34 years of hard work serving my people both abroad and in Independent Namibia.

Women in Politics

I wasn't a politician in the true sense but I used politics as a gateway to do my work unfettered. My main reason for leaving the country had been to become a doctor and I became a doctor by choice, and a politician by chance. I was a member of the SWAPO Central Committee from the time of the Tanga Congress in 1969, a position I hold to this day. Politics helped me serve the people. I was able to do my work without disturbance because I had some decision-making powers and took decisions without fear and favour; I was my own boss, so to speak. That left me with plenty of room to run my projects.

As a politician, life was not always smooth. I quickly learned that I must develop a thick skin and fast. I decided that I would just concentrate on my work. Sometimes I'm asked how I was treated as a woman in politics. Well, I worked with comrades who knew me from my school days at Augustineum, who knew my strengths and weaknesses; thus I was just one of the team. Thankfully, our President and Founding Father, Sam Nujoma, had unwavering trust in me through my twenty years in government as Minister and Deputy Prime Minister.

I can confidently say that, in Namibia, women in politics have performed exceptionally well, in whichever portfolio they have been given. Even the councillors and mayors of towns are doing a good job. However, female representation went down during the elections of 2004 and 2009 and has not yet reached the 30 per cent women's representation in Parliament agreed in United Nations and Southern African Development Community Protocols. This is because the men gang up to elect each other. I know the blame for the lack of women representation is simplistically put at the door of the women, namely that they don't elect each other. This argument is instigated by men who don't understand the serious problems women face; I know they will deny it but it's true. To be elected, the parties demand we start from sections to regional conferences and women don't have that luxury of campaigning in villages. While their male counterparts are hanging out with their buddies in shebeens and bars, politicking, women have to start from the early hours to till the land, milk the cows, and prepare the children to go to school, feed their children and even those husbands, and do the household chores. Thus they are not attending the meetings at some of those village and regional levels. Some meetings also start at night and how would women in rural areas attend these meetings when they tend their crops till late? Women work, starting at dawn and coming home at sunset. They come home late and cook for the children and their families, so they miss meetings, and it's obvious that unless they attend meetings, nobody will know them.

Thus the challenge is daunting for women unless they are assisted to get on the political train. Even if she gets on the list, there is no guarantee that a woman will be elected. She is losing out, because these days, in order to keep the women out, there's a catch phrase: 'We don't know this woman, she doesn't attend the meetings.' In that way she is left out. But if it's a man nobody asks who knows him. I want to encourage my party, SWAPO, that a quota system be introduced so that women can be elected and play a meaningful role in the affairs of this country. We all know by now that the majority of women perform well when elected.

When I became the first Minister for Housing and Local Government in 1990 at Independence, I introduced the quota system for local government. I had lived in Sweden and studied the system there. Although there was initial resistance during the debate in the

National Assembly, the introduction of that system has given women the power to be appointed, and today we are very proud to have many women as local councillors and as mayors of cities and towns. I firmly believe that the same procedure must be introduced in political parties if we are serious about the emancipation of women. Why should representation not be 50 per cent, let alone 30 per cent? I'm convinced that the upheavals we see in some countries are because of the exclusion of women from decision-making positions.

Women in Namibia

In Namibia, we have an equal society in theory but women are still not totally free. A very important Law in terms of promoting women's rights was introduced by the Ministry of Justice in the 1990s. This was the Married Persons Equality Act, passed into law in 1996. It was meant to give equal opportunities to women and men in terms of equal pay for equal work and also in appointments in the workplace, political appointments, and all spheres of life. This Bill was necessary because under the old system women were treated as minors. They couldn't own property or buy land and their salaries were lower than those of men, for the same work. The excuse was that men were the breadwinners.

When that legislation came to Parliament for discussion and later ratification, there was a war in the House. Members of Parliament who were priests, and some lay preachers, were up in arms against it. In fact, almost all men were against it, except for President Nujoma who supported the women. The preachers came with Bibles. There were Bibles from the Lutherans, the Catholics, and the AME church. The only religious book missing was the Koran! The Bible was used to justify male opposition to the Bill, by quoting the passages such as 'women were made out of the rib of a man', and other verses. The interpretation of the law from the people outside the parliament was amazing and amusing, bordering sometimes on the ridiculous. There were those who said that this law would allow women to have two husbands and that women would now have the right to propose to men. One old uncle of mine cornered me and asked whether this new law would mean that he must wash the petticoats of his wife. I have found that anything dealing with the rights of women becomes an issue of ridicule by men. However, I couldn't help laughing when one MP jokingly poked fun at another and

asked him whether any woman would propose marriage to him now that women had the right to do so, because he didn't have good looks. Of course, there was no such clause in the Bill. Actually, most of the time the arguments were seriously flawed; the discussions would be bogged down with issues that had nothing to do with the Bill.

There are men who will never accept women as equal partners in marriage. The Bill has brought about awareness of the rights of women and many cases of abuse of women that were unreported before are now reported. However, violence against women has increased in the past ten years. I don't attribute the increase of violence against women to the passing of the Bill, but it's possible that men have felt they are the powerful ones and will control their female partners, regardless of the Bill. I also think it will take some time before women are accepted as equal partners in our societies. We need to change how we bring up our male children, so that all children are shown sensitivity and love and boys aren't expected to conform to a macho male stereotype. We need to teach boys to respect women and girls of their own age, as well as their mothers. Often the boys fend for themselves and learn bad behaviour on the streets and from their peers. Many times there is a lack of a father figure in the house, and a poor relationship between mother and father, with mothers being abused in front of the children. This sets a terrible example for the boys. The Namibian Parliament has ratified all UN conventions dealing with the rights of women and children, but I see no improvement in the relationship between women and men, nor much change in how society in general perceives the position of women. Issues such as forced marriage, teenage pregnancy and male teachers impregnating school girls are often covered up by families or justified as tradition.

I will fail in my story if I don't bring in the issue of our former President, our Founding Father, who had a very profound trust in women in general and in me in particular. Without his insistence and support, the Married Persons Equality Act would not have become law. After it was passed by the National Assembly, the National Council didn't want to pass the Bill. They referred it back to the National Assembly, but the President stepped in, used his powers to declare the Bill as law, and signed it.

President Nujoma has recognized what I have done since I first met him Dar es Salaam in 1962. He has been the anchor in my life and my work. When his beloved mother, Helvi-Mpingana Kondombolo Nujoma, also known as Kuku GwaKondo, passed away in 2008, I was assigned as the Director of Ceremonies at her funeral. I was profoundly touched by this gesture and honour. Kuku GwaKondo passed away at the magnificent age of 108 years old. Surely there were many people who could have been given that honour, who had known her and were from her village? But that honour was given to me.

Only someone who has a full trust in you will give that responsibility to you. I am still profoundly humbled by that gesture. I thank my President for recognizing me and trusting me. I am ever grateful and extremely humbled by his trust. We, the Namibian women, have come a long way with his support and trust in our ability as women, and we have not disappointed him. During his Presidency, he appointed many women as Ministers of important ministries, such as Finance, Home Affairs, Local Government and Housing, Health, and Justice.

Retirement

I retired on the 21st March 2010. I made a farewell speech and received a standing ovation from the Members of Parliament in the National Assembly. This was an unusual gesture of appreciation from Namibian parliamentarians. I received many moving tributes from other Namibians, expressing their appreciation and recognition for the work I have done for the Namibian nation. The Office of the Prime Minister gave me a wonderful farewell party. Amongst the letters of tribute I want to single out four letters. The first one is from the Archbishop of Windhoek, Liborius Nashenda. I was humbled by his tribute and especially appreciated it since I am not Catholic. The second letter came from a struggle comrade, expressing gratitude for my contribution to the struggle. The third came from my former Deputy Minister of Health, Richard Kamwi, who is the current Minister of Health and Social Services (2012). The last letter is from the Attorney General, Comrade Albert Kawana. These letters are all in Appendix I.

I feel grateful and blessed and thank everyone who phoned or wrote wonderful tributes to me. I'm grateful to be alive and to hear how people appreciate my work. Normally, such tributes are showered at one's

funeral and unfortunately they are told to your dead body in the coffin, and you cannot hear them. I am amongst the few who are alive and can hear and appreciate what my contribution meant to my nation. I would like to thank everyone for their kind words. God bless you.

Medals and Awards

There are some other tributes I have received that I would like to mention. The first came in 1991. Early one morning I was in my office, writing a speech I was to deliver at a workshop, when I had an unannounced visit from the Resident Representative of the United Nations Development Programme (UNDP) in Windhoek. He told me that I had been nominated for a very important award of United Nations High Commissioner for Refugees (UNHCR), the 'Nansen Medal'. I had no idea what he was talking about. What did it mean to be nominated? Was I competing with others? He told me that the award ceremony would take place that October in Geneva. I took the nomination paper he gave me and went and stored it in my safe. I thought I would wait a bit before even telling my husband, as it might turn out that another person got the award.

When the time came, I flew to Switzerland and was awarded the Nansen Medal by the UNHCR for the work I had done in refugee settlements during the liberation struggle. It was a personal medal for my work and I'm extremely proud of that recognition. While one is working hard expecting nothing but complaints from some ungrateful customers, there is the international community watching your contribution and your every move.

Many African diplomats and those working in the UN offices came to the ceremony in Geneva. I remember how proud the Senegalese Ambassador was. I mentioned earlier that I used to carry a Senegalese passport before Namibia's independence and the Senegalese people felt like my countrymen and women. All the Africans were so proud. I was not just a Namibian but an African woman representing the continent, and the first African woman to receive that award.

I shared the award with Dr Wise, and his son came to collect his father's posthumous award. Dr Wise had been a medical doctor and what we had in common was that both of us had worked in refugee camps during times of conflict. He had worked with refugees during

the Second World War, while I had worked in refugee camps during our long struggle for Independence. The award was US$100,000. We shared the prize but it wasn't until 1993 that I found time to go to collect my share; US$50,000.

Mindful that I had received this award because of the work I had done with women and children in refugee camps, I thought I would share the money with women by putting up a centre to honour them, so I donated N$30,000 to construct a woman's centre in Ongwediva. During that time, Comrade Netumbo Nandi-Ndaitwah was the Director of Women's Affairs in the President's Office. She put up a basic structure with that money and added more money from her office budget to extend the building and make it attractive. Today it's a beautiful building and I hope that it's used for the purpose it was meant for, that is to serve women. They can have conferences and workshops there.

I worked closely with women all the fourteen years I lived and worked in refugee settlements in exile, and I never heard them quarrelling or fighting. They never failed me. They looked after the children of other women who were absent on different assignments, as if they were their own, without complaint or ill feelings, and they never abused those children but gave them love and care. I have the greatest respect and admiration for Namibian women, and that's why I decided to share my medal and prize with them. It pains me so much when I hear of women being murdered by men in this country. What makes them so callous that they don't appreciate these wonderful souls who sacrificed so much to nurture them? I say, 'Long live the Namibian women and God bless them.'

When President Mandela visited Namibia soon after his inauguration in 1994, I spent the whole afternoon with him, taking him to Katutura and squatter settlements around town. He was very impressed with what he saw, and as he is a very humble person and also very pleasant to be with, I have very fond memories of him. He has also a good sense of humour and I enjoyed being with him that wonderful afternoon. He asked me whether I thought he should appoint a female Minister of Housing; I answered 'yes' and meant it. I've noticed that when it comes to a house, women are the home-makers. I don't know whether our discussion influenced Mandela's choice of a female Minister of Housing after the first Minister, Joe Slovo, died in 1995, but I hope that

he thought about it when making his appointment. In 1996 I invited the South African Minister of Housing, Ms Sankie D. Mtembie-Mahanyele. I took her around to show her what we were doing in Namibia.

Our work at the Ministry of Local Government and Housing and the different housing schemes we put in place to give roofs over the heads of the Namibian people, was also recognized. We reduced the housing backlog considerably. I'm also thankful that, even before dealing with the 'haves', we provided proper houses for the squatters – the 'have-nots'. Squatters are normally at the end of the receiving line but here in Namibia they were at the front of it. In 1993 we were awarded the Scroll of Honour by HABITAT and I went to the United Nations in New York to receive that award. Again in 1995, we also received a second award given by the Building Social Housing Foundation (BSHF). I went with the Director of Housing to Curitiba, Brazil, to receive that award. I'm very proud of what we achieved in the Ministry.

Of course, housing will never be adequate. As new houses are built, more people leave their rural villages and move to towns, to what they perceive as greener pastures, so cities will always have squatters. What we achieved in Namibia, however, during my tenure as Minister, was to make even the squatter settlements habitable by providing clean drinking water and sanitation. The other achievement was that as we developed towns in regions such as Khomas, Erongo, Omaheke, Otjozondjupa, Hardap, and Karas, we also built in the rural northern communal areas and developed towns such as Oshakati, Ongwediva, Ondangwa, and Rundu, just to name a few.

Before we were repatriated to Namibia, in 1987, I was honoured to receive the Ongulumbashe Medal, which is one of SWAPO's highest honours for bravery and long service. I also received the Most Excellent Order of the Eagle, First Class, one of Namibia's top awards, which was awarded to me at the ceremony to mark the opening of Heroes Acre on Heroes Day, 26 August 2002.

I have now dealt with my political experience during the 34 years of my political career. Today, I watched the Beatification of Pope John Paul II and recalled my Polish roots. I met Pope John Paul in New York when he visited the United Nations for the first time. I was in the queue to greet him and when I finally got to him, I greeted him in Polish. He was startled and lingered a little longer with me, asking

me where I had learned to speak such perfect Polish. I told him that I had studied Medicine in Poland. Today, as I watched his Beatification ceremony, I even shed a tear. I love Poland and its people. I regret that I have forgotten the Polish language that I once spoke so fluently, due to lack of practice.

Life as a Farmer

I am very happy to have retired. My pension is adequate to see me through my remaining years; I was also given a generous handshake and other assistance for a soft landing. I enjoy the farm. However, I am discovering that farming is not for the faint hearted. I don't know how to rest. I still wake up early and go with my workers to the cattle post and I take part when we brand the cattle; I keep the fire going and make sure that the branding iron is hot.

Coming home as a retired politician was traumatic. I went to the farm on the Thursday after I had retired and cried myself to sleep. I missed Jafed and Kapere, my two drivers for the last ten years and my loyal secretary, Rendah Swartz; these people were my anchors. Then I pulled myself together and on the Saturday morning I resolved to stop this nonsense of crying over people I couldn't get back even if I wanted to. They must continue their lives without me. I also recalled my grandmother's teaching that I was good enough to do what other people do. I woke up that morning, had breakfast, and drove my 4-wheel-drive Mahindra vehicle to the cattle post, and that was the end of my drama. I settled down and started doing things on my farm. I still miss my former staff members but I don't cry anymore. Fortunately I have not completely cut the umbilical cord with them. I still see them and when I need help in any way they are always there for me, which is a blessing.

Initially I wasn't that keen on farming, but I love sheep and I started with eleven Damara sheep, which I kept in Fransfontein before I bought the farm. My driver Jafed was always pestering me about buying a cow for milk. He is a committed farmer himself and I think he knew that once there is one cow you become hooked on cattle. He would always encourage me to buy even one cow with a calf so that I might drink *omaere* (sour milk). I told him that as a child I grew up with lots of cattle and it was lots of work, and I wasn't going to get involved in farming, particularly with cattle.

One rainy day I was visiting my elder sister who was sick, when my childhood friend, Daniel Luipert, came with two cows, both with calves, and handed them to me on behalf of the Fransfontein community, as a token of appreciation for coming back home to serve them. Jafed was elated; his dream had come true. He helped my nephew to transport those animals to the farm. To add to these four cattle, I was given a cow by my brother as part of my inheritance from his mother. This was my mother's older sister, the one who came to fetch me when I came home in 1989; she is also my mother. So I started with eleven cattle given to me by friends and family members, and I bought five more cows and a bull. Jafed was very active and helped to brand my cattle and dose them; he also taught me about vaccinating the cattle. In fact he was the one vaccinating them because I found the cattle hard to inject. When he came to the farm I felt as if my son had come, and I wouldn't bother to go to the cattle post that day, because he had already finished what was supposed to be done that day at the cattle post and he would take care of the workers before I even woke up. That is also partly why I was crying so much for him when I retired!

I bought the farm to have peace of mind and to keep my sheep safe. Farming on communal land is stressful; people help themselves to animals that don't belong to them and if your animals don't come home you can't sleep, wondering whose kraal they are in. One day in Fransfontein I missed one sheep and I didn't sleep that night but, fortunately, it was later found and brought back. Also grazing is a problem in the communal areas. Fransfontein is so overgrazed; there's hardly any land to graze your animals there.

My sister looked after my animals in Fransfontein while I stayed in Windhoek. We had four happy years together there. After she died, I was dejected and felt lost and lonely; even being in my place of birth felt meaningless. I had no family left whom I loved like that sister of mine. When we were children she was always on my side and carried me to school when I got tired. So I decided to look for a farm of my own and to move away from communal land. I 'sold' my house there to my remaining younger sister and bought my farm in the Omaheke Region, about 170 kilometres from Windhoek.

Before I bought it, I looked around the farms but I didn't like the old dilapidated farmhouses I saw with lots of garbage, old cars and other

things around them. The farmhouses looked so old that I suspected there might even be snake eggs in those roofs. Heavens knows how many people had died in those old houses. I decided I wanted a piece of land without a house, so that I could build one to my taste, and I had a lucky break. One day when I was buying fodder for my sheep, a white man approached me and informed me that he knew of a farmer who was selling a 2000-hectare farm. I made an appointment there and then to go and see it. I immediately liked the farmland when I visited and I bought it at N$400 per hectare. That was the last farm at that price; today you pay over N$1,000 per hectare.

I built a cosy house, brought in electricity and built three houses for my workers. I also built a kraal for the sheep, a house for my ducks and chicken, and a kraal for goats; thus every living soul has a house. The man who got me that farm is my very helpful and good neighbour and my best friend, Gert Hamon. I farm now mainly with Brahman cattle, Damara sheep, goats, ducks, and chicken. I must warn aspiring farmers that farming is hard work and a money spender. You are constantly busy and the money just goes, but the peace of mind and the quiet life are worth it. When the auction comes, you notice the smiles on the faces of the farmers; you can make some money as well.

A difficult part of adjusting to retirement for me was to learn to drive a manual 4-wheel-drive bakkie. I went to the army driving school in Okahandja for two weeks and after that training, I was still not confident to face these ever-in-a-hurry drivers and unpredictable and lawless taxis drivers in Windhoek. Therefore, I went for advanced driving training at the police driving school, and there my driving instructor was a no-nonsense, bulky police officer. He gave me confidence, and after his training I am now a professional driver and drive around the farm. I have a driver in Windhoek because parking has become a nightmare. If I have errands to run in Windhoek I can't complete the programme of the day, as I will always be hunting for parking.

People think that when you retire you sleep late or sunbathe on the beach, or spend time under the tree day-dreaming. It's not like that. I wake up at the same time as when I was in government and there's lots of work to be done on the farm. It's a problem to find committed farm workers. After trial and error, I've found some fine workers, but it's a fluid situation; they can sometimes desert you. After going to funerals

or on their annual holiday they may not come back, and you end up holding the fort.

Another thing I've had to learn about is animal health. I needed to learn the new treatments that are available. When I was a child in Fransfontein, the only thing we did was to provide the salt block to the animals; we had never heard of vaccinations and licks. But now animals have special diets. So I took short courses, to learn how to take care of my animals. The lecturer who taught us about the licks condemned salt blocks and I told him that my grandfather would turn in his grave if I didn't provide a salt block for my cattle. I also learnt about the vaccination schedule for both small stock and cattle. My Brahman cattle particularly gave me problems when we wanted to walk them to auction pens, which are within walking distance of my farm. They walked up to the last gate and then refused to cross the fence; they bolted and ran back to the farm. So I bought an electric prodder and they got even more wild. One day I went to the farm of one of Namibia's leading Brahman breeders to buy a bull. Seeing how tame his animals were, I told him about the problems I had encountered with my Brahman cattle, and I mentioned to him that I had bought an electric prodder to chase them with. The man nearly fainted. He was very distraught and said to me softly but firmly, 'Doctor, go and throw away that prodder of yours. Never use it again.' He taught my two workers and me how to treat the Brahman cattle. You don't shout at them; you treat them gently, touch them, and talk to them.

When I bought the beautiful bull, born on the same day as me, 10 December, I took the batteries out of the prodder. I didn't throw it away but I put it away, hopefully for good. We're now practising what this man taught us. The bull and all other cattle are safe from the torture of the prodder and the animals have calmed down. I sometimes feed the bull from my hand, he is so gentle. Now I also try to feed the old bull but he doesn't trust me and turns away. One is never too old to learn. I must say that the white farmers, who have been farming for many years in the same area and have vast experience, are very helpful to us, the new upcoming farmers. They go out of their way to assist with anything we need, particularly with advice and training. I'm very happy on my farm. The fact that we have good, reliable neighbours is very reassuring. We

are more than four black women farmers in the area and we're doing pretty well.

I have not yet mastered the feeling that I'm retired; my adrenaline levels have not yet stabilized. I keep on waking up early and watching the birds. Seeing the animals and springbucks scared of me and jumping around when they see me is so liberating. Someone should teach me how to 'retire and relax', but what I know for sure is that I enjoy my farm. The walk to the cattle post, which is 1.2 kilometres from the house, is also liberating. It is my daily exercise.

Retirement, however, is proving elusive. One morning in 2012, I was told that I must come back to Windhoek. The Minister of Labour and Social Welfare, Immanuel Ngatjizeko, gave me the responsibility of chairing the Wage Commission on Domestic Workers, from June 2012 until February 2013. This entails visiting all the regions of Namibia to investigate the conditions of work of domestic workers, and make recommendations for a minimum wage structure for them. Hard but important work calls once again!

I will end here because otherwise I could go on for ever with my story.

Appendix I

Tributes to Dr Amathila on her Retirement

22 July 2010

To: Dr. Libertina Amathila, M.D.
 Retired Deputy Prime Minister
 Office of the Prime Minister
 P/Bag 13338
 Windhoek

Dear Dr. Libertina Amathila

A TRIBUTE OF GRATITUDE TO A GREAT NAMIBIAN WOMAN

Since your retirement, it has been difficult to relinquish and ignore the remarkable imprint you have made in the hearts of the Namibians, as well as those who have encountered you in the international sphere, through your being the President of the 53rd Session of the World Health Assembly.

Rightly, we can claim that you have left a vacuum which nobody else could ever replace due to your unswerving and authentic service to our people. The role you have played in the span of 20 or more years – for the emancipation of Namibia - will remain etched in our hearts. Indeed, over and above your life-giving profession as Namibia's first female doctor, you did this country proud with your political competency via the National Assembly of Namibia, the SWAPO Central Committee, the Ministry of Regional and Local Government and Housing, the Ministry of Health, onto your service as Deputy Prime Minister.

The Roman Catholic Church definitely appreciates all that you have done, especially for the health sector as well as for our marginalized San brothers and sisters. More so, it is cognizant of your compassion for the impoverished communities and your concern for the well-being of our environment, during the exile, on to the post independence era.

On this Feast of St. Mary Magdalene – [according to our church calendar], I can only see a striking parallelism in the sense that as the courageous saint eagerly sought and waited for the Risen Lord, so do I see you, Madam, as a woman of substance who does things with passion – eagerly awaiting the more meaningful and much-needed emancipation of our people – for us to rise from poverty, economic instability, moral degradation, gender inequality and the like.

Thus, this humble tribute of gratitude to one great gift to Namibia: **Dr. Libertina Amathila**.

Sincerely yours in the Lord,

✝ Nashenda

+Most Rev. Archbishop Liborius N. Nashenda, OMI
ARCHDIOCESE OF WINDHOEK

Republic of Namibia

Ministry of Health and Social Services

Private Bag 13198	Ministerial Building	Tel +264 61 203 2003/5
WINDHOEK	Harvey Street	Fax +264 61 231784
Namibia	WINDHOEK	E-mail: rkamwi@mhss.gov.na

| Enquiries: RN Kamwi | Date: 22nd March 2010 |

OFFICE OF THE MINISTER

Hon. Dr. Libertine Amathila
Deputy Prime Minister
WINDHOEK
Republic of Namibia

Dear Dr Amathila,

On the 18th March, 2010, you had your valedictory statement to bit farewell to the 4th Parliament of the Republic of Namibia. The Hon. Members of Parliament gave you a standing ovation to acknowledge without reservation your immense contribution to nation-building. The Founding President and Father of the Namibian Nation declared you as a National Heroine of the Liberation Struggle.

I had been privileged to have served under your dynamic leadership as Minister for Health and Social Services for five years. Indeed, I remain grateful that I bear testimony that you are such a hardworking person, an actor and a woman of action, an initiator of several projects and programmes, a politician par excellence. You are such a person that if you want something to be done, you immediately take action and accomplish with some distinction.

For example, I recall, vividly in 2002, during an introduction of prevention of mother-to-child transmission, the officials were still hesitant for the launch when you called me: "Deputy, come, let's go to the Country Club Resort and Casino". That was to go and launch the Pilot Project of the above for Katutura and Oshakati Intermediate Hospitals. Within a short space of time, the rolling out of the above followed to district hospitals and spread like wild fire. To date, we have more than 97 % babies born from HIV positive mothers being negative, indeed, death due to AIDS has significantly declined.

I remain grateful that I did not fail you with the unfinished programmes, especially in regard to the rolling-out of the Antiretroviral Therapy to the rest of the district hospitals, health centres and clinics. In addition, the Cardiac Unit is up and running, upgrading and renovation of health facilities countrywide is ongoing. The training of sub-professionals including enrolled nurses, pharmacy assistants, laboratory assistants, environmental health assistants, etc. at the National Health Training Centre and other six training centres for enrolled nurses is progressing well. Thanks to your visionary and quality leadership. To date, we are rapidly closing the gaps of so many vacant posts.

During the Ground Breaking Ceremony for the UNAM School of Medicine, which took place on the 11th March, 2010, I had the following, "I recall that when I joined the Ministry of Health and Social Services now ten years ago the dream of one day having our own Medical school was on the cards. Under the able leadership of then Hon. Minister for Health and Social Services, Dr Libertina Amathila; we came up with a Pre-medical Programme which laid a foundation for where we are today.

2

I want to therefore thank Dr Libertine Amathila and Dr Kalumbi Shangula who made immense contribution to the forerunner to this Project. We now have a number of young Namibian medical doctors who graduated following the Pre-medical Programme". This is how much I value your contribution to the health sector.

During my term of office as Deputy Minister, you gave me conducive environment to serve the Namibian people, you indeed exposed me regionally and internationally. Clearly, it was because of your guidance that I only served one term as Deputy Minister and was soon elevated to the position where I find myself. I shall forever remain indebted for the immense support that you made to who I am today. For me you are a heroine of public health.

As a token of appreciation and remembrance for your immense contribution to nation-building and to my political carrier, I decided to enlarge and frame a beautiful photo of yourself and trust that you will love it. Please, it is meant for your farm-house.

I wish you a well deserved sabbatical leave and thank you for making yourself available as a living librarian to the nation at large.

Comradely,

Dr Richard Nchabi Kamwi, MP
MINISTER

My Dear Doctor,

You will be truly missed by all of us, your Comrades. Thank you very much my Doctor. Please be rest assured that we will always <u>Knock</u> on your door to establish how you are Keeping up.

Thank you very much for your countless contribution and personal sacrifice for the liberation of our country, the Land of the Brave. I thank you from the bottom of my heart. You are a TRUE HEROINE of Namibia.

As a member of the National Assembly, I will always be available for whatever assistance within my disposal. Should I find myself as a member of the Executive, my door will always be OPEN. Please note that I will be offended if you make an appointment. You will be welcome at ANY time. Kawana, 18/03/10 Xxx

Mwahafar *Xdilula*

Xdakolula

18th March 2010

Dear Dr. Libertine Amathila

On behalf of the young and old and those born under your care [inclusive my own daughter] at Nyango (Zambia) whom you served with distinction, love and selfless dedication, please accept these flowers as a token of our deepest appreciation for the service rendered and the way you touched our hearts.

On this day of your retirement from active politics, we would like you to know that *THERE WAS NONE BETTER!*

Mwahafar

SWAPO PARTY ELDERS' COUNCIL

Certificate Of Recognition

This certificate is awarded to

Hon. Dr. Libertine Amathila

In recognition of her enormous and outstanding contribution to the Liberation Struggle for Independence as well as the Development of the Republic of Namibia.

Secretary for SWAPO Party Elders' Council

Solidarity • Freedom • Justice

Appendix II

Autobiographical Profile of
Libertina Inaaviposa Amathila

Libertina Inaaviposa Amathila

Born in Fransfontein in the Kunene Region of Namibia

Education

Fransfontein School (preparatory classes)
Otjiwarongo School (primary)
Augustineum School, Okahandja (secondary)
Wellington College, South Africa (senior secondary)
Medical degree, Warsaw Medical Academy, Poland (1962-69)
Post-graduate Diploma in Human Nutrition, London School of Hygiene
 and Tropical Medicine (1970-71)
Post-graduate Diploma in Public Health, London School of Hygiene
 and Tropical Medicine (1977-78)
Diploma in French, Vichy, France (1980)
Diploma in Epidemiology, Bamako, Mali (1983)
Advanced Executive Programme, UNISA, South Africa (1992)
Financial Course for Non-Financial Managers, Columbia University,
 USA (1993)

Work and Politics

Joined SWAPO in 1962
Went into exile that same year through Bechuanaland, Southern and
 Northern Rhodesia, to Dar es Salaam, in Tanganyika
Joined SWAPO Central Committee (1969)
Director of SWAPO Women's Council (1970-76)
SWAPO Deputy Secretary for Health and Welfare (1970-89)
Medical internship at Mushimbili Teaching Hospital, Dar es Salaam,
 Tanzania (1969-70)
Medical internships in Sweden (1971-75)
Organizer of the clinic at SWAPO's Nyango centre in Zambia (1975-79)
Organizer of health projects in SWAPO settlements in Angola
 (1979-89)
 Director of the Natalia Mavulu Children's Centre at Kwanza Norte,
 Angola (1979-84)
 Founder and Director of the Morenga Village Children's Centre and
 Nursing School at Kwanza Sul (1984-89)

Returned to Namibia from exile after 27 years (September 1989)
Director of Health in SWAPO's Election Directorate (1989)
Member of the Constituent Assembly (November 1989 to February 1990)
Member of the National Assembly from 1990 to 2010
Member of the SWAPO Politburo since 1991
Minister of Regional and Local Government and Housing (1990-96)
> Initiated programmes for street children; housing for squatters; low-cost housing for low-income earners; the Build-Together Programme; tarring and electrification of streets in Katutura; an after-school centre for children, situated between Katutura and Khomasdal; the horseshoe market in Katutura; the market and low-cost housing in Rundu

Minister of Health and Social Services (1996-2005)
> Built new clinics in rural areas; started New-Start Centres for HIV/AIDS testing and counselling; started Anti-Retroviral treatment for HIV-positive patients; founded the Cardiac Unit at the Central Hospital in Windhoek although it was only completed after Dr Amathila became Deputy Prime Minister

Chairperson of the World Health Organisation's Regional Committee for Africa (1999-2000)
President of the World Health Assembly (2000-2001)
Deputy Prime Minister (2005-2010)
> Responding, on behalf of government, to emergency situations, creating settlements at Uitkoms farm and elsewhere, and development opportunities for the marginalized San people; and setting up three villages in Kunene for the 'mountain people' – the Ovatue – who were starving after prolonged drought in the area

Acting President of the Republic of Namibia on three occasions while serving as Deputy Prime Minister
Retired 21 March 2010

Languages

Fluent in English, Afrikaans, Otjiherero, and Nama-Damara (Khoekhoegowab). Dr Amathila also studied Polish, Swedish and French, but is no longer fluent in these languages because of lack of practice.

Awards

SWAPO's highest honour, the Ongulumbashe Medal for Bravery and
 Long Service (1987).

Nansen Medal (1991) – The first African woman to win this medal from
 the United Nations, in recognition of her work with women and
 children in the refugee camps before Namibia's Independence.

UN HABITAT Scroll of Honour (1993) and the Building Social Housing
 Foundation (BSHF) Award (1995), in recognition of her work in
 providing housing.

Most Excellent Order of the Eagle, first class, conferred by President
 Sam Nujoma at a ceremony to mark Heroes Day, on 26 August
 2002, at the opening of Heroes' Acre.